CHANGE IN BYZANTINE CULTURE IN THE ELEVENTH AND TWELFTH CENTURIES

D1649019

A. P. KAZHDAN AND ANN WHARTON EPSTEIN

CHANGE IN BYZANTINE CULTURE IN THE ELEVENTH AND TWELFTH CENTURIES

UNIVERSITY OF CALIFORNIA PRESS
Berkeley · Los Angeles · London

University of California Press
Berkeley and Los Angeles, California

University of California Press, Ltd.
London, England

Library of Congress Cataloging in Publication Data

Kazhdan, A.P. (Aleksandr Petrovich), 1922–
Change in Byzantine culture in the eleventh and twelfth centuries.

(The Transformation of the classical heritage; 7)
Includes index.
1. Byzantine Empire—Civilization—527—1081.
2. Byzantine Empire—Civilization—
1081-1453. I. Epstein, Ann Wharton. II. Title. III. Series.
DF601.K39 1985 949.5 84-188
ISBN 0-520-06962-5

Printed in the United States of America

1 2 3 4 5 6 7 8 9

TO FRIENDSHIP

CONTENTS

LIST OF ILLUSTRATIONS

FOLLOWING PAGE 136

ABBREVIATIONS

PERIODICALS

AB	*Analecta Bollandiana*
ABull	*Art Bulletin*
ADSV	*Antičnaja drevnost' i srednie veka*
AJA	*American Journal of Archaeology*
Arch.	*Archeologija*
BMGS	*Byzantine and Modern Greek Studies*
BS	*Byzantinoslavica*
Byz.	*Byzantion*
Byz. Bulg.	*Byzantinobulgarica*
Byz. Forsch.	*Byzantinische Forschungen*
BZ	*Byzantinische Zeitschrift*
CA	*Cahiers archéologiques*
DOP	*Dumbarton Oaks Papers*
EEBS	*Epeteris Hetaireias Byzantinon Spoudon*
EO	*Echos d'Orient*
GRBS	*Greek, Roman and Byzantine Studies*
IRAIK	*Izvestija Russkogo Archeologičeskogo Instituta v Konstantinopole*
Izv. Arch. Inst.	*Izvestija na Archeologičeskija Institut*
JÖB	*Jahrbuch der Österreichischen Byzantinistik*
PPSb	*Pravoslavnyj Palestinskij sbornik*
REB	*Revue des études byzantines*
RESEE	*Revue des études sud-est européennes*
TM	*Travaux et mémoires*

VOč	*Vizantijskie očerki*
VV	*Vizantijskij vremennik*
ZRVI	*Zbornik radova Vizantološkog instituta*

PRIMARY SOURCES AND COLLECTIONS

AASS	*Acta Sanctorum Bollandiana* (Paris, 1863–1940)
An. C.	Anna Comnena, *Alexiade*, ed. B. Leib and P. Gautier, vols. 1–4 (Paris, 1967–76)
Attal.	Michael Attaleiates, *Historia*, ed. I. Bekker (Bonn, 1953)
Ben. Tud.	Benjamin of Tudela, *Itinerary*, ed. and transl. A. Asher (New York, 1907)
Bibl. eccl.	A. Demetrakopoulos, *Bibliotheca ecclesiastica* (Leipzig, 1866)
Boissonade	J. F. Boissonade, *Anecdota graeca*, 5 vols. (Paris, 1829–33)
Bryen.	Nikephoros Bryennios, *Histoire*, ed. P. Gautier (Brussels, 1975)
Chr. Mytil.	Christopher of Mytilene, *Die Gedichte*, ed. E. Kurtz (Leipzig, 1903)
CMH	*Cambridge Medieval History*, vol. 4, part 2, ed. J. M. Hussey (1967)
Esp.	See Eust. *Esp.*
Eust. *Esp.*	Eustathios of Thessaloniki, *La espugnazione di Tessalonica*, ed. S. Kyriakidis (Palermo, 1961)
Eust. *Opusc.*	Eustathios of Thessaloniki, *Opuscula*, ed. Th. L. F. Tafel (Frankfurt, 1832; reprint: Amsterdam, 1964)
Fontes	W. Regel, *Fontes rerum byzantinarum*, vols. 1–2 (St. Petersburg, 1892–1917; reprint: Leipzig, 1982)
Hist. Ged.	Theodore Prodromos, *Historische Gedichte*, ed. W. Hörandner (Vienna, 1974)
Kek.	Kekaumenos, *Sovety i rasskazy*, ed. G. G. Litavrin (Moscow, 1972)
Kinn.	John Kinnamos, *Epitome rerum ab Ioanne et Alexio* [*sic*; should read: *Manuele*] *Comnenis gestarum*, ed. A. Meineke (Bonn, 1836)
Kosm.	L. Petit, "Typicon du monastère de la Kosmosotira près d'Aenos," *IRAIK* 13 (1908), 17–77

Lavra	*Actes de Lavra*, ed. P. Lemerle, A. Guillou, N. G. Svoronos, D. Papachryssanthou, vol. 1 (Paris, 1970)
Leo Diac.	Leo the Deacon, *Historiae libri X*, ed. C. B. Hase (Bonn, 1828)
Logoi dyo	Nicholas of Methone, *Logoi dyo*, ed. A. Demetrakopoulos (Leipzig, 1865)
MGH SS	*Monumenta Germaniae Historica, Scriptores*, ed. G. H. Pertz, Th. Mommsen, et al. (Hannover, 1826–1934)
Mich. Akom.	Michael Choniates, *Ta sozomena*, ed. S. Lampros, vols. 1–2 (Athens, 1879–80)
Mich. Ital.	Michael Italikos, *Lettres et discours*, ed. P. Gautier (Paris, 1972)
MM	F. Miklosich and J. Müller, *Acta et diplomata graeca*, vols. 1–6 (Vienna, 1860–90)
Nic. Kall.	Nicholas Kallikles, *Carmi*, ed. R. Romano (Naples, 1980)
Nic. Mesar.	Nicholas Mesarites, "Description of the Church of the Holy Apostles at Constantinople," ed. and trans. G. Downey, *Transactions of the American Philosophical Society*, n.s. 47 (1957), 857–924
Nik. Chon.	Niketas Choniates, *Historia*, ed. J. A. van Dieten (New York, Berlin, 1975)
Nik. Chon. *Orat.*	Niketas Choniates, *Orationes et epistulae*, ed. J. A. van Dieten (Berlin, 1972)
Opusc.	See Eust. *Opusc.*
PG	J. P. Migne, *Patrologiae cursus completus, series graeca* (Paris, 1857–66)
PL	J. P. Migne, *Patrologiae cursus completus, series latina* (Paris, 1840–80)
Poèmes prodr.	*Poèmes prodromiques en grecque vulgaire*, ed. D. C. Hesseling and H. Pernot (Amsterdam, 1910; reprint: Wiesbaden, 1968)
Ps. *Chron.*	Psellos, *Chronographia*, ed. E. Renauld, 2 vols. (Paris, 1926–28)
Ps. *Scripta min.*	Michael Psellos, *Scripta minora*, ed. F. Kurtz and F. Drexl, vols. 1–2 (Milan, 1936–41)
Reg.	F. Dölger, *Regesten der Kaiserurkunden des oströmischen Reiches*, vols. 1–2 (Munich, Berlin, 1924–25)

Reg. patr.	V. Grumel, *Les regestes des actes du Patriarchat de Constantinople*, vols. 2–3 (1936–47)
Sathas, *MB*	K. N. Sathas, *Mesaionike bibliotheke*, vols. 1–7 (Venice, Paris, 1872–94)
Scripta min.	See Ps. *Scripta min.*
Skyl.	John Skylitzes, *Synopsis historiarum*, ed. J. Thurn (Berlin, New York, 1973)
Skyl. Cont.	John Skylitzes, *He synecheia tes chronographias*, ed. Eu. Tsolakis (Thessaloniki, 1968)
Takt.	Leo VI, *Taktika*, *PG* 107 (1863), 672–1120
Theoph.	Theophanes, *Chronographia*, vol. 1, ed. C. de Boor (Leipzig, 1883; reprint: Hildesheim, 1963)
Theoph. Cont.	Theophanes Continuatus, ed. I. Bekker (Bonn, 1838)
Tzetzes, *Ep.*	John Tzetzes, *Epistulae*, ed. P. A. M. Leone (Leipzig, 1972)
Tzetzes, *Hist.*	John Tzetzes, *Historiae*, ed. P. A. M. Leone (Naples, 1968)
Zepos, *Jus*	J. and P. Zepos, *Jus graecoromanum*, vols. 1–8 (Athens, 1931)
Zon.	John Zonaras, *Epitome historiarum*, vol. 3, ed. M. Büttner-Wobst (Bonn, 1897)

ACKNOWLEDGMENTS

This work is a collaborative effort by a historian and an art historian that began in the spring of 1979. Alexander Kazhdan had then recently arrived from the Soviet Union to take a position at the Center for Byzantine Studies at Dumbarton Oaks in Washington, D.C.; Ann Epstein was still in residence there as a Fellow for the 1978–79 academic year. We drafted the first chapter together in the summer of 1979. Drafts of the other five chapters have made numerous journeys between Washington and Durham, North Carolina, generating in their rounds a great deal of scrap paper and fruitful argument. Our disagreements were, in fact, small; the areas of our agreement are vast. Most fundamentally, we believe that understanding is best gleaned through a synthetic approach to culture. The narrow borders of any discipline impose arbitrary limitations on history. In this era of increasing specialization, the stimulation and insight that come of working closely with a colleague in a neighboring discipline is one of the few remedies for the desiccation of the humanities. Our shared purpose and perspective was complemented by our mutual affection and respect.

Our work has entailed many debts. We both want to thank Peter Brown, editor of this series, and Doris Kretschmer of the University of California Press, and as well James Epstein, Robert Browning, Anthony Cutler, Charles Young, and Kent Rigsby, for their comments on various drafts of this work. Our collaboration was greatly facilitated by a grant from the American Philosophical Society, as well as by the Center for Byzantine Studies at Dumbarton Oaks and its director, Giles Constable. Elizabeth Mansell and David Page of the Department of Art at Duke

University and Charlotte Burk of the Photographic Archive at Dumbarton Oaks have kindly assisted us in the illustration of this volume. We particularly want to thank Mary Cash and Denise Franks for their care and patience in typing our manuscript. Ann Epstein wishes to express her gratitude to the Humanities Council of Duke University, who supported her leave from teaching responsibilities during the academic year 1981–82 with a faculty grant from the Mellon Foundation.

INTRODUCTION

When little is known of a society, whether it is distanced from us by time or by geography, there is a tendency to conceive of it as simple and static. Byzantium, that dark sphere at the eastern edge of medieval Europe, is regarded by even a well-educated layman as the immutable residue of Rome's decline, interesting for its resplendent decadence, intrigues, and icons. Battles and provinces might be won or lost, dynasties might end in a flurry of nose splittings and blindings, but the ideological construct remained unperturbed: a sumptuous still-life, a world of static values and changeless institutions. The assumption of Byzantium's changelessness grows from the West's bias for the rhythms of its own development: in comparison to the social and political upheavals of medieval Europe, the Eastern empire seems quiescent. This prejudice is, furthermore, complacently maintained because of a scarcity of sources from Byzantium and because of the conservatism of those sources that do survive. But all cultures, past or present, are rich in their complexities. That some societies are survived by less documentation than others does not mean that they were less complicated. An anonymous work of art is not necessarily cruder or more easily understood than one associated with a name or even with a personality; a culture cannot be judged immutable because it had no newspapers.

In an effort to modify this sensuously ponderous image of Byzantium, we have put our emphasis on change in the empire, change within the narrow bounds of the eleventh and twelfth centuries. By limiting the time-frame of our study, we can consider change on a human scale: we can look at material changes that occurred over decades as well as at abstract changes that occurred over centuries. The reader may feel in the

end that we have overdramatized the changes that took place in Byzantium. If we have, it is in a desire to stimulate discussion of both the structural shifts in the empire and the means of identifying these basic developments.

The sources for Byzantine history are limited. There are no clay tablet shopping lists or papyrus shipping accounts. Only a few monastic archives survive with documents concerning land donations and peasant taxes, and most of these date from the first half of the fourteenth century. The works of Byzantine historians are usually reliable, but often they provide information rather than insight, facts rather than perceptions. Developments in the form and emphasis of these histories have proved more useful for identifying changes in society than have the political events the historians recorded in them. Similarly, by their style and approach the authors of works in other literary genres, from poetry through encomia and saints' lives to foundation documents, unwittingly have provided glimpses into Byzantium's preoccupations. But largely because of its fragmentary nature, Byzantine literature is not an enviable resource for understanding the medieval East. Consequently, we have sought to supplement our evidence by considering less explicit media.

Our primary sources apart from literature are the material remains of Byzantium. Potentially the richest field of investigation is archaeology. Answers to questions of land and livestock use, as well as of urban expansion and dwelling modes, lie just below the surface of the Macedonian massif and of the Boulevard Ataturk. Unfortunately, there they are likely to remain until archaeological expeditions are better funded than they now are. Such information as has so far been gathered in the trenches we have incorporated into our analysis. The economic life of the empire, as reconstructed from the encrusted pocket money of the Rhomaioi, also figures in our overview.

But the part of the material culture of Byzantium that most absorbs our attention is its art. Byzantium's contribution to the stock of the world's great works has long been appreciated. Art historians have, however, tended to enshroud the empire in a cloak of artistic predestination, plotting its stylistic and iconographic path from antiquity to the fall of Constantinople. Its forms are often presented as having a life distinct from and, indeed, above that of the society that produced them. One architectural historian went so far as to remark, "How strange that such a decadent society could produce such great architecture." We do not believe that life and art are so separate. In the present study, manuscript illuminations, mosaics, buildings, and other art forms are treated as evidence for understanding social change. As with literature, we have at-

tempted to interpret in these forms not only shifts in subject matter but also reflections of the broader patterns of the culture. This way of looking at art is new to us. By no means have we seen all that can be seen. Our essay represents only an initial effort in using art as a historical document.

Three technical points must be mentioned. First, regarding the transliteration of Greek terms and names: following the old Roman principle, we have represented Greek letters by their Latin equivalents. Pronunciation has not been taken into account. Thus both *epsilon* and *eta* are represented by *e*, although in spoken medieval Greek they were pronounced differently; or again, the Greek *chi* has nothing to do with the English sound *ch* used in this book to render it. We also followed tradition by rendering the *upsilon* as *y*, rather than as *u*. Our treatment of Greek diphthongs is an exception to our basically graphic approach. It would be ridiculous to write *aytokrator*, considering such English forms as "automobile." We deviated from Latin principles by rendering the diphthongs *oi, ai,* and *ou* as such, and not as *oe, ae,* and *u* (e.g., *paroikoi, scholai*) and by using *k*, not *c*, for the Greek *kappa*.

Transcribing Byzantine names is even more problematic. We tried to preserve traditional forms for all geographic names: e.g., Athens, Constantinople. Familiar first names we tried to render as closely as possible to modern English: John, Nicholas, and Constantine, not Ioannes, Nikolaos, or Konstantinos. For rare first names and for family names that have no English equivalents, we applied the same principles as for the terms, e.g., Alexios and Psellos, not Alexius or Psellus. We did, however, retain conventional spellings for well-known last names, such as Comnenus and Palaeologus.

Second, because the points that we make from literature, like those that we make from monuments, require illustration, we have included texts as well as plates in this volume. Although both texts and plates might function better were they introduced into the book at the point at which they are discussed, such an arrangement is prohibitively expensive. Consequently they are gathered in two sections at the end of the work.

Finally, regarding references: because of the flood of scholarly literature, references threaten to outgrow the text. The danger is especially great in books, such as this one, that treat a broad range of subjects. We tried to control our appetite for references, not always successfully. We sought to place short references within the text itself and to avoid "explanatory notes," those minute monographs rarely relevant to the sub-

ject of the book. When they do occur in our volume, they are usually due to final revisions. Dates of emperors and other prominent individuals have been included in the index. We ask the readers' forbearance in respect to any failures of consistency and hope that they will remember how many more troublesome difficulties we had to overcome, being persons of different ages, backgrounds, and fields of study.

· I ·

BACKGROUND: FROM LATE ANTIQUITY TO THE MIDDLE AGES

RESTRUCTURING THE EMPIRE: THE SEVENTH CENTURY

No state titled Byzantium by either its population or its government ever existed. This conventional label appeared only in the sixteenth century, well after the fall of the empire. The people who inhabited the empire's towns and countryside in the Middle Ages continued to use the tradition-honored title, the Roman Empire (*basileia ton Rhomaion*), as their self-designation. The term *Byzantion* was applied only to the empire's capital, but even that usage was an affected anachronism, alluding to the remote past, since in 330 A.D. the old city of Byzantium on the Bosporus had been rededicated by Constantine the Great to his own glory as Constantinople. Contemporaries usually referred to the capital as "the imperial city" or, literally, "the queen of cities," the Greek word for "city" (*polis*) being feminine. The state was called Romania by its western neighbors and Rum by some of its eastern ones. And there are still scholars who prefer "the East Roman Empire" to "the Byzantine Empire." Since, then, no emperor, senate, or band of audacious rebels ever abolished the Roman Empire and introduced in its stead a new Byzantine state, any date chosen as marking the transition from Roman antiquity to medieval Byzantium remains as conventional as the name Byzantium itself. In their yearning for strict definition and exact chronology, scholars have identified this transition with certain events of political history, such as the inauguration of the city in 330 or the division

of the Late Roman Empire in 395. But neither date satisfactorily fixes a moment of transition. The division of the empire in 395 was by no means final, and Constantinople remained an imperial residence rather than the capital of the empire until at least the mid-fifth century. The essence of the matter is that the Late Roman Empire, despite all its alterations, remained an ancient state, with life focused on the city—the *polis* or *municipium*. Culture remained predominantly urban in character. The seventh century was more critical to the evolution of medieval society than was the fourth. It was then that, by and large, this ancient, urban way of life disappeared. Of course not all cities ceased to exist in the seventh century. Nor was urban decline limited to the seventh century; already in the sixth century, city life was losing its cultural importance. Moreover, the crisis of the ancient *polis* took different forms in different regions. The seventh century is simply a crude demarcation for this shift, though one with a rationale: the Byzantine Empire was differently clad after the seventh century than it had been before.

Many basic changes in the culture of the eastern Mediterranean occurred during this period. Numismatic evidence suggests that during the second half of the seventh century and throughout the eighth century a barter economy became increasingly important,[1] as it did in the West over the significantly longer time that has been disdainfully labeled the Dark Ages. Archaeologists have demonstrated the desertion of many provincial cities from the mid-seventh century onward. Even in Constantinople building activity was limited to modest repair work. The gap in literary production is particularly appalling: not only were historians silent after the middle of the seventh century, but even the hagiographers, writers in the dominant genre of the Middle Ages, cannot claim any notable literary achievements until the end of the eighth century.

Perhaps an analysis of the social background of the heroes of hagiography will shed some light on the shift in the seventh century. Many saints of the fourth to sixth centuries originated in an urban milieu— both in large cities such as Constantinople, Alexandria, and Antioch, and in smaller *poleis* like Emesa, Apameia, Perge, Edessa, and Chalcedon. Very few saints of this period can be shown to have been connected with the peasantry. Theodore of Sykeon, who died at the beginning of the seventh century, is harbinger of a change: he was a peasant himself, and

 1. C. Foss, "The Persians in Asia Minor and the End of Antiquity," *The English Historical Review* 357 (1975), 728–42; Ch. Bouras, "City and Village: Urban Design and Architecture," *JÖB* 31/2 (1981), 615.

his *vita* shows a close concern with the problems of the country life. Among saints of the seventh to ninth centuries a few may be associated directly with Constantinople, and fewer still with Thessaloniki. Smaller provincial towns rarely appear in the hagiographic scene. Theodore of Edessa and Elias the Younger of Heliopolis seem to be the only genuine townspeople within this group, but, quite typically, both of these saints lived beyond the imperial frontier. During the same period a significant number of saints stemmed from peasant families (e.g., David, Symeon, and George of Mytilene, Demetrianos of Cyprus, Euthymios the Younger, Ioannikios the Great, Philaretos), were children of country priests, or belonged to the country gentry. The provincial *polis*, so picturesquely described in the *vita* of Symeon the Fool,[2] virtually disappeared from hagiography after the seventh century; its absence corresponds to the disappearance of city life on the periphery of the empire.

The microstructures and cultural values of urban civilization similarly went into abeyance. Ancient civilization was open and public. City life concentrated on the marketplace, the theater, and the circus. It was found in the broad porticos flanking the main streets. In Byzantium all public forms of life were radically recast. Traditional city planning based on the Greco-Roman gridiron system was abandoned, and trading often centered on the narrow, organic alleys of medieval sites. The last defense of the theater was voiced in the sixth century—thereafter the theater was equated with paganism and with moral decadence.[3] The circus, too, was abandoned, or at least it lost its social significance. Public baths ceased to function. Not only were public libraries and "universities" closed, but the book itself acquired a new shape, the codex, better fitted for reference work and for individual use than the ancient roll, which required two hands to hold and which for the most part was read aloud. Silent reading without lip movement began to become more common around 400—St. Augustine was still amazed when he saw St. Ambrosius reading a book silently to himself.

Concurrently, basic social structures also changed. The family, so loose and feeble during the last centuries of the Roman Empire, became

2. L. Rydén, *Das Leben des heiligen Narren Symeon von Leontios von Neapolis* (Stockholm, 1963), used by A. P. Rudakov, *Očerki vizantijskoj kul'tury po dannym grečeskoj agiografii* (Moscow, 1917), 103f. and C. Mango, *Byzantium, the Empire of New Rome* (London, 1980), 64f. On the life of a provincial center, see also G. Dagron, *Vie et miracles de Sainte Thècle* (Brussels, 1978).

3. J. J. Tierney, "Ancient Dramatic Theory and Its Survival in the *Apologia mimorum* of Choricius of Gaza," *Hellenika*, parartema 9, no. 3 (1958), 259–74.

increasingly tightly knit from the sixth century on, functioning as the nucleus of society. The ancient *gens*, or clan, lost any significance, and even the usage of the *nomen gentile*, or family name, was abandoned. Practically, the nuclear family was the essential social microstructure, but ideologically the Byzantines went even further, proclaiming celibacy and virginity as the highest social ideal.

Life became increasingly constricted. In antiquity the typical upper-class dwelling had been open to nature. Even urban houses had centered on an *impluvium*, which introduced fresh air and rain into the interior; a small garden had also usually been part of the house, and, further, naturalistic floor mosaics and frescos had shown plants and animals indoors. In Byzantium the open habitat was apparently replaced by two- or three-story buildings with little interior open space. The only courtyard appears to have been that cut from the space of the public street, although the roof may have been used for domestic purposes. The ground floor seems to have been given over to utilities—storage rooms or even a donkey-drawn mill.[4]

Increasing self-isolation is also evident in the Byzantines' spiritual life. Religious ritual was progressively deprived of its public features. With the popularization of Christianity, religion was transferred from the open space of the public altar to the enclosed space of the church building. Perhaps to compensate, the church interior came to be interpreted by theologians and probably the people too as a microcosm; the annual, weekly, and daily liturgies represented the cyclical nature of time. Early ecclesiastical entries that had moved between the exterior and the interior of the church were incorporated within the structure. The scale of sanctuaries changed equally dramatically. The voluminous monuments of the sixth century had no counterparts of equal size in later centuries.

To condemn the seventh and eighth centuries as a Dark Age of decline and collapse would be misleadingly simplistic. Basic internal changes occurred under the tumultuous surface of history, processes so broad that they largely escaped the attention of contemporaries and still remain unclear to modern scholars. For instance, it may be plausibly suggested that the crisis of the urban civilization of the seventh century coincided with an upsurge of the importance of villages. Unfortunately the archaeological study of the countryside in Asia Minor or in Greece is

4. See the description of an urban mansion in Michael Attaleiates' *typikon* of 1077 (MM 5:297f.). On two-story houses in medieval Cherson, see A. L. Jakobson, *Rannesrednevekovyj Chersones* (Moscow and Leningrad, 1959), 185f.

in its infancy; work in the Crimea, however, indicates that the decline of Late Roman Cherson was concurrent with the flourishing of local villages in the eighth century.[5]

Diet and agriculture may also have changed. Little evidence survives concerning Byzantine food consumption. Nonetheless, a comparison of the figures established by E. Patlagean for bread consumption in the Late Roman Empire with those for the eleventh and twelfth centuries shows a sharp decrease in the amount of bread eaten.[6] This reduction may have been at least in part due to Byzantium's loss of Egypt and North Africa during the seventh century; these had been the two most important sources of grain in the Roman Empire. Other Byzantine granaries were also lost. Sicily was seized by the Arabs by the ninth century, and the steppes on the Black Sea coast were also removed from imperial control for a time. Did these changes lead to food shortages and an increased danger of starvation, or was the diminishing grain supply replaced by other varieties of nourishment? We can only speculate on the answer. Several registers available for Late Roman Asia Minor and neighboring islands show serious underdevelopment in sheep and cattle breeding. Yet at a later medieval date foreigners expressed surprise at the number of cattle in Byzantium and especially at the large herds on the Aegean islands.[7] If a change did take place, is it possible to determine when?

The Farmer's Law may provide significant reflections on change, although the document is notoriously problematic.[8] We know neither the' date nor the place of its promulgation nor what its exact nature was. Whether the Farmer's Law was a state regulation or a collection of local customs is unclear. Exactly how broad or narrow was the geographical sphere of its application is also unknown. It is generally recognized, however, that the Farmer's Law was issued sometime in the seventh or the eighth century. Since olive trees are not mentioned in the text, it is likely that the Farmer's Law related to inland areas (of Asia Minor?). The lack of any mention of horses and the frequent references to wild beasts and forests suggest a mountainous region. In any case, the Farmer's Law

5. A. L. Jakobson, *Rannesrednevekovye sel'skie poselenija Jugo-Zapadnoj Tavriki* (Leningrad, 1970), esp. 146 and 181. Some remarks on the countryside in Messenia have been made by J. Rosser, "A Research Strategy for Byzantine Archaeology," *Byzantine Studies* 6 (1982), 117–22.

6. A. P. Kazhdan, "Two Notes on Byzantine Demography of the Eleventh and Twelfth Centuries," *Byz. Forsch.* 8 (1982), 117–22.

7. See below, Chapter 2.

8. P. Lemerle, *The Agrarian History of Byzantium* (Galway, 1979), 27–67.

does apply primarily to those peasants engaged in cattle breeding. Not only does the number of entries dedicated to cattle breeding outstrip those related to farming, but also it occupies a privileged position: cattle breeding is the only occupation still involving slave labor. Further, in the case of damage caused by a domestic animal, the law protects the owner of the animal rather than the owner of the field or vineyard. This has a parallel in the Western *leges barbarorum*, which also favored livestock owners. Bulgarian excavations provide some further evidence of increased cattle breeding in Byzantium (see Chapter 2, pp. 29 ff.).

Along with the crisis of urban life and the basic economic shifts in Byzantium there occurred a simplification of the social structure. The *curiales*, the elite of provincial cities, disappeared after the seventh century; moreover, there is no evidence from the eighth century of the continued existence of large estates. The only document that can be cited in this connection is the *vita* of St. Philaretos, written by the saint's nephew Niketas of Amnia.[9] From information in his *vita*, Philaretos appears to have been a wealthy landlord: he is said to have had about fifty estates (*proasteia*) and numerous herds of cattle (the figures are slightly different in the two surviving versions of the *vita*). If these *proasteia* had been comparable to later estates, and if his herds had been large, then Philaretos would indeed have been a rich man. But the fact is, all fifty of Philaretos's estates were located within a single village, Amnia, and all his herds grazed on the grass around the same village. Further, although Philaretos possessed the roomiest and the most beautiful house in the village, his life was not one of leisure. He appears in his *vita* plowing his allotment along with other members of the village. Any evidence of wealth provided by saints' *vitae* must be treated cautiously.

Not only are provincial elites and their estates absent from eighth century sources; so also are the dependent peasantry (*paroikoi*). An *argumentum ex silentio* is always very weak; a decline, however, in the number of dependent peasants in the eighth century is suggested by a general unfamiliarity with the terms for them when they do reappear in the second half of the ninth century. When Byzantine legislators tried to reintroduce Roman law (as discussed below, p. 16), they used Roman designations for dependent peasants without understanding their original meanings. Even the term *paroikoi*, known during the Late Roman period and eventually used for the major group of dependent villagers, was conceived in the eighth and ninth centuries only in its Biblical sense, "stranger" or "tenant."

9. On this *vita*, see J. W. Nesbitt, "The Life of S. Philaretos (702–792) and Its Significance for Byzantine Agriculture," *GRBS* 14 (1969), 159–80.

While provincial urban life disappeared and rural society was sim-
plified, there was some continuity of social organization in the capital.
Most notably, elements of the state bureaucracy survived. The ruling
class seems to have been unstable, loose, and fraught with the insecuri-
ties of vertical mobility. Only rarely did children inherit their fathers' ad-
ministrative positions. At least within the imperial circle relatives were
regarded as competitors rather than as—later—the natural supporters
of the ruler. Thus it appears that the first concern of an emperor was to
mutilate his brothers and uncles in order to frustrate their ambitions.
The history of the seventh century is full of the bloody maiming of impe-
rial relations. Among the more bizarre instances of this habit is that of
Justinian II, whose nose was cut off after his deposition, but who man-
aged to regain the throne and take his revenge on those who had de-
throned and mangled him.

It is very hard to determine the values held by this unstable elite offi-
cialdom. Neither noble origin, nor martial prowess, nor fealty, nor large
landholdings, nor trade profit were regarded in themselves as virtues.
Saints' *vitae* sometimes mention the noble origin of their subjects and
the wealth of their parents, but this may be a *topos*. Theophanes, the
leading historian of the early ninth century, is very careful in his use of
the term "noble" (*eugenes*). According to Maximos the Confessor's *vita*,
the saint belonged to an ancient and noble family, yet this noble heritage
is not mentioned by Theophanes. In contrast, Theophanes calls Muham-
med's spouse *eugenes*, although he could not have intended to flatter the
wife of the Moslem "pseudo-prophet." Nor was Theophanes enamored
of military heroism; for instance, he did not hesitate to describe victories
won by Constantine V, whom the historian styled "dung-named"
(*kopronymos*), the "worst" among the hated Iconoclast emperors. Mer-
cantile activity was also regarded as valueless. In the mid-ninth century
Emperor Theophilos ordered the ship of his wife, Theodora, to be
burned with all its freight. He was disgusted with the empress's trading
interests and wished to avoid being called "shipowner" or "captain."

Contemporary definitions of the Byzantine elite are very rare, espe-
cially in this period. Therefore an edict issued by Empress Eirene that
classes elites is particularly valuable. She included in her group of
"honorable" persons the clergy, two strata of officials (the *archons* and
the so-called *politeuomenoi*), soldiers, and those who lived in piety.[10] In
fact, piety remained the only universally acknowledged value of social
ethics; it tended to be substituted for all the fragile, mundane values of

10. L. Burgmann, "Die Novellen der Kaiserin Eirene," *Fontes minores* 4
(1981), 20.54–56.

the ancient world. The image of the holy man as an ideal of social behavior acquired tremendous significance. Although this image was a creation of an earlier age, it had grown enormously in stature by the eighth century, even overshadowing the image of the ideal emperor.[11] Concurrently, the eighth century witnessed the expansion of the cults of relics and of icons—a veneration that at times took peculiar and exaggerated forms.

Because urban centers contracted and the provincial "small aristocracy" practically disappeared, there was no stable layer between the bureaucratic elite of the capital, supported by salaries, imperial grants, extortions, and bribes, and the working population, which consisted largely of legally independent peasants. Peasants formed the village community, but the integrity of the Byzantine village community remained rather loose. The Byzantine countryside, which is for the most part stony and hilly, supported labor-intensive agriculture (vineyards, gardens, olive trees).[12] With irrigation rarely and poorly used and transhumance common, conditions did not favor any form of collective labor or collective supervision of fields. Peasants' lots were surrounded by ditches and stone walls; there is no hint of an "open-field" system. The plow was light and wheelless, of the so-called *ard*-type, requiring only two oxen (in contrast, eight-oxen teams were common in northern Europe). In the East, consequently, peasants had no reason for pooling their efforts to till the soil. The basic social unit of the countryside was the nuclear family supported by close relatives and neighbors. Neighbors might even obtain an enlarged usufruct, including the rights to mow grass or collect chestnuts on neighboring allotments. The village could act communally at fêtes and in danger, but this unity was not organic, and the community was atomized, consisting of isolated families.

The wealth of Byzantium was dependent largely on the peasants. Of course, no figures exist by which their agricultural contribution to the Byzantine economy can be calculated, but the general impression is that from the seventh century the role of craft and trade diminished significantly. The number of coins, especially copper pieces, in circulation, di-

11. P. Brown, *Society and the Holy in Late Antiquity* (Berkeley and Los Angeles, 1982), esp. 103–52 and 251–301.

12. No comprehensive survey of Byzantine agriculture has yet been published. Enormous but unsystematized material is presented by Ph. Koukoulès, *Vie et civilisation byzantines* 5 (Athens, 1952), 245–343. Also see A. P. Kazhdan, "Iz ekonomičeskoj žizni Vizantii XI–XII vv.," *VOč* 2 (Moscow, 1971), 186–95; J. L. Teall, "The Byzantine Agricultural Tradition," *DOP* 25 (1971), 33–59.

minished as well, suggesting that Byzantine country life from the seventh to the ninth centuries was based more on a barter economy than on money.

The peasants were both the taxpayers and the protectors of the frontier. The Roman fiscal machine seems to have decayed by the seventh century; how taxes were collected after that time is unclear. At any rate, *municipia* ceased to be centers of fiscal organization, and representatives of the Constantinopolitan administration assumed the responsibility of gathering taxes. Since revenues were collected primarily in coin, of which there was a severe shortage, peasants often had recourse only to usurers; consequently, tax collectors and moneylenders became the principle objects of the people's hatred. Many peasants further supported the empire as soldiers. Despite the fact that the empire was almost continuously at war, there was no professional army. The bulk of the rather large Byzantine army consisted of the so-called *stratiotai*, whose duty it was to serve during military campaigns or enemy invasions. They supplied their own horses and weapons. During periods of peace, however, these same men worked their fields and vineyards. Their property was not significantly larger than a peasant's; this made their burden particularly onerous. Even the scanty surviving sources occasionally preserve the complaints of poverty-stricken warriors.

Other social and political forms show a general trend toward simplification. During the seventh and eighth centuries Byzantium was divided into new territorial units called *themata*, or themes. The themes coincided neither territorially nor administratively with Late Roman provinces. In contrast to the sophisticated network of civil and military officials in Late Roman provinces, themes were ruled by a single governor (*strategos*) who functioned as judge, tax collector, and commander of the local militia. Restrictions were imposed to limit the powers of the governor: the post could not be inherited, the *strategos* was not allowed to acquire lands within his theme, and the central government tried to move *strategoi* constantly from one theme to another. Nevertheless, by the beginning of the eighth century, these governors had managed to assume considerable independence and influence. The political chaos of the beginning of the eighth century was apparently caused principally by the *strategoi* of the larger themes, who embroiled the empire in civil wars in their lust for the throne. Especially powerful were the great themes of Anatolikon, Armeniakon, Thrakesion, and Opsikion.

The Byzantine peasantry of the eighth and ninth centuries had also become uniform. Whereas Libanius in the fourth century might assert

that slaves were ubiquitous, and John Chrysostom, in his treatise *On Vainglory*, used terms for slaves more frequently than those for God, slaves had evidently become quite rare at the time of the Farmer's Law. Nor is there any trace of *coloni*. Some peasants were richer, some poorer; some could not till their lots and instead let them to more substantial villagers for a sort of rent; some preferred to work on the soil of another, usually as shepherds. Although these hirelings, *misthioi* or *misthotoi*, had a low social status, they were nevertheless free people. Their lack of dependability was notorious: the verse of Saint John's Gospel 10:13, "The *misthotos* fleeth because he is a hireling, and careth not for the sheep," was often quoted by Byzantine authors.

This period of disruption of old social links was simultaneously one of titanic external menace. While the invasions of the Germanic tribes and the Huns, however, destroyed the western half of the empire, Constantinople survived this bitter initial onslaught. Later invaders from the north, such as the Avars, Slavs, and Bulgars, were less a threat to Constantinople. The Avars disappeared unexpectedly; some Slavic tribes invaded, settled on Byzantine territory, and were subsequently slowly hellenized; other Slavs created independent states on the frontier of the empire. From the seventh century onward, the greatest danger to the empire came not from the north, but rather from the east. First, the Persians threatened the existence of Byzantium, and just when that danger had been repulsed by Emperor Heraclius, the Arab invasions began. The Arabs conquered the Byzantine provinces of Syria, Palestine, Egypt, Cyrenaica, and Africa, and even attempted to seize Constantinople itself. In eastern Asia Minor between the empire and the Caliphate a large no-man's-land was inhabited by an ethnically and religiously mixed population. Here Moslems, Orthodox Christians, Monophysites, Arabs, Syrians, Greeks, Armenians, and Georgians lived side by side.

All these invasions changed the character of the provinces but did not destroy the empire itself. Byzantium emerged from the crises of the "Dark Ages" more rapidly than did the western part of the ancient Roman Empire. It was never completely overwhelmed by the barbarian onslaught, and consequently the old political, economic, and cultural traditions were less thoroughly disrupted there than in Gaul or in Spain. While there is no reason to assume absolute continuity in Byzantium, fragments of antiquity were more available in the East than in the West. Nevertheless, although the military dangers of the seventh and eighth centuries did not end in collapse, they contributed both to the political chaos of the empire and perhaps also to a consolidation of the most resistant social structures.

RECONSOLIDATION:
THE NINTH AND TENTH CENTURIES

Numismatic evidence indicates that an economic revival began in the first half of the ninth century, primarily in Constantinople and the coastlands of the Aegean Sea.[13] Culture began to revive around 800. One of the signs of its revival was the invention of a new, more rapid means of writing, the minuscule script. The introduction of a faster mode of lettering reflected an increased demand for literature. The milieu of this cultural revival was consistently monastic: among the intellectuals of the first half of the ninth century, the vast majority were "professional" monks and nuns, that is, persons who assumed the habit in their youth, usually in their twenties, rather than on the verge of death. Theophanes, Theodore of the Studios, Joseph of Thessaloniki, Kassia, Niketas of Amnia, Patriarch Methodios—almost all the great names of the time (perhaps with exception of only Patriarch Nikephoros and Deacon Ignatios) belong to this category. The Monastery of Studios was probably the most important center of this early revival.

This monastic revival—which cannot in any way be called a renaissance—seems to have developed in reaction to Iconoclasm, an anti-image movement lasting between 730 and 843 that embodies ideological and political perspectives then current in Byzantium. Concern over the worship of icons is expressed as early as the fourth century A.D. Already at that time the principal positions of the debate had been defined; the arguments relating to images were derived from the ancient philosophers. Both the Iconoclasts ("image-breakers") and the Iconodules ("icon worshipers") of the eighth and ninth centuries adopted the fourth-century formulas; the most notable feature of the controversy was not the originality of the opinions expressed but the emotional tension and violence of the debate. What in the fourth century had been an academic question became from 730 onward a locus of social and cultural confrontation. Why?

Iconoclasm of the eighth and ninth centuries was directed, first and foremost, against monastic institutions. Leo III and Constantine V, the great Iconoclast emperors, along with their followers, did not seek to acquire monastic lands, since there was no extensive monastic landownership at the time. Nor did they desire the accrued wealth of the monasteries. New regulations were not directed at the confiscation of gold, silver, and precious stones but rather were aimed at the abolition

13. D. M. Metcalf, *Coinage in the Balkans. 820–1355* (Thessaloniki, 1965), 17–29.

of the monastery as an institution. The Byzantine monastery as established by Pachomius and Basil the Great in the fourth century and developed by Theodore of the Studios about 800 was a *koinobion*, a community of brethren who not only slept, ate, and prayed together but also worked together. Theodore's regulations describe minutely the vineyards and kitchen gardens, ateliers, and scriptoria that belonged to the Studios; the monks themselves provided the labor.[14] In the atomized Byzantine society of the eighth century the *koinobion* formed an odd social group bound internally by stable and perpetual if not organic links. It contradicted Byzantine social order.

The Iconoclasts did not simply attempt to abolish the institution of monasticism, they obviously tried to replace the *koinobion* by the most individualized microstructure possible—the nuclear family. When Michael Lachanodrakon, the *strategos* of Thrakesion and one of the most enthusiastic supporters of Constantine V, closed the monasteries in his theme, he pressed monks and nuns to marry each other. Theophanes relates that Lachanodrakon gathered all the monks and nuns of Thrakesion in the plain of Tzykanistrion near Ephesus, ordering the monks to clothe themselves in white and immediately choose wives. Those who would not obey he threatened to blind and exile to Cyprus. He also ordered the sale of monastic possessions, including lands, holy vessels, books, and cattle; the wealth thus gathered was presented to the emperor. Those books that dealt with monastic customs, including the stories about Egyptian and Syriac founders of monasticism (*paterika*) were burned along with the relics of the saints. Many of the "stubborn" monks were whipped and mutilated (Theoph. 1.445f.). Although it is hard to determine to what extent Theophanes exaggerated out of hatred for the Iconoclasts, the marriage ceremony did in fact take place. This was not simply a sort of mockery; it reflects the structural urge for social atomization.

The veneration of icons and relics was in essence a collective experience: icons and relics were not only adored by the mass of believers, they also excited collective emotions. Pope Gregory the Great stated that icons were "books" for the mass of illiterate Christians. The veneration of icons in Byzantium was very different from the quiet contemplation of sacred images assumed on the basis of the religious habits of the twentieth century. The power exhibited by icons through miracles, like that shown by relics, was predominantly public. The icon participated in

14. On the Studios's economy, see A. P. Dobroklonskij, *Prep. Feodor, ispoved-nik i igumen studijskij* 1 (Odessa, 1913), 404–19.

battles, defending Byzantine cities and extending the empire's territories; icons were carried by armies, paraded by clergy and populace around the walls of beleaguered towns, and prominently displayed in the triumphs of victorious emperors. The communal nature of the icon was apparent in the first Iconoclastic gesture of Emperor Leo III: the removal of the image of Christ from above the so-called Brazen Gate, the main entrance to the Great Palace—the most public of places. His action caused a riot. Emperor Michael II, a lukewarm Iconoclast, noted in his letter to Louis the Pious that icons were not to be destroyed, but rather reset higher in the church so that in their frenzy the pious would not worship them as idols. This again is indicative of the communality of the image as well as of its potential power. Thus, not surprisingly, it was during the struggle over the veneration of icons that the emotions of the people reached a crescendo. In contrast, the act of Communion, on which the Iconoclastic idea of salvation concentrated, was highly individualistic. By taking the consecrated elements, the celebrants partook individually of the Lord's flesh and blood. They were each isolated from the throng; they each personally merged with the Divinity.

Individualization of worship and, accordingly, of salvation, is only one side of Iconoclasm. Another major consequence of the movement was an increasingly important role for the emperor both in civil administration and in ecclesiastical matters. During a period of political and military difficulties, the problem of imperial power acquired great significance. Leo III, who initiated Iconoclasm, wrote to the pope that he considered himself not only an emperor, but also a priest (*Reg.* 1: no. 298). The elevation of the authority of the emperor over that of the church was combined with a campaign against the cult of saints. The image of the holy man created in late antiquity as a denial of Greco-Roman values and virtues was a dangerous rival for imperial propaganda; his veneration was to be restricted.[15] In their attack on icon worship, the Iconoclasts accused their adversaries of the Nestorian heresy, averring that worshipers of icons venerated the human aspect of Christ, His divine nature being inconceivable and undepictable. No such charge could be raised against the veneration of the icons of saints; nevertheless the Iconoclasts strove also to abolish the cults of the icons and of the relics of saints.

In 843 the government of Empress Theodora restored the veneration of icons. But the Iconodules were only apparent victors. Certainly images were returned to the churches, but it was the Iconoclasts' social

15. Brown, *Society and the Holy*, 290f.

principles that became increasingly dominant. This is particularly clear in intellectual life: formerly controlled by monks, Byzantine culture in the ninth and tenth centuries became predominantly secular. After George Hamartolos, the historian of the 860s, there was not one significant monastic figure among Byzantine writers until Symeon the Theologian, about 1000. Significantly, also, the Byzantine monastery was losing its cenobitic form. The monastic community of working brethren gave place to individualistically structured *lavras* (gatherings of hermits) and small monasteries dependent upon state grants in kind and in money (*solemnia*). The ideal of the poor brotherhood was very popular in the tenth century, when Emperor Nikephoros Phokas supported the recently founded communities on Mount Athos, with their ideal of the monastic denial of property. He could not have imagined that these *lavras* would eventually accumulate immense estates and numerous *paroikoi*. The tendency toward individual isolation was also reflected in the emphasis on personal means of salvation that developed during the tenth century. The teachings of Symeon the Theologian epitomized this disposition. Symeon proclaimed a vision of divine light and personal inspiration, somewhat minimizing the efficacy or sufficiency of the sacraments. Further, he rejected basic social ties such as friendship and even the family, considering mortals as standing lonely and naked before the majesty of God and of the emperor (see Chapter 3, pp. 90 ff.).

It might well be suggested that it was the emperor who gained most from Iconoclasm. The Byzantine church was made subject to imperial power. After the end of the ninth century, emperors twice placed the patriarchate within the imperial family. Leo VI set his brother Stephen on the patriarchical throne, as did Romanos I Lakapenos his son Theophylaktos. The idea of the emperor-priest as expressed by an Iconoclast emperor found its realization, albeit in a slightly altered form, after the defeat of Iconoclasm.

The emperors of the ninth and tenth centuries not only won a victory over the monastery and the church; they also assumed a fundamental role in the consolidation and reorganization of the empire after the chaos of the seventh and eighth centuries. The ninth and tenth were "imperial" centuries; their intellectual character has been appropriately titled "encyclopedic" by Paul Lemerle.[16] An enormous effort was made to systematize the received intellectual tradition. Initially, there was a phase of transmission: ancient manuscripts were collected and recopied in minuscule script. Editions of the Greek classics, including Homer, the

16. See the concluding chapter in P. Lemerle, *Le premier humanisme byzantin* (Paris, 1971), 267–300.

tragedians, Plato, and Aristotle, were produced at this time. Concurrently the ancient heritage was surveyed. Encyclopedism can be dated from Photios's *Myriobiblon*, a bibliographical description of more than three hundred works of ancient historians, geographers, philosophers, theologians, rhetoricians—only poets did not gain a place in his collection. This phase ends with a famous lexicon preserved under the conventional title *Souda*. There were further collections of fragments gathered for Emperor Constantine VII Porphyrogenitus: *On Embassies*, *On Virtue and Vice*, *On Plots against Emperors*, and so on. An anonymous author produced the *Geoponika*, a compilation from Greek writers on agriculture also sponsored by Constantine VII.

The encyclopedism of the ninth and tenth centuries also fulfilled more practical tasks. A great many works considered the administrative system. Constantine Porphyrogenitus, with the help of learned aides, produced three major books—on the themes of the empire, on the goals of Byzantine diplomacy, and on the ceremonies of the imperial court. The last subject was also elucidated in a series of the so-called *taktika*, whose authors are anonymous, excepting a certain Philotheos who finished his *Kletorologion*, a manual of court life, in 899. This literary genre first appeared around 842 and did not survive beyond the end of the tenth century. Lists of officials, whose authors attempted to reconcile the administrative tradition with the late Byzantine reality, appeared again only in the fourteenth century. The same chronological limits apply to military *taktika* and *strategika*. Emperor Maurice or an anonymous contemporary was the last of a series of Late Roman writers on military science. After a silence lasting from the seventh through the ninth centuries, Leo VI revived the genre in about 900 by producing his *Taktika* in imitation of Maurice's work. Throughout the tenth century the genre of military manuals continued to flourish; some of these treatises may be ascribed to Nikephoros Phokas, some remain anonymous. Nikephoros Ouranos, a courtier and military commander under Basil II, was probably the last to write about the military arts: after 1000 this genre disappeared, as did the *taktika* of the imperial court. Similarly, although the two surviving instructions to tax collectors are not precisely dated, they too may best be assigned to the tenth or early eleventh century.[17]

17. The first of them was published by W. Ashburner and later by F. Dölger, *Beiträge zur Geschichte der byzantinischen Finanzverwaltung* (Munich, 1927; reprint: Darmstadt, 1960), 113–23; the second by J. Karayannopoulos, "Fragmente aus dem Vademecum eines byzantinischen Finanzbeamten," *Polychronion*, *Festschrift Franz Dölger*, ed. P. Wirth (Heidelberg, 1966), 321–24. For an English translation, see C. M. Brand, "Two Byzantine Treatises on Taxation," *Traditio* 25 (1969), 35–60.

Important also was the reconsideration (reception) of Roman law, or as the Byzantines put it, the "cleansing" (*apokatharsis*) of the law. Leo III in 726 attempted to substitute his brief *Ekloge* for the voluminous *Corpus* of Justinian. He introduced substantial changes in both the marriage and the penal code. Legislators of the ninth and tenth centuries condemned and rejected the Iconoclast emperor's efforts, even though several principles presented in the *Ekloge*, particularly the new approach to marriage and the family, were generally accepted. In contrast to Leo III's concise codification, Leo VI promulgated a gigantic bulk of sixty books, the *Basilika*, which consisted largely of translations from Justinian's *Corpus*, including even some obsolete legislation. Minor legislative works of the epoch (*Procheiron*, *Epanagoge*, and others) were also based more or less on Roman law.

Ecclesiastical setting and ritual were probably also regularized. While regional variations continue to be found, church architecture and decoration acquired a greater homogeneity in form and scale after 900. Ecclesiastical structures were small, often with tripartite sanctuaries, and commonly of the so-called cross-in-square plan. This plan, which remained popular in Byzantium throughout the High Middle Ages, had a square nave divided internally into nine bays covered with a central dome, lower barrel vaults over the transverse and longitudinal bays, and groin vaults or cupolas over the corner bays. The pyramidal space thus constructed was adorned with images of the Godhead, the Virgin, angels, prophets, and saints, arranged hierarchically according to their status. The liturgy also became more consistent. One of the major civil administrators of the end of the tenth century, Symeon Metaphrastes, compiled a monumental collection—again, a collection—of saints' lives for ecclesiastical feasts.

Imperial regulation was generally extended throughout the empire during this period. This is reflected in attitudes toward state lands. While Late Roman imperial estates have been repeatedly investigated by scholars, there has been as yet no thorough examination of the scattered sources concerning imperial property in the tenth century. In theory, the Byzantines drew a strict line between state and royal property, though it cannot be assumed that this strict distinction existed in practice. Leo VI in his Novel 51 differentiated quite clearly between *basilikon*, *demosion*, and private land. But the distinction disappeared when it came to practical problems. For instance, law required that a treasure found on private soil should be divided equally between the proprietor and the finder; if, however, the land on which the treasure was discovered belonged to the state or to the emperor, it was in both cases the *demosios*,

the treasury, that received half.[18] Thus, at least in this case, no real distinction was made between the *basilikon* and the *demosion*.

There is unfortunately no way to calculate what percentage of the cultivated land in the empire belonged to the imperial demesnes. It seems likely, however, that imperial possessions increased during the second half of the ninth century and throughout the tenth century. Emperor Basil I is said to have been bequeathed eighty estates (*proasteia*) by Danielis, a rich widow in the Peloponnese (Theoph. Cont. 321.9); perhaps she was an independent ruler there. When in 934 the Byzantine army moved eastward and conquered the region of Melitene, Emperor Romanos Lakapenos ordered the newly acquired territory be transformed into an imperial curatory, from which he received considerable silver and gold (Theoph. Cont. 416.23). Imperial estates are commonly mentioned in various sources of the tenth century. For instance, in the *vita* of St. Paul of Latros imperial estates in Thrakesion are mentioned as being administered by a certain *protospatharios*;[19] the title had extremely high status at that time, being awarded to theme governors. New curatories were created around 900: Basil I, according to his panegyrist and grandson Constantine Porphyrogenitus, was not inclined to spend state resources on his private needs; he therefore decided to establish the "curatory of Mangana," which provided special agricultural revenues destined for imperial feasts (Theoph. Cont. 337.1–10). Probably during Romanos Lakapenos's reign the "curatory of the palace of Lord Romanos" was created for much the same reason. Numerous officials were kept busy administering imperial estates: curators, *ktematinoi*, *episkeptitai*, and *epi ton oikeiakon*, among others.

Further, in the tenth century the Byzantine state proclaimed its supreme right over all the lands of the empire. Leo VI in his Novel 114 asserted that property throughout the Byzantine Empire (*pan akineton*) was *hypodemosios*, that is, literally, "put under the treasury" or "due to taxation." Did Leo consider *pan akineton* to be in some sense state property, or simply taxable property? He clarified his position further by stating that private property was allowed to individuals who fulfilled state "burdens." Basil II in the Novel of 996 affirmed that the claims of the exchequer could not be denied through reference to *praescriptio longis temporis*: the emperor had the right to reclaim all lands that had at any time belonged to the state, even if they had been in private hands since the time of Augustus (Zepos, *Jus* 3: 315.20–23). Whether or not the notion of

18. P. Noailles and A. Dain, *Les novelles de Léon VI le Sage* (Paris, 1944), 197.21–24.

19. *AB* 11 (1892), 138.18.

the *dominium directum* could be applied to the Byzantine concept of state ownership of land is controversial. Two important points, however, are evident: the Byzantine state possessed rights to most of the taxes on the population, and the state could confiscate estates of any magnate, whether lay or ecclesiastical.

The levies collected by the state did not differ essentially from those of private lords: state *corvées* included the building of fortifications and ships, construction of bridges and roads, and the cutting of forests.[20] The billeting of imperial envoys, of commanders, and of foreign ambassadors, and even of the emperor and his court was a special form of compulsory service. The population was also obliged to serve the *cursus publicus*, or imperial post—special stations provided with horses were situated throughout the empire. In addition to various other services the Byzantine peasantry was also obliged to supply both the emperor and the administration with a variety of stores such as fish, fodder, grain, and cattle. Storehouses were built under the supervision of *oriarioi*. Notable among the numerous seals of Byzantine *oriarioi* of the tenth and eleventh centuries is that of the *notarios* Constantine, titled "*oriarios* of holy [i.e., imperial] wares" in the town of Kios in Bithynia.[21] Finally, the state demanded tax payments in cash, most particularly the so-called *kapnikon*, a levy on each house or fireplace.

To fulfill state requirements, the population was divided into several special categories according to their rent or service, both military and agricultural. Some sense of these divisions was conveyed by the twelfth-century historian Zonaras in his criticisms of Emperor Nikephoros Phokas's exorbitant taxation. The emperor's tax collectors, wrote Zonaras, wrongly forced people into tasks above their station. Peasants had to assume the duties of the *cursus publicus*; those obliged to serve the *cursus publicus* were listed as sailors, the sailors as infantry, the infantry as plain cavalry, and the plain cavalry as armored cavalry, the *kataphraktoi*. By so doing, summed up Zonaras, the state increased the burden on each taxpayer (Zon. 3.502.5–9).

The last four groups mentioned in Zonaras—sailors, infantry, plain cavalry, and *kataphraktoi*—were all known by the common term *stratiotai*, "soldiers." In the imperial edicts of the tenth century, *stratiotai* appear as holders or owners of special plots, so-called soldiers' holdings. This

20. On Byzantine taxation, A. P. Kazhdan, *Derevnja i gorod v Vizantii IX–X vv.* (Moscow, 1960), 142–74; G. G. Litavrin, *Vizantijskoe obščestvo i gosudarstvo v X–XI vv.* (Moscow, 1977), 196–236; S. Vryonis, "Byzantium: The Social Basis of Decline in the Eleventh Century," *GRBS* 2 (1959), 157–75.

21. V. Laurent, *La collection Orghidan* (Paris, 1952), no. 11.

form of property is not mentioned in any source of the previous century and therefore may be regarded as an innovation. The law of Constantine VII describing these holdings as the basis of the soldiers' livelihood and their means of equipping themselves prohibited alienation.[22] Constantine added that sailors of the imperial navy should possess allotments valued at no less than two pounds of gold, while cavalry soldiers and the marines of the themes should have plots at least twice that size. But their landholdings were not enough to assure security; the loss of a horse could mean the ruin of a soldier's family. Theophanes Continuatus related the story of a general who seized the horse of a *stratiotes* as a gift for the emperor; the soldier, deprived of his most substantial property, died and left his children beggars (Theoph. Cont. 92f.). Though Leo VI's *Taktika* (*PG* 107.672–1093) characterized *stratiotai* as well-to-do (para. 4:1), in fact they were hardly better off than the normal peasant. Leo made it clear that agriculture was the main occupation of the *stratiotai*. If they were summoned for a military expedition, they were required to arrange for someone else to till their soil in their absence. Leo emphasized further (para. 20:71) that *stratiotai* had to pay state tax as well as the *aerikon*, a special judicial payment; they had to be compensated, however, if they were drafted for construction *corvées*. Thus while the distinction between the soldier and the peasant was vague, it did nevertheless exist. Leo's *Taktika* (para. 11:11) put this distinction in social terms, stating that there were two occupations necessary for the flourishing of the state: peasant labor, which nurtured soldiers, and military activity, which defended the peasantry. A similar formulation is found in Romanos Lakapenos's Novel of 934: the payment of taxes and military service are the two pillars of the state (Zepos, *Jus* 3:247.9–13). Basically the *stratiotai* were soldiers; the peasants, *georgoi*, were the taxpayers.

The peasantry, like the military, was divided into several categories. Zonaras wrote of the people whose duty was the service of imperial post (*dromikai strateiai*), *dromos* being a technical name designating the state postal service. Peasants obliged to provide means for the imperial post were called in eleventh-century sources *exkoussatoi dromou*. The term *exkoussatoi*, without the clarification *dromou*, is found in various texts of the tenth century as well. Its literal meaning is "exempted from the principal taxes," but the question arises, who were these "exempted" ones? Since some *exkoussatoi* were included in grants to mighty landlords, scholars tend to regard them as dependent tenants. An unexpected reference, however, in a work by Basil the Younger, archbishop of Caesarea

22. On Constantine VII's novel, see Lemerle, *Agrarian History*, 116–25.

in the tenth century, shows the fallacy of such an assumption. In his marginal notes on the works of Gregory Nazianzus, Basil mentions imperial armorers, "who in our Caesarea are called *exkoussatoi*."[23]

The next category of the peasantry, although omitted by Zonaras, is identified in two imperial charters of 974 and 975:[24] they are called *prosodiarioi*. If it can be assumed that *prosodion*, mentioned in a charter of 995, was a tax in kind, then perhaps the *prosodiarioi* were those peasants obliged to supply the state or the emperor with various goods. The term *exkoussatoi* could have been employed also for these peasants obliged with payments in kind. One such case occurred in the village of Tembroi, where there were *exkoussatoi* whose duty it was to catch fish for the imperial table.[25]

Exkoussatoi and *prosodiarioi* are mentioned very infrequently, mostly in tenth-century sources. More often, references are found to the lowest class considered by Zonaras, the poor (*ptochoi*). In the imperial legislation of the tenth century the term *ptochoi* was commonly applied to peasants—taxpayers as opposed to soldiers. In the charters of the tenth century another term was repeatedly used: *demosiarioi*. The term is usually thought to designate tenants of imperial estates, but this interpretation has little evidence to support it; perhaps *demosiarioi*, like *georgoi* and *ptochoi*, was a technical term used by the treasury for the common peasantry. All these distinctions, in any case, suggest that, in contrast to a generally uniform rural population in the eighth and ninth centuries, by the tenth century a series of fiscal distinctions was being made within the peasantry. Not only were there different terms in use for each category; they may have been officially strictly recognized: Nikephoros Phokas's attempt to sidestep these categories was regarded by the later Byzantine historian Zonaras as illegal.

The Byzantine government also attempted to stabilize the categories it imposed on the population. A considerable amount of tenth-century imperial legislation was aimed at preserving the village community:

23. R. Cantarella, "Basilio Minimo II," *BZ* 26 (1926), 31.1–3.

24. *Lavra* 1, no. 6.5; Joakeim Iberites, "Sigillion peri ton monon Kolobou, Polygyrou kai Leontias," *Gregorios ho Palamas* 1 (1917), 787.5. On these documents, see G. Ostrogorsky, *Quelques problèmes d'histoire de la paysannerie byzantine* (Brussels, 1956), 17.

25. Constantine Porphyrogenitus, *De cerimoniis*, ed. Io. Ia. Reiske (Bonn, 1829), 488.18. *Escusati Ducatus* in Venice of the ninth century (L. A. Muratori, *Rerum Italicarum Scriptores* 12 [Milan, 1728], 188) were probably to supply the doge with fish and game. On *prosodion*, see F. Dölger, *Aus den Schatzkammern des Heiligen Berges* (Munich, 1948), no. 56.13, as well as the chrysobull of 1074 (*Lavra* 1, no. 36.15).

powerful persons and institutions—high officials in the bureaucracy, army commanders, bishops, and *hegoumenoi* (abbots)—were restricted in their right to buy peasants' and soldiers' holdings. Family members and neighbors had so-called *protimesis*, preemption rights: any villager inclined to sell his allotment was obliged to offer his land to his relatives and neighbors in an established order of precedence. Only after all these had refused might a *dynatos* (powerful man) buy the property.

Conversely a peasant was responsible in general for his neighbors. As early as the beginning of the ninth century Emperor Nikephoros I enjoined the *ptochoi* to acquire military arms with the assistance of their neighbors (Theoph. 1.486.24). A tenth-century regulation required that soldiers who were unable to equip themselves should receive aid from so-called *syndotai* (literally, "those who give together").[26] These *syndotai* were members of the same community who supplied the soldier with a coat of mail, spear, sword, and horse. The first evidence that the peasants were obliged to pay the tax arrears of their neighbors if they died or fled is dated to the first half of the tenth century: Symeon Metaphrastes mentions this regulation as existing (or introduced?) during Romanos Lakapenos's reign.[27] The Byzantine treatise on taxation provides a name for this regulation, *allelengyon*.[28] In certain cases neighbors were not subjected to this burden; the escheated holding formed a special category of land, the *klasma*, which might be sold by the treasury after thirty years. According to a law issued by Basil II, only the *dynatoi* were subjected to the *allelengyon* and had to pay taxes for missing or deceased neighbors.[29] Also reflecting state concern for the countryside was the concept of *justum pretium*, "just price," which was widely operative in tenth-century Byzantium. If a peasant was forced by circumstances such as a bad harvest or coerced by the *dynatoi* to sell his holding for a price considerably lower than the just price, he could reclaim his allotment.

The state attempted to regulate not only agrarian but also commercial conditions. Usury was a problem in Byzantium: although condemned by the Church Fathers, it was an important part of the Byzantine economy. The number of insolvent debtors was so high that in the late ninth or early tenth century Patriarch Euthymios begged Leo VI to free them of their debts.[30] Romanos Lakapenos was forced to bow to this

26. Constantine Porphyrogenitus, *De cerim.* 695.18. On *syndotai*, see also Lemerle, *Agrarian History*, 134f.

27. Quoted by K. E. Zachariae von Lingenthal, *Geschichte des griechisch-römischen Rechts* (Berlin, 1892; reprint: Aalen in Württemberg, 1955), 235 n. 761.

28. Dölger, *Beiträge*, 119.24.

29. Skyl. 347.76–80, 375.54–55.

30. *Vita Euthymii patriarchae CP*, ed. P. Karlin-Hayter (Brussels, 1970), 63.5.

demand: the treasury paid all the debts in Constantinople regardless of the social status of insolvent debtors; the vouchers were burned. It was Leo VI's father, Basil I, who had most radically attacked the problem of usury. The collection of interest was prohibited completely—only minors and orphans were allowed to use their money for this purpose.[31] Mortgages were also restricted: the mortgage debt was to be repaid partially in produce. In addition, Basil's lawbook, the *Epanagoge*, prohibited the peasant from mortgaging his field. Basil's legislation failed. His son and heir, Leo, abolished the law because, he wrote, it badly afflicted the economy of the whole country. Leo, however, established the legal ceiling on interest at 5.5%.[32]

Emperors also tried to regulate the trade activity of Byzantine merchants and craftsmen. Again the only known collection of trade regulations, the so-called *Book of the Eparch*, was promulgated by Leo VI.[33] The purpose of the regulations in the *Book of the Eparch* was to protect the members of the trade guilds in Constantinople from the competition both of the *dynatoi* and of the non-guild craftsmen and peddlers, who were not admitted to the privileged trade organizations of the capital. At the same time, the *Book of the Eparch* outlined the rights of the state in respect to the guilds. In some cases direct services were stipulated. But more important was the exercise of state control over the trades. It was the state, not the guilds and their administrators, that checked the quality of products, the size of workshops (*ergasteria*), the wages of the journeymen or hired workers (*misthioi*), and market prices. Members of the elaborate staff of the civil governor of Constantinople (eparch) could poke their noses into every nook of the *ergasterion*, where the master worked with his family and—relatively seldom—with a couple of *misthioi*.

The ruling class of the Byzantine Empire was the higher officialdom of the capital. According to the *taktika* discussed above, it consisted of various ranks, among which *magistroi*, *anthypatoi*, patricians, and *protospatharioi* were regarded as forming the highest body politic—the senate. Titles were not inherited, but granted by the emperor; in some cases they could even be purchased. Though in practice unstable and changing because of imperial favoritism, this system was rigid in theory and in ceremony: a specific place at the imperial banquet was assigned to every official rank. The bureaucracy consisted of several dozen central departments and tribunals administering frequently overlapping judicial and

31. *Epanagoge* 28:2, ed. Zepos, *Jus* 2:320f.
32. Novel 83, ed. Noailles and Dain, *Les novelles*, 281f.
33. The best edition, with a Russian translation and commentary, is by M. Ja. Sjuzjumov, *Vizantijskaja kniga eparcha* (Moscow, 1962).

fiscal tasks. Conversely, one department might perform functions that from our perspective appear quite different. Thus, the department of the *dromos* directed not only the imperial postal service, but also foreign affairs and political security. No general head of all departments existed; the emperor was regarded as head of the whole administration, as well as the supreme judge, ultimate legislator, and commander-in-chief. The relative independence of the provinces was eliminated: the major themes of the eighth century were divided into smaller units, and the power of the *strategoi* was restricted by thematic judges and tax collectors.

Thus the whole economic, social, and intellectual life of Byzantium was systematized during the ninth and tenth centuries. Byzantium became a state rigidly governed from its center by the imperial court and by the multibranched bureaucracy. Under this surface, however, two important processes began to develop at least by the tenth century: the growth of provincial towns and the emergence of a semi-feudal *seigneurie*. The state seems to have been ultimately centralized, but in fact new forces were evolving that were destined to shatter the monolithic structure of the Byzantine Empire. These forces came to the fore in the eleventh and twelfth centuries.

DECENTRALIZATION AND "FEUDALIZATION" OF THE BYZANTINE STATE

The period from the mid-ninth through the early eleventh century has been traditionally regarded as one of great political and cultural resurgence due to a sagacious protection of peasants and soldiers by the emperors of the Macedonian dynasty.[1] In contrast, the later eleventh and the twelfth centuries are commonly considered a time of disintegration and collapse. The ignominious defeat of the Byzantine army by the Seljuk Turks in 1071 at Manzikert and again in 1176 at Myriokephalon, the Normans' conquest of southern Italy, completed by 1071, and their capture of Dyrrachium and Thessaloniki in 1185, the Pechenegs' onslaught of the eleventh century, and the successful rebellion of the Bulgarians in the 1180s seem to have presaged the disastrous fall of Constantinople, the previously unconquered capital of the empire, to the Latins of the Fourth Crusade in 1204. These military setbacks have been attributed to the growth of feudal tendencies and to the decentralization of the state. Likewise, it has been assumed that serious internal political decay was associated with a collapse of the economy and a demographic crisis. Such assumptions may be questioned.

Even the precarious military situation may perhaps be explained differently. Certainly the defenses of Byzantium were not always adequate. In the third quarter of the eleventh century, the invasions of the Seljuks in the east, the Normans in the west, and the tribes of the steppes in the north resulted in considerable territorial losses. Constantinople itself

1. E.g., G. Ostrogorsky, *History of the Byzantine State*, 2d ed. (Oxford, 1968), chap. 4, "The Golden Age of the Byzantine Empire (843–1025)," 210–315.

was threatened. Again, in the quarter-century after Manuel I's death in 1180, Byzantium fell prey to the Latins. But apart from these two moments of great danger, the empire continued to enjoy its traditional place of prestige in the Mediterranean world. Through the middle of the eleventh century Byzantium remained strong enough to annex several Armenian principalities. More importantly, from the end of the eleventh century the emperors of the Comnenian dynasty, Alexios I, John II, and Manuel I, reasserted Byzantine power through the reconquest of most of the coast of Asia Minor and the subjugation of Serbia and Hungary. Until the late twelfth century, the Byzantine Empire remained an important political power between Catholic Europe and the Islamic Near East.

The interpretation of the economic evidence for Byzantium during this period is more ambiguous. The debasement of Byzantine coinage during the eleventh century has traditionally been seen as an expression of economic decline. The Byzantine *nomisma-solidus*, struck of high-quality gold (twenty-four carats), had remained stable until the mid-eleventh century; around the second and the third quarters of the century, gold coinage was debased to eight carats.[2] This debasement may, however, be interpreted as a reaction to an increased demand for circulating coinage and may therefore be associated with a general economic resurgence.[3] Gold coinage, which had functioned primarily as a symbol of imperial power from the mid-seventh through the mid-ninth centuries, seems to have become instead an important vehicle of exchange. To judge from coin finds discovered in excavations and from coin hoards buried inside and outside Byzantium, the eleventh century seems to have seen a great increase in coin use.[4] In any case, during the

2. P. Grierson, *Catalogue of the Byzantine Coins in the Dumbarton Oaks Collection*, vol. 3, part 1 (Washington, D.C., 1973), 39–44.

3. C. Morrison, "La dévaluation de la monnaie byzantine au XIe siècle: essai d'interprétation," *TM* 6 (1976), 24–30.

4. A. P. Kazhdan, *Derevnja i gorod v Vizantii IX–X vv.* (Moscow, 1960), 271f.; M. F. Hendy, "Byzantium, 1081–1204: An Economic Reappraisal," *Transactions of the Royal Historical Society* 20 (1970), 47f. For a few examples: at Curium, Cyprus, there is a gap in coin finds between ca. 666 and ca. 989: D. H. Cox, *Coins from the Excavation at Curium, 1932–1953* (New York, 1959), 82; at Kenchreai, between Constans II and Leo VI: R. L. Hohlfelder, *Kenchreai, Eastern Port of Corinth*, vol. 3, *The Coins* (Leiden, 1978), 74f. At that site, coinage apparently became more abundant after Basil II. In Asia Minor between 668 and 867, "bronze coins are considerably rarer than in earlier and later periods" (C. Foss, "Archaeology and the 'Twenty Cities,'" *AJA* 81 [1977], 470). Also D. M. Metcalf, "The Coinage of Thessaloniki, 829–1204, and Its Place in Balkan Monetary History," *Balkan Studies* 4 (1963), 277, suggests that between ca. 650 and 829, "the circulation of petty coinage dwindled drastically."

reign of Alexios I Comnenus, the *nomisma* was again stabilized at approximately the same level as the old standard, and there it remained until at least the middle of the thirteenth century.[5] In all, the nature of the economic "crisis" of the eleventh century is not so clear as has often been suggested.

Similar problems of interpretation surround Byzantine demography. It is commonly held that after the middle of the eleventh century the empire suffered a continuous population decline.[6] Research on Greece, however, suggests that after an abrupt depopulation in the second half of the eleventh century, village life was stable until the second half of the thirteenth century.[7] Only the so-called *praktika*, inventories of villagers, mostly from Macedonia of the first half of the fourteenth century, allow a statistical investigation of the problem. These *praktika* are lists of peasants, including information about family members, the size of fields and vineyards, and number of domestic animals (Ex. 1). For the village of Radolivo, which belonged to the monastery of Iviron on Mount Athos, we possess, however, not only a set of inventories of the fourteenth century, but also a *praktikon* of about 1100; comparison of these documents leads unexpectedly to the conclusion that during this period of severe political problems the population of Radolivo did not decrease but rather expanded significantly; moreover, the average size of the family seems to have grown,[8] a fact that radically contradicts the common opinion of a perpetual demographic decline in Byzantium after the defeat at Manzikert. The absence of inflation in Byzantium—in contrast to the West—has also been seen as indicative of a demographic crisis;[9] it has been argued that prices did not rise because demand decreased. It might just as well be suggested that increased supplies kept pace with new demands for goods.

5. M. F. Hendy, *Coinage and Money in the Byzantine Empire, 1081–1261* (Washington, D.C., 1969), 14–25.

6. N. G. Svoronos, *Études sur l'organisation intérieure, la société et l'économie de l'Empire byzantin* (London, 1973), part 9, 389; H. Ahrweiler, *Erosion sociale et comportements excentriques à Byzance aux XI^e–XIII^e siècles* (Athens, 1976), 18f.

7. H. Antoniadis-Bibicou, "Villages désertés en Grèce," *Villages désertés en histoire économique* (Paris, 1965), 364. The author assumes that when a site ceases to be mentioned in surviving sources it is deserted. In view of the paucity of contemporary documents, such an argument is extremely weak.

8. G. Ostrogorsky, "Radolivo," *ZRVI* 7 (1961), 67f. J. Lefort, "Le cadastre de Radolibos (1103). Les géometres et leurs mathématiques," *TM* 8 (1981), 268–313.

9. H. Antoniadis-Bibicou, "Problèmes d'histoire économique de Byzance au XI^e siècle: démographie, salaires et prix," *BS* 28 (1967), 256, 259f.; "Démographie, salaires et prix à Byzance au XI^e siècle," *Annales* 27 (1972), 215–46.

The problem of demography is, of course, closely connected with that of agricultural development. Modern historians have emphasized the number of crop failures and famines in Byzantium in the eleventh century (Ex. 2).[10] Famines also occurred earlier in Byzantine history. The famine following the severe winter of 927–28 is perhaps the best known of these. But famines are virtually unmentioned in twelfth-century sources.[11] In fact, Western observers in the eleventh and twelfth centuries, participants in the First through the Fourth crusades, all described the abundance of grain, wine, oil, and cheese.[12] English chroniclers even commented that there were more olives in the southern Peloponnese than anywhere else in the world.[13] Greece was furthermore able to supply grain to Illyricum and to Sicily.[14] In the twelfth century, Italian merchants exported grain, wine, and meat from "Romania."[15] In certain specialized forms of agriculture, such as beekeeping, the Byzantines seem to have been more developed than their Western counterparts.[16]

In general, Byzantine technology was extremely conservative. Byzantine agricultural implements remained virtually unchanged from Roman times. The peasant continued to use the light plow dragged by a pair of oxen. It was made of wood and had a removable iron plowshare; it did not have wheels, so the plow bit rather than cut the soil. The scythe was not in use in Byzantium, and the image of Death with its scythe in hand, so popular in the West, would have left the Byzantines unmoved.

10. For a catalogue of the "people's ills" in the eleventh century, N. A. Skabalanovič, *Vizantijskoe gosudarstvo i cerkov' v XI veke* (St. Petersburg, 1884), 250–58, reproduced without notable alterations in Svoronos, *Études sur l'organisation intérieure*, part 9, 348f.

11. Only a few local famines are noted. For instance, Nicholas Mouzalon records a famine on Cyprus in the first half of the twelfth century. In this case the land produced fruit, but there were no laborers available to harvest it. S. Doanidou, "He paraitesis Nikolaou tou Mouzalon apo tes archiepiskopes Kyprou," *Hellenika* 7 (1934), 136. Nilos, bishop of Tamasia, mentions a famine on Cyprus at the end of Manuel I's reign, MM 5:395f. For complaints concerning the lack of grain in Athens and on Chios, Mich. Akom. 2:41, 237.

12. A. P. Kazhdan, "Iz economičeskoj žizni Vizantii XI–XII vv.," *VOč* 2 (Moscow, 1971), 190f.

13. H. Lamprecht, *Untersuchungen über einige englische Chronisten des 12. und des beginnenden 13. Jahrhunderts* (Torgau, 1927), 117.

14. A. P. Kazhdan, "Brat'ja Ajofeodority pri dvore Manuila Komnina," *ZRVI* 9 (1966), 91f.

15. A. Schaube, *Handelsgeschichte der romanischen Völker des Mittelmeergebietes bis zum Ende der Kreuzzüge* (Munich, 1906), 238, 245.

16. S. Krauss, *Studien zur byzantinisch-jüdischen Geschichte* (Leipzig, 1914), 113.

They used the sickle to harvest their corn, cutting away the ears and leaving the high stalks in the field, protecting their left hands with rough gloves. The sheaves were brought to a threshing floor usually placed at the top of a hill in order to exploit the wind for winnowing. No flails were used in threshing; the Byzantines drove donkeys and oxen over the sheaves to separate the grain from the chaff. The animals either trampled out the grain or dragged a threshing sledge. The line from Deuteronomy 25:4, "Thou shalt not muzzle the ox when he treadeth out the corn," was frequently quoted by Byzantine rhetoricians. Barley was predominantly sown in Greece, and wheat in Asia Minor. Bread and wine formed the major part of the Byzantine diet, though various vegetables and fruits were produced in Byzantine gardens, where vines, fruit trees, and cabbage were planted side by side. Little is known about the yield in the twelfth century.[17] Eustathios of Thessaloniki bragged that he reaped fifty-nine *medimnoi* on a field where he had sown only three *medimnoi* (Eust. *Opusc.* 155.69–71). Even if he was emphasizing the exceptional size of his yield, the figure must have been exaggerated—in fourteenth-century Greece a ratio of five to one was remarkably high; contemporary Italy produced three or four measures to one. Fertile soil, warm climate, and irrigation allowed two harvests a year in some areas. Gregory Antiochos, a Byzantine official, wrote with disdain about Bulgarian agriculture. Among its disadvantages was the fact that in the vicinity of Sofia it was possible to reap only one harvest a year.[18]

As mentioned in Chapter 1, cattle breeding was important in the Byzantine economy; it is, however, impossible to suggest what percentage of the Byzantine diet was meat. Some sense of the importance of flocks and herds is provided by the *vita* of St. Lazarus of Mount Galesios. While wandering in Galatia, a monk came across a flock of sheep that was guarded only by dogs. These fierce creatures, having surrounded the poor man on a rock, tore all his clothes away before giving up on their quarry. Soon after, another flock is mentioned. While the monk Paphnoutios was climbing a tree in search of fruit, a shepherd, mistaking him for an animal, shot him with an arrow. The *vita* gives the impression that even before the Seljuk invasion, already in the first half of the eleventh century, the country was full of sheep and their protectors

17. N. Kondov, "Über den wahrscheinlichen Weizenertrag auf der Balkanhalbinsel im Mittelalter," *Études balkaniques* 10 (1974), 97–109.
18. J. Darrouzès, "Deux lettres de Grégoire Antiochos écrites de Bulgarie vers 1173," *BS* 23 (1962), 279.18–19.

(*AASS* Novembris III, 517D, 521E; see also 581B). Bulgaria was especially abundant in sheep and cattle. The Byzantines described it as a land rich in cheese, pork, wool, and fowl.[19] Foreign observers found the number of cattle in Byzantium remarkable. The Russian pilgrim Daniil at the beginning of the twelfth century was surprised by the size of the herds he saw on islands such as Patmos, Rhodes, and Cyprus.[20] In addition, bone evidence from Bulgaria indicates that at least in some areas there was an increase in the percentage of cattle among the livestock, which in turn suggests a higher level of agricultural production.[21]

Such agricultural development may explain an apparent shift in attitudes toward the land that took place in the eleventh century. Evidently landownership became increasingly attractive, as is reflected in changes in the treatment of taxes. Until the tenth century, the Byzantine state had been concerned with the collection of rent from deserted land, hence the *allelengyon*, the previously mentioned custom that made the community liable for land taxes if an individual defaulted. But from the eleventh century on, abandoned land seems to have been increasingly sought after. Monasteries, for instance, requested that the state award them deserted allotments not already included in their inventories.[22] The *allelengyon* was evidently no longer necessary; it was abolished by Romanos III.

As there are indications that previously abandoned land was brought back into use in the eleventh century, a further question remains. Were great secular and monastic estates in the eleventh century increased in size only by such redistribution, or was arable land extended, in addition, and labor intensified? Byzantine data concerning the clearing

19. R. Browning, "Unpublished Correspondence between Michael Italicus, Archbishop of Philippopolis, and Theodore Prodromos," *Byz. Bulg.* 1 (1962), 285.82–89; reprinted in his *Studies on Byzantine History, Literature and Education* (London, 1977).

20. Daniil, "Žitie i chožen'e," *PPSb* 1, no. 3 (1885), 8.

21. Ž. Vŭžarova, *Slavjano-bulgarskoto selišče kraj selo Popina, Silistrensko* (Sofia, 1956), 89. The excavations of Džedžovi lozja (Ž. Vŭžarova, *Slavjanski i slavjanobŭlgarski selišča v bŭlgarski zemi ot kraja na VI–XI vek* [Sofia, 1965], 208, table 2) seem to contradict this conclusion: the percentage of cattle bones is lower there in the layer of the eighth to eleventh centuries than in that of the seventh to eighth centuries. However, as that settlement did not survive the mid-eleventh century, the published figures do not reveal changes in the crucial period of the eleventh through twelfth centuries.

22. N. G. Svoronos, *Recherches sur le cadastre byzantin et la fiscalité aux XIe et XIIe siècles* (Paris, 1959), 127f.

of woods—so important in the contemporary West—are vague;[23] the sources do, however, mention the reclamation of deserted, stony, or barren areas. St. Christodoulos's foundation of a monastery on rocky, mountainous terrain in Patmos is an example of such amelioration. In his testament Christodoulos relates how Emperor Alexios I endowed him with lands on the island of Patmos, but his monks refused to move there as the island was deserted and a constant object of piratical assaults. "They were afraid," says Christodoulos, "they fled from me; they left me alone" (MM 6:88.24–26). But step by step the Monastery of John the Baptist on Patmos increased its property both on the island and outside, attracting some peasants from neighboring areas as laborers. Fields were worked more by the hoe than by the plow; vineyards were planted, and the successors of Christodoulos flourished where in Alexios I's time there had been only a stony desert.[24] Fields might also be brought into use by irrigation. According to Michael Choniates, Patriarch Theodosios, when exiled to the island of Terebinthos, made water available and planted trees, "extracting oil and honey from stone" (Mich. Akom. 2.49.22–25). A century earlier Psellos dreamed about developing his estate in Medikion by buying oxen, acquiring sheep, planting vineyards, diverting streams, and directing water through channels (Sathas, *MB* 5:264.6–7).

Other literary sources may also reflect the development of agriculture in the eleventh and twelfth centuries. The literati took a new interest in the land. Echoing classical values, Kekaumenos praised farming as the most appropriate enterprise for the wealthy.[25] As mentioned above, Gregory Antiochos while sojourning in Bulgaria occupied himself with writing a detailed comparison of agrarian conditions there and in Byzantium.[26] In his letters, Eusthatios of Thessaloniki devotes much attention to the large harvests and the high quality of the fruit produced on his farms; his works are full of agricultural allusions.[27] Similarly, ques-

23. Eustathios Boilas in the middle of the eleventh century cleared lands in the eastern part of the empire "with axes and fire," P. Lemerle, *Cinq études sur le XIᵉ siècle byzantin* (Paris, 1977), 22. Data concerning the clearing of woods in Byzantium have not yet been collected. The word *apokatharsis* does not appear in the index of Ph. Koukoulès, *Vie et civilisation byzantines* 5 (Athens, 1952).

24. E. Vranuse, *Ta hagiologika keimena tou hosiou Christodoulou* (Athens, 1966), 111–16; and by the same author, *Byzantina engrapha tes mones Patmou* 1 (Athens, 1980), 39–49.

25. G. G. Litavrin in Kek. 58.

26. Darrouzès, "Deux lettres de Grégoire Antiochos," 278–80.

27. A. P. Kazhdan, "Vizantijskij publicist XII v. Evstafij Solunskij," *VV* 28 (1968), 74f.

tions about grain production are prominent in the correspondence of Michael Choniates (e.g., Mich. Akom. 2.211.17–19). This interest in agriculture is not common before the eleventh century. The contrast of concerns is perhaps most remarkable in the writings of two religious figures. The mystical works of Symeon the Theologian, from the end of the tenth and beginning of the eleventh centuries, are full of metaphors from court life and the trades. In contrast, Elias Ekdikos, a theologian of the eleventh or twelfth century, delights in agricultural images.[28] In all, while too little evidence remains to chart Byzantine agricultural development in any detail, it appears that especially during the twelfth century farming flourished in Byzantium.

Thus the common assumption of decline in the eleventh and twelfth centuries may be seriously questioned. Byzantium was alive and economically well. With this understanding, it is possible to consider the basic cultural shifts that occurred in the empire during this period and then to identify their underlying significance.

DECENTRALIZATION

URBAN EVOLUTION IN THE PROVINCES: ARCHAEOLOGICAL AND LITERARY EVIDENCE

An understanding of the conditions in the Byzantine provinces is essential to the broader view of Byzantine society and culture. Although economic revival began in Byzantium in the early ninth century, at that time only Constantinople, its immediate environs, and a narrow strip of the Aegean coast were affected. From the eleventh century onward improvement was seen over a considerably larger area, notwithstanding foreign political hindrances. While the evidence for urban evolution is very limited—Byzantinists still are in general more interested in studying monuments than in urban archaeology—nevertheless, a survey of the available material shows a pattern of urban growth, varying from region to region.

Recent Bulgarian and Rumanian excavations allow an insight into urban life in the northern Balkans. Unfortunately, national prejudices have sometimes limited the scope and biased the interpretation of the archaeological expeditions; many Bulgarian scholars have ignored the

28. A. P. Kazhdan, "Das System der Bilder und Metaphern in den Werken Symeons des 'Neuen' Theologen," in P. Hauptmann, ed., *Unser ganzes Leben Christus unserem Gott überantworten* (Münster, 1982), 225f.

period of the "Byzantine yoke," suppressing the evidence of the eleventh century and ascribing the finds from the twelfth century exclusively to the Second Bulgarian Empire, although that was established only at the very end of the century. Nonetheless it was a Bulgarian scholar, Lišev, who first demonstrated, largely on the basis of literary and numismatic evidence, that Bulgarian towns prospered under Byzantine rule.[29] Even the old centers of Bulgarian power, Pliska and Preslav, survived the Byzantine conquest of 1001–18, although the fine ceramic ware typical of the tenth-century capitals disappeared with the Greek occupation.[30] New towns were founded, one of them on the site of the Thracian Sebtopolis; its inhabitants not only cultivated the land and bred cattle, they also produced iron implements, bone and wood carvings, jewelry, and ceramics.[31] Inscriptions of the eleventh century referring to Adrianople, Apros, and Mesembria also attest to building activity in the northern Balkans.[32] Mesembria remained a trade center even

29. S. Lišev, *Bŭlgarskijat srednovekoven grad* (Sofia, 1970), 64. A biased approach to economic development of towns under the "Byzantine yoke" is characteristic of archaeological research in Sofia. According to M. Stančeva, "Sofia au moyen âge à la lumière de nouvelles études archéologiques," *Byz. Bulg.* 5 (1978), 215, it is "impossible d'admettre" that there was building activity in the town during the eleventh and twelfth centuries, even though the author mentions both a hoard of gold and silver of that period (226) and "urban architecture" of the eleventh century (223). On the basis of a study of eleventh-century ceramics from Sofia (twelfth-century ware is ignored in this connection), M. Stančeva and L. Dončeva-Petkova, "Sur la surface habitée de Sredec au IX^e–XIV^e s.," *Izv. Arch. Inst.* 35 (1979), 124–33, state that the population of the town decreased under the "Byzantine yoke"; see also below, n. 36. However, recent studies indicate the expanded use of new ceramics ("perhaps" of Byzantine origin) in the eleventh and twelfth centuries throughout Bulgaria: see especially I. Ščereva, "Prinos kŭm proučvaneto na srednovekovna keramika v Bŭlgarija (XI–XII v.)," *Arch.* 19, no. 3 (1977), 6–11. Very reluctantly S. Georgieva, "Srednovekovna keramika ot Melniškata krepost," *Arch.* 22, no. 2 (1980), 51, acknowledges the existence of the twelfth-century ceramics in Melnik—but without mentioning their Byzantine connections and without reference to eleventh-century ware. P. Gatev, "Nakiti ot pogrebenija ot XI–XII v.," *Arch.* 19, no. 1 (1977), 30, emphasizes that most jewelry of this area may be dated to the eleventh and twelfth centuries and reproaches his predecessors for not distinguishing it from earlier or later production.
30. V. Neševa, "Srednovekoven nekropol vŭv Vŭtrešnija grad na Preslav," *Arch.* 21, no. 2 (1979), 53.
31. J. Čangova, *Srednovekovno selišče na trakijskija grad Sevtopolis. XI–XIV vek* (Sofia, 1972).
32. *Corpus Inscriptionum Graecarum* vol. 4, fasc. 3, no. 8713; A. P. Kazhdan, "Grečeskaja nadpis' XI v. s upominaniem armjanina-stratega," *Istoriko-filologičeskij žurnal*, 1973, no. 2, 189f.; V. Velkov, "Zur Geschichte Mesembrias im 11. Jahrhundert," *Byz. Bulg.* 2 (1966), 267–73.

later. In 1134 the charter of the Russian prince Ivan Rostislavič mentioned merchants from Mesembria.[33] That Mesembria remained commercially important is also confirmed by discoveries of Byzantine coins in the city.[34] Further Byzantine ruins of the eleventh and twelfth centuries have been found in many Bulgarian sites, including Pernik, Tverdica, and Loveč:[35] the necropolis excavated near Loveč is dated to the tenth through the thirteenth centuries;[36] the eleventh-century Byzantine fortress near the village of Mezek (district of Svilengrad) evidently served as a refuge for the neighboring peasantry in times of peril.[37] Often originally defensive sites later became settlements in their own right. The permanent occupants of the fortress on the island of Păcuiul lui Soare lived by fishing and by small-craft production through the eleventh century.[38] Coin finds indicate that other towns on the Danube—Dinogetia-Garvăn, Noviodunum-Isaccea, and many others—reappeared in the eleventh century and survived well into the twelfth.[39]

33. I. Gŭlŭbov, *Nesebŭr i negovite pamjatnici* (Sofia, 1959), 49f.

34. *Nessèbre* 1 (Sofia, 1969), 22f. See also V. Gjuzelev, "Die mittelalterliche Stadt Mesembria (Nesebär) im 6.–15. Jh.," *Bulgarian Historical Review* 6 (1978), 52ff.; Ž. Čimbuleva, "Pamjatniki srednevekoùvja v g. Nesebre," *Byz. Bulg.* 7 (1981), 128f.

35. J. Čangova, "Archeologičeski proučvanija na Perniškata krepost," *Izvestija na Bŭlgarskoto istoričesko družestvo* 26 (1968), 123–37; and the same author's "Srednovekoven Pernik," *Vekove* 5 (1975), 5–12; A. Popov, "Srednovekovnite kreposti Tvŭrdica i Mŭgliž," *Izvestija na Bŭlgarskoto istoričesko družestvo* 27 (1970), 273; J. Čangova, "Razkopki na Loveškata krepost," *Arch.* 8, no. 2 (1966), 32, 36.

36. Bulgarian scholars who have published the material assert that a decline in the quality of artifacts reflects the deterioration of the economy under Byzantine rule. This important conclusion is, however, drawn from a single observation of the "coarseness and simplicity" of bronze necklaces found in a tomb along with coins of the reign of Manuel I. S. Georgieva, R. Peševa, "Srednovekoven bŭlgarski nekropol kraj gr. Loveč i nakitite, namereni v nego," *Izv. Arch. Inst.* 20 (1955), 551. On Loveč, also J. Čangova, "Srednovekovniat Loveč," *Vekove* 5 (1976), 26–31.

37. K. Mijatev, *Architekturata v srednovekovna Bŭlgarija* (Sofia, 1965), 129–31.

38. P. Diaconu and D. Vilceanu, *Păcuiul lui Soare, cetatea bizantina* 1 (Bucharest, 1972).

39. I. Barnea, "Dinogetia et Noviodunum, deux villes byzantines du Bas-Danube," *RESEE* 9 (1971), 352f. (Dinogetia is sometimes identified with the Byzantine Demnitzikos: A. Bolşakov-Ghimpu, "La localisation de la cité byzantine de Demnitzikos," *RESEE* 5 [1967], 543–49); G. Florescu, R. Florescu, and P. Diaconu, *Capidava* 1 (Bucharest, 1958). In this collective work, Florescu insists on the basis of ceramic finds that Capidava existed uninterruptedly from Roman times (227–32). Diaconu on the basis of coin evidence assumes on the contrary that the city existed only from the end of the tenth to the middle of the eleventh century (238–44). See also P. Diaconu, "Une information de Skylitzès-Cédrénos à la lumière de l'archéologie," *RESEE* 7 (1969), 43–49. In contrast, I. A. Božilov

Further, there are indications that agriculture in Bulgaria was adapted to a money economy.[40] A new exploitation of Danubian quarries, which dates from this period, also indicates new construction on a large scale in the northern Balkans.[41] Thus it appears that, though the northern Balkans suffered from the invasions of the steppe tribes, the Pechenegs in the eleventh century, and the Polovtsy (the Cumans of the Byzantine sources) in the twelfth, town life flourished.

Similar urban development seems to have been characteristic of the Balkan Peninsula as a whole. Despite the sad fact that many Byzantine layers in Athens have been destroyed in search of classical antiquity, some patterns of medieval settlement can be restored. Much of old Athens was abandoned during the seventh and eighth centuries; the city was confined to the Acropolis and to the area immediately around it. Revival began in the second half of the ninth century with the construction of the Church of St. John Mangoutis, but the height of medieval prosperity was achieved in the eleventh and twelfth centuries. The commercial center has not been located, but it may be surmised that the trades developed in residential areas where houses had ground-floor storerooms and workshops. Some industries, such as soap manufacturing and tanning, which required a water supply and were notorious for their bad smells, were located on the outskirts of the town, at the Dipylon and at the Olympieion respectively. The administrative and religious center continued to be the fortified Acropolis.[42] The systematic ex-

believes these were Bulgarian towns that fell to John Tzimiskes rather than new Byzantine strongholds: "Kŭm tŭlkuvaneto na dve izvestija na J. Skilica za gradovete po Dolnija Dunav v kraja na X vek," *Izvestija na narodnija muzej Varna* 9 (1973), 119.

40. G. G. Litavrin, "Tempove i specifika na socialno-ikonomičeskoto razvitie na srednovekovna Bŭlgaria v sravnenie s Vizantija (ot kraja na VII do kraja na XII v.)," *Istoričeski pregled* 26 (1970), 38; Lišev, *Bŭlgarskijat srednovekoven grad*, 36–45, 54–64; J. Čangova, "Kŭm vŭprosa za ustrojstvoto na srednovekovnija bŭlgarski grad (IX–XIV)," *Architekturata na Pŭrvata i Vtorata bŭlgarska dŭržava* (Sofia, 1975), 93f.

41. P. Diaconu and E. Zah, "Les carrières de pierre de Păcuiul lui Soara," *Dacia* 15 (1971), 305.

42. The principal monographs on Athens are I. Traulos, *Paleodomike exelixis tes poleos ton Athenon* (Athens, 1960), 149–72; H. Thompson and R. E. Wycherley, *The Agora of Athens* (Princeton, 1972). General surveys of the development of Byzantine urban life include A. P. Kazhdan, "Vizantijskie goroda v VII–XI vv.," *Sovetskaja archeologija* 21 (1954), 177–79; P. Tivčev, "Sur les cités byzantines aux XIᵉ–XIIᵉ siècles," *Byz. Bulg.* 1 (1962), 152–56; V. Hrochová, *Les villes byzantines aux 11ᵉ–13ᵉ siècles: phénomène centrifuge ou centripète dans l'évolution de la société byzan-*

cavations at Corinth allow more clear-cut conclusions concerning the layout of the medieval city: the settlement lacked any plan; it developed spontaneously, with small houses and workshops covering what had been the free space of the ancient *polis*. Like Athens, Corinth experienced a boom in industry and construction in the eleventh and twelfth centuries.[43] Growth in Sparta during the twelfth century can be suggested as well. At that time the town extended beyond its southern wall: some houses and a public bath from this period were discovered in that area. It seems also that Cadmeia in Thebes was densely populated in the twelfth century.

There is little evidence from Thessaly, Epiros, and Euboea; Macedonia and Thrace have been better studied. Thessaloniki was the largest city in this region; although archaeological data concerning its ceramics and houses have not yet been published, the medieval sources, at least, present Thessaloniki as an important commercial city. The anonymous author of the dialogue *Timarion* (Ex. 3–4) describes the annual fair in Thessaloniki of the first half of the twelfth century, to which merchants came from Italy, from Egypt, from the northern coast of the Black Sea, and from Spain. The twelfth-century Western chronicler Robert de Torigny mentioned Thessaloniki as an important trade center.[44] According to the tenth-century *vita* of Photios of Thessaloniki, small towns that had formerly surrounded the city were at the author's time in ruins;[45] but quite a different picture appears from texts of the eleventh and twelfth centuries. For example, Rodosto attracted considerable grain trade.[46] In Macedonia archaeologists have uncovered some sections of medieval walls, but except for those of Servia, where they indicate a tripartite division of the city—lower city, upper city, and acropolis—these remains are too fragmentary to allow any conclusions about urban life to

tine (Athens, 1976), 6–9. On the economic development of cities, D. Zakythinos, *Byzance: État, Société, Economie* (London, 1973), part 5, 320; J. Koder and F. Hild, *Tabula Imperii Byzantini*, vol. 1, *Hellas und Thessalien* (Vienna, 1976), 65. Also see the important survey by Ch. Bouras, "City and Village: Urban Design and Architecture," *JÖB* 31/2 (1981), 611–53, who dates "the renaissance of the cities" from the exact date (!) of 961 (p. 616).

43. On Corinth, R. L. Scranton, *Medieval Architecture in the Central Area of Corinth*, Corinth, no. 16 (Princeton, 1957); see also D. M. Metcalf, "Corinth in the Ninth Century: The Numismatic Evidence," *Hesperia* 62 (1973), 180–251.

44. *Chronique*, ed. L. Delisle, vol. 2 (Rouen, 1873), 87.

45. Arsenij, *Pochval'noe slovo sv. Fotiju Fessalijskomu* (Novgorod, 1897), 13f.

46. K. Dieterich, "Zur Kulturgeographie und Kulturgeschichte des byzantinischen Balkanhandels," *BZ* 31 (1931), 42.

be drawn from them.[47] Church buildings are more informative. The rather large congregational basilicas constructed or rebuilt and elaborately decorated in Verria, Servia, Manastir, and Ohrid, as well as the great and small private chapels constructed in Thessaloniki, Kastoria, and elsewhere in the province, attest the revitalization of urban life in Macedonia (figs. 1–3). Although archaeological evidence for the rest of Greece is minimal, the relatively large number of fresco programs surviving from the later twelfth century suggests broadly distributed prosperity in the province by that time.[48]

It would appear, then, that urban life in the Balkans flourished during the eleventh and twelfth centuries,[49] even though some towns, especially those on the lower Danube, were destroyed and abandoned at the end of the eleventh. Conditions in Byzantine towns in Asia Minor are much harder to reconstruct. Vryonis has consistently denied economic progress in Asia Minor. In his opinion, towns declined in the eleventh century and were plundered by the Seljuks in the twelfth; any revival during the Comnenian period was short-lived and of little consequence.[50] In constrast, Tivčev recognizes the existence of larger urban centers in Asia Minor during the eleventh and twelfth centuries, and Karayannopoulos suggests that the traditional view of decline in the elev-

47. A. Xyngopoulos, *Ta mnemeia ton Serbion* (Athens, 1957), 12.

48. For the most recent survey, K. Skawran, *The Development of Middle Byzantine Fresco Painting in Greece* (Pretoria, 1982).

49. P. Charanis, "Observations on the Demography of the Byzantine Empire," *Proceedings of the XIIIth International Congress of Byzantine Studies* (London, 1967), 459f., reprinted in his *Studies on the Demography of the Byzantine Empire* (London, 1972); Tivčev, "Sur les cités," 156f.; J. Karayannopoulos, *Kentrophygoi kai kentromoloi dynameis ston Byzantino kosmo* (Athens, 1976), 19f.; Bouras, "City and Village," 616, contrasts decline and decay in twelfth-century Asia Minor to a further activity of cities in Greek lands. He mentions, however, a densely occupied settlement in Pegamum of the twelfth century (635). For the architecture of Macedonia, Ch. and L. Bouras, "Byzantine Churches of Greece," *Architectural Design* 98 (1972), 30–37. For Manastir, D. Koco and P. Miljkovic-Pepek, *Manastir* (Skopje, 1958); for Ohrid, A. W. Epstein, "The Political Content of the Paintings of Saint Sophia at Ohrid," *JÖB* 29 (1980), 325–29; for Veljusa on the Strumica, R. Hamann-MacLean, *Die Monumentalmalerei in Serbien und Makedonien* 2 (Giessen, 1976), 255–61.

50. S. Vryonis, *The Decline of Medieval Hellenism in Asia Minor and the Process of Islamization from the Eleventh through the Fifteenth Centuries* (Berkeley, Los Angeles, and London, 1971), 78–80; also see his review of *TM* 1 in *Byzantina* 1 (1969), 219, and his reply to his critics, *GRBS* 27 (1982), 230f. He did not include this point in the major "seven theses of the book" that he endeavored to defend.

enth century is simply an exaggeration.[51] The work of Foss, in any case, now helps establish a probable pattern of urban existence in Asia Minor.[52] Smyrna seems to have been the only city in the region in which urban life continued uninterrupted from late antiquity. Ephesus retained its harbor facilities, but the populace slowly migrated to a nearby hill.[53] A great many Ionian *poleis*, Miletus, Priene, and Pergamum, for example, were abandoned in the seventh century and rebuilt after the tenth. These new Byzantine towns bore no resemblance to the highly ordered, gridiron-planned cities of antiquity. Pergamum, which was particularly densely populated and was refortified by Manuel I, was a settlement of unsystematically arranged small houses and workshops.[54] Sardis, after a long period of desertion, reappeared again around the tenth century as a group of villages built near a stronghold. It flourished in the eleventh century and then again at the end of the twelfth.[55] Exiguous material from Ankara, including coins and pottery, indicates some reoccupation also of that city in the tenth and eleventh centuries.[56] That urban life revived, then, in Asia Minor in the eleventh and twelfth centuries appears probable from the archaeological evidence.

Written sources confirm this probability. After Side was deserted, urban life grew up in Attaleia:[57] at the end of the tenth century, the Arab geographer Ibn Hauqal described Attaleia as a fortress amid wheat-producing land;[58] by the eleventh century, Attaleia was a major commercial center.[59] A letter of 1137 characterized the neighboring town of

51. Tivčev, "Sur les cités," 165f.; Karayannopoulos, *Kentrophygoi kai kentromoloi dynameis*, 18f.

52. Foss, "Archaeology and the 'Twenty Cities,'" 469–86.

53. C. Foss, *Ephesus after Antiquity: A Late Antique, Byzantine and Turkish City* (Cambridge, 1979), 107. Foss admits both "a notable decline" of the city during the Dark Ages (103) and a "medieval recovery" (116–37); he is inclined to begin the recovery around 850, although the scanty archaeological evidence dates to the tenth through thirteenth centuries.

54. W. Radt, "Die byzantinische Wohnstadt von Pergamon," *Wohnungsbau im Altertum* (Berlin, 1979), 199–223; also see his "Pergamon. Grabungskampagne im Herbst 1973," *Türk Arkeoloji Dergisi* 22, no. 1 (1975), 99–107.

55. C. Foss, *Byzantine and Turkish Sardis* (Cambridge, Mass., 1976), 70–76.

56. C. Foss, "Late Antique and Byzantine Ankara," *DOP* 31 (1977), 84.

57. A. M. Mansel, *Die Ruinen von Side* (Berlin, 1963), 14.

58. X. de Planhol, *De la plaine pamphylienne aux lacs pisidiens. Nomadisme et vie paysanne* (Paris, 1958), 84.

59. A. Scharf, *Byzantine Jewry* (London, 1971), 108; Vryonis, *The Decline of Medieval Hellenism*, 131.

Seleukia in Isauria as flourishing and well-to-do.[60] Other sources con-
stantly mention the foundation and reconstruction of towns in Asia
Minor.[61] Under Alexios I the coastal cities from Smyrna to Attaleia were
rebuilt (An. C. 3:142.8–9, 217.24–25), as were Korykos and Seleukia
(346.2–3). Kallikles writes about the building of cities under John II,
exclaiming that the death of the emperor would be lamented by the cities
of Europe and of Asia.[62] Under John II, Lopadion was also rebuilt (Kinn.
38.8–10). Manuel I both founded new towns and reconstructed old cen-
ters of which only the names remained (*Fontes* 1:32.21–24, 127.14–18;
Eust. *Opusc.* 208.69–71; see also Kinn. 38.18). Dorylaion was refounded
on territory regained from the Seljuks (Kinn. 295.10–11);[63] the fortress of
Soublaion was built nearby.[64] Tornikes praised Isaac II for founding the
town of Angelokastron on the site of the stronghold of Choma, recap-
tured from the Turks (*Fontes* 2:261.4–16).[65]

These archaeological and literary records of Byzantine Asia Minor
suggest certain differences between Balkan cities and those in the east-
ern parts of the empire. With exceptions such as Ephesus, Nikomedia,
Nicaea, and Attaleia, the towns of Asia Minor were fortresses rather
than trade and craft centers, as Niketas Choniates confirms. In writing
about commercial activity, Choniates refers to Constantinople and such
Balkan cities as Thebes, Corinth, or Philippopolis; he alludes only to ag-
riculture in his references to towns in Asia Minor. He mentions the abun-
dant crops and fruit trees of Pergamum, Chliara, or Adramytion (Nik.
Chon. 150.40–44), the threshing floors in Chonae (400.88–89), the herds
in Brusa (288.46–49). He also describes how Laodicaea in Phrygia, be-
fore being encompassed by a wall, consisted of several scattered villages
(124.13–15). Overall, the towns of Asia Minor seem to have been largely
agricultural communities; they lagged behind their Balkan counterparts
and did not become urbanized. It is not clear why this was so. Perhaps
the damage caused by the Moslem invasions and the militarization due

60. S. D. Goitein, "A Letter from Seleucia (Cilicia) Dated 21 July 1137," *Spe-culum* 39 (1964), 298–303.

61. H. Glykatzi-Ahrweiler, "Les forteresses construites en Asie Mineure face
à l'invasion seldjoucide," *Akten des XI. internazionalen Byzantinisten-Kongresses*
(Munich, 1960), 184–89.

62. Nic. Kall. 113.20–22, 29–30.

63. On Dorylaion, K. G. Mpones, "Euthymiou tou Malake dyo enkomias-
tikoi logoi eis ton autokratora Manouel I Komnenos," *Theologia* 19 (1941–48), 529.

64. Ibid., 547.23–24.

65. H. Ahrweiler, "Choma-Aggélokastron," *REB* 24 (1966), 281f.

to the constant threat of enemy incursion was, in the long run, more destructive of urban institutions than was the temporary Slavic occupation of the Balkans of the seventh and eighth centuries. Or perhaps the growth of a strong rurally based military aristocracy stifled a widespread redevelopment of urban life. Whatever the cause, there is less to indicate an urban revival than in the Balkans, despite ample evidence—for instance, the foundation and decoration of monasteries—of rural prosperity in the heartlands of Asia Minor from the tenth through the first three quarters of the eleventh century. While different provinces of the empire, then, developed somewhat different social forms in the tenth through twelfth centuries their economies by and large improved.

URBAN EVOLUTION IN THE PROVINCES: ARTS AND CRAFTS

How did economic growth in towns of the eleventh and twelfth centuries affect the traditionally hegemonic capital of the empire, Constantinople? An investigation of the crafts produced in the provinces provides some indication of a changing balance in their relationship.

The craft most clearly reflective of endemic localism is the building trade. The markedly regional character of construction may be seen in the many surviving churches of one Macedonian town, Kastoria. There, the characteristic cloisonné method employed in construction indicates that a continuous building tradition was maintained in the city between the tenth and thirteenth centuries under both Bulgarian and Byzantine rule (figs. 3–4).[66] Similarly, regional building traditions informed by the local geology and by the prosperity of local patrons are found throughout Byzantium from Cyprus to southern Italy.

Provincial building techniques also improved recognizably throughout the eleventh and twelfth centuries. The most obvious sign of this progress is found in the facing of the buildings: the mortared rubble or rough ashlar of the ninth and tenth centuries was superseded by a more decorative combination of brick and well-cut stone. The churches of Hosios Loukas, Nicholas in the Fields, Panagia Lykodemou, and Daphni in central Greece from the eleventh and twelfth centuries and, from the twelfth century, the Argolid group in the Peloponnese (with a closely related member, the Soter church in Amphissa, to the north in Phokis) indicate not only the strength of local traditions but also the ar-

66. A. W. Epstein, "The Middle Byzantine Churches of Kastoria in Greek Macedonia: Their Dates and Implications," *ABull* 62 (1980), 190–207.

chitectural refinement that might be achieved in the Byzantine provinces (figs. 5–7 and 38).[67] In contrast to the apparent architectural evolution in the provinces, improvements in Constantinopolitan architecture are less easily identifiable. Between the tenth and twelfth centuries in the capital there were changes in building style, involving a general opening of interior space and broadening of proportions; in plan, with experiments in the domed octagon; in construction method, most notably with the introduction of the recessed-brick technique; and even in articulation, for instance in the modeling of apse exteriors through registers of niches.[68] But there was no significant aesthetic or technological advance in architecture.

Ceramic evidence, which survives in mass and is relatively well preserved, is a less grand but perhaps more reliable economic indicator than monumental art. Provincial centers in the eleventh and twelfth centuries increased their ceramic production;[69] this has been especially well studied in Corinth, but it is also manifest in Athens, Thessaloniki, Sparta, and Olynthus, as well as in such towns of Asia Minor as Pergamum, Priene, Sardis, and Ephesus.[70] Recent excavations at Bulgarian sites uncovered large quantities of ceramic ware of a Byzantine type.[71] From the end of the tenth and in the eleventh century here, too, ceramic production evidently improved and increased.[72] In contrast, Constantinopolitan ceramic manufacture, which flourished during the

67. E. Stikas, *Oikodomikon chronikon tes mones tou H. Louka Phokidos* (Athens, 1970); R. Krautheimer, *Early Christian and Byzantine Architecture* (Harmondsworth, 1976), 375f. n. 9; S. Savvas, "Étude de quatre églises du XIIᵉ siècle se trouvent en Argolide," *Theologia* 29 (1958), 368–76.

68. P. L. Vocotopoulos, "The Concealed Course Technique: Further Examples and a Few Remarks," *JÖB* 28 (1979), 247–60.

69. Kazhdan, *Derevnja i gorod*, 213–18.

70. The resurgence of ceramic production in Corinth took place in the eleventh to mid-twelfth century: C. H. Morgan, *The Byzantine Pottery*, Corinth, no. 11 (Princeton, 1942), 59f.; T. S. MacKay, "More Byzantine and Frankish Pottery from Corinth," *Hesperia* 36 (1967), 273, 280. For Corinth, also see B. Adamsheck, *Kenchreai, Eastern Port of Corinth*, vol. 4, *The Pottery* (Leiden, 1979), 100–104. On Byzantine ceramic ware of the twelfth century, possibly produced on the mainland of Asia Minor and recovered from a shipwreck off the northern Dodekanese Islands, R. M. Randall, "Three Byzantine Ceramics (The Walters Art Gallery, Baltimore)," *Burlington Magazine* 111 (1968), 461f.

71. K. Mijatev, "Vizantijska sgrafito keramika v carskija dvorec v Tŭrnovo," *Arch.* 9, no. 3 (1967), 8; J. Čangova, "Srednovekovni amfori v Bŭlgarija," *Izv. Arch. Inst.* 22 (1959), 255–59. Also see Ščereva's article, above, n. 29.

72. M. Stančeva and L. Dončeva-Petkova, "Srednovekovna bitova keramika ot Eskus pri s. Gigen," *Arch.* 14, no. 1 (1972), 30; L. Dončeva-Petkova, "Trapeznata keramika v Bŭlgarija prez VIII–XI v.," *Arch.* 12, no. 1 (1970), 22f.

second half of the ninth and the first half of the tenth century, appears later to have declined, most sharply at the close of the twelfth century.[73] Precisely at that time, however, a new type of pottery known as Zeuxippos Ware made its appearance. Vessels were fired at a high temperature one inside the other and separated by tripod stilts, which allowed more pots to be finished more rapidly. A large find of this pottery in the baths of Zeuxippos initially led scholars to believe that it was produced in Constantinople.[74] It is, however, so widely distributed—it has been found in the Aegean basin, on Cyprus, on the northern coast of the Black Sea, in Antioch, Egypt, and as well in Corinth, Pergamum, and Preslav[75]— that it no longer can be assumed that it was manufactured exclusively in the capital. It is just as likely that new urban demands in the provinces led to the widespread introduction of a new technique for increased production.

A brief consideration of a few other Byzantine crafts both suggests that Byzantium was by no means technologically backward in the eleventh and twelfth centuries and confirms the impression that Constantinople no longer held a monopoly in the production of goods. Byzantine silk continued to be produced from the tenth through the twelfth centuries. But beginning in the eleventh and most especially in the twelfth century, silk production spread beyond Constantinople to the Peloponnese, to Thebes, and perhaps to Thessaloniki.[76] It was from Thebes and Corinth that the Normans abducted silk weavers in 1147 in order to establish this prestigious craft in Sicily. Decentralization of craft skills is clear in this case.

So far as can be judged from the colophons and scriptoria that have been studied, a book culture also was active in provincial towns and monasteries in the eleventh and twelfth centuries.[77] In Asia Minor, de-

73. R. B. K. Stevenson, "The Pottery, 1936–1937," *The Great Palace of the Byzantine Emperors* (Oxford, 1947), 47f., 52.

74. A. H. S. Megaw, "Zeuxippus Ware," *Annual of the British School at Athens* 63 (1968), 68f., 87.

75. Megaw, "Zeuxippus Ware," 77f.; MacKay, "More Byzantine and Frankish Pottery," 259f.

76. Kazhdan, *Derevnja i gorod*, 230f.

77. R. Devreesse, *Introduction à l'étude des manuscrits Grecs* (Paris, 1954), 56f. Devreesse's references to Constantinople are evidently incomplete. He did not include manuscripts from the Studios that he knew quite well or illuminated works ascribed to imperial scriptoria. But even a recently established list of manuscripts produced in the Studios's scriptorium reveals the same pattern: twelve manuscripts can be dated to the ninth century, nine to the tenth, seven to the eleventh, and none to the twelfth: B. Fonkič, "Vizantijskie skriptorii," *JÖB*

spite the Seljuk invasions books continued to be made through the third quarter of the eleventh and into the twelfth century,[78] although after 1072 Anatolian towns no longer appeared in the colophons of Greek manuscripts. Devreesse mentions only two books written in Opsikion in 1161/62 and in 1186. In continental Greece, however, and on the islands, book production apparently flourished through the twelfth century. For instance, of the seven manuscripts of eastern Mediterranean isles included in Devreesse's list, five date between 1100 and 1204.[79] Some sense of how many books might have been being produced is provided by the library of the Cypriot monk Neophytos, an ardent scribe and writer, who owned at least sixteen volumes, some of which he may have copied himself.[80] Even illuminators appear to have been widely dispersed, if we may judge from the distribution of manuscripts associated through their illustrations with the Rockefeller McCormick New Testament.[81]

Glass manufacture also continued throughout this period. From the excavations at Sardis it would seem that glass was rare after 700 but reappeared in the tenth and eleventh centuries.[82] The only Byzantine glass factory that has been studied in any detail is that at Corinth, which dates to the eleventh and twelfth centuries.[83] Glassmaking at this time seems to have undergone technological changes. While traditional Roman methods continued to be used, new workshop techniques also appeared.[84] As were silk weaving and book production, the highly skilled

31/2 (1981), 433f., who provides an enormous bibliography, primarily of works dedicated to special problems. For a general survey, see above all J. Irigoin, "Centres de copie et bibliothèques," *Byzantine Books and Bookmen* (Washington, D.C., 1975), 18, who stresses that scriptoria have not been adequately studied; in another article, "Pour une étude des centres de copie byzantins, II," *Scriptorium* 13 (1959), 195–204, he establishes a group of Athonite manuscripts of the beginning of the eleventh century.

78. J. Darrouzès, "Le mouvement des fondations monastiques au XIᵉ siècle," *TM* 6 (1976), 172f.

79. Devreesse, *Introduction*, 57.

80. I. P. Tsiknopoullos, ed., *Kypriaka Typika, Pegai kai meletai tes Kypriakes historias* (Nicosia, 1969), 83f.

81. For instance, A. W. Carr, "Byzantine Manuscript Illumination in Twelfth-Century Palestine," *Abstracts of the Second Annual Byzantine Studies Conference* (New York, 1976), 15f.

82. Foss, *Byzantine and Turkish Sardis*, 75.

83. G. R. Davidson, "A Mediaeval Glass Factory at Corinth," *AJA* 44 (1940), 302f.

84. J. L. Ščapova, "Le verre byzantine du Vᵉ–XIIᵉ siècle" in *Srednovekovno staklo na Balkanu (V – XV vek)* (Belgrade, 1975), 41–47.

manufacture of glass was known in the provinces as well as in the capital of the empire.

The production of some luxury goods remained, however, a monopoly of the capital. Figural stained glass, for instance, has so far been found only in Constantinopolitan churches of the twelfth century, not in provincial monuments.[85] Whether the secrets of this medium originated in the East or in the West, it is clear at least that Byzantine craftsmen possessed the technology to produce glass of high quality.[86] Similarly, both literary and epigraphic evidence indicate that large-scale bronze casting—another extremely expensive and technologically sophisticated process—was not common outside Constantinople. Byzantine casting is known principally from a number of bronze doors that can be more or less precisely identified as to date and provenance.[87] Although there are earlier examples of Byzantine bronze doors, such as those at St. Sophia, the height of bronze door production occurred in the tenth through eleventh centuries and ended in the twelfth. These doors were often exported beyond the borders of the empire; a number of them still exist in Italy, where they were later imitated by local masters.[88]

The art of mosaic laying may also have been restricted to Constantinople. Mosaic programs executed in Constantinople during the second half of the twelfth century are known almost exclusively from literary sources.[89] The fragment of an archangel in mosaic discovered in the restoration at Kalenderhane Camii in Constantinople provides some

85. A. H. S. Megaw, "Notes on Recent Work of the Byzantine Institute in Istanbul," *DOP* 17 (1963), 362–64; A. Underwood, *The Kariye Djami* 1 (New York, 1966), 19.

86. Against the theory of Byzantine priority, J. Lafond, "Les vitraux histories du moyen âge decouverts récemment à Constantinople," *Bulletin de la Société nationale des antiquaires de France*, 1964, 164–66; "Découverte de vitraux historiés du moyen âge à Constantinople," *CA* 18 (1968), 231–38.

87. Ch. Bouras, "The Byzantine Bronze Doors of the Great Lavra Monastery on Mount Athos," *JÖB* 24 (1975), 229–50; W. E. Kleinbauer, "A Byzantine Revival: The Inlaid Bronze Doors of Constantinople," *Archaeology* 29 (1976), 16–29. The Byzantine origin of the so-called Korsunskie vrata (Gates of Cherson) in the Church of St. Sophia in Novgorod is debated: A. V. Bank, "Konstantinopol'skie obrazcy i mestnye kopii," *VV* 34 (1973), 193–95.

88. M. E. Frazer, "Church Doors and the Gates of Paradise, Byzantine Doors in Italy," *DOP* 27 (1973), 143–62; G. Matthiae, *Le porte bronzee bizantine in Italia* (Rome, 1971).

89. P. Magdalino, "Manuel Komnenos and the Great Palace," *BMGS* 4 (1978), 101–14; P. Magdalino and R. Nelson, "The Emperor in Byzantine Art of the Twelfth Century," *Byz. Forsch.* 8 (1982), 123–81.

indication of the high quality of the lost works (Fig. 9).[90] Further evidence indicates that mosaicists traveled from Constantinople to neighboring states to work abroad. In about 1070, Desiderius, abbot of Monte Cassino, sent to Constantinople for mosaicists to decorate his new basilica.[91] The *Paterikon* of the Cave Monastery (Pečerskij monastyr') in Kiev is also quite explicit: Greek artists, it says, were sent by God's will and that of the Virgin from the Queen of Cities to embellish the Church of the Cave; it dates this event to the reign of Prince Vsevold Jaroslavich (1078–93).[92] It is also commonly thought that Constantinopolitan craftsmen were involved in Manuel I's efforts to restore the major pilgrimage shrines in the Holy Land in the later twelfth century. The literary evidence provided by Manuel's contemporary, John Phokas, affirms the emperor's patronage of work undertaken at the Holy Sepulcher and elsewhere, but fails to indicate the origins of the craftsmen employed in these restoration and redecoration programs. The single exception, found in the passage describing the complete reconstruction of the Monastery of the Holy Prophet Elias "through a Syrian who was in charge of it," suggests that at least some of the builders were local (*PG* 133.944A, 952B, 956C–D). In contrast, Constantinopolitan masons and perhaps even Byzantine bricks were used in Constantine IX Monomachos's reconstruction of the Holy Sepulcher of 1042–48.[93] Despite a lack of literary documentation, it is generally assumed that Constantinopolitan mosaicists were employed by the Norman kings of Sicily to adorn their sacred and secular buildings. Certainly the mosaic figures of William II's Monreale show a close stylistic affinity to the fragmentary archangel of Kalenderhane Camii (figs. 8–9).[94] From an earlier date, in the late eleventh century, there is stylistic evidence that mosaicists also came from Byzantium to the northern Adriatic to work in Venice[95] and Torcello.[96] As in the case of large-scale bronze casting, it seems unlikely that any provincial center outside of Con-

90. C. L. Striker and Y. Doğan Kuban, *Kalenderhane Camii in Istanbul: Final Excavation Report* (Washington, D.C., forthcoming).

91. "Chronica monasterii Cassinensis," *MGH SS* 7:718.

92. D. Tschiževskij, ed., *Das Paterikon des Kiever Höhlenklosters* (Munich, 1964), 172.

93. R. Ousterhout, "The Byzantine Holy Sepulchre," *Abstracts of the Ninth Annual Byzantine Studies Conference* (Durham, N.C., 1983), 61–62.

94. Striker and Kuban, *Kalenderhane Camii*, forthcoming; E. Kitzinger, *The Mosaics of Monreale* (Palermo, 1960), fig. 40.

95. O. Demus, *The Mosaics of San Marco in Venice* (Chicago and Washington, D.C., 1984).

96. I. Andreescu, "Torcello," parts 1 and 2, *DOP* 26 (1972), 183–223; part 3, *DOP* 30 (1976), 245–341.

stantinople could sustain the continuous workshop tradition fundamental to a craft involving both great skill and advanced technology.[97]

The minor arts provide only ambiguous evidence concerning the relationship between the capital and the provincial cities because it is often difficult to identify the provenance of the objects. In the works produced for the court of the tenth century, ivory reattained a prominence it had not had since the first half of the sixth century.[98] While in the eleventh century ivory continued to be an important medium, it was replaced in the twelfth by steatite or soapstone.[99] It is unclear what caused this change in materials. There are no grounds for believing that ivory was no longer available; perhaps the cause was simply a growing appeal of small-scale relief carving. Figurally carved steatites, especially of the lighter, more translucent variety, were evidently highly valued.[100] In contrast, cloisonné enamel work remained highly refined throughout the period. The popularity of this medium, in which pieces of brilliantly colored glass are drawn into a figure in a web of gold wires, is typical of the Byzantines' taste for highly crafted, jewellike objects. The enamels of the upper register of the Pala d'Oro, probably originally from the sanctuary screen of John II Comnenus's Pantokrator Monastery in Constantinople, attest to the superb quality of the craft during the twelfth century.[101] On these golden plaques, Christological scenes from the liturgical calendar are rendered with the refined opulence that both mosaicists and manuscript illuminators strove to achieve. Similarly, silverwork of a high standard was produced in the tenth century after a lapse of nearly three centuries. Stylistic analysis may eventually allow developments in silverwork to be traced from the Limburg Staurothek of 964/65 through the

97. R. Cormack, "The Apse Mosaics of S. Sophia at Thessaloniki," *Deltion tes Christianikes archaiologikes hetaireias*, ser. 4, 10 (1980–81), 111–35, largely on the grounds of style, but also partially on the basis of its technical ineptitude, proposes that the mosaic Virgin in the apse of St. Sophia in Thessaloniki is a local product.

98. A. Goldschmidt and K. Weitzmann, *Die byzantinischen Elfenbeinskulpturen des X–XIII Jahrhunderts* (Berlin, 1930), vol. 1, 15. On the redating of ivories to the eleventh century, I. Kalavrezou-Maxeiner, "Eudokai Makrembolitissa and the Romanos Ivory," *DOP* 31 (1977), 304–25.

99. I. Kalavrezou-Maxeiner, *Byzantine Icons in Steatite* (Vienna, 1984).

100. I. Kalavrezou-Maxeiner, "The Paris Psalter," *Abstracts of the Eighth Annual Byzantine Studies Conference* (Chicago, 1982), 50–51.

101. On the Pala d'Oro, H. R. Hahnloser, "Magistra Latinitas und Peritia Graeca," *Festschrift für H. von Einem* (Berlin, 1965), 77f. K. Wessel, *Byzantine Enamels* (Shannon, 1969), 30f., suggests that enamelwork continued in Byzantium to Palaeologue times.

twelfth century.[102] For instance, there are a number of processional crosses decorated with silver repoussé and niello work that probably date to the eleventh century;[103] the only one with a generally accepted date and provenance is Michael Keroullarios's Constantinopolitan cross, now in fragmentary form in the Dumbarton Oaks Collection.[104] While the minor arts thus do reflect continued prosperity in Byzantium, their usefulness as a cultural barometer is qualified by the difficulty of ascertaining the exact date and the original source of many of the individual pieces.

In sum, the empire prospered through the eleventh and twelfth centuries. The material production recognizable from excavations and in surviving monuments implies a stable agricultural and demographic base and conscious local traditions. There appears to have been an economic shift away from the capital and in favor of the hinterland. This redistribution must have been, of course, very gradual. Constantinople continued to control not only the manufacture of many luxury goods but also the politics and high culture of the empire. Perhaps the discrepancy between the political domination of the capital and the economic importance of the provinces was alluded to by Michael Choniates, who wrote that Constantinople lived off the provinces, the nobility never caring for the countryside, but only sending there "the tax collectors with their bestial fangs" (Mich. Akom. 2:83.4–10).

URBAN ECONOMY AND INSTITUTIONS

While the provinces may have become increasingly important in the eleventh and twelfth centuries, political institutions in the Byzantine Empire were not structurally altered. Moreover, the emergence of provincial cities in Byzantium did not produce a new urban economy and ideology or innovative institutions and attitudes as in the West. This conservatism may be at least documented, if not satisfactorily explained.

Autarchy and cautious attitudes toward the market continued to determine Byzantine business practices.[105] Kekaumenos recommended avoidance of the marketplace. An efficient master, he wrote, would always see that his household produced everything it needed (Kek. 188f.).

102. A. V. Bank, "Opyt klassifikacii vizantijskich serebrjanych izdelij X–XII vv.," *VV* 32 (1971), 138.

103. A. V. Bank et al., "Études sur les croix byzantines du Musée d'art et d'histoire de Genève," *Geneva*, n.s., 28 (1980), 97–122.

104. R. Jenkins and E. Kitzinger, "A Cross of the Patriarch Michael Cerularius," *DOP* 21 (1967), 233–49.

105. Kazhdan, "Iz ekonomičeskoj žizni," 198f., 208–12.

If a market was indispensable, the master was advised to use it with caution. The *typikon* of the Monastery of the Virgin Kosmosotira instructed the *hegoumenos* to buy olive oil in the Aenos once a year, on the one day when the price was cheapest. He was to buy not from the merchants, but directly from those who brought the oil in their ships. Medicine also was to be bought once a year (*Kosm.* 50.1–4, 54.14–15). Similarly, one trusted one's own produce more than that which was purchased. Eustathios of Thessaloniki, living in the capital, was proud of the fruit of his orchard because it was not imported and had not changed hands repeatedly (Eust. *Opusc.* 111.42–45). In the same vein, Gregory Antiochos believed that foodstuffs acquired at the market were of poor quality.[106] Nicholas Mesarites admired the independence of the Church of the Holy Apostles in Constantinople. He praised the site of the church, which though within the city was surrounded by its own grainfields and thus safe from foreign invasion, storms, pirates, and the schemes of sailors (Nic. Mesar. 898, ch. 4.2).

In principle the Byzantine economy was based on money, but trading in kind was common. According to Zonaras not only money could be lent, but also wine, oil, and other kinds of foodstuffs (*PG* 138.40B). Taxes and rents in kind were collected; similarly, labor and services were also frequently paid for in kind in the capital as well as in the provinces. High officials and soliders received clothing and produce in addition to money. The clergy were rewarded with money and with grain. A medical doctor's honorarium might consist of money and of wine; his salary included both grain for his family and forage for his animals. A porter was to get dinner and a mug of wine; construction workers received both money and a ram upon completion of a church.[107]

The separation of crafts from agriculture was far from complete. The Arab geographer Idrisi emphasized the number of fields and vineyards and the abundance of grain and fruit in his descriptions of Byzantine towns such as Adrianople, Rhodosto, Athens, Serres, Zichnae, Serdica, and Larissa.[108] Similar observations are typical also of Byzantine authors. In his description of Dorylaion, Kinnamos, who thought of the town as a large one, sketched the agrarian merits of the site: valleys that grew dense grass and weighty ears of wheat, a river that supplied abundant water and fish (294.12–21). Psellos noted wells, wheatfields, and fruit trees in Antioch (*Scripta min.* 2.117.3–6). He mentioned that Cyzicus,

106. Darrouzès, "Deux lettres de Grégoire Antiochos," 279.39–50.
107. Kazhdan, "Iz ekonomičeskoj žizni," 200f.
108. Tivčev, "Sur les cités," 159–61.

like Antioch, was "wheat producing" (Sathas, *MB* 5:265.15). To Psellos's contemporary Attaleiates, Ikonion was best known for its cattle (Attal. 135.11–13). When Alexios I founded a new town—named Alexiopolis or Neokastron—near Philippopolis, he settled it with men who knew how to manage oxen and the plow and he granted them fields and vineyards (An. C. 3:184.21–28). Twelfth-century Athens was also an agricultural center. Michael Choniates lamented that a number of houses had been replaced by fields and that the famous Stoa had been transformed into a pasture (Mich. Akom. 1:159f.). When complaining of severe taxation in Athens, he referred above all to the poor quality of the land.[109] The rusticity of Athens as presented by Michael was confirmed by his brother Niketas, who told how when Leo Sgouros failed to capture the Acropolis, he turned in a fit of anger against the city, burning down the *oikopeda* (usually, "country houses") and taking all the cattle (Nik. Chon. 608.40–43). Even Constantinople had its rural side. Eustathios of Thessaloniki, as already mentioned, was proud of his orchard in the "Queen of Cities." While fruit of such quality, he wrote, could be found in the countryside occasionally, it was very rare in the capital (Eust. *Opusc.* 308.55–61). According to Odo of Deuil, there were gardens and free lands cultivated with shovel and plow within the city walls of Constantinople.[110] The fields around the Church of the Holy Apostles mentioned above were located almost in the center of the city.

Communication and trade over any distance remained extremely difficult.[111] Transportation was hampered by mountains, forests, and rivers. The great rivers, the Danube and the Euphrates, were on the outskirts of the empire: they were borders, not communication routes. Small mountain rivulets impeded rather than facilitated transportation. Theophylaktos of Ohrid wrote that when the Vardar rose, it could be forded neither on foot nor on horseback. Only a tiny boat was available for the crossing (*PG* 126.472C–D). During the winter, the fragile lines of communication were severed. The winter, wrote Eustathios, forced people to crawl into their dwellings as into lairs (*Opusc.* 86.61–63). Snow and winds made winter journeys almost impossible. Niketas Choniates

109. G. Stadtmüller, *Michael Choniates, Metropolit von Athens* (Rome, 1934), 161.13.
110. *De profectione Ludovici VII in orientem*, ed. and transl. V. G. Berry (New York, 1948), 64.
111. Kazhdan, "Iz ekonomičeskoj žizni," 170–83. According to H. Ahrweiler, *Byzance et la mer* (Paris, 1966), 269, the Byzantines made their last concerted attempt to restore the *thalassokratia* in the middle of the twelfth century.

stated that after the sun turned toward the winter, the road from Philippopolis to Serdica became impassable—the cold froze the rivers; snow covered the earth, filled the ravines, and blocked the doors of the houses. Even the road from Heraclea Pontica to Nicaea was apparently difficult in winter.[112] For transportation the Byzantines used donkeys and mules; only under especially favorable circumstances were oxen used to draw carts. Draft horses were seldom used, though the collar and horseshoe were known.[113] Byzantine cargo ships were small and slow. According to Antoniadis-Bibicou, their average capacity was 8.5—17 cubic meters—500–1,000 *modioi*.[114] They seem to have been much smaller than the ships of the Late Roman Empire, which, at least according to hagiographic texts, carried 20,000, 50,000, or even 70,000 *modioi*. Byzantine ships, called *strongyloi* (round), were short and broad for the sake of stability but very ponderous.

There is some information concerning travel time in Byzantium (Ex. 5). It took about three days to reach Adrianople from the capital and eight days from Thessaloniki to the shores of Danube. The trip from Paphlagonia to Constantinople, like that from Antioch to Nicaea, lasted eight days. Idrisi and Western travelers recorded longer travel times than their Greek contemporaries. For example, according to Idrisi, it took eight days to go from Nicaea to Amorium, but, as Anna Comnena measured it, it was only eight days from Nicaea to Antioch.[115] Sea travel was also slow; the Byzantines feared the open sea. As Theophylaktos of Ohrid put it, they preferred to sail along the coast, "touching the land with their oars" (*PG* 126.501C–504A). In good weather, sailing from Constantinople to Cyprus took ten days. Odo of Deuil wrote that it was possible to sail from Attaleia to Antioch in three days.[116] To sail from Paphlagonia to the northern shores of the Black Sea, it was necessary to allow three or even four days. Of course, neither the difficulties of the journey nor the fear of storms, of pirates, or of robbers could prevent travel. Pilgrims, merchants, and artists all journeyed across the country,

112. A. Heisenberg, *Neue Quelle zur Geschichte des lateinischen Kaisertums und der Kirchenunion* (Munich, 1923), now in his *Quellen und Studien zur spätbyzantinischen Geschichte* (London, 1973), part 2, section 3, 46.29–32.

113. Cf. Lefebvre des Noëttes, "Le système d'attelage du cheval et du boeuf à Byzance et les conséquences de son emploi," *Mélanges Ch. Diehl* 1 (Paris, 1930), 183–90.

114. H. Antoniadis-Bibicou, *Études d'histoire maritime de Byzance* (Paris, 1966), 132f.

115. Kazhdan, "Iz ekonomičeskoj žizni," 175f.

116. *De profectione Ludovici VII in Orientem*, 130.

sometimes forming large caravans. Bridges were constructed or re-
paired, inns established on roads and in large cities. People moved, but
slowly.

As in transportation, little progress was made by the Byzantines in
technology. In the West, water power started to be widely and effectively
used in the tenth century for craft production, especially in the woolen
industry and for forging; later the windmill was introduced.[117] Byzan-
tium seems to have lagged behind: although water mills were men-
tioned as early as the seventh or eighth century in the Farmer's Law,
millstones turned by donkeys remained the most common means of
grinding grain, and even hand querns continued in use; windmills were
unknown before the thirteenth century. There were idiosyncratic experi-
ments, however, such as the ox-driven kneading gear invented on Athos
at the end of the tenth century.[118] But generally speaking, new modes of
production did not arise.

Conservatism was also typical in urban political forms. There is little
doubt that Byzantine townspeople had some power. The crowd's exer-
cise of influence was common enough in the empire's history: crowds
could affect judicial proceedings (Kek. 120.16–20, 118.7, 200.23–24), and
officials apparently sought popular support. When, as Psellos relates,
the clerk (*notarios*) of a provincial judge wanted to praise his patron
while in Constantinople, he sought his platform in crowded squares
among the *demoi* and mobs, rather than at the Treasury or in small gath-
erings (Sathas, *MB* 5:298.12–16). There also seem to have been rudimen-
tary forms of local political action. Eustathios of Thessaloniki mentions
"a good [person], elected for a year"—perhaps an annually elected mag-
istrate—who was constantly seen in the marketplace (*agora*) and at the
city council (*bouleuterion*). Large numbers of common folk sought his ad-
vice on marriage, trade, and contracts of different kinds (Eust. *Opusc.*
92.3–4, 32–36). Urban conventions and councils continued to be sum-
moned occasionally in the eleventh and twelfth centuries, despite the
prohibition of Leo VI.[119] In one of his speeches, Michael Choniates al-
luded to regular public meetings, describing them with some derision:
in the past, he said, the gatherings of the barbarians, the Sybarites, and

117. L. White, *Medieval Technology and Social Change* (Oxford, 1962), 82–87.
118. Ph. Meyer, *Die Haupturkunden für die Geschichte der Athosklöster* (Leip-
zig, 1894), 157.9–10.
119. E. Kirsten, "Die byzantinische Stadt," *Berichte zum XI. internazionalen
Byzantinisten-Kongress* (Munich, 1958), 27 (Edessa); A. P. Kazhdan, "Gorod i de-
revnja v Vizantii v XI–XII vv.," *Actes du XIIᵉ Congrès international d'études byzan-
tines* 1 (Belgrade, 1963), 37 (Amasia).

the Phoenicians had been noisier than flocks of jackdaws, while the Hellenes had gone even to battle in silence. Now everything was changed; the Celts, Germans, and Italians preserved solemnity and order during meetings, whereas the Greeks, whose upbringing should have contributed to their eloquence and decorum, went crazy when they discussed their common affairs (Mich. Akom. 1:183.3–15). The inhabitants of Constantinople in the eleventh century were politically effective at certain critical moments. Their political potency was recognized by the emperors, who on occasion addressed both the people and the senate.[120] According to Attaleiates (Attal. 70.16), Constantine X assembled the urban corporations (*somateia*) and delivered a speech in their presence. His son, Michael VII, is said to have addressed the *politai*, the citizens of Constantinople, as well as the senators (Attal. 186.20–22). Later on, when Michael's power had been shaken by a revolt he sent a chrysobull to the *ekklesia*, a gathering of the inhabitants of the capital, that had elected Nikephoros Botaneiates emperor. Attaleiates says they had assembled in St. Sophia and were acting "democratically." Michael's chrysobull was a failure: when read in the meeting, it elicited only disdain and laughter (256f.).

Traditional forms of corporate organization, however, were weakened rather than strengthened. Sources do mention corporate bodies distinct from the senate—*somateia* (Attal. 70.16) or *systemata* (Kek. 124.22), perhaps signifying urban organizations. The *systematikoi*, for instance, were ordered by Alexios I not to take oaths in private houses (*Reg.* 2: no. 1091). Other sources of that period seem to reflect the existence of trade-related organizations: apprentices, journeymen, guild, and market aldermen are all mentioned in the texts.[121] Trade regulations as well as craft titles were retained. Tzetzes alluded to the rules craftsmen were obliged to follow; if a master refused to comply with them, he was debarred from his work.[122] This seems to be confirmed by Michael Choniates, who described a "fake" cloak made contrary to regulation (Mich. Akom. 2:345.19–20). But neither Tzetzes nor Michael referred to the regulatory body; it is unclear whether it was a trade corporation or the state. Furthermore, a tradesman does not seem to have been as-

120. S. Vryonis, "Byzantine *demokratia* and the Guilds of the Eleventh Century," *DOP* 17 (1963), 302–14; Lemerle, *Cinq études*, 290–93.

121. *PG* 126.521D; Eust. *Opusc.* 79.83–90; *Poèmes prodr.* no. 4, 97.115; Attal. 12.10. The act of 1008 referring to Thessaloniki, F. Dölger, *Aus den Schatzkammern des Heiligen Berges* (Munich, 1948), no. 109.

122. P. A. M. Leone, "Ioannis Tzetzae iambi," *Rivista di Studi bizantini e neo-ellenici*, n.s. 6–7 (1969–70), 138.123–25, 141.213–14.

signed to a specific guild group. When Kekaumenos recommended that
craftsmen not change their trades, he did so not because of legal restric-
tions but because it was unprofitable (Kek. 244.2–8). Nicholas of Meth-
one wrote specifically that the Byzantines didn't restrict people possess-
ing the necessary skill or talent in their choice of living-place or trade
(*Bibl. eccl.* 279). Hence Prodromos, or rather the subject of his poems,
could leave his trade as soon as his lack of skill became apparent (*Poèmes
prodr.* no. 4, 76). Manuel I's ordinance of 1151 or 1166 (*Reg.* 2: no. 1384)
allowed anyone who had bought a money-changer's shop to sell it to any
worthy person whatsoever. No internal control of the corporation is
mentioned by any source. Such freedom contradicts guild norms. What-
ever regulation existed was, then, most likely imposed by the state. Dur-
ing the twelfth century, traditional forms of corporate organization were
gradually lost; guilds in Constantinople vanished.[123] While, however,
there is no clear evidence of corporate life in the crafts and trades in the
eleventh and especially in the twelfth century, perhaps corporate life
in parochial districts originated at this time. Confraternities, united
around a parochial church or around an urban monastery, began to ap-
pear in the eleventh century.[124] It is noteworthy that when such a new
institution developed, it did so in a provincial, non-metropolitan setting.

 The free populations of the cities did not evolve forms of self-
government, *autonomiai*, as they were called by Michael Choniates (Mich.
Akom. 2:81.25–26), and transform the towns into independent com-
munes; communes evolved only on the periphery of the empire, in
Amalfi, Venice, and Cherson. But as no accommodation was made by
the imperial regulatory system for these new forms of government, the
communes were forced to break away from Byzantium—thus the em-
pire lost its most vigorous and efficient urban elements.[125] Other provin-
cial cities remained under the sway of the central imperial administra-

 123. E. Frances, "La disparition des corporations byzantines," *Actes du XII*
Congrès international d'études byzantines 2 (Belgrade, 1964), 98; R. S. Lopez, "Silk
Industry in the Byzantine Empire," *Speculum* 20 (1945), 24. N. Oikonomidès,
Hommes d'affaires grecs et latins à Constantinople (Paris, 1979), 108–14, argues on
the contrary that guilds did not disappear after the *Book of the Eparch*. He bases
his argument on data of the thirteenth and fourteenth centuries.
 124. See the rule of the lay confraternity associated with the monastery of
the Virgin in Naupaktos, J. Nesbitt and J. Wiita, "A Confraternity of the Comne-
nian Era," *BZ* 68 (1975), 364–68.
 125. A. P. Kazhdan, *Centrostremitel'nye i centrobežnye sily v vizantijskom mire
(1081–1261)* (Athens, 1976), 18.

tion.[126] At the same time they did not escape the "seignorial" power of the church and of the local aristocracy. The episcopate took upon itself the functions of the city community, even defending urban interests against the central government. The bishop and the town were not, then, antagonists, as was seen whenever the church and the people acted in concert against the central government. The sensible administrative concern of Michael Choniates, metropolitan of Athens, for his parishioners in the face of predatory secular tax collectors is well documented.[127] Further, bishops were often important in the defense of their cities, as were both Michael Choniates and Eustathios of Thessaloniki. In return for his concern, the bishop might well receive the support of the populace. For example, when Aimilianos, patriarch of Antioch in the 1070s, was ordered to Constantinople to face civil charges, crowds in his city frustrated attempts to remove him.[128] This riot in support of the local prelate was as typical of Byzantium as the riot of Laonese citizens against their bishop was in the medieval West. Such traditions of political organization militated against the development of new administrative forms.

A considerable conservative influence was asserted over provincial cities by local magnates also.[129] According to Kekaumenos, the urban population considered such a magnate as their lord, pledging him their fidelity and obedience in recognition of his family's past position; nevertheless they might desert him at a moment of external menace (Kek. 198.15–202.11). The urban magnate had some jurisdiction over the inhabitants, including the right to punish them (232.9–236.11). It was even possible for the emperor to bestow an entire city on a Byzantine or foreign noble. At the end of the eleventh century, Thessaloniki was granted to Nikephoros Melissenos (An. C. 1:89.9–10), and Trebizond was awarded to Theodore Gabras (An. C. 2:151.27), whose descendants

126. H. Glykatzi-Ahrweiler, *Recherches sur l'administration de l'Empire byzantin aux IX^e–XI^e siècles* (Paris, 1960), 48, 63, 72.

127. E.g., C. Brand, *Byzantium Confronts the West, 1180–1204* (Cambridge, Mass., 1968), 149f. Another example of an efficient metropolitan is Theophylaktos of Ohrid. On him, B. Panov, "Ohrid vo krajot na XI i početokot na XII v. vo svetlinata na pismata na Teofilakt Ohridski," *Mélanges D. Koco* (Skopje, 1975), 191f., and his "L'activité de Theophilakt d'Ohrid en Macédoine," *La Macédoine et les Macédoniens dans le passé* (Skopje, 1970), 45–60.

128. Bryen. 203f. See Skabalanovič, *Vizantijskoe gosudarstvo*, 421f.

129. On nobles dwelling in cities, see N. G. Svoronos, "Sur quelques formes de la vie rurale à Byzance," *Annales* 11 (1956), 325ff.

still ruled there during the reign of John II.[130] Often, too, small towns
and strongholds fell under seignorial power.[131] The interests of landed
magnates and of city populations could, of course, coincide, and urban
movements were occasionally led by seigneurs. In 1057, Emperor Mi-
chael VI was dethroned by the combined efforts of a popular insurrec-
tion in Constantinople and an aristocratic rebellion in Asia Minor headed
by Isaac Comnenus and Katakalon Kekaumenos, both of them able gen-
erals supported by the local nobility. In 1078, Nikephoros Botaneiates,
also a noble general, was proclaimed emperor by the people from the
agora, including tradesmen as well as the representatives of the clergy
and of the senate. Some of the ruling authorities hoped to smash the
rebellion, since the crowd, they said, consisted predominantly of crafts-
men inexperienced in warfare, but the frightened Michael VII allowed
the rebels to take over.[132] In 1181, soon after Manuel I's death, when the
throne was occupied by the youth Alexios II and the administration was
controlled by the unpopular weakling Alexios the Protosebastos, an aris-
tocratic conspiracy was formed that included Manuel I's nearest rela-
tions, his daughter Maria and his illegitimate son Alexios the Protostra-
tor, as well as military commanders such as Andronikos Lapardas. The
Constantinopolitan population immediately sided with the conspirators.
Priests carrying icons led the mob, which assembled in the Hippodrome
and began to assail the palace, cursing the regent and hailing the em-
peror.[133] And again, when Andronikos Comnenus proclaimed himself
defender of the young Alexios II and marched against the capital from
his exile in Paphlagonia to overthrow the regency of Alexios the Proto-
sebastos, the common people of Constantinople provided the staunchest
support for his usurpation. But his alliance with the masses did not last
long. Despite propaganda describing Andronikos I as a ruler who pro-
vided the people both economic prosperity and security from tax collec-
tors—contemporary leaflets praised his protection of the peasantry,
who might finally lie at ease under their fruit trees—the urban popula-
tions defected. First provincial rebellions arose in Nicaea, Brusa, and
Lopadion. Everywhere magnates sided with the local populace. An-
dronikos Lapardas, commander of the Byzantine troops fighting the

130. A. A. M. Bryer, "Byzantine Family: The Gabrades," *University of Bir-
mingham Historical Journal* 12 (1970), 175f.
131. N. Oikonomidès, "The Donations of Castles in the Last Quarter of the
11th Century," *Polychronion, Festschrift Franz Dölger*, ed. P. Wirth (Heidelberg,
1966), 413–17.
132. Vryonis, "Byzantine *demokratia*," 309–11.
133. Brand, *Byzantium Confronts the West*, 34f.

Hungarians, was married to Manuel I's niece and therefore closely bound up with the Comnenian clan, which was threatened by Andronikos I's policies. Lapardas̨ sailed to Bithynia to join the rebels, but was seized at Adramytion, blinded, and imprisoned in Constantinople. Other leaders of the revolt belonged to such noble families as the Kantakouzenoi and Angeloi. The revolt, however, was crushed. In Nicaea, Andronikos I executed or exiled many of the nobles, and in Brusa insurgents were hanged or thrown into pits to die. Theodore Angelos was blinded, put on an ass, and driven away toward a region occupied by nomadic Turks. Later on, Constantinople itself revolted against Andronikos I, and again the Angeloi headed the rebellion. The same population that had hailed Andronikos I a few years earlier as a savior now assailed him. His hands were cut off and his teeth pulled out. He was bound to a mangy camel and driven through the streets, where he was bombarded with stones, blows, dung, and urine until he was finally suspended between two columns in the Hippodrome and tortured to death.

Governmental and aristocratic traditions seem to have stifled innovative urban institutions; the inhabitants of Byzantine towns never developed the urban self-consciousness typical of medieval culture in the West. There was no distinction in Byzantine terminology between fortress (*kastron*) and town (*polis*), or between town and borough (*polichnion*),[134] and there did not exist a special notion analogous to the *burgensis* of the West. When rhetoric was revived in the eleventh and twelfth centuries, praise of the city (*polis*), a theme well known to Menander, the foremost rhetor of the third century A.D., was not practiced by the Byzantines. Their epideictic attention was devoted to such traditional institutions as the imperial court and the patriarchate, and only after the fall of Constantinople in 1204 did *enkomia* of the *polis* begin to appear at all. Late Antique civic pride in one's *polis* never revived. The Byzantines sought to define the *polis* not by its administrative or legal, nor by its social or economic peculiarities, but by its external appearance, or even

134. A. Carile, "Partitio terrarum Imperie Romanie," *Studi Veneziani* 7 (1965), 227, suggests that Byzantium did retain the Roman principle of distinction between the capital (*polis*), the town (*kastron*), and the countryside (*chora*). See also V. von Falkenhausen, *Untersuchungen über die byzantinische Herrschaft in Süditalien vom 9. bis zum 11. Jahrhundert* (Wiesbaden, 1967), 132f., and objections by A. P. Kazhdan in a review of this book, *VV* 33 (1972), 236. Also see his review of A. Guillou's publications concerning Italy, *VV* 37 (1976), 273. For reference, L. V. Gorina, "Nekotorye voprosy terminologii srednevekovogo bolgarskogo goroda," *Sovetskoe slavjanovedenie* (Minsk, 1969), 580–85, and K.-D. Grothusen, "Zum Stadtbegriff in Südosteuropa," *Les cultures slaves et les Balkans* 1 (Sofia, 1978), 132–47.

by the virtue of its inhabitants. According to Michael Choniates, a city's typical features included fortifications, an entrance bridge, and a large population (Mich. Akom. 2:106.13–17). Moreover, he saw the peculiarity of the *polis* "not in the strong walls or tall houses, the creations of carpenters, not in markets and temples, as the ancients imagined, but in the existence of pious and courageous, chaste and just men" (2:258.12–16).

To summarize: while there was economic growth in provincial towns during the eleventh and twelfth centuries, this was not accompanied by political liberation. Subjugated to the state, to the episcopate, and to the landed magnates, the urban populations did not become an independent, antifeudal political and cultural force.

"FEUDALIZATION" OF THE BYZANTINE SOCIAL STRUCTURE

THE NATURE OF THE BYZANTINE ESTATE

Concurrent with urban and agricultural development in the provinces came the expansion of lay and ecclesiastical estates.[135] Whether this displaced the traditional balance of small and large properties in Byzantium is unclear. The sources doom scholars to impressions and to speculations, providing neither exact figures nor clear conclusions. As earlier indicated, there is no evidence of the existence of both large estates and dependent peasants throughout the eighth and, with a few questionable exceptions, even the ninth century. The tenth century presents a different picture. Imperial legislation indicates a struggle between the old free peasantry and the new *dynatoi* (powerful), secular and ecclesiastical dignitaries, who endeavored to substitute the exploitation of dependent holders for the free village community. Their success over the following

135. N. G. Svoronos, "Le domain de Lavra jusqu'en 1204," *Lavra* 1, 64–72; "Remarques sur les structures économiques de l'Empire byzantin au XIᵉ siècle," *TM* 6 (1976), 52; *Études sur l'organisation intérieure*, part 9, 373–76, 3, 142f. J. Lefort, "En Macédoine orientale au Xᵉ siècle: habitat rural, communes et domaines," *Occident et Orient aux Xᵉ siècle* (Paris, 1979), 251–72, and his "Une grande fortune foncière au Xᵉ–XIIIᵉ siècles: les biens du monastère d'Iviron," *Structures féodales et féodalisme dans l'Occident méditerranien* (Rome, 1980), 727–42; A. Guillou, "Economia e società," *La civiltà bizantina dal IX all' XI secolo* (Bari, 1978), 330–41; G. G. Litavrin, "K položeniju vizantijskogo krest'janstva v X– XI vv.," *Beiträge zur byzantinischen Geschichte im IX.–XI. Jahrh.* (Prague, 1978); S. Lišev, "Nekotorye voprosy feodal'nych otnošenij v Bolgarii v X v. i v epochu vizantijskogo gospodstva," *VV* 41 (1980), 30–38.

centuries is difficult to determine. It goes without saying that some large landowners, both lay and ecclesiastical, acquired new lands notwithstanding active imperial legislation in the tenth century. The charters from the archive of the Lavra of St. Athanasios on Mount Athos indicate a policy of land acquisition. For example, in 993 the Lavra acquired the island of Kymnopelagisia (*Lavra* 1, no. 10); in 1014, Constantine and Maria Lagoudes gave their possessions to the Lavra (no. 18); and about 1016, the widow of the *koubouklesios* John gave her lands on the island of Skiros as a gift to the Lavra (no. 18). But did such donations lead to a change in the social structure of the empire, or were they simply transferences of land from one large proprietor to another within a traditional rural framework? Further, could it not be assumed that some lands were distributed among smaller landowners at the same time that other *dynatoi* enlarged their estates? An exceptionally valuable source, the so-called land register of Thebes, reflects conditions in Boeotia in the second half of the eleventh century.[136] The register contains forty-five *stichoi*, or fiscal units, located throughout at least twenty-three *choria* (villages). Since the register was compiled for fiscal purposes, it does not reveal the nature of the property or the social relationships on the land; no dependent peasants, slaves, or wage workers are mentioned in the text. Some conclusions, however, concerning the status of the taxpayers (i.e., of the landowners) can be drawn from the document—no persons are described as peasants, with the single exception of a man who is called *ptochos* (poor), a term widely used in tenth-century agrarian legislation in contrast to *dynatos*. But terms indicating high social status are very frequent: *archon* is used 8 times; *protospatharios*, 43; *spatharokandidatos*, 12; *spatharios*, 8; *kourator*, 11; *protokankellarios*, 6; *droungarios*, 7; *proedros*, 4. At least in this region the land was by the end of the eleventh century in the hands of the *dynatoi,* some of whom lived far from their fields in cities such as Athens, Thebes, Euripos, or Avlon. Some landowning families were even connected with southern Italy and with Sicily, or at least had Italian origins. Contradicting the impression this document gives is a fragment of an inventory (*praktikon*) from Attica issued, according to the editors, before 1204. While this document does not mention any aristocratic families in the region, it does in contrast to the Theban register refer both to dependent peasants (*paroikoi*) and to domanial estates (*pro-*

136. Published and analyzed by N. G. Svoronos, "Recherches sur le cadastre byzantin et la fiscalité aux XIe siècle: le cadastre de Thebes," *Bulletin de Correspondance Hellénique* 83 (1959), 1–166, reprinted in his *Études sur l'organisation intérieure*, part 3. Also see, P. Lemerle, *The Agrarian History of Byzantium* (Galway, 1979), 193–200.

asteia).[137] So while it is evident that great estates grew during this period, it does not follow that free peasants or even free villages disappeared. The Crusaders came across independent *vici* in Bulgaria who paid taxes to the state but who had no private lords.[138] In the Taygetus Mountains in the Peloponnese they also encountered independent village populations of Slavic stock who were obliged only to serve in the army—they knew neither private rents nor state taxes. Because of a lack of comparable sources, particularly of inventories, from the tenth through the twelfth centuries, it is difficult to provide a detailed description of this process. Nevertheless, some of the peculiarities of the Byzantine estate may be gleaned from the documents. As a rule, Byzantine aristocrats were not solely dependent on their lands for their income, but were also in the employ of the state. According to his testament of the late eleventh century, Smbat Pakourianos left approximately 340 pounds (*litrai*) of gold. His landed property consisted of four *proasteia*, with an annual gross profit calculated by G. Litavrin as 3.5 *litrai*. The inconsistency between the two figures is striking. Pakourianos's wealth could not have been accumulated from the income of his land alone. In fact, Smbat Pakourianos was *kouropalates* by rank, and a *kouropalates'* salary would bring him about 40 *litrai* of gold every year, that is, ten or even twelve times more than his *proasteia*.[139] Even wealthier was the *nobelissimos* Constantine, one of the brothers of Michael IV, in the mid-eleventh century. When he was arrested, the government confiscated about 50 *kentenaria*—i.e., about 5,000 pounds—of gold. In 1157, an agreement was concluded between Manuel I and Baldwin III of Jerusalem: Manuel agreed to marry his niece Theodora to Baldwin, offering a dowry of 100,000 golden *hyperpera*—one pound of gold consisted of 72 *hyperpera*—as well as gifts worth 30,000 *hyperpera* and 10,000 more for wedding expenses. Theodora received as her dower from Baldwin not gold or precious stones but the stronghold of Acre and all its territory.[140] The agreement of 1157 thus clearly reveals the differences between two distinct economic systems— in Byzantium wealth was measured in bullion, while in the Latin world property was still the measure of prosperity.

137. E. Granstrem, I. Medvedev, and D. Papachryssanthou, "Fragment d'un praktikon de la région d'Athènes (avant 1204)," *REB* 34 (1976), 5–44.

138. C. Asdracha, *La région des Rhodopes aux XIIIᵉ et XIVᵉ siècles* (Athens, 1976), 213.

139. G. G. Litavrin, "Otnositel'nye razmery i sostav imuščestva provincial'noj vizantijskoj aristokratii vo vtoroj polovine XI v.," *VOč* 2 (Moscow, 1971), 164–68.

140. *PL* 201.734A–B; also see S. Runciman, *A History of the Crusades* 2 (Cambridge, 1952), 349f.

There was considerably more direct state exploitation of the primary producer in Byzantium than in the contemporary West. Even though the extent of the *dominium directum*, the right of the state over all the territory within its boundaries, is controversial, it seems likely that in the eleventh and twelfth centuries most Byzantine peasants paid taxes in gold and in kind to the state, in addition to fulfilling various services.[141] Private estates, though certainly increasing in size and number, were still not the rule. Accordingly, the notion of freedom was radically different in Byzantium from that in the West or from what it had been in antiquity. The Roman concept of freedom as the opposite of slavery was still preserved in juridical manuals, such as that of the eleventh-century judge Attaleiates, but it had lost its practical significance. Similarly the Western concept of freedom as a positive quality—the possession of landed wealth and independent jurisdiction—was also inoperative in Byzantium. The same Attaleiates denied the Roman definition of freedom in his *History*. Those who were genuinely free, he stated, were not those who obtained liberty with a gold ring and a box on the ear (referring to the ancient ritual of manumission), but those who were safe from fear of taxes (Attal. 284.6–9). In the taxpaying society of Byzantium, real freedom was the freedom from levies.

Related to the government's right of taxation was its right to confiscate private possessions or to force landowners to resettle. Manuel Straboromanos wrote that all his father's belongings were forfeited, remarking further that this was by no means exceptional. His property was confiscated by certain officials without the emperor's knowledge. Manuel's father was clearly not a criminal; he remained free, squandering what little he had left after his dispossession. When he died, he left his family impoverished.[142] Equally, ecclesiastical estates were not exempt from confiscation. Theophylaktos of Ohrid complained that a village that the archbishopric of Ohrid had long owned was confiscated (*PG* 126.533D–536A). From a charter of 1095 emerges the story of several properties of the Monastery of Esphigmenou on Mount Athos; at some earlier time the monastery acquired a *proasteion* at Portareia from the family of the *protospatharios* Theodore Gymnos. Later on this *proasteion* was reallocated by a financial official to the *sebastokrator* Isaac Comnenus

141. The principal objections against the state control of property have been expressed by G. G. Litavrin, "Problema gosudarstvennoj sobstvennosti v Vizantii X–XI vv.," *VV* 35 (1973), 51–74, and M. Ja. Sjuzjumov, "Suverenitet, nalog i zemel'naja renta v Vizantii," *ADSV* 9 (1973), 57–65.

142. P. Gautier, "Le dossier d'un haut fonctionnaire d'Alexis Ier Comnène, Manuel Straboromanos," *REB* 23 (1965), 183f.

and an allotment of 412.5 *modioi* in a neighboring village was substituted
for the estate. This grant was in its turn modified. The land was given to
a certain Stroimer, and the monastery received other acreage in ex-
change.[143] In theory the acquisition of land was invalid without imperial
sanction or confirmation. Cyril Phileotes once met Emperor Alexios I
and told him about the possessions of his monastery. Some of these
lands had been inherited by Cyril and his brother from their "ances-
tors," others were acquired later "by their own toiling." Alexios re-
sponded that the land of Phileotes' monastery had to be considered the
property of the state; special imperial "grace" was necessary for it to be
treated as a monastic estate. But he promised to give this "grace" and
thereby free the land from any treasury claims.[144] Thus the acquisition of
land did not lead to landownership, but only to *detentio*, i.e., occupation
and use. Imperial sanction, a chrysobull or *prostagma*, was necessary for
real ownership.

The supreme right of the emperor over the land did not exclude pri-
vate property of various types: large and small, secular and ecclesiastical
or monastic. Some owners lived on the land, some dwelt in urban cen-
ters and only visited their *proasteia* from time to time, most often during
the harvest. It may even be suggested that from the eleventh century on-
ward more and more land was included in private estates and that some
of the rents levied on the basis of "public law" were gradually replaced
by private rents.[145] Although aristocratic landholdings in Byzantium
never obtained the size or independence of Western baronial estates and
although the emperor never lost control of the private property of his
magnates, the real power of the great Byzantine landowners was
considerable.

The power of the landed aristocracy was exercised in various ways.
Along with lands worked by dependent peasants (*paroikoi*) and those
tilled by paid laborers (*misthioi*) and slaves, the Byzantine lords held so-
called incorporeal rights, which allowed them to appropriate the surplus
labor of free peasant taxpayers.[146] In the eleventh century, *pronoia* (liter-
ally, "foresight" or "care") began to be mentioned. At that time, the term

143. *Actes d'Esphigménou* (Paris, 1973), no. 5, 4–18.
144. E. Sargologos, *La Vie de Saint Cyrille le Philéote moine byzantin* (Brussels,
1964), 231f.
145. E. Patlagean, "'Economie paysanne' et 'féodalité byzantine,'" *Annales*
30 (1976), 1384–89; now in her *Structures sociales, famille, chrétienté à Byzance* (Lon-
don, 1981), part 3.
146. H. Ahrweiler, "La concession des droits incorporels. Donations condi-
tionnelles," *Actes du XIIᵉ congrès international des études byzantines* 2 (Belgrade,
1964), 103–14.

was applied to land endowments given for life;[147] it did not have a military character. Another feature of large lay landholdings was their admixture with monastic property. Secular magnates received monasteries according to the rights of *charistikion*, that is, of conventional possession for a lifetime or for as long as three generations.[148] Lords functioned also as monastic founders (*ktetores*), establishing houses to which they granted a share of their riches apparently with the economic intention of stabilizing their property in the unstable conditions of the time. These monastic establishments may be seen in some ways as the Byzantine equivalent of Western castle building.

Unquestionably, medieval lordship, *seigneurie*—involving a dependent peasantry and the principal forms of medieval rent (rent in cash, in kind, and by *corvée*)—did exist in Byzantium. Even the exploitation of the so-called free peasant on state lands was associated with the seigneurial system. But this *seigneurie* cannot be equated with "feudalism" as the term has been used historiographically to describe Western society. The specific structure, involving links of personal obligation both vertical and horizontal, that characterizes the medieval West, and particularly its ruling class, is found only in an embryonic state in Byzantium. Similarly the characteristic ties binding together people of the same social layer in a feudal society are underdeveloped in the empire. Nevertheless, certain social and economic features emerged in Byzantium that resembled feudal links.

During the eleventh and twelfth centuries there did exist large retinues owing allegiance to great magnates.[149] Such retinues perhaps repre-

147. J. Karayannopoulos, "Fragmente aus dem Vademecum eines byzantinischen Finanzbeamten," *Polychronion*, 322.57. On the *pronoia* of the eleventh and twelfth centuries, see G. Ostrogorsky, *Pour l'histoire de la féodalité byzantine* (Brussels, 1954), 20–54, and A. Hohlweg, "Zur Frage der Pronoia in Byzanz," *BZ* 60 (1967), 288–308. For Ostrogorsky's answer, see "Die Pronoia unter den Komnenen," *ZRVI* 12 (1970), 41–54. For the special issue of the *pronoia* in the Peloponnese, see D. Jacoby, *Société et démographie à Byzance et en Romanie Latine* (London, 1975), part 4, 479–81; A. Carile, "Sulla pronoia nel Peloponneso bizantino anteriormente alla conquista latina," *Studi urbinati* 46 (1972), 327–35; also in *ZRVI* 16 (1975), 55–61.

148. P. Gautier, "Requisitoire de patriarche Jean d'Antioche contre le charisticariat," *REB* 33 (1975), 77 n. 1 (bibliography).

149. V. A. Arutjunova, "K voprosy ob *anthropoi* v 'Tipike' Grigorija Pakuriana," *VV* 19 (1968), 64–72; *Tipik Grigorija Pakuriana*, translation and commentary by V. A. Arutjunova-Fidanjan (Erevan, 1978), 28–30; B. Ferjančič, "Apanažni posed kesara Jovana Rogerija," *ZRVI* 12 (1970), 196–98; A. P. Kazhdan, "Odin netočno istolkovannyj passaž v 'Istorii' Ioanna Kinnama," *RESEE* 7 (1969), 469–73; H. G. Beck, *Ideen und Realitäten in Byzanz* (London, 1972), part 11, 14–32; Ja. Ferluga, *Byzantium on the Balkans* (Amsterdam, 1976), 399–425.

sented the reaction of threatened populations to the feebleness of the state's defensive apparatus; groups may have formed around local dynasts in an attempt to protect themselves. But the relationship between a lord and the local peasantry never became formal vassalage.[150] These Byzantine retinues, although undoubtedly looser and more unstable than their Western counterparts, strengthened the private power of the magnates.

Tax privileges, *exkousseia*, facilitated the establishment of semi-feudal properties. They completely or partially freed the lands of magnates and monasteries from the payment of state levies and protected privileged territories from the access (Latin *introitus*) of fiscal and judicial officials.[151] While properties did not enjoy full immunity from central authority or from the emperor himself, the *exkousseia* restricted interference from local and minor functionaries. In practice, the *exkousseia* led to the creation of seigneurial authority in the assessment of levies and in the jurisdiction of the dependent population, although even the *paroikoi* preserved the right of appeal against their lords.

In the twelfth century, Emperor Manuel I attempted to legalize privileged properties. He prohibited the transfer of a certain type of land to anyone except high army officers (*strategoi*) and senators, i.e., to anyone but members of the military and civil nobility. This legislation was, however, canceled soon after his death (*Reg.* 2: nos. 1333, 1398). At the same time that tax immunity created a privileged landownership, a new concept of freedom was being elaborated, most clearly expressed by the jurist and historian Attaleiates who regarded as free those who obtained tax privileges (see above). Thus, there seems to have been a perceptible change in the relationship between the social elite of Byzantium and the land. The nobility slowly appropriated property and the attributes of private power. At the same time, the character of the aristocracy itself was modified.

THE NATURE OF THE BYZANTINE NOBILITY

The Byzantines designated the members of their upper class by the relatively vague term *archon*, literally "magistrate" or "ruler." At the beginning of the eleventh century the term was still associated with court-

150. H. Ahrweiler, "Recherches sur la société byzantine au XIᵉ siècle," *TM* 6 (1976), 117f.

151. G. Ostrogorsky, "K istorii immuniteta v Vizantii," *VV* 13 (1958), 65–73 (French translation: *Byz.* 28 [1958], 182–97); M. M. Freidenberg, "Ekskussija v Vizantii XI–XII vv.," *Učenye zapiski Velikolukskogo pedinstituta* 3 (1958), 339–65; A. P. Kazhdan, "Ekskussija i ekskussaty v Vizantii X–XII vv.," *VOč* 1 (Moscow, 1961), 186–216.

iers and officials; it had no feudal connotations. Symeon the Theologian asked rhetorically about the servants of the earthly king:

> Are they those who dwell in their own estates or rather accompany him wherever he goes? Are they those who loiter in their *proasteia* or those enlisted in the army? Those who stay at home in luxury and lascivity or those who act bravely on the battlefield, who are smitten and would smite in their turn, who kill numbers of the enemy, who rescue captive comrades and cover the foe with disdain? . . . These *strategoi* and *archons* are the servants known to the emperor, his friends, as well as to men under their command.[152]

Although from the tenth century on, a landed, hereditary nobility began to arise, it was never fully established; vertical mobility remained characteristic of Byzantine society through the eleventh century.[153] During that century, the aristocracy was divided into two major groups according to military and civil functions. The military aristocracy originated primarily in the frontier regions: Cappadocia, Armenia, and Syria in the east, Bulgaria and Macedonia in the northwest. Even when settled in Constantinople and embedded in the imperial hierarchy, these aristocrats preserved connections with their homelands. There they possessed estates (*oikoi* or *proasteia*) or even palaces and small fortresses to which they could retire in case of imperial disfavor. Not coincidentally, the military aristocrats of the eleventh century often drew their family names from the sites where their estates were located: the Botaneiates of Botana, for example, or the Dokeianoi of Dokeia, or the Dalassenoi of Dalassa. The history of the Dalassenoi is typical of the Byzantine military aristocracy.[154] They were landowners, military commanders, and provincial governors closely connected with other aristocratic families. They took great pride in their noble birth and could afford to posture in dissidence. Damianos, founder of the family, was *magistros* and *doux* of Antioch in 996–98. His son Constantine had the rank of *patrikios* and, like his father, he served as governor (*katepano*) of Antioch. His brother Theophylaktos, the famous general who put down an aristocratic re-

152. Symeon the Theologian, *Traités théologiques et éthiques*, ed. J. Darrouzès, vol. 2 (Paris, 1967), 106.133–41, 152–55.

153. G. Ostrogorsky, "Observations on the Aristocracy in Byzantium," *DOP* 25 (1971), 3–12; A. P. Kazhdan, *Social'nyj sostav gospodstvujuščego klassa Vizantii XI–XII vv.* (Moscow, 1974). For a comprehensive summary in French, I. Sorlin, "Publications soviétiques sur XIᵉ siècle," *TM* 6 (1976), 367–80. For recent monographs on individual families, W. Seibt, *Die Skleroi* (Vienna, 1976); J.-F. Vannier, *Familles byzantines. Les Argyroi* (Paris, 1975).

154. N. Adontz, *Études arméno-byzantines* (Lisbon, 1965), 163–67; A. P. Kazhdan, *Armjane v sostave gospodstvujuščego klassa Vizantijskoj imperii v XI–XII vv.* (Erevan, 1975), 92–97.

bellion in 1022, is titled *anthypatos, patrikios, vestes,* and *doux* of Antioch on a lead seal. It seems that the administration of Antioch at that time was firmly in the hands of the Dalassenoi. Further, their power extended beyond Antioch. Romanos, third son of Damianos, was *katepano* of Iberia; eventually Theodore Dalassenos occupied the post of the *doux* of Skopje. Women of the family married members of famous houses such as the Doukas and the Charon. Anna Dalassena, daughter of Alexios Charon, governor of Italy, married John Comnenus. Their son was Alexios I, founder of the Comnenian dynasty. The estates of Constantine Dalassenos are mentioned several times in the *Chronicle* of Skylitzes; one of his *oikoi* was located in the theme of Armeniakon. Constantine lived on his estates, even though he also possessed a mansion in Constantinople. Constantine VIII, immediately before his death in 1028, endeavored to appoint Constantine Dalassenos his heir, but was dissuaded by an influential courtier who favored Romanos Argyros. When Romanos ascended the throne, the Dalassenoi concealed their rivalry but behaved ambiguously. In 1030, Romanos sent to Syria a great army, which depended heavily for assistance on the Dalassenoi, as they held Antioch. The expedition was a disaster; Arab sources ascribe the Byzantine defeat to "the son of the *doux*" who aspired to the throne and, to that end, desired the ruin of Emperor Romanos. Apparently the *doux* was Damianos, and the son Constantine. Romanos III Argyros was drowned in a bathhouse in 1034, but Michael IV gained both Romanos's wife and his throne; Constantine Dalassenos failed in his expectations once more. He was indignant, especially since his rival was, as Constantine put it, "a vulgar and worthless [literally, "three-penny"] man" (Skyl. 393.34–35), an arrogant, aristocratic criticism, though one with some foundation— Michael came from a family of usurers and money-changers, not warriors and governors. Moreover, Michael IV represented a real threat to the Dalassenoi. Constantine was summoned from his estate to the capital. He refused to go without a pledge that nothing evil would happen to him. A eunuch was sent with holy relics, including a letter written by Christ and an icon of the Virgin. On these relics the eunuch swore the desired oath, and Constantine rode off to Constantinople. He was received courteously, granted an even higher title, and allowed to live in his mansion in the capital. In the meantime, however, an imperial functionary had uncovered a subversive plot in Antioch, the seat of the Dalassenoi's power. Eleven rich and noble men were arrested and identified as Dalassenos's supporters; Dalassenos was seized and banished on this pretext. When friends and members of his family protested, they were exiled or imprisoned and their property was confiscated. It is clear

from such episodes that despite their considerable power, landed aristo-
crats were restricted in their independence; they were not autonomous
barons but imperial functionaries who could be dismissed, exiled, or
dispossessed at any time. This certainly led, in Ahrweiler's terms, to the
"Constantinopolitization" of the Byzantine aristocracy, with its tight
bonds with the capital and imperial court.[155] Probably only toward the
end of the twelfth century was there formed a substantial stratum of
provincial aristocracy that, while not tied to imperial service, neverthe-
less received the highest imperial titles.

The civil aristocracy was more differentiated than the military no-
bility. It included, above all, the noble families in imperial service:
judges, tax collectors, chiefs of the chancelleries, who from generation
to generation held similar positions. The Kamateroi, Xeroi, Xiphilinoi,
Serbliai, Zonarai, and others who belonged to this group are mentioned
in the sources throughout the eleventh and twelfth centuries. Occasion-
ally people from unknown families were also found in the ranks of the
civil aristocracy.[156] In contrast to the military aristocracy, the civil nobility
originated primarily from Constantinople, Greece, the Aegean islands,
or the coastal cities of Asia Minor. Some of these families had practiced
urban trades and crafts; their patronyms, which are sometimes derived
from the professions (e.g., Saponai, "soapmakers"; Phournatarioi,
"bakers") or from Constantinopolitan quarters (e.g., Akropolitai,
Blachernitai, Makrembolitai) testified to their past. Families of the civil
nobility also included a number of well-educated individuals, rheto-
ricians, theologians, and jurists. Recruited primarily from this sector
were the highest clergy, provincial bishops, and the deacons of
St. Sophia, who formed the staff of the patriarchate.

The civil nobility's property consisted primarily of urban houses and
a variety of concessionary rights, i.e., *charistikia* and founders' privileges
over monasteries as well as *basilikata* and *episkepseis*, which were impe-
rial land leases of some sort, and *solemnia*, the rights to tax revenues.
Neither special education nor state examinations were mandatory for the
civil service, although professional jurists and notaries were counted
among the officials. Resourcefulness, flattery, and obedience, as much
as specialized knowledge or skill, determined the success of an official's
career. If the fate of the military aristocrats was precarious, that of the

155. Ahrweiler, "Recherches sur la société byzantine," 104–10.
156. On the civil nobility, see in addition to the works cited in no. 153
G. Weiss, *Oströmische Beamte im Spiegel der Schriften des Michael Psellos* (Munich,
1973); B. Laourdas, "Intellectuals, Scholars and Bureaucrats in the Byzantine So-
ciety," *Kleronomia* 2 (1970), 273–91.

civil nobles was even more so. They could be promoted, demoted, or dismissed at the whim of the emperor. Theodore Styppeiotes was one of the high-ranking bureaucrats at the court of Manuel I, acting as the emperor's secretary (*grammatikos*). Theodore Prodomos praised him as the most trustworthy scribe of the young Manuel I and as the guardian of secrets. He became influential serving as the assistant of John Hagiotheodorites, an imperial favorite. Not willing to remain an underling, Styppeiotes "directed his way toward the peak," as Niketas Choniates wrote (Nik. Chon. 58.87–88). Through intrigue, he managed to have Hagiotheodorites sent off to "a most remote place" as the civil governor (*praetor*) of the theme of Hellas and the Peloponnese. Ascending from one office to another, Styppeiotes reached the position of *kanikleios*, that is, guardian of the imperial inkstand. The *kanikleios* did not have a staff, and his function was limited to holding the pot of purple ink for the emperor when he signed august documents from the imperial chancellery. But in the Byzantine world, closeness to the autocrat was the essence of power. Choniates suggested that Styppeiotes gladly fulfilled the emperor's orders and that consequently the emperor followed Styppeiotes' advice (59.11–12). Styppeiotes became the victim of intrigue in his turn. His principal rival was John Kamateros, logothete of the *dromos*, i.e., the minister of foreign affairs, the post office, and state security. Although his functions were incomparably more complex and important than holding the imperial inkstand, Kamateros had a lesser role in court life than the *kanikleios*. While Styppeiotes could enter the imperial inner sanctum at any time, Kamateros had access to the emperor only during special and limited hours. Styppeiotes achieved his goals quite easily; Kamateros saw his demands dispersed in the air like dreams (111.34–41). In frustration Kamateros forged correspondence between Styppeiotes and the Norman king William II of Sicily, hid it so that it was easily discovered, and then charged Styppeiotes with treason. Manuel I's judgment was immediate and severe: Styppeiotes was blinded and, according to one contemporary historian, his tongue was cut out.[157]

Of course, although instability was pervasive, not every Byzantine official's career ended in disaster. In practice, many families retained for centuries their influential positions within the state apparatus. The transfer of power to a new emperor was not necessarily followed by a radical change in bureaucratic personnel. The form and style of chrysobulls of the second half of the eleventh century remain the same despite

157. See O. Kresten, "Zum Sturz des Theodoros Styppeiotes," *JÖB* 27 (1978), 49–103.

frequent turnovers in imperial power. This may indicate bureaucratic stability within the chancellery. The significant modification of the formulas of imperial documents in the middle of Alexios I's reign may, in the same vein of argument, indicate a wholesale clearing of the bureaucratic establishment—a move that would have been quite in keeping with the tenor of Alexios's rule.[158]

Byzantine nobility of the eleventh century also included two peculiar groups: eunuchs, who traditionally occupied high positions in the civil and military administration, and foreign mercenaries, who commanded certain troops of the Byzantine army. At least thirty eunuchs are known to have occupied important posts within the state and ecclesiastical organization between the death of Basil II (1025) and the beginning of the reign of Alexios I (1081).[159] Among them are Nicholas, *domestikos* of the *scholai* during the reign of Constantine VIII, and Niketas, *doux* of Iberia and perhaps later, about 1030–34, the governor of Antioch. There were John Orphanotrophos in the mid-eleventh century, logothete of the *dromos* Nikephoritzes, and Michael, metropolitan of Side at the time of Michael VII. During Constantine IX's rule, several eunuchs assumed the highest posts in the army. *Sebastophoros* Stephen Pergamenos was *strategos-autokrator*; Nikephoros, *stratopedarches*; Basil the Monk, governor of Bulgaria. It is not clear why eunuchs were so important in the Byzantine administration. Were they more reliable because eunuchs were not allowed to ascend the imperial throne? But they could, as John Orphanotrophos showed, acquire the throne for their brothers or nephews. Were they less arrogant because of their castration? But there are numerous testimonies to the haughty behavior and impudent aspirations of eunuchs. Or was perhaps the prominence of castrates in Byzantium a symbol of the civil nature of power, an emblematic denial of the aristocratic principle of blood and lineage? It is worth noting that the eunuch became prominent in hagiography: angels appeared as youths or eunuchs clad in white robes before the eyes of mortals; in pious visions eunuchs accompanied the Virgin. For whatever reason, eunuchs were important both in myth and reality in the tenth and eleventh centuries.

158. A. P. Kazhdan, "Die Schrift einiger byzantinischen Kaiserurkunden und die konstantinopolitanische Kanzelei in der zweiten Hälfte des XI. Jahrhunderts," *Studia codicologica* (Berlin, 1977), 263f.

159. A. P. Kazhdan, "Sostav gospodstvujuščego klassa v Vizantii XI–XII vv. Anketa i častnye vyvody, c. VI: Evnuchi," *ADSV* 10 (1973), 184–94. There is no survey of foreign mercenaries and tradesmen in Byzantium; older articles on particular problems, e.g., Marquis de la Force, "Les conseillers latins du basileus Alexis Comnène," *Byz.* 11 (1936), are out of date.

The prominence of foreign mercenaries in Byzantium is perhaps easier to understand. Mercenaries largely provided loyal support for the emperor; Normans, Pechenegs, Germans, and Englishmen lacked the necessary Byzantine roots to present any dynastic threat to the reigning family. Nevertheless, mercenaries apparently harbored a strong sense of independence. They sometimes created their own principalities ("feuds") on Byzantine territory and even occasionally attempted to elevate submissive rulers to the throne. The chronicler Skylitzes (484f.) relates the story of a Norman knight, Hervé, known in Byzantium as Frankopoulos, who was awarded many honors at court. Offended by Emperor Michael VI, Hervé left Constantinople around 1057 for his *oikia*, Dagarabe in the theme of Armeniakon, on the eastern borders of the empire. There he gathered a host of about three hundred Franks (Normans) and joined the Turks. This alliance was, however, of short duration: by a ruse the emir of Chliat managed to defeat the Normans and capture Hervé, who was sent to the emperor. Another Norman soldier, Roussel de Bailleul, left the Byzantine army after a successful service in order to plunder the imperial provinces of Lycaonia and Galatia. He fought both the Turks and the Byzantines; he even attempted to proclaim his own emperor, the uncle of Michael VII, *caesar* John Doukas. Only after a number of battles and long negotiations was Roussel brought in chains to Constantinople by the youthful general Alexios Comnenus.

Among the clergy, notwithstanding its social mobility, stable groupings may have been formed within the higher ranks. Provincial metropolitans and bishops, to some extent connected with the local aristocracies, would have constituted one of these. An anonymous cleric, sometimes identified as Niketas of Ankara, in an eleventh-century treatise described the ideal position of the provincial bishop. He stressed, for instance, the rights of the metropolitans to control the patriarch, who was but one among them. Moreover, the writer insisted on the metropolitans' independence from the emperor.[160] The deacons of the Church of St. Sophia, the numerous officials of the patriarchate who managed the church's fiscal and judicial functions, its archives, and its treasury, and who were closely connected with the lay functionaries and intellectuals in the capital, formed another such group.[161]

160. J. Darrouzès, *Documents inédits d'ecclésiologie byzantine* (Paris, 1966), 198.13–19, 200.21–26, 214.5–8, 242.9–11.

161. V. Tiftixoglu, "Gruppenbildungen innerhalb des konstantinopolitanischen Klerus während der Komnenenzeit," *BZ* 62 (1969), 25–72.

CHANGES IN THE SOCIAL CHARACTER OF THE BYZANTINE ARISTOCRACY

Neither the growth of provincial cities nor the consolidation of the military aristocracy caused a breakdown of the traditional state apparatus. Despite an inchoate urban autonomy, the extension of basic seigneurial jurisdiction, and the embryonic development of private military retinues, the Byzantine Empire remained a centralized monarchy governed from the capital. Nevertheless, in the eleventh and twelfth centuries, two aspects of the administrative structure of the empire changed. One of these was in the social character of the governing stratum.

The mid-eleventh century witnessed the full realization of traditional Byzantine vertical mobility; during that period an attempt was made to draw urban, principally Constantinopolitan, elements into state government.[162] Attaleiates' evidence concerning the myriads of senators receiving rewards during the reign of Nikephoros III suggests that senatorial ranks were then swollen with foreigners and merchants living in Constantinople (Attal. 275.12–19). At the end of the eleventh and in the twelfth century, dramatic changes took place. The highest military elite was consolidated in a closed body of powerful families connected by intermarriage and forming a "clan" around the ruling Comnenian dynasty. The higher military administrative functions were monopolized by the Comnenian clan, while the families of the military aristocracy who were not included in this clan either disappeared or entered the ranks of the civil nobility. Consequently, the nature of the Byzantine hierarchy changed (Ex. 6). From the beginning of the twelfth century, old titles (e.g., *magistros, patrikios, protospatharios*) were replaced with new ones (*sebastokrator, protosebastos, sebastos*), inaugurating a new principle of title granting. While previously titles had depended ultimately on function, in the Comnenian period they were granted according to kin proximity (e.g., *sebastokrator* to sons of the emperor, *sebastos* to nephews).

In the eleventh century there was no unbridgeable gap between the military and civil elites. Some families of the civil aristocracy performed military functions. Intermarriage between the two groups was common. After the Comnenian clan was established, the situation changed: marriage between members of the Comnenian dynasty and the bureaucratic families was discouraged; in general, the senators, i.e., the civil elite, were regarded as socially inferior. The consolidation of a narrow ruling stratum (landowners and military commanders) excluded from power

162. Lemerle, *Cinq études*, 287–93.

both the eunuchs and the foreign mercenaries. As mentioned above, about thirty eunuchs appear in the sources for the years between 1025 and 1081; many of them occupied high administrative positions. The number of eunuchs at Alexios I's court was still considerable; twelve are mentioned in the sources. Only one of them, however, Leo Nikerites, *strategos* and *doux* of several districts, belonged to the highest echelon of the Byzantine elite. In addition, Eustratios Garidas was patriarch, and two men, Eustathios Kyminanos and Symeon, were grand *droungarioi*. Garidas and Symeon, notably, were active only in the earliest years of the reign of Alexios. Alexios's other eunuchs were servants, doctors, and the like, with no political power. And in the reigns of John II and Manuel I (i.e., the years 1118–80), only five eunuchs are found in the sources, none of whom possessed a military command—they were church hierarchs, courtiers, and princes' teachers.

The consolidation of Comnenian power also led to the exclusion of foreigners. The Comneni were regarded by contemporaries as being benevolent toward the Latins (Ex. 7). Even Latin writers such as William of Tyre or Robert of Auxerre eulogized Manuel for his esteem of the Latins, whom he is said to have promoted to important positions (*PL* 201.857D; *MGH SS* 26:246). Prosopographical analysis, however, does not support this view: surprisingly, Latin generals do not seem to have held high military positions in significant numbers. There was no one in those years comparable to Hervé or Roussel in the eleventh century. Except for some hellenized families such as the Rogers or Petraliphas, Latins at the Byzantine court served as diplomats or theologians rather than as military commanders. Turks played a greater role in the armies of John II and Manuel I, but even they were not mercenaries, but rather immigrants.

The consolidation of the semi-feudal aristocracy at the end of the eleventh and in the twelfth century had political and social significance. The military and landed aristocracy was conscious of its privileged position and its hereditary superiority. Initially formed around the Comnenian house, it acted as a centripetal force that contributed to the temporary strengthening of the state. But in vain: the military nobility was demolished under Andronikos I. At the end of the twelfth century, the influence of the civil aristocracy, which was connected with the upper layers of the merchant and craft classes and with the intellectuals of Constantinople, again increased.

CHANGES IN THE BUREAUCRACY

The social character of the governing elite was one aspect of the administrative structure of the state that changed during the eleventh and

twelfth centuries. The second was the machinery of the bureaucracy. Minor bureaucratic reforms reflecting the increasingly autocratic ideology of the Constantinopolitan court and officialdom were introduced in the eleventh century.[163] The old financial departments were remodeled. The logothete of the treasury (*genikon*) became less important, and the chief of the military exchequer (logothete of the *stratiotika*) disappears from the sources after 1088.[164] Concurrently, the imperial demesne was increased, along with the chancelleries administering it (most notably the *sekreton epi ton oikeiakon*).[165]

Alexios I introduced changes of a more radically "patrimonial" nature. "He performed his functions," says Zonaras, "not as public or state ones, and he considered himself not a ruler, but a lord, conceiving and calling the empire his own house" (Zon. 3.766.11–16). The rise of patrimonialism in the Comnenian administration was reflected not only in the dynasty's animosity toward the senate (Zon. 3.766.17–19) but also in its attempt to simplify and regularize state machinery. The central offices that were preserved fell under the control of a single supervisor (logothete of the *sekreta*).[166] Further, the judicial system was reformed, although perhaps not very successfully, in an attempt to simplify legal procedure and to eliminate corruption.[167] Manuel I was particularly active in this area (Kinn. 277.1–7).

Provincial administration was also remodeled. In the eleventh century the old system of provincial divisions—the theme system—collapsed. The military administrator (*strategos*) was replaced by a civil administration with the theme judge at its head. The themes were diminished in size. Seemingly in contradiction to this shift, a new system of great military districts—*doukates* and *katepanates*—developed from

163. N. Oikonomidès, "L'évolution de l'organisation administrative de l'Empire byzantin au XIᵉ siècle," *TM* 6 (1976), 150ff.; H. Ahrweiler, *L'idéologie politique de l'Empire byzantin* (Paris, 1975), 54–56.

164. Oikonomidès, "L'évolution de l'organisation," 135f.

165. Kazhdan, *Derevnja i gorod*, 129–37; Oikonomidès, "L'évolution de l'organisation," 136.

166. R. Guilland, "Les Logothètes," *REB* 29 (1971), 75–79; Oikonomidès, "L'évolution de l'organisation," 131f.

167. An attempt to rehabilitate the Byzantine judicial system of the eleventh century was made by G. Weiss, "Hohe Richter in Konstantinopel. Eustathios Rhomaios und seine Kollegen," *JÖB* 22 (1973), 117–43. In contrast, D. Simon, who analyzed the same source as Weiss, the *Peira* (see chapter 4, n. 65), believes that Byzantine law was purely casuistical; it was enough to be a good rhetorician to achieve success as a lawyer: *Rechtsfindung am byzantinischen Reichsgericht* (Frankfurt a. M., 1973), 17, 32.

the end of the tenth through the eleventh and twelfth centuries. This secondary system, which was initially established in the most vulnerable frontier areas, covered the mesh of smaller themes. These military districts formed the core of the Comnenian provincial administration, while the theme system virtually disappeared in the first half of the twelfth century.[168]

Similar ambivalent trends also marked military organization. As early as the second half of the tenth century, a reorganization of the army replaced the theme conscript army (*stratiotai*) by professional forces whose core was formed of *kataphraktai*, heavily armed "knights" (see Chapter 1).[169] Simultaneously, the Byzantines hired greater numbers of foreign mercenaries and began to employ new military tactics adopted from their neighbors.[170] At the same time, centripetal tendencies were particularly evident in the military administration. The provincial governor (*doux* or *katepano*), who was usually appointed from among the family relations of the ruling dynasty, held both civil and military authority (Ex. 8); furthermore, the troops were directed from Constantinople. Their overwhelming numbers astounded their enemies. Although contributing to the army's strength, central direction and large size made it cumbersome; this was further aggravated by the army's heterogeneity, for it included private retinues and large contingents of foreign mercenaries. An unwieldy army and a lack of on-site initiative, caused by the constant necessity of awaiting imperial direction, proved liabilities, particularly in the face of the intense military pressures being exerted on the borders of the empire. As in the case of administrative and judicial reforms, the changes in army administration did not prove successful.

The antinomy of historical development is manifest in the contrast of social and economic improvement to contemporary political misfortune. The loss of provinces in Asia Minor and Italy, although the traditional domain of the landed aristocracy, does not seem to have curtailed the pretensions of that elite group. On the contrary, "feudalization" seems to have intensified through the twelfth century. At the same time, the loss of these provinces meant the loss of important trading

168. Glykatzi-Ahrweiler, *Recherches sur l'administration*, 89ff.; G. G. Litavrin, *Bolgaria i Vizantija v XI–XII vv.* (Moscow, 1960), 285–87.

169. A. P. Kazhdan, "Vizantijskaja armija v IX–X vv.," *Učenye zapiski Velikolukskogo pedinstituta* 1 (1954), 18–31; V. V. Kučma, "Komandnyj sostav i rjadovye stratioty v femnom vojske Vizantii v konce IX–X vv.," *VOč* 2 (Moscow, 1971), 86–97.

170. Oikonomidès, "L'évolution de l'organisation," 144.

towns. Yet provincial commerce does not appear to have been weakened by the elimination of these centers. It may be concluded that the socio-economic development of Byzantium in the eleventh and twelfth centuries was determined by the general evolution of the medieval world rather than by political successes or by the failures of its armies on the battlefield. Those main tendencies were, indeed, similar to those of western Europe: the growth of (provincial) towns, the establishment of the feudal or semi-feudal landed estates, and the seigneurial exploitation of peasant labor. But in these areas Byzantium moved slowly by comparison with the West. Nevertheless, the urban growth and the nascent "feudalization" of society implied serious changes in the social and cultural activity of the empire and were reflected above all in altered external forms of everyday life.

· III ·

POPULAR AND ARISTOCRATIC CULTURAL TRENDS

Byzantine tendencies toward urbanization and feudalization and the concomitant economic development in the provinces in the eleventh and twelfth centuries certainly affected contemporary culture, although different sectors of society reacted in distinct ways. In Byzantium the peasantry and craft-working classes have left few traces. Even aristocrats and intellectuals can be only partially envisioned from their documents and monuments. The subject of this chapter is thus primarily the elite of the society. Two seemingly contradictory inclinations may be identified within that stratum: first, a popular one, through a consideration of the religion and the mundane habits of the *Rhomaioi*; and second, an aristocratic one, as apparent from an analysis of family structure and ideal types. Further evidence of both trends is found in Byzantine art and literature.

POPULAR TENDENCIES IN BYZANTINE SOCIETY

CHANGES IN THE DAILY REGIME: DRESS, DIET, AND DIVERSION

For want of evidence, it is impossible to trace with assurance the evolution of dress, diet, entertainment, and the like. Nevertheless, a few contrasts may be drawn between Byzantine habits of the eleventh and twelfth centuries and those of earlier periods, and it is tempting to relate

them to changes in the social structure of the empire. Most strikingly, Byzantines seem to have become better dressed.[1] There is, for instance, a great difference between the impressions made by the Constantinopolitan populace on foreign travelers of the tenth century and those of the twelfth. Liutprand of Cremona, on an embassy to the Byzantine capital in 968, was astonished at how shabbily dressed the people were. The German thought the solemn procession led by Nikephoros II was a wretched sight. The people in the crowd went barefoot, and even the magnates were wearing shabby hand-me-downs.[2] Liutprand's writing may have been affected by what he thought his own emperor, Otto, wanted to read. But Ibn Hauqal, who also wrote in the tenth century, held much the same opinion.[3] In contrast, in the twelfth century, Benjamin of Tudela was struck by the fact that the Constantinopolitan masses were clad not worse than princes; Odo of Deuil also described in detail their splendid jewelry and silk apparel.[4]

It appears that the Byzantines were not just better dressed; they were also more variously and elaborately clad. Writers of the eleventh and twelfth centuries unanimously emphasized their contemporaries' delight in rich, bright fabrics adorned with gold and silver thread and embroidered decorations. Psellos, who preferred simple garments, described a noblewoman who wore an "unhabitual embellishment" on her head, gold around her neck, and on her wrists bracelets in the shape of serpents; she wore pearl earrings and a girdle shining with gold and pearls (Ps. *Chron.* 2:135, no. 87.4–7; 2:49, no. 152.6–10). He remarked, evidently with surprise, that Empress Zoe disdained gold garb, ribbons, and necklaces and wore rather only simple, light clothing (2:49, no. 158.11–14). Eustathios of Thessaloniki, commenting on a Homeric metaphor (he believed "don a coat of stone" [*Iliad* 3.58] was a euphemism for

1. On Byzantine dress, see Ph. Koukoulès, *Vie et civilisation byzantines*, vol. 2, part 2 (Athens, 1948), 5–59; vol. 6 (1957), 267–94; M. G. Houston, *Ancient Greek, Roman and Byzantine Costume and Decoration* (London, 1947), 134–61. C. Mango, "Discontinuity in Byzantium," *Byzantium and the Classical Tradition* (Birmingham, 1981), 51f., treats changes in upper-class costume in late antiquity but not in medieval Byzantium.

2. Liutprand of Cremona, *Die Werke*, ed. J. Becker, 3d ed. (Hannover and Leipzig, 1915), 171.

3. Ibn Hauqal, *Configuration de la terre*, ed. and transl. J. H. Kramers and G. Wiet (Paris and Beirut, 1964), 195.

4. Ben. Tud. 12f.; Odo of Deuil, *De profectione Ludovici VII in Orientem*, ed. and transl. V. G. Berry (New York, 1948), 64. For Odo, Constantinople surpassed all cities in wealth; he described with delight the heaps of gold and silver on the tables of money-changers (74).

death by stoning), unexpectedly referred to contemporary fashion, re-
marking on robes besprinkled with pearls and precious stones.[5] Appar-
ently a greater variety of materials might readily be procured by clothiers
of the era. Wool remained the most common material, but silk, cotton,
and linen were all available for finer garments.[6] High-ranking Byzantines
seem to have had a variety of styles from which to choose. The tradi-
tional full-length patrician costumes, the full caftan with wide sleeves
and the straight caftan with tight sleeves, worn with high boots, remained
in use, as manuscript illuminations show (Fig. 10).[7] These are also
known from literary descriptions; for instance, Constantine Manasses
wrote that when aristocrats went hunting, they tucked up the long hems
of their robes, which normally dragged on the ground.[8] But revealing
clothing was introduced in the twelfth century. Western observers at
that time were surprised by the close-fitting apparel that they found in
the East. Odo of Deuil remarked upon the tight cut of Greek clothing:

> They do not have cloaks, but the wealthy are clad in silky garments that
> are short, tight-sleeved, and sewn up on all sides, so that they always
> move unimpeded, as do athletes.[9]

It is not clear whether trousers were in continual use from Late Ro-
man times (*braccarii*, "breeches makers," are mentioned in Diocletian's
Edict of Prices and in some Egyptian papyri) through the early Middle
Ages, but they were being worn again by the twelfth century. Eustathios
of Thessaloniki several times mentioned with disapproval "the covering
of the pudenda [breeches], known by the Romans as *braccae* or *ana-
xyrides*."[10] For instance, in his description of the knavish governor of
Thessaloniki, David Comnenus, Eustathios noted that nobody had ever

5. *Commentary on the Iliad* 379.24–25, ed. M. van der Valk, vol. 1 (Leiden,
1971), 598.27–28.

6. *Poèmes prodr*. no. 1, 93; no. 2, 35; and esp. no. 1, 59. For a commentary,
Koukoulès, *Vie et civilisation* 6, 270f. Longibardos (ca. 1000) still disdained "airy"
clothing of linen and silk. N. Festa, "Longibardos," *Byz*. 6 (1931), 116. Authors of
the eleventh to twelfth centuries often mentioned fine linen: Koukoulès, *Vie et
civilisation*, vol. 2, part 2, 23; vol. 6, 275f.

7. Perhaps most obviously in the illustrated Skylitzes manuscript in Ma-
drid: S. Cirac Estopañan, *Skyllitzes Matritensis*, vol. 1, *Reproducciones y miniaturas*
(Barcelona, 1965), e.g., fols. 12v, 50v, etc. The manuscript has been convincingly
ascribed to twelfth-century southern Italy. See N. G. Wilson, "The Madrid
Scylitzes," *Scrittura et civiltà* 2 (1978), 209–14.

8. K. Horna, *Analekten zur byzantinischen Literatur* (Vienna, 1905), 10.140–41.

9. *De profectione Ludovici VII in Orientem*, 26.

10. *Commentary on the Iliad* 22.9; 216.5, ed. van der Valk, vol. 1, 36.11;
328.28–29.

seen him clad in armor or riding a horse; rather David went about on a mule, wore *braccae*, newfangled shoes, and a red Georgian hat (Eust. *Esp.* 82.6–8). Niketas Choniates also commented acidly on David Comnenus's dress, mentioning that his tight trousers (*anaxyrides*) were held up by a knot in the back (Nik. Chon. 298.30–32). Trousers were mentioned twice more by Choniates in ambiguous descriptions of emperors. Rather than walk, as was traditional for emperors, Andronikos Comnenus preferred to ride to the Shrine of Christ the Savior. Choniates recorded that the first explanation for this innovation suggested by the people was the usurper's fear of the crowd. Others sneered that "the old man," exhausted by the day's work and the weight of imperial regalia, would soil his *braccae*, being unable to retain the "dirt of his stomach" if he had had to walk (273.85–89). Choniates also wrote of a soldier who reproached Manuel I, "Had you been a strong man as you claim to be, or had you had on your *anaxyris*, you would have smashed the gold-robbing Persians, routed them courageously and brought back their loot to the Rhomaioi" (186.73–75). Though Choniates was clearly suspicious of trousers as a new fashion, the expression "to wear trousers" seems to have already become synonym for manliness. Even the liturgical vestments of bishops evidently became more complicated during this time, with the regular addition of a rectangular embroidered cloth (*encheirion*) attached to the right side of the belt of the prelate's tunic (Fig. 11).[11] Availability of alternative fashions was not limited to clothing; it also extended to personal grooming. A considerable continuity of certain features of Greek hairstyles from Mycenae to Byzantium has been assumed; however, a new vernacular term, *parampykia*, designating a curl on the forehead, appeared only in the twelfth century in the writing of Eustathios of Thessaloniki.[12] Also in the twelfth century, for the first time since late antiquity, Byzantines might be clean-shaven, a fad perhaps introduced by the Latins.[13]

The Greeks' new concern for their appearance is reflected in the numerous complaints of conservative members of society about their contemporaries' vanity. Zonaras disdainfully wrote that some men wore wigs and had free-flowing hair down to their waists, like women (*PG* 137.848B–C). Niketas Choniates' conservatism was reflected in his nos-

11. N. Thierry, "Le costume épiscopal byzantin du IX^e au XIII³ siècle d'après les peintures datées (miniatures, fresques)," *REB* 24 (1966), 308–15.

12. On the continuity of hairstyles, see Ai. G. Korre, "'Korone'-parampykia-phlokos," *EEBS* 41 (1974), 128–35. See Eustathios, *Commentarii ad Homeri Iliadem* 1280.52–60, ed. J. G. Stallbaum, vol. 4 (Leipzig, 1830), 257.26–37.

13. Koukoulès, *Vie et civilisation* 4 (Athens, 1951), 344f., 359f.

talgic description of a statue of Athena, on which, he wrote, the folds of the goddess's long robe covered everything that nature had ordained be covered (Nik. Chon. 558.52–54); it was also shown in his disdain for clothing of a new, open fashion. Andronikos Comnenus, for instance, wore a slit mauve costume sewn of Georgian fabric that came down to his knees and covered only his upper arms; he had a smoke-colored hat in the shape of a pyramid (252.73–76; also see 139.50–52). According to Choniates' description of Andronikos's public portrait, he presented himself "not arrayed in golden imperial vestments, but in the guise of a much-toiling laborer, dressed in a dark, parted cloak that reached down to his buttocks, and having his feet shod in knee-high white boots" (332.35–37).[14] The openness of the costume clearly sparked Choniates' indignation—the short parted cloak and short sleeves might be convenient for freedom of action, but, after all, naked arms were unchaste (509.11–12) and symbolic of humiliation and unconditional submission (285.79). Even emperors might be critical of new fashions. Choniates recorded that John II inspected his courtiers' hairdos and shoe styles, not allowing them to chase new fashions and discouraging silliness about clothing and food (47.67–70). In contrast, the *protosebastos* Alexios, regent of the young Alexios II, not only followed new fashions but even introduced them, which gained him considerable support among the nobility. It is not, however, clear that the new fashions in which Alexios was interested concerned clothing. Choniates noted that he set a fashion of sleeping during the day and entertaining during the night and, further, that he cleaned his teeth and replaced those that fell out with new ones made of resin (244.51–60).

Ethnic diversity, too, was to be seen in eleventh- and twelfth-century Byzantine dress. Illuminated manuscripts suggest, for instance, that Bulgarians had an identifiable costume,[15] and other ethnic groups within the empire also wore traditional attire. Skylitzes reported that a certain Alousianos, a Bulgarian noble exiled to Armenia, escaped from his place of banishment by dressing in Armenian clothing, thereby going unnoticed (Skyl. 413.1). Dress also varied according to social status; a member of the elite could always be distinguished from a peasant or an artisan. In manuscript illumination, common people are represented with short tunics, patricians generally with long ones. Similarly, monks could be identified by their habits (*schemata*), although only the relative simplicity of clerics' garments might distinguish them from laymen.

14. Translation from C. Mango, *The Art of the Byzantine Empire* (Englewood Cliffs, N.J., 1972), 234.

15. J. Ivanov, *Le costume des anciens Bulgares* (Paris, 1930).

Within the elite, however, clothing did not greatly vary. In this, Byzantium contrasts with late antiquity, when dress reflected class and professional affiliation quite explicitly. Sailors, doctors, lawyers, and teachers, besides senators, each had their particular costume. Such differentiation among the largest sectors of society probably disappeared during the general collapse of urban life in the seventh and eighth centuries. Dress remained a mirror of rank only at a court. There dignitaries were assigned their different colors, special embroideries, and distinct embellishments. The city prefect (eparch), for example, wore a black and white tunic (*chiton*); its colors symbolized "the judicial axe," the illegal black being separated from the lawful white (Chr. Mytil. no. 30). The *sebastokrator* wore blue shoes and the *protovestiarios* was entitled to green shoes. Red sandals and purple garments were the prerogative of the emperor, although by the end of the twelfth century a few high officials of the court had the right not only to wear purple themselves, but also to adorn their horses with it.[16]

Court costume was not the only feature of Byzantine society to recall in a rarified form Late Roman urban life. For instance, the tradition of luxurious communal bathing, abandoned by the populace since the eighth century,[17] remained a peculiar privilege of certain emperors. At the beginning of the tenth century there was apparently no great concern for hygiene: Nicholas Mystikos thought that having a dirty face was shameful but did not worry about filth on other body parts, visible or not.[18] To what degree bathing was revived with the reemergence of urban life is unclear. At least one bathing establishment was rebuilt in the twelfth century and then transformed into a church.[19] Further, there are a few descriptions of baths in the countryside. Michael Choniates ridiculed one such place: it was no more than a hut heated by an open hearth; the door could not be properly closed, so that the bathers suffered from smoke and heat and at the same time shivered from the draft. The local bishop, Choniates joked, washed with his hat on, afraid of catching a cold (Mich. Akom. 2:235.13–19). Another small country bath was depicted in the *typikon* of the Kosmosotira. There was room for the bathers to rest; women's days were Wednesdays and Fridays and the re-

16. Nik. Chon. 438.43–45. On the imperial ceremonial costume, M. Hendy, *Coinage and Money in the Byzantine Empire, 1081–1204* (Washington, D.C., 1969), 65–68.

17. C. Mango, "Daily Life in Byzantium," *JÖB* 31/1 (1981), 338–41.

18. Nicholas I, patriarch of Constantinople, *Letters*, ed. R. J. H. Jenkins and L. G. Westerink, (Washington, D.C., 1973), esp. 32.101–3.

19. K. Horna, "Die Epigramme des Theodoros Balsamon," *Wiener Studien* 25 (1903), 190, no. 26.

maining time belonged to men. Though such references are rare, they suggest that the communal bath might not have been altogether forgotten outside the palace walls. Further, while the bath may have ceased to be an element of everyday life, it was regarded as a medical remedy: doctors recommended that sick people bathe twice a week.[20] Monks presumably bathed less often than laymen, but *typika* dictate variously between bathing twice a month and three times a year, although the most common monastic practice was evidently a bath once a month (e.g., *Kosm.* 66.28–29; MM 5:369.22). In any case, Prodromos mocked a monk who never appeared in a bath between Easters (*Poèmes prodr.* 52.80–81). Perhaps the man was following the ascetic advice to wash with tears rather than with water.

In the eleventh and twelfth centuries the Byzantines showed the same diversity in diet as they did in clothing. Hagiographers, of course, maintained the traditional ideal of fasting; their heros were able to refrain from food for weeks or to restrict themselves to small amounts of bread and water. Elias Speleotes in the tenth century was said to have eaten only a little green barley once a day (*AASS* Septembris III, 877A, 879B). Sabas the Younger was completely abstinent during the first five days of Lent; on Saturday he satisfied himself with a small portion of bread and water, and in the following weeks he only took bread after the communion, and even then no more often than three days a week.[21] Had the diet of a saint undergone any change by the twelfth century? Perhaps: Meletios of Myoupolis, who was praised for his traditional bread and water diet, also had a modest quantity of wine and a simple cooked dish seasoned with olive oil.[22] Kekaumenos had a conservative attitude toward food; he recommended a well-balanced breakfast and no lunch (Kek. 214.4, 216.4–5). Another source evidencing a conservative diet is the monastic *typikon*, or rule; *typika* indicate that one or at the most two meals were eaten daily.[23] The *typikon* of the Pantokrator Monastery, writ-

20. P. Gautier, "Le Typicon du Christ Sauveur Pantocrator," *REB* 32 (1974), 91.1051–52. On the Byzantine bath also see G. C. Spyridakis, *L'usage des bains à l'époque byzantine, les origines de la médicine en Grèce* (Athens, 1968), 55f.; Koukoulès, *Vie et civilisation* 4, 419–67; A. Berger, *Das Bad in der byzantinischen Zeit* (Munich, 1982), esp. 56f. Tzetzes, a literate man and close to the upper crust of society, was not ashamed to acknowledge that he bathed only two or three times a year—cited by N. G. Wilson, *Scholars of Byzantium* (Baltimore, 1983), 191.

21. *Historia et laudes SS. Sabae et Macarii*, ed. G. Cozza-Luzi (Rome, 1893), 19.1–11.

22. Ed. V. Vasil'evskij, *PPSb* 17 (1886), 7.19–24.

23. A. P. Kazhdan, "Skol'ko eli vizantijcy?" *Voprosy istorii*, 1970, no. 9, 215–18. On Byzantine diet see also J. L. Teall, "The Grain Supply of the Byzantine Empire, 330–1025," *DOP* 13 (1959), 99.

ten in 1136, carefully detailed the meals for the year—providing the monks with a diet far removed from the hagiographic ideal. For instance, "On Saturdays and Sundays, one serves three plates, one of fresh vegetables, one of dry vegetables, and another of shellfish, mussels and calamari, and onions, all prepared in oil; one also gives them the habitual pint of wine. . . ." [24] Like Kekaumenos, the *typika* enjoin a good breakfast; they limit the evening meal to bread and wine, occasionally with vegetables and fruit in addition.

From less conservative sources it appears that by the twelfth century there was both a greater desire for sumptuous meals and a greater availability of different foodstuffs. The variety of seasonings and edibles—including pepper, caraway, honey, olive oil, vinegar, salt, mushrooms, celery, leeks, lettuce, garden cress, chicory, spinach, goosefoot, turnips, eggplant, cabbage, white beets, almonds, pomegranates, nuts, apples, hempseed, lentils, raisins, etc.—listed by Prodromos (*Poèmes prodr.* no. 2.38–45) mirrors both a concern with good eating and a new diversity of dishes. Symeon Seth's compilation of the dietary advantages and disadvantages of different foods, dating from the late eleventh century, also shows an increased interest in eating. [25] But perhaps the new, Rabelaisian delight in consumption is best conveyed by Eustathios of Thessaloniki. With great excitement, he described a fowl on which he had feasted: it was seasoned with fragrant juice (*anthochymos*, Eustathios's neologism) and swimming in a sort of nectar. He called it "unusual, good, a sweet marvel." Eustathios's account is in the form of a riddle: it was a fowl yet not a fowl; from the fowl it borrowed blooming skin, wingbones and legs, but the rest had no bones at all and certainly did not belong to the realm of birds. His consideration of the stuffing brought further delighted confusion. Apart from the almonds, he didn't recognize any of the ingredients: "I could not help inquiring frequently, what is it? To look at the thing was to suffer from starvation [literally, "likened the mouth to suffering from dropsy"], so I set my hands in motion and tore the chicken into pieces" (Eust. *Opusc.* 311.42–56). In another letter he described the bird as "whitish, abluted with wine, like the sun by the ocean, according to Homer"; it was rich with fat, tinged "by noble red" from the wine in which it was drenched; it was not hidden with a curtain of horrible feathers, but exhibited in all its beauty (311.80–93). The subject of culinary overindulgence was also treated by Choniates, though more critically. His frequent disgust at great drinking bouts seems to indicate that such excesses were not uncommon. He ridiculed the Latins,

24. Gautier, "Le Typicon du Pantocrator," 57.466–82.
25. On Symeon Seth, see below, Chapter 4.

who consumed chines of beef boiled in great pots, or ate smoked pork with ground peas, or sharp sauces with garlic (Nik. Chon. 594.1–5). Byzantine gluttons were equally dispicable. John of Putze could not refrain from eating right in the middle of the street. Although members of his retinue tried to convince him that proper food was waiting for him at home, John seized a pot of his "beloved dish," *halmaia* (a sort of sauerkraut), and gorged himself on both the cabbage and the juice (57.53–63). John Kamateros also was a notorious glutton and drunkard, who outdrank all "the rulers of the tribes," swallowing down barrels of wine and emptying amphoras as if they were small cups. He could destroy whole fields of green peas. Once he saw peas on the far side of a river and immediately took off his *chiton* (shirt), swam the river, and consumed most of the field of peas on the spot, taking the rest back to his tent to eat later. He ate as though he suffered from starvation (113f.). Isaac II, wrote Choniates, lived in luxury, arranging spectacular feasts even during the day. On his table it was possible to see hills of bread, coppices full of animals, streams of fish, and seas of wine (441.9–12). The sumptuous meals were enlivened with jokes and wisecracks; Choniates' description of an imperial dinner provides some sense of the atmosphere of revelry. On one occasion Isaac asked that the salt be passed to him. The mime Chaliboures, who attended the dinner, retorted immediately with a play on the Greek word for salt (*halas*) and the feminine plural of the word for other (*allas*). Looking around at "the choir of the emperor's concubines and relatives," Chaliboures cried out, "Your majesty, would you first taste of these, and later on order to have others brought in?" (441.23–27). Everyone burst into laughter.

While greater wealth and a propensity toward self-indulgence seem identifiable in the relatively private spheres of dress and diet, the atomization of Byzantine culture is most apparent in the highly public domain of popular entertainment. Byzantine mass amusements became less spectacular and less officially contrived in the eleventh and twelfth centuries. Roman horse racing had continued to be exceedingly popular during the first centuries of Byzantine history, even playing a part in state ceremonial. By the eleventh century, however, the circus spectacle was relegated to a minor role in Byzantine social life;[26] its place was taken by the carnival. In contrast to the spectator sport of the circus, the carnival, with its masquerading, carousing, and buffoonery, allowed for

26. According to the sources of the tenth through the twelfth centuries, the number of chariot races was drastically reduced. As pointed out by C. Mango, at some unspecifiable time chariot racing ceased to be a competitive sport and became an imperial pageant: "Daily Life in Byzantium," 349.

the full participation of the common man. The riotousness of these festivals often elicited the censure of the more staid members of society. Theodore Balsamon criticized both the lay participants in a popular January festival who masqueraded as monks and clerics and the clergy who disguised themselves as warriors and animals (*PG* 137.729D).[27] Both Balsamon and Zonaras wrote that sometimes the festivities held on saints' days became so lewd that pious women fled the feasts in fear of being assaulted by the lecherous participants (*PG* 138.245D–248B). Balsamon (Ex. 9) also describes a ritual fortunetelling celebrated annually on June 23, which included dancing, drinking, public parading, and numerous acts of a superstitious nature regarding a virgin oracle (*PG* 137.741B–D). No doubt this rite's pagan overtones led to its being banned by Patriarch Michael III; its obvious traditional folk elements make its mention here relevant. Christopher of Mytilene depicts in a long but unfortunately now badly preserved poem a procession of masked students from the notarial schools on the feast of SS. Markianos and Martyrios.[28] In sum, then, there is some evidence that communal entertainment had become participatory and more popular by the twelfth century.

Buffoonery even seems to have penetrated the Constantinopolitan court (Ex. 10). According to Psellos, Constantine IX was a pleasure-loving fellow, fond of practical jokes (Ps. *Chron.* 2:34; no. 132.3–8; 2:39f., no. 142.3–25). He amused himself by digging pits in his garden into which his unsuspecting guests might tumble. The element of social protest that might be read into popular carnivals, however, cannot be ascribed to the pranks of an emperor. These may rather be placed in the category of inconsequential aristocratic pastimes, of which Anna Comnena complained. She lamented that the investigation of lofty subjects was forsaken by noblemen in favor of dice games and similar impious entertainments (An. C. 3:218.14–17). But if popular elements cannot be specifically identified in the games played by the nobility, they can perhaps in the adoption of peasant costume by members of the court as alluded to by Choniates (see above). Popular features are even more easily identifiable in the literary tastes of Comneni.

POPULAR ELEMENTS IN LITERATURE

Byzantine literature was traditionally written in Hellenistic Greek (*koine*), which educated Byzantines mastered in the early years of their

27. See Y. V. Duval, "Des Lupercales de Constantinople aux Lupercales de Rome," *Revue des études latines* 55 (1977), 222–70.

28. Chr. Mityl. no. 136. He also describes (no. 1), the horrible crush of the crowd during St. Thomas's festival.

schooling. *Koine* represented a rigid linguistic ideal, incorporating antique grammatical structures, vocabulary, and literary conceits. Before the twelfth century, elements of vernacular vocabulary and grammar were found in Byzantine chronicles, but the vernacular language was still unacceptable in a sophisticated literary context. In fact the popular idiom remained so far removed from literary expression that Anna Comnena, when including in her writings a mocking-song chanted by the populace of Constantinople, thought it necessary to translate it into *koine*.[29] This condescending attitude toward the vernacular did change, however. In the twelfth century, vernacular even became a literary vehicle.

Poetry perhaps most markedly shows vernacular innovations. Works of three authors in the common idiom survive from the twelfth century: four poems by Theodore Prodromos, a didactic poem by an author called Spaneas in some manuscripts, and the *Verses Written in Jail* by Michael Glykas. Despite the unresolved questions associated with these works—the vulgar verses ascribed to Prodromos or Ptocho-Prodromos in manuscript lemmas, for instance, may not actually have been written by him—a few conclusions may be deduced from them. First, vernacular was no longer unbridgeably separated from *koine*; both *koine* and the vernacular could be encompassed in the oeuvre of a single author. Glykas also, for instance, composed letters in the traditional literary language still used by the educated people of the twelfth century. As for Prodromos, vulgar lexical and grammatical elements may be discovered even in his "classical" verses, for which he is best known. Second, though the authors of vulgar poems did not belong to the upper nobility, they may have been connected with that class; certainly they constantly addressed it. Glykas polemicized with Manuel I, while Spaneas and Prodromos wrote for the highest members of the aristocracy, either preaching morality or begging grants. One may surmise that the Comnenian court did not eschew the fashion for vernacular literature.[30]

Concurrently as vernacular vocabulary was being introduced into

29. H. G. Beck, *Geschichte der byzantinischen Volksliteratur* (Munich, 1971), 27. Also see W. J. Aerts, *Anna's Mirror, Attic(istic) or Antiquarian?* (Athens, 1976), 5. On "stylistics" in Byzantine literature, I. Ševčenko, "Levels of Style in Byzantine Literature," *JÖB* 31/1 (1981), 289–312.

30. J. Grosdidier de Matons, *Courants archaïsants et populaires dans la langue et littérature* (Athens, 1976), 4–6, has pointed out that Byzantine "demotic" literature was addressed to the nobility, in contrast to its use in the West, where vernacular literature was first addressed to the masses. He also notes the "hyperdemotism" of Ptocho-Prodromos, whose language was close to slang, stressing the artificiality of Byzantine vernacular literature in the twelfth century.

literature, metrical structure was changing. The distinction between long and short syllables on which ancient meters had been based disappeared from everyday speech before the foundation of Constantinople. Early hymnographic verses already depended for their rhythm on the alternation of stressed and unstressed syllables. But tonic metrical structure was known in Byzantine poetry no earlier than the tenth century, the date to which the first experiments with fifteen-syllable, so-called political line have been ascribed.[31] Like the vernacular idiom, political verse was ambiguously received in literary circles. Purists refused to acknowledge it as a legitimate meter, regarding it as suitable, with a simplified vocabulary, only for a didactic function.[32] Members of the Comnenian aristocracy, in contrast, evidently found the fifteen-syllable verse quite attractive. Tzetzes complained that his noble customers expected his poems to be written in political verse.[33] Almost half of the lines in Prodromos's historical poems were in this meter. Thus, political meter, representing a break from rarified, traditional literary forms, seems to have been readily accepted at the Comnenian court.

This new acceptance of popular elements into the literary milieu of the twelfth century was perhaps related to the social shifts of the age. One is tempted to suggest that the urbanization of society contributed to the broadening of literary culture, and comments made by twelfth-century writers can be seen as supporting such a hypothesis. John Tzetzes, a philologist and admirer of ancient culture, wrote mockingly that everybody in his day was engaged in producing poems: women, tod-

31. The earliest examples of this verse form so far identified come from the beginning of the tenth century, if they are in fact contemporary with the events described in them. I. Ševčenko, "Poems on the Death of Leo VI and Constantine VII in the Madrid Manuscript of Skylitzes," *DOP* 23–24 (1969–70), 222–25. W. Hörandner, *Hist. Ged.* 128–31 and esp. n. 295, and *Traditionelle und populäre Züge in der Profandichtung der Komnenenzeit* (Athens, 1976), 7f., connects the origin of political verse with popular acclamations and church chants. M. J. Jeffreys, "Byzantine Metrics: Non-Literary Strata," *JÖB* 31/1 (1981), 323–29, also assumes that political verse at a vernacular and oral level was already widespread before 900, when it was accepted by intellectual and social elites in Constantinople. Unfortunately, such a suggestion remains hypothetical. J. Koder, "Der Fünfzehnsilber am kaiserlichen Hof um das Jahr 500," *BS* 33 (1972), 219, to the contrary, denies that fifteen-syllable verse could develop directly from folksong. On the evolution of political verse, see V. Tiftixoglu, "Digenis, das 'Sophrosyne'-Gedicht des Meliteniotes und der byzantinische Fünfzehnsilber," *BZ* 67 (1974), 46–58.

32. M. J. Jeffreys, "The Nature and Origins of the Political Verse," *DOP* 28 (1974), 166.

33. Jeffreys, "The Nature and Origins," 173–75.

dlers, artisans, and even the wives of barbarians.[34] Prodromos followed Tzetzes: in his eulogy to Isaac, Alexios I's son, he depicted Philosophy carping at Ares, the god of war, for successfully wooing to his service the ablest men of the land, leaving to her only amateurs and craftsmen.[35] While these authors undoubtedly exaggerated the popularity of literary pursuits among the people, it may well be that a wider urban interest carried the spoken idiom into the previously arcane sphere of Byzantine literature.

That this literary innovation was associated with a secular, urban society perhaps explains a reaction against the assimilation of vernacular elements in hagiographic literature. In contrast to the monastic writings of the fourth to sixth centuries, which were commonly enlivened with vernacular elements, the churchmen of the eleventh and twelfth centuries tended to take a purist tack.[36] The destruction of the *vita* of St. Paraskeve, ordered by Patriarch Nicholas IV Mouzalon in the mid-twelfth century (*Reg. patr.* 3: no. 1032) on the grounds that it was compiled by a peasant in a vulgar dialect (*idiotikos*), appears typical of the struggle against a demotic hagiography. The church's conservative response here serves to underline the radical implications of the vernacularization of literature.

POPULAR FEATURES IN RELIGIOUS LIFE

While the church scorned the vernacular, it did not remain untouched by the major social developments of the period. In fact, because monastic life is relatively well documented by the surviving *typika*, cultural changes may be better observed in the religious sphere of activity than in any other. Most notably, there was a marked tendency toward atomization, with its concomitant emphasis on individualism and, in some instances, provocation of indiscipline. From the beginnings of Byzantine monasticism two primary forms of ascetic community co-existed: the *lavra*, in which hermits were loosely affiliated, meeting together on Sundays and feast days, and the *koinobion*, in which monks led a more communal life under the authority of the abbot (*hegoumenos*). Often these two types of monastic life were conjoined, with brethren progress-

34. John Tzetzes, *Historiarum variarum chiliades*, ed. Th. Kiessling (Leipzig, 1826), 517.

35. B. Kurtz, "Unedierte Texte aus der Zeit des Kaisers Johannes Komnenos," *BZ* 16 (1907), 116.

36. "Déjà la métaphrase avait rendu un des genres religieux les plus populaires, l'hagiographie, plus difficilement accessible aux esprits non formés à la culture classique," Grosdidier de Matons, *Courants archaïsants*, 9.

ing from the community to a neighboring hermitage. According to Christodoulos (MM 6:61.8–9), the monks were simultaneously divided and united by this system.[37] As mentioned in Chapter 1, notable advocates of communal discipline in Byzantium were St. Theodore of the Studios in the ninth century and St. Athanasios of Athos, who in the tenth century introduced the cenobitic life to the Holy Mountain despite the strident opposition of the resident hermits. During the eleventh and twelfth centuries, however, monasticism in Byzantium developed differently not only from that of earlier periods, but also from that in the contemporary West. Western monasteries tended to be transformed into coherent communities bound by the strict discipline of the monastic orders. The Cluniacs, then the Cistercians, were powerful reforming organizations that imposed an institutional unity on communities otherwise isolated by political boundaries. Perhaps because of the more unified nature of the empire, such monastic links were unnecessary. In any case, in Byzantium there was an opposite move toward both greater individual independence within the establishment and greater freedom of the monastery within the wider community. Theodore Balsamon, patriarch of Antioch, made this East/West comparison in a striking if somewhat exaggerated form. He noted that at his time, at the end of the twelfth century, few true *koinobia* survived. The monks did not lead a common life; only in some women's convents were common meals and common dormitories preserved. Monks ate and slept in their own separate cells. In contrast, Latin monks received their food as a community in the refectory and took their rest together in common quarters (*PG* 138.176C–D).

The Byzantine monastery usually included both elements of communal organization and individualism on various levels. The Monastery of Mount Galesios in the eleventh century was cenobitic. Gregory, who wrote the *vita* of its founder, Lazarus, regarded this type of monastic community as a broad, easy, "imperial highway" to salvation (*AASS* Novembris III, 567B). But even there the brethren were urged to stay as much as possible inside their cells in order, as Gregory put it, to escape quarrels and scandals (562F–563A); sometimes they even ate in their cells (535C, 551F). The cells were not intended to be comfortable: Lazarus ordered tables taken out of the cells (552A–B); even icons and candles were not to be used in them (549A–B). Lazarus forbade his monks to have keys to their cells (530C)—a rule that suggests that private locks existed

37. D. Papachryssanthou, "La vie monastique dans la campagne byzantine du VIIIe au IXe siècle," *Byz.* 43 (1973), 158–80; J. M. Sansterre, "Une laure à Rome au IXe siècle," *Byz.* 44 (1974), 514–17.

in other monastic communities. Moreover, Lazarus's monks, especially the craftsmen, were permitted to work for themselves and earn a private income, at least at an early stage of the monastery's history (566A). Later, despite Lazarus's regulations, many monks attempted to retain their private property in some form. The most popular excuse was a pious one: the need for personal alms giving. Side by side with this semi-cenobitic community, a completely individualistic form of salvation was practiced: Lazarus himself and his chosen disciples dwelt on columns. This style of life was regarded as the most praiseworthy and the most difficult; hence, through the status that this ascetic practice conferred upon him, the holy stylite Lazarus dominated the community. He dictated the rules, indoctrinated the monks on theological problems, and monitored their morals. As he came to the verge of death, the brethren panicked for fear that the father would die without writing a *typikon* that would compensate for their loss of their founder. Yet they were afraid to remind the old man of his inescapable destiny. When they found him dead on the top of his column, the monastery possessed nothing but a draft copy of a rule written by one of the monks, without even Lazarus's signature. But miraculously, when the corpse was brought into the church by the lamenting community, the dead man opened his eyes and immediately an ingenious monk, Cyril by name, put a reed pen into Lazarus's right hand and guided it so that the holy man might sign the document (585B–587B). Thus, even in death, the will of the ascetic stylite was imposed on the *koinobion*.

The differences between Eastern and Western monasticism were embodied in the monastic buildings of the age (figs. 12–13). The plan of St. Chrysostomos on Cyprus, founded in the late eleventh century, was typical of Byzantine *koinobia*. The main church (*katholikon*) of the monastery, with a secondary chapel (*parekklesion*) organically appended to it, was the focus of the small, irregular complex. The secondary buildings are for the most part of later date, but their mud-brick or mortared-rubble predecessors on the site probably were very similar in plan and arrangement: a range of individual cells, a kitchen, and storage rooms organized in a somewhat disorderly fashion. The whole was enclosed for protection by a wall. Outside the precincts were the retreats for the hermits and an ossuary for the deceased monks' bones. The scale of the undertaking is very small; little detailed architectural planning was required, especially for the domestic buildings. Apparently additions were made to the structures as they were required by an increase in the size of the cenobitic family. This spatial informality provides some insight into the flexibility of the monastic mode in Byzantium. In contrast, the Mon-

astery of Cluny II represents the rigid organization of monastic existence in the reformed French orders of the mid-eleventh century. Not only is there material evidence of communal eating and sleeping, but the relations between structures are much more controlled: church, dorter, refectory, chapterhouse are all bound cogently together by the passage of the cloister. Movement is contained and determined. Even the neat angularity of the complex hints at the linear precision of the life that was sought, if not always attained, in a Western monastery. Its scale also implies its pretensions.

The casualness of the Byzantine monastic plan is revealed, too, in monastic literature. The *vita* of the late-tenth-century saint Nikon the Metanoeite ("You should repent") reveals that in his monastery the monks' cells opened not only into a monastic courtyard, but also down some stone steps into the town square (*agora*).[38] The tendency toward atomization in Byzantine monasticism allowed the ancient custom of extra-ecclesiastical communion to continue. According to his tenth-century *vita*, Luke the Younger visited the archbishop of Corinth. The hagiographer noted that Luke appeared "not empty-handed," but carrying some vegetables from his garden for the archbishop and his *archons*. Luke asked the bishop a fundamental question: how could hermits partake of divine communion if they had neither a church (*synaxis*) nor a priest? In response, the archbishop described in detail how the ritual of communion could be celebrated by a monk on his own: the vessel with holy bread was to be put on a clean pallet or bench; it was to be carefully covered; specific psalms were to be sung; genuflections were to be made; instead of water, a cup of wine was to be drunk. The archbishop also provided advice as to how the holy particles might safely be preserved for the next service (*PG* 111.453D–457A).

Unity within the Byzantine monastery was also disrupted by the inequality of the monks. Although a monk's position in the institution's hierarchy ostensibly depended on his function, it was often fundamentally affected by his former position in secular society and by his material contribution to the house. Monks and nuns of aristocratic origin might have not only their own suite of rooms within the monastery, but also their own servants. In the monastery founded by St. Christodoulos there were in addition to *misthioi* (hired workers) also *hypourgoi*, young men who were specifically prohibited from sitting in the refectory and drinking wine (MM 6:86.26–27). The *typikon* of the Heliou-Bomon Monastery expressly prohibited monks from having either slaves or *hypour-*

38. Ed. S. Lampros, *Neos Hellenomnemon* 3 (1906), 218.20–23.

goi, stating that everyone was obliged to serve both himself and others. But there were exceptions to this principle: should a magnate, accustomed to luxury, wish to enter the monastery, he would be allowed to have a monk-*hypourgos*, especially if this aristocratic brother was likely to be beneficial to the foundation through his status or his grants.[39] Similarly, while egalitarianism was emphasized in the *typikon* of the Pantokrator Monastery, there were again special cases. "If there is a person essential to the monastery, because the necessity of things requires persons capable of rendering the services that he renders, he can be treated with a certain leniency, for he is of aristocratic origin or has a sophisticated breeding; it is up to the *hegoumenos* to endow him with some privileges, bearing in mind the benefit to the monastery."[40] Certainly such privileges were awarded. Constantine Paphnoutios, who made a grant to the Monastery of St. John on Patmos in 1197, was given in exchange certain benefits: in addition to clothing and food, the monastery assigned him a servant and promised not to overburden him with menial chores (MM 6:134f.). Provisions were made for the granddaughters of Empress Eirene Doukaina in the *typikon* of the Virgin Kecharitomene. Since the girls were accustomed to luxury and unable to endure monastic abstinence—the formula is very similar to that found in the *typikon* of the Heliou-Bomon Monastery–their participation in the ascetic life would be restricted to their confession to the spiritual father. The noble nuns would sing hymns and pray alone. They were to have separate cells and would be served by two maids, free or unfree (MM 5:366.1–2). A noble lady would be allowed only one maid (336.27–35). Also significant is the fact that Byzantine monks possessed and could bequeath their own belongings.

Aggravating this privatization of Byzantine monasticism was the absence of institutional links among communities. Byzantium did not have monastic orders, albeit the rules of a famous foundation like the Studios Monastery in Constantinople might serve as models for new foundations. Although monastic republics, such as that on Athos, existed, they, too, were splintered rather than unified—the power of the Athonite *protos*, nominally the supreme power in the coalition, remained restricted. Indeed, *hegoumenoi* of the larger Athonite monasteries enjoyed more real respect and power than the *protos.*

Monastic individualism was epitomized by the activity and work of Symeon the Theologian, a monk and *hegoumenos* in Constantinople at

39. *Typika*, ed. A. Dmitrievskij, vol. 1 (Kiev, 1895), 749.16–17; 742.31–743.9.
40. Gautier, "Le Typicon du Pantocrator," 61.525–29.

the beginning of the eleventh century. Symeon was born in Paphlagonia to a well-to-do family; as a boy he was sent to the capital, where his uncle was a courtier of Emperor Basil II. If Symeon's disciple and hagiographer Niketas Stephatos is to be believed, the uncle was able to have him promoted to the senate at the age of fourteen. The young senator soon fell under the spell of Symeon Eulabes, a monk of the Studios, who became his spiritual father and teacher. After six years of imperial service, Symeon left the world and entered monastic life at the Studios. But the neophyte did not find peace there; the brethren of the Studios disapproved of his all too pious behavior. He moved to the Monastery of St. Mamas, where he was appointed *hegoumenos*. Symeon demanded unconditional obedience. Some indication of his severity is provided by an anecdote: Symeon's favorite disciple, Arsenios, was unfortunate enough to be caught casting a disapproving glance at the fried pigeons that had been prepared for an influential guest of the *hegoumenos*. In indignation, Symeon pushed one of the birds at Arsenios. As disobedience was a greater sin than the eating of flesh, Arsenios, his eyes full of tears, began to chew. Before he had swallowed the first bite, however, the *hegoumenos* cried, "Stop, and spit it out! You are a glutton; all these pigeons are not enough to satiate you!" Symeon's stringent rule finally instigated a riot in the monastery. While Symeon was delivering a sermon, suddenly about thirty monks tore off their clothing and started shouting menacingly at the *hegoumenos*; thereafter, they broke through the bars of the gate and fled to the patriarch, who, however, sided with Symeon. He would have banished the rebels, had not Symeon asked forgiveness for them. Symeon also came into conflict with the high-ranking clergy, led by Stephan of Nikomedia, over the veneration of the late Symeon Eulabes, in whose honor Symeon had established a feast day at St. Mamas's. Stephan achieved his ends: Symeon Eulabes' cult was abolished, his icons destroyed, and Symeon the Theologian exiled to a small town near Chrysopolis. Though acquitted with the help of the nobility of the capital, Symeon did not return to Constantinople, but rather founded a small community at the site of the ruined *eukterion* (chapel) of St. Marina. That the monks were not regarded as a welcome addition to the rural society in which they found themselves is indicated by another detail from his *vita*: the local peasants met Symeon with considerable hostility; they threw stones at him, swore at him, and tried to intimidate him and his monks. They called Symeon a hypocrite and a deceiver; a certain Damianos even struck him. Symeon died at St. Marina probably in 1022.

Symeon's teaching was consistently individualistic. Not good deeds,

charity, church services, or sacraments could automatically assure salvation. The only effective means was ultimate obedience or self-abasement before Almighty God, the internal enthusiasm that results in seeing the divine light. For Symeon, the believer stood alone before God in the universe, before the emperor in society, and before the spiritual father in the monastery. In fact, there is a sense in Symeon's work that communal or brotherly concerns were distracting, as is apparent from his hymns, in which he wrote, "How senseless to save everyone, if you yourself find no salvation! How senseless to free your fellow man from the jaws of wild beasts, if you then fall victim to them! How senseless to pull a person from a well, only to fall into it yourself!"[41] Such allusions reflect something of Symeon's attitudes toward his fellows. But he was even more explicit about family and friends—such relations he regarded as illusory and deceiving.[42] This is a clear expression of an ideal isolation. Symeon's search for individual salvation may be seen as a reaction against tenth-century institutionalization and order. It was quite natural that he tried to substitute the emotional and spiritual exhilaration of self-discipline for the cold organization of the Byzantine church. It was just as natural for the ecclesiastical establishment to oppose this form of individualism, whereby people related directly to God. The hierarchy attacked Symeon exactly where his theology was most personalized, in the "heretical" veneration of his friend and monastic master, Symeon Eulabes.

This monastic tendency toward individualism was evidently accompanied by a breakdown of discipline. Eustathios of Thessaloniki censured monks who succumbed to secular temptations, accusing them of sacrificing their hair and nothing else. Except for their tonsure, he insisted, they remained laymen—trading, breeding cattle, and toiling in vineyards. The *hegoumenos* lectured his monks on good husbandry rather than on divine theology. Monks were illiterate and hypocritical; they mingled with the mob, swore in the marketplace, and slept with women. Instead of veiling their faces to escape daily affairs as in the past, monks leered at anything that might be considered obscene (exs. 11–12).[43] In

41. Symeon the Theologian, *Hymnes*, ed. J. Koder (Paris, 1969–73), nos. 41.173, 49.41–42, 49.55–56.

42. Symeon the Theologian, *Chapitres théologiques, gnostiques et pratiques*, ed. J. Darrouzès (Paris, 1957), III.13; *Hymnes*, nos. 22.117–21, 56.7–12; *Catéchèses*, ed. B. Krivochéine (Paris, 1963–65), no. 4.284–90.

43. A. P. Kazhdan, "Vizantijskij publicist XII v. Evstafij Solunskij," *VV* 28 (1968), 67f.

keeping with this characterization was Psellos's description of a monk he knew. This man, by name Elias, besides being a glutton, was a connoisseur of Constantinople's bawdyhouses. At the same time Elias was educated, well traveled, and philosophically inclined. According to Psellos, he combined service to the Muses—scholarly interests—with the worship of the Charites, i.e., appreciation for the fine arts. He was a monk of the "new fashion."[44]

The changing perception of the holy man also reflected the progressive privatization of society in the empire. Holy hermits, who through their denial of the material world obtained spiritual illumination, traditionally were of considerable ideological and political importance in Byzantium. As these individuals were free from vested interests and were as well divinely inspired, their opinions and prophesies were taken very seriously by the ruling elite, who sought their favor and their company.[45] Before Alexios Comnenus ascended the throne, he took the monk Ioannikios with him on his campaigns, not only for spiritual consolation, but also for important military assignments (An. C. 1:31.2–11). The evolution of the image of the "fool for Christ's sake," from St. Symeon of the fifth century to St. Andrew, whose *vita* was written by a certain Nikephoros in the tenth century, manifests the institutionalization of the holy man within Byzantine society. As J. Grosdidier de Matons suggests, Andrew's "madness" was less aggressive than that of his ancient paragon; he was, for example, opposed to the cruelty of the Constantinopolitan mob. Andrew was rather a moralist and a prophet than an actual *salos*, or fool. Whereas Symeon was an "asocial being," Andrew avoided scandalizing the public and especially the church. Moreover, in order to mitigate the harsh impression of Andrew's strange behavior, appearance, and dress, the hagiographer Nikephoros introduced a second holy figure, Andrew's disciple Epiphanios, a handsome youth of noble origins who had never disrupted his ties with the establishment but who nonetheless was highly rewarded for his piety.[46]

By the twelfth century, the attitude of Byzantine society toward the holy man had changed once again. It was sharply differentiated: while intellectuals and courtiers rejected the veneration of the *saloi*—dirty hermits in iron chains—their popularity in the streets and marketplaces

44. J. N. Ljubarskij, *Michail Psell. Ličnost' i tvorčestvo* (Moscow, 1978), 74–79.

45. P. Brown, *Society and the Holy in Late Antiquity* (Berkeley and Los Angeles, 1982), 143–51, 268f.

46. J. Grosdidier de Matons, "Les thèmes d'édification dans la Vie d'Andrée Salos," *TM* 4 (1970), 304–9.

grew.[47] In a letter addressed to a certain sausage maker in Philippopolis, Tzetzes complained that any disgusting and thrice-accursed wretch (like his addressee) could be honored in Constantinople as a saint above the apostles and the martyrs. It sufficed to hang bells from one's penis, fetter one's feet with chains, or hang ropes around one's neck. Society women adorned their private chapels not with icons of saints, but with leg irons of these damned villains (Tzetzes, *Ep.* 151.9–152.5). While evidently popular with many, the holy man was distrusted by intellectuals. Eustathios of Thessaloniki's *vita* of St. Philotheos appears to be entirely at variance with the ideal created by Symeon the Theologian. While Eustathios admitted that the solitary life, in which "every man cares only about himself" was one way to salvation, such "escape from the marketplace" was not the only or even the most honorable road to everlasting life. Eustathios believed that "our life is an arena in which God is the umpire [*agonothetes*]" and that those who struggled in solitude were observed only by "the all-seeing emperor God." Non-ascetics had to fight "the enemy in front of thousands of eyes." Therefore, a righteous man "should not feel shame before the hermit; I think," wrote Eustathios, "even that he surpasses him in his deeds." For the hermit ran "on the even ground of the stadium where no hurdle is erected," while one who struggled "in the streets of the world" had to contend with caltrops and stumbling blocks; thus his victory was an even greater adornment. Although certainly the sun is beautiful while it is under the earth where no one can see it, how much more beautiful is it when it rises and makes things splendid? (Eust. *Opusc.* 148.37–87). Eustathios denied the efficacy of asceticism even more directly when he explained that Philotheos did not deplete his flesh or emaciate himself for the sake of a holy appearance. Rather, "the earth and the wealth produced by the earth and by other means of life sanctified by God made him rich in everything that is blessed on earth. So he would take of the excessive load of life and give it to the poor, and in so doing, he prepared himself for the divine and righteous [a play on words: *theian* and *eutheian*] path" (147.76–89). Nicholas of Methone, the pious author of the twelfth-century *vita* of St. Meletios of Myoupolis, showed an equal skepticism of (false) asceticism. Two monks, Stephen and Theodosios, wrote the hagiographer, were seduced by the desire for human glory and assumed a mock ascetic life. When Stephen was brought before the emperor, he tried to attack the true saint Meletios. Using as his weapon "the poverty of spirit," he presented

47. P. Magdalino, "The Byzantine Holy Man in the Twelfth Century," *The Byzantine Saint* (Birmingham, 1981), 51–66.

himself as a simple hermit, illiterate and unaware of sophisticated monastic doctrine.[48] The literati not only mocked the fanatic and debunked his pretensions, they also tended to disdain hagiography as a literary genre. Twelfth-century hagiographic writing is remarkably meager, while derisory commentary is surprisingly rich.

The tendency reflected in the loosening of strictures on monastic life may have affected the secular church as well. Church decoration shows evidence of secular influence, though perhaps not to the degree found in the Iconoclast period, when scenes of hunting and horse racing were said to be depicted in place of holy images in the sanctuaries of the capital city. The inlaid stone floor (*opus sectile*) of the main church (*katholikon*) of the Pantokrator Monastery, dating to the first half of the twelfth century, was elaborated with specifically secular scenes including the four seasons, signs of the zodiac, and the hunt (Fig. 14).[49] Secular images are also found in the provinces. In addition to the flora and fauna traditionally used in architectural ornament, reused pagan sculpture as well as the zodiac and mythological beasts appear, for instance, among the low relief plaques on the façade of the Little Metropolis in Athens (Fig. 15).[50] Further, in the twelfth century complaints about the neglect of Christian ritual seem to have become more frequent. A metropolitan of Athens visiting Thessaloniki stated with astonishment that the public temples of the city stood empty.[51] As mentioned above, Zonaras was indignant at the transformation of the anniversaries of holy martyrs into indecent feasts. These complaints of impieties and weaknesses in the church and monastery smack of secularism. But perhaps they should rather be read as the penetration of religious institutions by habits of daily life. The forms of spirituality were popularized.

Neglect of the established church appears to have been just one result of a new self-concern. Another was the development of private devotional patterns. Pietism was reflected in the increasing popularity of relics. Christopher of Mytilene's description of a relic collector indicates

48. Ed. V. Vasil'evskij, *PPSb* 17 (1886), 15.32–16.16.

49. P. Schweinfurth, "Der Mosaikfussboden der komnenischen Pantokratorkirche in Istanbul," *Journal des Deutschen archäologischen Instituts* 69 (1954), 489–500; A. H. S. Megaw, "Notes on Recent Work of the Byzantine Institute in Istanbul," *DOP* 17 (1963), 333–64.

50. Laskarina Bouras ascribes the church and its decoration to the period of the episcopate of Michael Choniates, metropolitan of Athens between 1182 and 1205, in part because of his great interest in the classical past.

51. P. Wirth, "Das religiose Leben in Thessalonike unter dem Episkopat des Eustathios im Urteil der Zeitgenossen," *Ostkirchliche Studien* 9 (1960), 293f.

not only how avidly holy items were sought, but also in what disdain the practice was held by the well educated: he censured the foolishness of the monk Andrew, who was consumed with a passion for relics. Andrew had managed to collect ten hands of the martyr Prokopios, fifteen jaws of St. Theodora, eight legs of St. Nestor, four heads of St. George, five breasts of St. Barbara, twelve forearms of St. Demetrios, and twenty hips of St. Panteleimon. Christopher remarked on the monk's ardent gullibility, which led him to transform a hermit into a hydra, a martyred virgin into a bitch with innumerable nipples, and a holy warrior into an octopus. Christopher went on sarcastically to offer Andrew further relics for his collection—Enoch's thumb, Elias the Tishbite's buttocks, and a piece of Gabriel's wing—in the pious hope of being counted among Andrew's friends and benefactors (Chr. Mytil. no. 114). While this image of a monk obsessed with relics may lack psychological depth, such bitter wit and sarcasm on the part of the observer is rare in Byzantine literature. The popular veneration of relics also affected the highest levels of society. Manuel I met the stone of Christ's unction at the Boukoleon harbor of the Great Palace when it was brought from Ephesus to Constantinople and carried it on his own shoulders to the Chapel of the Virgin of Pharos. This was less a penance than an identification with Joseph of Arimathea, at least according to an inscription reportedly on the slab:

> Our lord, Emperor Manuel reenacts the resolve of the Disciple as he bears on his shoulders that stone upon which the Lord's body was placed and prepared for burial in a winding sheet. He lifts it up announcing in advance his own burial, that in death he may be buried together with the Crucified One and may arise together with our buried Lord. . . .[52]

This passage also indicates that relics were believed to endow proximity to the Godhead.

Images associated with relics also proliferated. Icons of the Mandylion, miraculous images of the Virgin, and other similar objects of personal devotion multiplied.[53] The introduction of altar cloths with full-length images of the dead Christ (*epitaphia*)—recently connected with the Turin Shroud—has been ascribed to the late eleventh century.[54] Even

52. C. Mango, "Notes on Byzantine Monuments," *DOP* 23–24 (1969–70), 272–75.

53. A. Grabar, *La Sainte Face de Laôn: le Mandylion dans l'art orthodoxe* (Prague, 1931), esp. 22f.

54. H. Belting, "An Image and Its Function in the Liturgy: The Man of Sorrows in Byzantium," *DOP* 34–35 (1980–81), 1–16.

within the church, the icon generally became increasingly accessible and immediate. Images of veneration (*proskynetaria*), though known already in monuments of the late ninth and early tenth centuries, were given greater prominence in the church's decorative scheme, emphasizing the intercessory capacity of the Virgin and of popular saints (Fig. 16).[55] Processional icons, too, such as the paired twelfth-century panels from the Enkleistra of Neophytos and Lagoudera in Cyprus, became more common (Fig. 17). Relics and images are characteristically associated with popular spirituality.[56]

Religious iconography also displayed what might be called popular features during this period. Christological and Mariological scenes from the annual cycle of church feasts, as well as liturgical images, became more elaborate. For instance, from the late eleventh and early twelfth centuries, apocryphal subplots appeared in images more regularly. The story of Jephonias the Jew, for example, who had his hands cut off by an angel after attempting to upset Mary's bier, was introduced in an image of the Death of the Virgin (*Koimesis*) (Fig. 18); the disgraced personification of Synagogue was shown being pushed away from the cross of the Crucifixion by one angel while another brings forward Ekklesia bearing a chalice to catch Christ's blood.[57] In the sanctuary, on the wall of the apse, holy bishops were represented moving toward the eucharistic elements in the center (Fig. 19). The host was rendered as the infant Christ prepared for sacrifice.[58] This new interest in storytelling, this new concern with didactic elaboration, reflected a taste for literalism that bespeaks popularization.

Style in both manuscript illumination and monumental art also changed remarkably in the eleventh and twelfth centuries. The voluptuously modeled, pastel-colored figures set in illusionistic space of the Paris Psalter and Leo Bible and the majestic naturalism of the apsidal Virgin of St. Sophia in Constantinople cannot be said to be typical of late-ninth- and tenth-century art, but they indicate what court artists might

55. G. Babić, "La décoration en fresques des clôtures de choeur," *Zbornik za Likovne Umetnosti* 11 (1975), 3–49.

56. E.g., L. Rothkrug, "Popular Religion and Holy Shrines," *Religion and the People*, ed. J. Obelkevich (Chapel Hill, N.C., 1979), 20–86.

57. A. W. Epstein, "Frescoes of the Mavriotissa Monastery near Kastoria: Evidence of Millenarianism and Anti-Semitism in the Wake of the First Crusade," *Gesta* 21 (1982), 21–29.

58. G. Babić, "Les discussions christologiques et le décor des églises byzantines au XII⁰ siècle. Les évêches officiant devant l'Hétimasie et devant l'Amnos," *Frühmittelalterliche Studien* 2 (1968), 368–86.

achieve (figs. 20–21).[59] In contrast, images of the eleventh century are
commonly populated with severe figures, unaccompanied by muses and
personifications or elaborate stage props. The sumptuous illumination
of the Gospel lectionary, Dionysiou 587, ascribed to the mid-eleventh
century, is typical of the painting style of this period (Fig. 22).[60] On fol.
116r is an elaborately framed image of St. Symeon the Stylite with his
hands raised in a schematic gesture of prayer. He is abbreviated as a bust
atop his handsome Corinthian column. Not only does Symeon not have
a body, but his symmetrically arranged male and female attendants
seem equally to lack physical substance despite the fact that they are
shown full-figure. They stand as if weightless on symbolic steps leading
upward to the holy man. This appearance of insubstantiality is not the
result of the artist's inability to model, as the subtle modeling of the fig-
ures' flesh proves. Rather, the painter's concern was with the unam-
biguous expression of the relation between Symeon and his three sup-
plicants—the one on either side of his column and the viewer before
him. Indeed, the viewer is dramatically confronted by the figures; the
gold ground and the single ground line of the frame eliminate recession
into separate pictorial space. This more abstract mode has been character-
ized as "ascetic."[61] However, from the eleventh century on, there is an in-
creased emphasis on vibrant, jewellike color as well as on gold. Moreover,
in manuscript illumination and in monumental art elaborate, brilliant or-
nament became abundant (Fig. 23). All this belies the hypothesis that a
new ascetic atmosphere pervaded the artists' ateliers of the empire.
Rather, this change of style from classicizing illusionism to opulent ab-
straction might possibly be interpreted as a shift to a more popular, less
sophisticated visual mode of expression. It is commonly assumed that
illusionism—the artistic attempt to recreate on a two-dimensional plane
the three dimensions of our visual perception by means of artificial de-
vices such as perspective or shading—is easily understood because of its
familiarity. But illusionism depends on many space-creating accessories,
such as landscape setting, architectural props, and unnecessary figures

59. For a sketch of the general stylistic evolution of Byzantine art during the
period of the Macedonian dynasty, see V. Lazarev, *Storia della pittura bizantina*
(Turin, 1967), 124–36. Also see K. Weitzmann, *Geistige Grundlagen und Wesen der
Makedonischen Renaissance* (Cologne, 1962), translated as "The Character and In-
tellectual Origins of the Macedonian Renaissance," *Studies in Classical and Byzan-
tine Manuscript Illumination*, ed. H. Kessler (Chicago, 1971), 176–223.

60. S. M. Pelekanides et al., *The Treasures of Mount Athos* 1 (Athens, 1980),
434–36.

61. K. Weitzmann, "Byzantine Miniature and Icon Painting in the Eleventh
Century," reprinted in his *Studies*, 271–313.

that actually divert the viewer's attention from the principal subject. The difficulty of identifying scenes in the villas of Pompeii and the ease of recognizing images in a Byzantine church is due at least in part to the relative simplicity with which the idea was conveyed in the latter. The abstraction of the eleventh century was in fact the clarification of the stage space as well as of the figures that occupy it. The subject became increasingly accessible; moreover, the work was elaborated with intricate, highly colored ornamentation, the appeal of which is universal. All this provides a parallel to the introduction of vernacular elements in poetry.

THE "ARISTOCRATIZATION" OF CULTURE

THE BYZANTINE FAMILY

The crystallization of the nuclear family that had taken place by the ninth century (see Chapter 1) drastically changed the social role of women. Still during the Iconoclast dispute women were active in public affairs, participating fully in the struggle over the veneration of icons. It was not fortuitous that the effort to restore images was furthered by two women, the empresses Eirene and Theodora. The *vita* of Anthony the Younger preserves a precious detail that demonstrates that women's activity was not limited to religious disputes: when the Arab fleet, in about 825, attacked Attaleia, the governor of the city summoned to the walls not only men, but also young women dressed in male clothing.[62] Social development in the tenth century, however, led to women's confinement within the narrow circle of the family; the change in the hagiographic image of the woman reflected these social shifts. As E. Patlagean has shown, the type of holy woman who, for the sake of salvation, donned masculine garb and broke the rules governing female behavior disappeared by the ninth century. This variety of holiness was replaced by the image of the ideal spouse, like Maria the Younger or Thomais of Lesbos, who patiently and piously endured the cruelty, jealousy, or indifference of an unworthy husband.[63]

The traditional picture of the Byzantine patriarchal, nuclear family was drawn by Kekaumenos: the family was a world unto itself, surrounded by an invisible wall to separate it from outsiders. Anyone who was not a close relation, even a friend, once within the family circle

62. Ed. A. Papadopoulos-Kerameus, *PPSb* 57 (1907), 199.1–4.
63. E. Patlagean, *Structures sociales, famille, chretienté à Byzance IVᵉ–XIᵉ siècle* (London, 1981), part 11, 620–23.

might seduce the women, overhear household secrets, and generally disrupt familial order. A good wife, he continued, was half of life, the promise of good fortune. The author enjoined spouses to be faithful, condemning even the second marriage of a widower. Child rearing was also taken very seriously. Kekaumenos expected children to regard the patriarch of the family with awe and respect, though this regard was to be inspired by benevolent guidance rather than by birch rods. Daughters, of course, were to be concealed from the eyes of unrelated men.[64] This confinement of women, wives as well as daughters, was also alluded to in other contexts. For instance, in describing an earthquake of 1063, Attaleiates remarked that women, who normally kept themselves to the interior parts of the house reserved especially for them, forgot all shame and ran outdoors when the tremors began (Attal. 88.13–15). Anna Comnena also indicated that women venturing out of doors carefully veiled their faces (An. C. 1:78.29).

A comparison of Byzantine laws on divorce with those of Western Rome again indicates the importance of the nuclear family in the East. In Rome divorce in accordance with the wish of either party was still allowed in the ninth century.[65] In Byzantium, the ancient practice of free divorce had been abolished by the eighth century. The independence of the property of the spouses, acknowledged in the Justinianic code, gave way to the notion of familial property, formed of the dowry and the prenuptial gift, as an indivisible whole.[66] Only after the husband's death was property divided. It had to be shared equally by the wife and the children. The concept of primogeniture was unknown. The importance of the nuclear family is further evident in donors' panels. From imperial dedicatory portraits, such as those of Constantine X Doukas, his wife Eudokia, and one of their sons in the Barberini Psalter, to images of local notables like the *magistros* Nikephoros Kasnitzes, his wife, and son in the Church of St. Nicholas Kasnitzes in Kastoria in northern Greece, the parents and, most commonly, one or two children are carefully depicted (Fig. 24).[67]

While the family remained important in Byzantium throughout the

64. G. G. Litavrin in Kek. 99–101.

65. K. Ritzer, *Formen, Riten und religiöses Brauchtum der Eheschliessung in den christlichen Kirchen des ersten Jahrtausends* (Münster, 1961), 104.

66. A. Guljaev, *Predbračnyj dar v rimskom prave i v pamjatnikach vizantijskogo zakonodatel'stva* (Tartu, 1891), 132, 142f.

67. J. Spatharakis, *The Portrait in Byzantine Illuminated Manuscripts* (Leiden, 1976), 26–36; S. Pelekanides, *Kastoria* 1 (Thessaloniki, 1953), pl. 62.

Middle Ages,[68] the traditional family structure seems to have been modi-
fied in the late eleventh and twelfth centuries. The narrow limits of the
nuclear family were widened to include blood relations. This shift in do-
mestic structure from the nuclear family to the extended family may be
detected in the actions and attitudes of the ruling dynasty. As men-
tioned above, in the seventh century uncles and cousins were regarded
by the emperor as his rivals and potential enemies. Their mutilation and
blinding became almost obligatory. Some vestiges of these attitudes re-
mained later, for instance, in the words of John Doukas, who recom-
mended that Emperor Nikephoros III take the Georgian princess Maria
as his wife because, as an alien, she had no relations to bother the
basileus (An. C. 1:107.25–26). In contrast, Nikephoros's successor, Alex-
ios I, was guided by opposite principles, regarding his lineage and kin-
ship relations as the main support of his throne.

Reflecting this loosening of traditional internal family structures
was the again-increased prominence of women. While the family re-
mained patriarchal, women began playing a more visible role, at least
among the elite.[69] A comparison of late-eleventh- and twelfth-century
aristocratic ladies with their predecessors manifests the trend in Comne-
nian society. Empress Zoe, though historically significant (along with
her sister, Theodora) as the last in the line of the Macedonian dynasty,
was politically a pathetic figure, more concerned with unguents, oint-
ments, and the marriage bed than with the affairs of state (Ex. 13). Zoe's
female contemporaries, as described by the chroniclers, also remained
figures of the gynaeceum, not of the larger society. By contrast, from the
late eleventh century on, there appeared in the palace a series of ener-
getic, educated, politically astute women. Anna Dalassena was officially
recognized as co-ruler with her son, Emperor Alexios I. Again, Eirene
Doukaina, Alexios I's wife, not only followed her husband in his military
expeditions, but also overtly intrigued against her son, John II (Ex. 14).
Anna Comnena, Alexios I's daughter, was a writer, patron of the arts,
and center of a political and literary circle opposed to her nephew Man-
uel I. The *sebastokratorissa* Eirene, the widow of Andronikos, the second
son of John II, sponsored many scholars and writers. Like Anna Com-

68. On the development of the marriage law, see H. Hunger, "Christliches
und Nichtchristliches im byzantinischen Eherecht," *Österreichisches Archiv für
Kirchenrecht* 18, Heft 3 (1967), reprinted in his *Byzantinische Grundlagenforschung*
(London, 1973), part 11, 305–25.
69. A. Laiou, "The Role of Women in Byzantine Society," *JÖB* 31/1 (1981),
242, 251–54.

nena, she stood in opposition to her brother-in-law Manuel I. On her be-
half Prodromos or Pseudo-Prodromos wrote the long poem (which in-
terestingly includes numerous vernacular expressions) addressed to
Manuel I (Ex. 15). In this work Eirene was portrayed audaciously accus-
ing the emperor of unjustly persecuting her. Maria Comnena, Manuel I's
daughter, together with her husband, the *caesar* John (Renier of Montfer-
rat) led the aristocrats' plot of 1181, which ended in an armed skirmish
on the streets of Constantinople. At the end of the twelfth century, Eu-
phrosyne, Alexios III Angelos's wife, governed state affairs; everybody
in search of imperial favor turned to her. Although she was banished
from the capital after being accused of infidelity, she later returned to
vindicate herself and to reacquire her former position.

A new concern with lineage (see below) and the modified status of
women may have helped undermine the nuclear family; certainly a weak-
ening of that institution in the twelfth century was obvious in the open-
ness with which adultery was committed. Manuel I, who lived with his
own niece Theodora, set an example. His liaison with Theodora was so
well established that his wife, Empress Bertha of Sulzbach (called Eirene
in Byzantine sources), was completely disregarded at court; her power
was restricted to charitable deeds and to the education of her daughter.
Though Theodora was married to the *sebastos* Nikephoros Chalouphes,
her child by Manuel, named Alexios, was recognized as the emperor's
son and indeed received a title, *sebastokrator*, appropriate to that station.
Manuel's cousin Andronikos I gave his natural daughter Eirene in mar-
riage to Alexios, and it was even assumed for some time that Alexios
would succeed Andronikos to the throne. The amorous relations of An-
dronikos were also well known. The affairs of Manuel I and of Androni-
kos were not simple infidelities. While their legal marriages had been
arranged according to political, economic, or genealogical considera-
tions, their mistresses were determined only by passion. Indeed, lovers
were also often close relations. This public flouting of both moral codes
and canon strictures on incest reveals the social tendencies of the era
even more than do the acts themselves.

SEARCH FOR LEGITIMACY: THE
IMPORTANCE OF LINEAGE

With the shift in the structure of society toward the extended family,
lineage became increasingly important in determining an individual's
status and power. The use of patronymics was an external sign of this
new concern. Although patronymics occasionally appear in the sources

from the late ninth century, they become commonplace only after 1000. Patronymics did not consistently indicate patrilinear sequence. A man could assume his mother's name or that of his mother's mother, as well as that of his father. The widespread adoption of patronymics, in any case, corresponds with the emergent ties between the individual and the extended family. The glories and honors of one generation began to be assumed by another.

Similarly, interest in genealogy grew. The status of the individual became increasingly tied to the historic position of his forebears. Constantine Manasses' eulogy of Nikephoros Comnenus, grandson of the *caesar* Nikephoros Bryennios, a veritable apotheosis of nobility, included an elaborate genealogy.[70] The writer was not content simply to allude to the aristocratic ancestry of the deceased, but rather insisted that his hero was descended from kings. These kings were not the sons of impious gods like the wretched Pelops or Kekrops, but in fact scions of two noble families, the Comneni and the Doukai, who, in mixing their heroic blood, created a house renowned for its intelligence, power, and martial capacity. This fetish for lineage is rejected by Michael Italikos, who mocked his contemporaries' preoccupation with genealogical investigations (Mich. Ital. 148.18–24), and by Euthymios Tornikes, who censured those whose conceit was based solely on high birth.[71] While the military aristocracy was proud of its fabricated genealogies, the civil nobility used patronymics to extol its own moral virtues, names such as Eugenianoi ("of noble birth") and Eirenikoi ("peace lovers").

The concern with lineage can also be seen in the monuments. After the year 1028 the Church of the Holy Apostles—the great Constantinian martyrium rebuilt by Justinian in the sixth century and refurbished by Basil I in the late ninth century—was no longer used by Byzantine emperors as their final, communal resting place;[72] rather, private dynastic chapels became increasingly popular. Perhaps the best documented of these family mausolea is the Heroön, a funerary church dedicated appropriately to the military archangel St. Michael and constructed between the sanctuaries of the Pantokrator and the Eleousa as part of the large monastery founded by John II Comnenus and his wife Eirene

70. E. Kurtz, "Evstafija Fessalonikijskogo i Konstantina Manassi monodii na končinu Nikifora Komnina," *VV* 17 (1910 [1911]), 305–8.

71. J. Darrouzès, "Les discours d'Euthyme Tornikes," *REB* 25 (1968), 96.18–28.

72. P. Grierson, "The Tombs and Obits of the Byzantine Emperors (337–1042)," *DOP* 16 (1962), 21ff.

sometime after 1118 (Fig. 25).[73] In this chapel commemorative prayers were said not only for the immediate family, but also for distant relatives and trusted servitors. The Pantokrator was the most prominent of the twelfth-century family burial chapels, but the practice of adding subsidiary space for funerary commemorations had become increasingly common in the eleventh and twelfth centuries.[74] This architectural expression of the importance of self and family might also reflect an increasing concern with obtaining a place in paradise, a concern often associated with worldly insecurity.

THE CREATION OF AN ARISTOCRATIC IDEAL

The new emphasis on lineage and extended family ties was due to the emergence of the military aristocracy as the ruling elite of Byzantium. In the less concrete sphere of ideology the new power of the aristocracy was even more influential. The concept of nobility and the attributes of noble character were greatly elevated. At the same time, there was a modification of the imperial ideal.

By contrasting the attitudes of writers from the earlier and later parts of the period under consideration, one can trace the evolution of nobility in Byzantium. The traditional neglect of the aristocracy characterizing Agapetos and the *Strategikon* of Maurikios[75] continued into the eleventh century. For instance, Kekaumenos considered nobility in terms of moral excellence rather than as a quality of blood or of family origins. He tended to contrast the common fellow not to an aristocrat, but rather to a well-to-do, high-ranking official. But there were signs of change at the same time. Kekaumenos's contemporary Psellos drew a more complex picture of the aristocrat. To be sure, Psellos did not consider birth as the primary determinant in human fate and behavior. He approved of Constantine IX's appointing high functionaries without reference to family. Moreover, he questioned the fairness of replenishing the senate only with those of noble birth. He asked whether only those should be admitted to the palace who were of famous stock but remarkable only for their brainlessness and arrogance. Psellos consistently identified nobility with

73. Megaw, "Notes on Recent Work," 335f.; P. Gautier, "L'obituaire du Typikon du Pantokrator," *REB* 27 (1969), 247.

74. G. Babić, *Les chapelles annexes des églises byzantines* (Paris, 1969).

75. *Das Strategikon des Maurikios*, ed. G. T. Dennis (Vienna, 1981), 70.36, required of the general only piety and justice; aristocratic origins were not mentioned. See G. Ostrogorsky's comment, "Observations on the Aristocracy in Byzantium," *DOP* 25 (1971), 4f. On Agapetos, P. Henry III, "A Mirror for Justinian: The *Ekthesis* of Agapetus Diaconus," *GRBS* 8 (1967), 307f.

virtue and talent, though he implicitly recognized the value of good breeding.[76] He was indignant that people of inferior backgrounds could worm their way into power and censured the excessive vertical mobility of his society. He stressed that the nobility in the flourishing states of antiquity were distinguished from men whose origins were obscure. "In our state," he complained, "this excellent practice has been contemptuously abandoned, and nobility counts for nothing." In Byzantium, he continued, many administrators were ex-slaves bought from barbarians; the high offices of state were entrusted not to men of the stamp of Perikles or Themistokles, but to worthless rascals like Spartacus (Ps. *Chron.* 2:35, no. 134.14–17). Apparently Psellos felt an aristocratic presence was needed in society: he was confused by the social openness of Byzantium. While Psellos was somewhat ambiguous in his appreciation of the nobility, for his contemporary Attaleiates aristocratic birth was of unquestionable value. In contrast to Psellos, Attaleiates assumed that noble ancestry implied virtue, at least of a military nature:[77] he feigned a distinguished genealogy for his hero, Nikephoros Botaneiates, relating him not only to the Phokas family of the tenth century, but even to the Roman Fabii, who were noble both in blood and in action. For all his praise of nobility, it should be noted that Attaleiates was himself of simple origin and of civil occupation; he was not writing to aggrandize his own class, but rather reflected in his work a significant ideological shift.

Psellos's and, more notably, Attaleiates's writings show the new respect for the hereditary aristocracy that was attendant on the shift to the extended family. Literature also documents the development of a martial ideal for the nobility that must be related on one hand to the concern regarding lineage and on the other hand to the "feudalizing" tendencies of the society. Characteristically, the noble general became the hero of historical narrative. In Attaleiates, the military hero Nikephoros Botaneiates became the emperor; military deeds were only the means by which he obtained the "imperial summit." In Skylitzes, Katakalon Kekaumenos, a general without pretensions to the throne, was the hero, overshadowing even imperial figures. The historian related in detail Kekaumenos's successful ruse in the defense of Messina and his victories over the Russians and against Aplesphares (Abu-l-Uswar). When the Byzantine commanders refused to accept Katakalon's astute advice they were

76. A. P. Kazhdan, "K voprosu o social'nych vozzrenijach Kekavmena," *VV* 36 (1974), 166; *Social'nyj sostav,* 30–33.

77. A. P. Kazhdan, "Social'nye vozzrenija Michaila Attaliata," *ZRVI* 17 (1976), 5–14.

defeated by the Turks and Pechenegs. He figured prominently in the mutiny against Michael VI; had he been less modest, according to Skylitzes, Katakalon would have been enthroned instead of Isaac Comnenus. Skylitzes' chronicle ends with two episodes of apparently equal significance for the author: Katakalon Kekaumenos's promotion to the position of *kouropalates* on August 31, 1057, and Isaac Comnenus's coronation on the following day.[78]

A concern with the military aristocracy is even more evident in the *Memoirs* of Nikephoros Bryennios. In his presentation, history develops not as a result of actions of emperors in relation to their adversaries and functionaries, but rather as the outcome of aristocratic rivalries among the great families—the Doukai, Comneni, and Bryennioi. Bryennios's nobles were primarily military figures; their activities were consistently described as "valiant," "courageous," and "glorious." They were esteemed even by their adversaries: Alexios Comnenus, for instance, admired the strength and height of the usurper Nikephoros Bryennios (the author's grandfather or father), and Comnenus's victory was the greater for being won from a strong, brave general who possessed the soul of a hero (Bryen. 281.10–14). Further, Bryennios wrote respectfully of a number of noblemen, including Argyros ("noble and wealthy"), George Palaeologus ("valiant"), Alexios Charon ("reasonable, strong, and courageous"), and John Tarchaneiotes ("an experienced warrior").[79] In contrast, eunuchs and servitors were despised: Nikephoritzes was "wretched"; John Protovestiarios was "swaggering and cowardly." The work of Nikephoros Bryennios is probably the most aristocratically biased Byzantine history of this period; it presented the noble warrior in a fully generalized and idealized form. The *caesar* Bryennios, himself a great seigneur, was, in all, the ideologue of the Comnenian military aristocracy.

Theodore Prodromos, one of the most eminent Byzantine writers, belonged to a different social milieu. Though his family was not entirely destitute, his life, so he continually wrote, was wretched and dismal by comparison with those of his distinguished acquaintances. He perpetually moaned about his poverty, but his complaints should probably not be taken at face value. Prodromos owned a house in Constantinople and a suburban property and lands, including a vineyard. He may also

78. J. Shepard, "Scylitzes on Armenia in the 1040's and the Role of Catacalon Cecaumenos," *Revue des études armeniennes* 11 (1975–76), 269–311; A. P. Kazhdan, review of Skylitzes' *Synopsis historiarum, Istoriko-filologičeskij žurnal*, 1975, no. 1, 206–12.

79. On the aristocratic bias of Bryennios, A. Carile, "*Hyle historias* del cesare Niceforo Briennio," *Aevum* 43 (1969), 246–48.

have had servants or slaves. Thus, while not an aristocrat Prodromos had a comfortable social position as a small property owner; petty landowners, in fact, provided the main constituency for the Comnenian dynasty. Prodromos should have had a career in the army, as typical for a man of his social status, but ill health forced him to take up scholarship and writing (*Hist. Ged.* no. 38.11–40). Nevertheless, he envied the soldiers of John II for fighting their emperor's battles while he could only stay at home and pray for victory (no. 17.5–10). But Prodromos put his literary talents at the disposal of the Comneni, producing speeches and poems for special occasions such as births, marriages, funerals, and military victories; the heros of these pieces were not only emperors (although Prodromos delivered frequent encomiums of John II) but also noble warriors and noble ladies, primarily of the Comnenian clan. The "aristocratic panegyric" became a particularly popular genre from the end of the eleventh century—Prodromos had been preceded by Nicholas Kallikles as semi-official encomiast of the dynasty. It is often assumed that such rhetoric was vain and idle, but in fact it fulfilled an important social task. Along with such works as Bryennios's *Memoirs* it helped introduce a new concept of aristocratic lineage and behavior. Indeed, Prodromos was fascinated by everything connected with warfare. He glorified warriors far more eloquently than was required by mere convention: the two sons of Nikephoros Bryennios were both excellent riders, hunters, and soldiers; Stephen Kontostephanos was famous for his military skill; Alexios Phorbenos was a tall and mighty soldier; Alexios Kontostephanos had an excellent sword; Manuel Anemas was a wise general, the "great tower of the Rhomaioi." Then there was the family of the *sebastokrator* Andronikos, brother of Manuel I: Andronikos himself was a great hero and general, an excellent rider, a noble hunter, a man with magnificent armor and splendid horses. In a poem on the birth of Andronikos's son Alexios, Prodromos expatiated upon the ideal education of a young aristocrat: he should become a keen ball player, a fine hunter, and a first-class marksman. He had to be trained for battle so that he would acquire the skill and strength to slay barbarians (no. 44.74–81, 171–78).

Prodromos did not admire warlikeness alone; he also had a very high regard for wealth. He dreamed of having numerous servants to care for his horses, to serve him food and wine, to dress him in silk garments. He reveled in describing the inexhaustible riches of the infant Alexios (no. 44.15–55): his clothes were stitched in gold and decorated with emeralds and precious stones, he had great estates yielding a comfortable income, owned high-roofed houses, a throng of servants, a

crowd of grooms. Prodromos held noble birth, too, in the highest es-
teem. Again, his attitude was well illustrated in his poem on the birth of
Alexios. Any family rejoices at the birth of a child, but how much greater
is the celebration when the child is born to a noble family! So speaks Pro-
dromos at the start of the poem; he concludes in the same vein, with the
hope that Alexios may grow up to find a wife worthy of his noble line.
The self-confidence of a member of the imperial family was perhaps best
represented in the poem, ascribed to Prodromos, in the form of a plea
from exile addressed to Manuel I by the *sebastokratorissa* Eirene, widow
of the *sebastokrator* Andronikos (Ex. 15).[80] Prodromos provided this noble-
woman, in exile for plotting against her brother-in-law, a spirit and inde-
pendence rarely matched in medieval literature.

Like Prodromos, John Zonaras was not himself a noble but took no-
bility very seriously. His comprehensive chronicle begins with the crea-
tion of the world and continues through the same period treated by
Bryennios's *Memoirs* and a little beyond, to Alexios I's reign. By sifting
Zonaras's original contributions out from the bulk of his historiographic
borrowings, one can reconstruct a consistent political point of view for
the chronicler. Zonaras was restrained in his appreciation of the military
aristocracy but idealized the civil nobility. He accused Basil II of too little
esteeming clever people distinguished by their good birth and education
(Zon. 3:561.11–14). His opinion concerning Alexios I was even more
critical: "The emperor did not sufficiently respect or care for the mem-
bers of the senate; rather he attempted to humiliate them" (3:766.17–19).
Zonaras was a mouthpiece for the higher echelons of the state bureau-
cracy;[81] his attitude toward the Comnenian dynasty was consequently
critical, although he, like Bryennios, unreservedly accepted the impor-
tance of noble blood and treated the humble citizenry with aristocratic
disdain. He was also an outspoken defender of wealthy members of the
society concerned with protecting their property. He explained the elev-
enth canon of the Council of Chalcedon accordingly, emphasizing that
rich and poor must be judged alike in court; a poor man's debt must be
paid in accordance with the law (*PG* 137.429C). Apparently Zonaras felt
that too often a judicial sympathy for poverty cheated the rich out of
their rightful returns; he was evidently at odds with the ethical norms of
the tenth century.

More generally, it appears that nobility was praised by people from

80. S. D. Papadimitriu, "Ho Prodromos tou Markianou kodikos," *VV* 10
(1903), 155–63.
81. F. H. Tinnefeld, *Kategorien der Kaiserkritik in der byzantinischen Histo-
riographie* (Munich, 1971), 144f.

very different social strata—for example, a teacher, Eustathios of Thessaloniki, or a private citizen, Niketas Eugenianos, or an aristocrat, Nikephoros Comnenus. The glorification of the military aspects of aristocratic life was also mirrored in the games played by the ruling elite. Military competitions and tourneys were introduced, partially under Western influence, just at this time. An attempt by Nikephoros Phokas to conduct a military competition at the end of the tenth century created panic in Constantinople (Skyl. 276.94–98). In contrast, Byzantine noblemen and even emperors in the twelfth century readily participated in tourneys with Crusader knights, occasionally even suffering severe wounds.[82] Niketas Choniates offered a description of a tourney arranged in Antioch after Manuel I's solemn entry into the city in 1159 (108f.). Two detachments were arrayed against each other for "fighting with ironless spears." The Byzantine troop consisted of those imperial relatives especially capable of "brandishing pikes." Manuel himself entered the lists, grinning a little as usual and grasping his spear. He wore a fashionable cloak pinned at the right shoulder so that his hand remained free, and his "fair-maned horse" (an allusion to *Iliad* 5.323) was adorned with gold trappings that vied with his noble rider's array. The emperor ordered that every one of his companions be clad as beautifully as possible. Prince Geraldus (Reynald of Chatillon) came to meet him riding a stallion "whiter than snow" and wearing a long *chiton* split in two from the waist down and a tiara-shaped felt cap embellished with gold. The knights followed, all as mighty as Ares and tremendously tall. Then the contenders in this bloodless fight engaged in battle, "and you could see this brassless Ares tumbling on his neck and shoulders or thrown from his saddle like a ball; one fell on his belly, another on his back, and another turned round and fled headlong." Some were pale with fear and tried to cover themselves with their shields, some rejoiced seeing an adversary frightened. They rode merrily whistling at a full gallop, their pennants flapping. "If someone wished to express this pompously, the sight reminded one of Ares' intercourse with Aphrodite or the coming together of Enyo [the goddess of war] and the Charites—so diversified looked this mixed-up game." Other games, such as polo, that required adroitness, strength, and skill, were also popular.[83] Archery, too, and

82. On Byzantine "tournaments," Koukoulès, *Vie et civilisation* 3 (Athens, 1949), 144–47.

83. Byzantine polo is attested to by Kinnamos and Nikephoros Chrysoberges: Koukoulès, *Vie et civilisation* 3, 139–42. The game was known earlier in Byzantium. John Tzimiskes liked riding exercises involving ball-play. Skyl. 313.37–41.

horsemanship became mandatory in the upbringing of a young aristo-crat (*Hist. Ged.* no. 44.69–81).

Related to the martial interests of the Comneni was a new concern with blood sports.[84] Hunting was always important in Byzantine life, though tenth-century authors were particularly reserved in their appre-ciation of the chase. Although Basil I's physical prowess is often lauded in the life of the emperor ascribed to Constantine VII, discussions of hunting are absent. In this account even Basil's death is blamed on a gas-tric disorder, rather than to the freak hunting accident recorded in other sources (Theoph. Cont. 352.1–2; contrast with Ex. 17). Leo the Deacon also suggested that hunting brought nothing but harm to Romanos II (Leo Diac. 30.22–23). One can guess, but not prove, that this hostility was simply an Orthodox reaction to the heretical Iconoclast emperors' love of hunting. By contrast, in the twelfth century the hunt was a fre-quent and important scene in Byzantine literature; Constantine Manas-ses and Constantine Pantechnes even wrote treatises exclusively de-voted to the subject (Ex. 18).[85] Hunting became a part of the imperial image: Prodromos, for example, regarded the emperor as a perfect hunter, pursuing his adversaries like game.[86] This complemented a new vision of the emperor as the archetypal warrior.

IMAGE OF THE IDEAL RULER

The most visible characteristics of the new aristocracy seem to have been elevated into a social ideal. This remodeling of an ideal type is best exemplified in the person of the emperor, the embodiment of Byzantine ideology. When the Comneni, members of the Byzantine military aris-tocracy, took possession of the throne, they typified the new imperial virtues. The traditional conception of the emperor (*basileus*) originated with Agapetos in the sixth century and with Emperor Justin II's speech to his successor Tiberios in 574, which was preserved independently by Theophylaktos Simokatta and several other contemporary authors; Simo-

84. Koukoulès, *Vie et civilisation* 5 (Athens, 1952), 387–423, provides a wealth of references, unfortunately not chronologically ordered.

85. L. Sternbach, "Analecta Manassea," *Eos* 7, no. 2 (1901), 180–94; E. Kurtz, "Ešče dwa neizdannych proizvedenija Konstantina Manassi," *VV* 12 (1906), 79–88; E. Miller, "Description d'une chasse à l'once par un écrivain byzantin du XIIᵉ siècle de n. è.," *Annuaire de l'Association pour l'encouragement des études grecques en France* 6 (1872), 47–52.

86. *Hist. Ged.* 95. On the hunt in Byzantium in the twelfth century, see Ph. Koukoulès, "Kynegetika ek tes epoches ton Komnenon kai ton Palaiolo-gon," *EEBS* 9 (1932), 3–33; V. P. Darkevič, *Svetskoe iskusstvo Vizantii* (Moscow, 1975), 207–11.

katta's version was eventually revised by such chroniclers as Theophanes in the ninth century and Zonaras in the twelfth.[87] The main tenets of this concept were further developed in the ninth and tenth centuries, when there appeared three works all connected in one way or another with Basil I—the *Hortatory Chapters* attributed to Basil himself, the funeral speech dedicated to Basil and his wife by their son Leo VI, and Basil's biography written by his grandson Constantine Porphyrogenitus. All these writings stressed the Christian principles of imperial power: the emperor was believed to be chosen by God; he obtained divine succor by means of his love and imitation of God. The list of imperial virtues depended heavily upon classical ethics and included righteousness, philanthropy, generosity, chastity, love of truth, and intelligence. Neither martial deeds nor noble origins were included among the essential qualities. Quite the contrary, the *Hortatory Chapters* eulogized the emperor not as a warrior but as a peacemaker (*PG* 107.XLV B) and commanded, "Do not brag about the nobility of the body, nor be scornful of humbleness; neither honor beauty nor turn aside from ugliness, but look at the beauty of the soul and be loving of the soul" (XXV B–C). Further, it admonished, "Do not respect and admit those who are noble by dint of their body, but those who are dear by dint of their spirit." The author explained that horses' nobility consists in magnificent stature, dogs' in their hunting abilities, while human nobility was determined by the virtues of the soul (LII A–B). Leo VI preferred not to discuss his father's origins; he touched on them only so that he not be accused of ignorance. He mentioned a semi-official, quite legendary account of Basil's descent from the Armenian Arsacids and the Persian Artaxerxes, but he put the greatest emphasis on the personal virtues of his hero, not on his family. The humble man, he said, was embellished by his deeds, whereas the nobleman of necessity had to assume glory from his ancestry.[88] In Constantine Porphyrogenitus's biography, his grandfather's personal military achievements were never mentioned; rather, he vaguely confirmed that Basil extended the frontiers of the empire through his labor, his manliness, and his lofty spirit (Theoph. Cont. 265.5–7) and most warmly described Basil's successful administration of the state, not his command on the battlefield. The only military episode depicted in any detail was

87. V. E. Val'denberg, "Reč' Justina II k Tiveriju," *Izvestija Akademii nauk SSSR. Otdelenie gumanitarnych nauk,* 1928, no. 2, 111–40; I. S. Čičurov, "Feofan—kompiljator Feofilakta Simokaty," *ADSV* 10 (1973), 205; A. Cameron, "An Emperor's Abdication," *BS* 37 (1976), 161–67.

88. A. Vogt and I. Hausherr, "Oraison funèbre de Basile I^er par son fils Léon VI le Sage," *Orientalia christiana periodica* 26 (1932), 42.21–26; 42.29–30.

the crossing of the Euphrates, when the emperor carried a load three times heavier than that of the ordinary soldier (269.1–15). Constantine, too, spoke of Basil's Arsacid ancestry, albeit late in the narrative, but otherwise ignored the topic of noble origins.

By the end of the tenth century, chivalric virtues began to infiltrate the traditional image of the ideal emperor. Reshaping the imperial ideal began with literary portrayals of Nikephoros Phokas such as are found in the epigrams of John Geometres or in the history of Leo the Deacon; the new image may have been drawn from popular, oral sources or from works created for the Phokas family. Even the chivalric portrayal of Nikephoros Phokas was still suffused with monastic piety; the image had by no means been fully secularized and militarized.

Late-tenth-century descriptions of Nikephoros Phokas placed a singular emphasis on knightly virtues. The prevailing picture of imperial greatness was fundamentally non-military both before and after Nikephoros Phokas's reign. In the middle of the eleventh century John Mauropous contrasted the reckless bellicosity of the barbarians and of the rebel Leo Tornikes to the triumphant piety of the emperor.[89] Nor was there room for martial prowess in the imperial portraits drawn by Christopher of Mytilene. Kekaumenos, too, preserved the essential elements of a traditional imperial image: the pious emperor as God's elect (Kek. 274.9), the father of his subjects (284.8–10), and the just judge of his people (284.17–19, 274.11–13). Kekaumenos's written admonitions to the emperor contained no mention of the ruler's personal participation in battle. While the emperor had to care for the soldiers (stratiotai), the fleet, and the army because they reflected imperial glory and represented the strength of the palace, the author did not demand a display of military courage on the part of the emperor himself. For Kekaumenos the four essential qualities of the ruler were fortitude, justice, chastity, and reason, but with some qualifications. Fortitude referred not to military courage, but to spiritual perseverance. Nor were fortitude and reason considered absolute virtues, since they could be put to evil use.

Military attributes, previously associated exclusively with Nikephoros Phokas, began to reappear at the end of the eleventh century in the writings of historians and publicists. Attaleiates dedicated his historical work to the praise of Nikephoros Botaneiates. Besides the traditional imperial virtues, Attaleiates gave Nikephoros two new ones: noble birth and military prowess. The historian insisted that everyone loved the

89. J. Lefort, "Rhétorique et politique: trois discours de Jean Mauropous en 1047," TM 6 (1976), 285–93.

new ruler for his nobility and for his martial glory; his courage was tantamount to his noble origins. These virtues—nobility and courage—were constantly associated in the author's mind (Attal. 56.1–5, 185.16–20, 302.15).

Somewhat later than Attaleiates, Theophylaktos Hephaistos, the future Bulgarian archbishop, wrote a didactic work addressed to his pupil Constantine Doukas, the presumptive heir to Alexios I's throne. This author, too, required in his good emperor both military and traditional moral virtues: "Do not think that the servants of Ares, lionlike men, will bring you a crown of gold and a cloak of purple unless they see you donned in armor and directing the battle."[90] Thus, Theophylaktos and Attaleiates shared a common conception of the warrior emperor.

This warrior emperor type took on monumental proportions in the writings of Eustathios of Thessaloniki. This author sketched Manuel I as an ideal knight who scorned danger and took greater pride in his wounds than in the glitter of his diadem, toiled with his soldiers hewing stones and bearing them on his shoulders to build fortresses, slept little, was abstinent in eating, liked to exercise, endured readily extremes of cold and heat, and excelled all in steadfastness.[91] Eustathios was echoed by Prodromos, according to whom Manuel, for the sake of his subjects, lived day and night in his armor, withstanding thirst, cold, and rain (*Hist. Ged.* no. 30.33–35). Kinnamos also emphasized Manuel's personal bravery and his chivalrous readiness to aid his brothers-in-arms.[92] Manuel seemed to embody the ideal Theophylaktos had anticipated. But the increasingly military characterization of the emperor was not simply a necessary response to the political circumstances of the empire. Byzantium throughout its history had had to cope with external pressures, but it was only from the end of the eleventh century that the warrior emperor emerged as an ideal type.

Militarization of the imperial image evidently had a parallel in state ritual. The Late Roman custom of proclaiming an emperor by raising him on a shield was probably revived around the middle of the eleventh century. This ritual, a mark of the bond between a ruler and his army,

90. *PG* 126.268B–C. In Theophylaktos's treatise there are two further new points. The election of the emperor is presented not as an act of divine choice, but as a result of a consent of the people (273B); the author also suggests that the emperor ought to seek the support of his friends (276B).

91. A. P. Kazhdan, "Vizantijskij publicist XII v. Evstafij Solunskij," *VV* 28 (1968), 64.

92. M. M. Friedenberg, "Trud Ioanna Kinnama kak istoričeskij istočnik," *VV* 16 (1959), 50.

seems to have been common in late antiquity, from the fourth to sixth centuries. After Phokas's usurpation of 602, however, it disappeared.[93] The fact that Constantine Porphyrogenitus in the middle of the tenth century mentioned this ceremony as a Khazar tradition[94] indicates that it had fallen into disuse in Byzantium. Revival of the custom is first clearly indicated in Psellos's writing. According to Psellos, the rebellious Bulgars in 1040 proclaimed Peter Deljan ruler by raising him on a shield (Ps. *Chron.* 1:77, no. 40.21–22). In a more thoroughly Byzantine milieu, the usurper Leo Tornikes was raised on a shield in 1047 (2:18, no. 104.4–5). In the twelfth century the description of the ruler raised on the shield even appeared as part of a Byzantine romance, *Rodanthe and Dosikles* by Prodromos (chap. 5, v. 109–11).[95] Akropolites in the thirteenth century treated Theodore Laskaris's elevation on a shield as a commonplace.[96] It is not clear, however, when between the middle of the eleventh and middle of the thirteenth century this ritual became customary.

This ritual was also well known in painting. The theme was often exploited by Byzantine miniaturists, particularly in connection with coronation of the kings of the Old Testament. The oldest representation of this kind is the image of Hezekiah in the Chludov Psalter, a manuscript usually dated to the ninth century. Two other illuminations showing the same subject occur in tenth-century manuscripts; the theme became much more common during the eleventh and twelfth centuries.[97] It is

93. *The Book of Ceremonies* noted that Nikephoros Phokas was raised up in 963 when the soldiers proclaimed him emperor, but it is unclear whether a shield was involved in the episode. O. Treitinger, *Die östromische Kaiser- und Rechtsidee nach ihrer Gestaltung im höfischen Zeremoniell* (Jena, 1938; reprint: Darmstadt, 1956), 23, suggests that Nikephoros could have been raised up on a shield. G. Ostrogorsky, *Zur byzantinischen Geschichte* (Darmstadt, 1973), 149, also admits this possibility, although he regards this act not as a coronation but as a spontaneous expression of the soldiers' *pronunciamento*. Others doubt that in 963 the ceremony of raising on a shield took place at all: Aik. Christophilopoulou, *Ekloge, anagoreusis kai stepsis tou byzantinou autokratoros* (Athens, 1956), 105f.; C. Walters, "Raising on a Shield in Byzantine Iconography," *REB* 33 (1975), 159.

94. Constantine Porphyrogenitus, *De administrando imperio*, ed. Gy. Moravcsik and R. J. H. Jenkins, (Washington, D.C., 1967), chap. 38.52–53.

95. *Erotici scriptores Graeci*, ed. R. Hercher, vol. 2 (Leipzig, 1859), 356.

96. G. Ostrogorsky, *Zur byzantinischen Geschichte*, 150, suggests that the ceremony was introduced into Byzantium under Western influence. In contrast, I. Dujčev, *Proučvanija vǔrchu bǔlgarskoto srednovekovie* (Sofia, 1945), 30, assumes that this custom existed continuously from Roman times.

97. This is evident from the stemma produced by Walters, "Raising on a Shield," 174.

found, for example, in the Barberini Psalter (Fig. 26), a Book of Kings (Vat. gr. 333), and twice in the Madrid Skylitzes.[98] Raising an emperor on a shield seems to be depicted also on two marble roundels usually dated to the twelfth century.[99] The popularity of this theme in art may be related to the reemergence of the imperial ceremony.

But the new image of the warrior emperor had an even broader impact on imperial iconography. Manuel I had his palace at Blachernae decorated with images of his own battles as well as of famous ancient ones (Ben. Tud. 53, exs. 19–20). The emperor evidently appeared also in a military attitude on luxury objects: an anonymous poet of the twelfth century describes a golden bowl decorated "in the habitual manner" with Manuel I pursuing the defeated king of the Persians and an innumerable host of Seljuks.[100] At the end of the twelfth century the courtier and rhetorician John Kamateros, in a speech addressed to Andronikos I, spoke about a "custom that existed in the society of Rhomaioi [Kamateros admitted that he did not know whether such a law had been accepted by any other people] according to which defeated barbarians, cities bringing their tribute, and hunting motives were presented not only in public places but even on the emperors' crowns." Kamateros understood that all these scenes were meant to glorify the ruler (*Fontes* 2: 244.21–245.107). Again, on the ivory casket at Troyes, dating probably to the eleventh century, the armed *basileus* is represented as victorious over his enemies; on other sides he is depicted in a boar-and-lion hunt.[101] Similar images are found on silver vessels.[102] The effigy of the emperor in military dress also appears on coins, first in the mid-eleventh century. Constantine IX produced *miliaresia* with the emperor in armor on the reverse, holding a cross in his right hand and his left hand on the hilt of his sheathed sword. The gold coins of Isaac I (1057–59) reveal an even more radical break with the traditional imperial image: the emperor

98. J. Lassus, *L'illustration du Livre des Rois* (Paris, 1973), fig. 25 (fol. 15v), fig. 83 (fol. 44), fig. 99 (fol. 89v), fig. 101 (fol. 95); Cirac Estopañan, *Skyllitzes Matritensis*, fols. 10v, 230.

99. H. Peirce and R. Tyler, "A Marble Emperor-Roundel of the XIIth Century," *DOP* 2 (1941), 3–9.

100. S. Lampros, "Ho Markianos Kodix 524," *Neos Hellenomnemon* 8 (1911), 172, translated into English by C. Mango, *The Art of the Byzantine Empire* (Englewood Cliffs, N.J., 1972), 228.

101. W. F. Volbach, "Profane Silber- und Elfenbeinarbeiten aus Byzanz," *Actes du XIVᵉ Congrès international d'études byzantines* 1 (Bucharest, 1974), 367f.

102. Darkevič, *Svetskoe iskusstvo Vizantii*, 139–54. The ethnic origin of some of the silver bowls published by Darkevič still remains a matter of dispute.

was presented grasping the scabbard with his left hand and holding a sword against his shoulder with his right.[103] Just this type of image prompted contemporaries to accuse Isaac of suggesting through his coinage that he obtained his authority not from God, but through the sword (Attal. 60.3–4 and especially Skyl. Cont. 103.3–4); such censures no doubt contributed to the suppression of the martial effigy of the emperor on coins of the twelfth century. The Comnenian emperors, however, continued to indicate their military concerns on their currency.[104] Instead of utilizing military portraits, the Comneni depended on the depiction of the great military saints. Alexios I introduced St. Demetrios, John II used St. George, Manuel I employed St. Theodore.[105]

The new fascination with the military image was not limited to the emperor and the aristocracy. John Mauropous testifies to the existence of a non-aristocratic cult of St. Theodore in Euchaita, where Mauropous served as metropolitan. He explained that Euchaita's Theodore was distinct from another, one mounted on horseback; he was a common recruit, not a general. As this saint was not an arrogant figure, "the poor, the common, and the infantrymen" came from all around to pay their tribute to him.[106] In small provincial chapels as well as in metropolitan foundations, military saints gained prominence. In Cappadocia in the eleventh century the pious scratched their prayers more often on images of holy knights than on any others, with the exception of representations of Christ or the Virgin. Portraits of the great early Christian martyrs continued to be conspicuously positioned in the heavenly hierarchy of saints, but now representations of them as knights on horseback became increasingly common. In the small Church of Asinou in Cyprus (Fig. 27), the late-twelfth-century image of the magnificently mounted St. George, with his splendid shield and cloak, dominates the interior of the narthex. This pictorial interest in chivalric ideals has a literary parallel in the romantic epic.

103. P. Grierson, *Catalogue of the Byzantine Coins in the Dumbarton Oaks Collection*, vol. 3, no. 2 (Washington, D.C., 1973), pl. LIX, nos. 7a1–7b3; pl. LXIII, no. 1,2-2-5. On coin no. 3,2-3, Isaac I is represented with a sword and a civil *insignium*, the *sphaira*.

104. The effigy of an emperor in a military caftan with a sword and a cross appears sometimes on the coins of Alexios I: M. Hendy, *Coinage and Money in the Byzantine Empire, 1081–1261* (Washington, D.C., 1969), 2, no. 13.

105. M. Hendy, *Coinage*, 437.

106. John Mauropous, "Quae in codice Vaticano graeco 676 supersunt," ed. P. de Lagarde, *Abhandlungen der historisch-philologischen Klasse der königlichen Gesellschaft der Wissenschaften zu Göttingen* 28, no. 1 (1881 [1882]), 208.17–28.

EPITOME OF ARISTOCRACY: DIGENIS AKRITAS

One of the most important literary productions of this period is a chivalric epic, *Digenis Akritas*. Summarizing the aspirations of the aristocracy in its narrative detail, it attested the appeal of the military nobility by its widespread, long-lasting popularity. The origins of the work are not fully understood. According to Beck, the epic consists of two quite separate parts: the song of the Arab emir Musur and the romance of Digenis.[107] The song of the emir, created just before 944, preserves evidence of the historical situation on the eastern frontiers of the empire at the beginning of the tenth century. The romance of Digenis is, in all probability, a product of the eleventh or twelfth century.

The romance provides a special insight into the mentality of the Byzantine military aristocracy. The hero, Digenis (literally, "of twofold origin"), was the offspring of the Arab emir of the song and a Christian noblewoman. By the age of twelve he displayed the skill and bravery of an experienced hunter, rather on the model of the young David. He contended successfully not only with nature, but also with brigands and robbers. In all, Digenis precociously certified his noble birth through noble actions. Digenis proved his manhood by winning an aristocratic wife worthy of himself against great odds, overcoming virtually invincible foes in great battles. Even his moral weaknesses, a violent temper and lust for a forsaken maiden or for a beautiful Amazon adversary, bespoke the nobility of his nature (exs. 21–22).

Through his spectacular acts and virile reputation, Digenis attracted the attention of the emperor. Just as in earlier centuries the Byzantine *basileus* would be moved by the sanctity of a famous holy man to visit him, so now the ruler came to Digenis because of the hero's aristocratic valor and virtue. Again, Digenis took the place of the ascetic prophet by lecturing the emperor on imperial duties. The banality of these instructions—to love his subjects, pity the poor, deliver from injustice the oppressed, and scatter the heretics—is less important than the relationship that this didactic episode implies: the aristocracy had established its power relative to the throne. Digenis, furthermore, received appropriately aristocratic recompense for the military services he promised his lord: he was given status in the form of entitlements, economic security in the form of hereditary land tenure, and power in the form of control over the frontiers.[108]

107. H. G. Beck, *Geschichte*, 71. Also see N. Oikonomidès, "L'´Épopée' de Digénis et la frontière orientale de Byzance aux Xᵉ et XIᵉ siècles," *TM* 7 (1979), 377.
 108. E. Trapp, "Hatte das Digenisepos ursprünglich eine antikaiserliche

The epic equally contains the clearest literary vision of the ideal of aristocratic leisure: Digenis's palace provided a life of physical and cultural refinement (Ex. 23). The four-squared mansion of ashlar was embellished with stately columns, the ceiling was adorned with mosaics, the pavement was bright with inlaid pebbles. The palace had a chapel dedicated, naturally, to a warrior saint, St. Theodore. The setting is reminiscent of the suburban estate of Blachernae enlarged and redecorated under the Comneni, a luxurious, fortified pleasure palace whose delights particularly fascinated the Crusaders (exs. 19–20). This move of the Comnenian emperors from the old Great Palace in the heart of the city to a new, semi-rural castle-villa accorded with the radical social change wrought by the dynasty. In the same sort of paradisial environment, Digenis plays the cithara and Eudokia, his wife, sings more sweetly than nightingales and Sirens, or dances on a silk carpet. These literary images are strikingly similar to the representations of courtly pleasures on twelfth-century silver vessels discovered in Berezovo and in other Russian sites. Among the reliefs is one showing acrobats, musicians, and dancers enframing the portrait of an empress.[109] Such festivity is brought to mind, too, by the enamel dancers accompanying Constantine IX and the empresses Zoe and Theodora on the crown now in Budapest (Fig. 28). Grabar considers the images on the so-called crown of Hungary unique in Byzantium and turns to Moslem art for parallels.[110] Considering not only the Berezovo vessel, but also Byzantine secular material that, though lost, is alluded to in literary sources, we may suppose these enamel scenes from court life were probably not so unusual as has been assumed. Digenis's pastimes were archetypally aristocratic: feasting, hunting, and, more unusually, bathing in his garden pool pavilion, all in the company of his noble friends. Digenis's demise was soon followed by that of his faithful spouse. The couple was mourned by their friends and their wealth was piously distributed to the poor; they were buried in

Tendenz?" *Byzantina* 3 (1971), 203–11, questions the anti-imperial tendency of the epic. In contrast, A. Pertusi, "Tra storia e leggenda: akrítai e ghazi sulla frontiera orientale di Bisanzio," *Actes du XIV^e Congrès international d'études byzantines* 1 (Bucharest, 1974), 263–67, assumes that the hero of the epic was critical of imperial power.

109. Darkevič, *Svetskoe iskusstvo Vizantii*, 159–87. The figures of actors and dancers are also found on ivory caskets. The assumption that all these images were copied from oriental sources seems unnecessary; e.g., Volbach, "Profane Silber- und Elfenbeinarbeiten," 368.

110. A. Grabar, "Les succès des arts orientaux à la cour byzantine sous les Macédoniens," *Münchner Jahrbuch der bildenden Kunst* 2 (1951), 42–47.

a great porphyry tomb—the stone was usually reserved for the imperial family—that could be seen for miles around. Even in death, Digenis epitomized aristocratic aspirations.

The reemergence of urban life, with its attendant revival of the provinces in Byzantium during the eleventh and twelfth centuries, contributed to the decentralizing tendencies of the state. This is reflected in the culture by the introduction of popular elements, especially in art, literature, and communal pastimes. Concurrently, with the shift toward feudalization, the status of the bureaucracy of the centralized state declined. The virtues of the new military aristocracy became socially dominant, permeating even the image of the emperor.

· IV ·

THE PURSUIT OF KNOWLEDGE

The Byzantine attitude toward learning can best be appreciated not through comparison with antiquity, but through the contrasts between the East and the West noted by contemporary writers. Latin authors dwelt on the Byzantines' heretical opinions and on their lack of martial prowess.[1] While the Greeks disdained Westerners for their barbaric habits and ignorance, they were equally annoyed by the Latins' contempt for the cultural achievements of the Rhomaioi. Niketas Choniates complained, "They ridicule us as scribes and scriveners, who ostentatiously carry reed pens and inkwells, and hold books in their hands" (Nik. Chon. 594.90–91). Choniates remarked bitterly that the Norman general Alduin mocked Emperor Isaac for having secluded himself from the heat of battle and dedicating himself to "the smoke of letters" (an allusion to Euripides, *Hippolytos* 954) and for having spent his youth visiting his teachers and training his hands in the use of the pen and the writing tablet. The only blows he suffered were those of his professor's cudgel; none came from struggles with warriors (365.70–77). It would seem that literacy was more common among Byzantines than among Westerners, although literacy was much reduced in the empire during the seventh and eighth centuries. The revival of urban life around 1000, however, provided considerable stimulus for the development of the Byzantine educational system and for the spread of knowledge.

1. A. D. V. den Brincken, *Die "Nationes Christianorum Orientalium" in Verständnis der lateinischen Historiographie* (Cologne and Vienna, 1973), 30–76, esp. 51.

THE EDUCATIONAL SYSTEM

ACADEMIC INSTITUTIONS

The organization and program of elementary and secondary educa-
tion was not radically transformed in Byzantium during the eleventh
and twelfth centuries. The curriculum remained essentially unchanged:
its foundations were grammar and rhetoric; its goal was the mastery
of the Hellenistic Greek language (*koine*) and the classics. As earlier,
schooling remained in the hands of private teachers, and lessons, al-
though sometimes free, took place in the teacher's house. Some general
structure may have been self-imposed.[2] Students and teachers in Con-
stantinople seem to have formed guildlike associations that established
particular norms of behavior and celebrated special feasts; the proces-
sion of costumed students described by Christopher of Mytilene was
held on such an occasion (see Chapter 3). State involvement in basic edu-
cation was minimal. Alexios I founded a Constantinopolitan orphanage
in which provision for the children's education was made, but such un-
dertakings were rare.[3] There was, however, one important development
within the lower schools—Constantinople's monopoly on secondary edu-
cation does seem to have been eroded during the eleventh and twelfth
centuries by the general economic and cultural resurgence in the prov-
inces. In any case, the private school directed by Eustathios in Thessalo-
niki was so popular that pupils were sent there even from the capital
(Eust. *Opusc.* 66.26–27).

While primary and secondary schooling remained somewhat static,
the introduction of institutions of higher learning was a fundamental in-
novation in the educational system. Recent investigations have shown
as improbable the widely held opinion that already in the ninth and
tenth centuries an imperial university and patriarchal academy existed
in Byzantium.[4] In fact, it was only in 1046–47 that a small, private law

2. P. Speck, *Die kaiserliche Universität von Konstantinopel* (Munich, 1974),
36–50.

3. D. J. Constantelos, *Byzantine Philanthropy and Social Welfare* (New Bruns-
wick, N.J., 1968), 244f.

4. H. G. Beck, "Bildung und Theologie im frühmittelalterlichen Byzanz,"
Polychronion. Festschrift Franz Dölger, ed. P. Wirth (Heidelberg, 1966), 69–81 (re-
published in his *Ideen und Realitäten in Byzanz*, part 3, [London, 1972]); P. Lemerle,
Le premier humanisme byzantin (Paris, 1971), 184f. For the traditional view on the
existence of the higher palace school in the ninth century, F. Dvornik, "Photius'
Career in Teaching and Diplomacy," *BS* 34 (1973), 211–18.

school in Constantinople was transformed into a state institution by an edict promulgated by Constantine IX and drafted, in all probability, by the scholar John Mauropous.[5] The initiative came from a circle of intellectuals associated with Constantine Leichoudes, who had temporarily gained the confidence of the emperor.

This "Museum of Legislation," created by Constantine IX, was conscientiously controlled by the state. It was directed by the "guard of the law" (*nomophylax*), a high official who was paid in gold, silk garments, and food. Life tenure supposedly came with the position, but in reality the director's job was precarious. Constantine IX's edict outlined the grounds for dismissal: ignorance, negligence, unsociability, and even disregard for the law itself. A pretext for discharging a *nomophylax* could be readily discovered in the unstable politics of Byzantine society. Concrete details of the institution's life are exasperatingly few. The school occupied the large building complex of the monastery of St. George of Mangana and possessed a special library. While its curriculum is not documented, the program of studies must have included, among other things, Roman law and Latin, as that language was required for the mastery of Roman legal terminology. There was no tuition. The legislator specifically prohibited the bribing of the *nomophylax* by students, although he regarded post-graduation donations as desirable and as having a certain ethical value in addition to contributing to the school's status. The institution's graduates received certificates testifying to their legal training as well as to their eloquence if they aspired to the bench or to their calligraphic skills if they chose a notarial career.

While a law school seems to have flourished in the eleventh century, the state of higher education in other disciplines is difficult to ascertain. Traditionally it has been thought that a philosophical department or school was also inaugurated by Constantine IX, but this has been questioned.[6] Nevertheless, some reform appears to have been made regard-

5. A. Salač, *Novella constitutio saec. XI medii* (Prague, 1954); E. Černousov, *Stranica iz kul'turnoj istorii Vizantii* (Kharkov, 1913); J. M. Hussey, *Church and Learning in the Byzantine Empire, 867–1185* (London, 1937), 51–72. Concerning the date, J. Lefort, "Rhétorique et politique: trois discours de Jean Mauropous en 1047," *TM* 6 (1976), 279f. On Mauropous, A. Karpozelos, *Symbole ste melete tou biou kai tou ergou tou Ioanne Mauropodos* (Ioannina, 1982).

6. G. Weiss, *Oströmische Beamte im Spiegel der Schriften des Michael Psellos* (Munich, 1973), 68–76. However, competition between law students and "the lovers of solemn knowledge" (students of philosophy and rhetoric) described by Psellos in his encomium on Xiphilinos indicates that contemporaries regarded both institutions as equal (Sathas, *MB* 4:433.4–6). Also see W. Wolska-Conus, "Les écoles de Psellos et de Xiphilin sous Constantin IX Monomaque," *TM* 6

ing this branch of knowledge; Constantine IX introduced the office of the consul (*hypatos*) of philosophers. This official's function was to supervise all state instruction in the capital. He was paid by the treasury and charged with the distribution of salaries to those teachers under his control. The administrative structure of the schools overseen by the *hypatos* of philosophers is not clear. The most important institutions of eleventh-century Constantinople were located in Chalkoprateia, in the churches of St. Peter, St. Theodore in Sphorakios, and the Forty Martyrs. It cannot be said, however, whether these schools were branches of a central theological or philosophical institution, or semi-independent bodies.

The eleventh century witnessed changes not only in institutions of higher education, but also in teaching techniques. Because intellectual activity in the tenth century was eclectic, education seems to have been somewhat impersonal; students were concerned with "objective" fact rather than with dynamic thought. But in the following century, as techniques of inquiry became increasingly emphasized, there was new scope for originality as well as for dialogue, debate, and demagoguery. Experiments were made in teaching grammar through prose and poetry composition exercises (the "new" schedography) instead of through simple memorization; such innovations were, however, widely criticized.[7] Instruction put more emphasis on discussion and on individual exercises, less on rote learning. Some sense of student-faculty interchange in the eleventh century can be gleaned from Psellos's writings. In a funeral speech for his mother, Psellos interjected a description of his own activity as a means not only of satisfying himself, but also of providing his audience an opportunity to sip from the cup of his knowledge. This knowledge included theory—Psellos probably meant theology—as well as history and literature. "I speak to some of my disciples about Homer, Menander, and Archilochos, about Orpheus and Mousaios, as well as women authors such as the Sibyllai, the poetess Sappho, Theano, and the wise lady of Egypt [perhaps Hypatia the mathematician]" (Sathas, *MB* 5:60.22–25). He explained to his students "the Trojan antiquities" and the meaning of words such as nectar or ambrosia used by ancient

(1976), 242f.; M. J. Kyriakis, "The University: Origin and Early Phases in Constantinople," *Byz.* 41 (1971), 170f.; P. Lemerle, *Cinq études sur le XI^e siècle byzantin* (Paris, 1977), 215–27.

 7. On schedography, R. Browning, "Il codice Marciano gr. XI.31 e la schedografia bizantina," in his *Studies on Byzantine History, Literature and Education* (London, 1977), part 16, 21–34. Also see A. Garzya, "Literarische und rhetorische Polemiken der Komenenenzeit," reprinted in his *Storia e interpretazione di testi bizantini* (London, 1974), part 7, 2–6.

writers. (In fact, a short treatise by Psellos on ancient, primarily Athe-
nian, legal terminology along with an odd reference to Origen has sur-
vived.[8]) The students urged him to tell them about the cure of the body
and about the diagnosis of ailments, Psellos continued; some even
dragged him "not by dint of words, but with their hands, to Italian
wisdom." This was not "Pythagorean philosophy, but the discipline that
contributed to the common weal and dealt with private and state *ac-
tiones*, with argumentation in court, with slavery and freedom, with
legal and illegal marriages, and with gifts and the profits derived there-
from, with the degrees of relationship, and with wills made by soldiers
and lay persons" (Sathas, *MB* 5:61.7–18). To this long list of the subjects
he taught, Psellos added Greek mythology and its allegorical interpreta-
tion. Finally he proclaimed, without any of the traditional scruples of
medieval modesty, that his students "pull me and they tear me into
pieces, since they love only my tongue and my soul, whose knowledge
surpassed that of other professors" (5:62.2–5). Psellos clearly enjoyed
his role in the intellectual limelight. "I am prepared to answer all your
questions," Psellos told his students, "and I have opened doors to the
sciences and all the arts."[9] He listed himself among those who embel-
lished Constantinople with scholarship and radiated the glory of educa-
tion over the whole *oikoumene* (Sathas, *MB* 5:491.26–27, 492.1–8; also
see 256.2–4). He was proud that the emperor counted him among the
most knowledgeable masters of both philosophy and rhetoric.[10]

The real relationship between students and their professors was by
no means as ideal as Psellos intimated in his mother's funeral oration.
Psellos himself gave a very different view of academia in a series of short
literary sketches. In these he presented his audience as an idle and un-
grateful crowd that played truant whenever possible. "I neglect every-
thing and dedicate myself completely to my care about you," Psellos ad-
monished his students. "I am vigilant until the small hours, prolonging
my day with my books, again and again—this is my habit. I read not to
have some profit for myself, but in order to collect from my volumes
some ideas to enrich your mind." And what was the reward for such dili-

8. R. Anastasi, "Sugli scritti giuridici di Psellos," *Siculorum Gymnasium* 28
(1975), 169–91.

9. The discourse *To Students Who Did Not Come to School Because It Was Rain-
ing*, ed. M. J. Kyriakis, "Student Life in Eleventh-Century Constantinople," *By-
zantina* 7 (1975), 383.72–74.

10. Sathas, *MB* 5: 417.25–27. About Psellos as a teacher, see P. V. Bezo-
brazov, *Vizantijskij pisatel' i gosudarstvennyj dejatel' Michail Psell* (Moscow, 1890),
122–81; Lemerle, *Cinq études*, 212–21.

gence? If it rained, the hall was empty. Whereas earlier students of philosophy had had to travel from Europe to Asia for the fruit of scholarship—if they sought philosophical wisdom they had to go to Egypt and for astronomical knowledge they went to Chaldea—his audience was lucky enough to possess in him the center of the universe, "the second ether." But nonetheless, they were stopped by any condensation in the air, by the appearance of clouds, or even by too hot a sun! The students came late, and they thought less of their studies than of the Hippodrome, the stage, or money. "If you should go to any other place, how fast are your legs, how efficient you are in squeezing in. . . . But if you decide to visit the *mouseion* you move like a caterpillar, utterly overburdened and with a confounded head. Your eyelids fall down and cover your eyes, as if they are contraptions of lead." [11]

The pleasures of an academic life were more wistfully expressed in Nicholas Mesarites' description of the school at the Church of the Holy Apostles, one of the best-known institutions in the city (Nic. Mesar. 916–18). A sense of well-being and beauty pervades his rendering of the trees, gardens, fountains, and porticos of the academy. But he seemed to take the greatest delight in the intellectual activities that were being pursued in this idyllic setting. Students of grammar, rhetoric, and logic roamed the porticos reading their notes, memorizing texts, or calculating on their fingers. Adults as well as youths met there to discuss scientific problems. Physicians also gathered to consider the nature of pulse or fever. Even church chants were taught in these halls. Mesarites compared the noise of discussion in the porticos to the sound of birds on a lakeshore. But disputes occurred here too. Evidently when a student or professor was incapable of proving his thesis by argument, he resorted to cursing. Unresolved arguments were settled by Patriarch John X Kamateros, who was presented by Mesarites as expert in grammar and physics. The church seems to have remained the ultimate judge.

The emphasis on debate in education and in intellectual discourse is alluded to in other sources. Psellos chastised two of his disciples for arguing: their disputes were too noisy; "Greek law and the rule of philosophers" required the tranquil and quiet deliberation of a problem. "Do not mimic the birds," he wrote, "to which Homer compared the Trojan camp." More significant is another of Psellos's statements: he called his students to peace, since they had a common task;[12] Lemerle suggests that this common task was polemics against another school of

11. Pseudo-Psellos, *De operatione daemonum*, ed. J. F. Boissonade (Nuremberg, 1838; reprint: Amsterdam, 1964), 143.9–26.
12. Pseudo-Psellos, *De operatione daemonum*, 131–35.

philosophy.[13] Anna Comnena commented that despite his bad grammar, John Italos could reduce his opponents to silence and despair through irrefutable discourse and powerful argument (An. C. 2:35.18–36.12). Moreover, according to Constantine Manasses, students participated in debating "contests" under the direction of a state dignitary (logothete) in the presence of the emperor.[14] Doubtless the internal dynamics of debate at least occasionally gave rise to arguments of dubious orthodoxy, whether religious or political; this exercise of the intellect too readily led its proponents into positions unacceptable to the controlling powers of church and state. A society whose stability depended on the omipotence of the emperor and, theoretically, of God, could not long tolerate training minds to question. The reaction of the *imperium* to the academy was ferocious, if not always consistent or successful.[15] It is best traced through the careers of academics.

ACADEMIC POLITICS

Michael Psellos was appointed the first *hypatos* of philosophers. The first *nomophylax* was John Xiphilinos. Both were young intellectuals from an urban milieu, Xiphilinos from Trebizond, Psellos from Constantinople. Psellos's relatives had thought to make him a tradesman, but his mother had insisted that after elementary school he continue his education. He studied with Mauropous—poet, rhetorician, and future metropolitan of Euchaita—as did Xiphilinos. With their appointment to high positions in the state bureaucracy they surpassed, in a professional sense, the achievement of their former master. In one of his letters, Mauropous disclosed both his respect for his former pupils and his bitterness over their career success. He recalled their lofty ideals and sharp wit, their love of beauty and respect for scholarship. But while he promised them his continued support and collaboration, Mauropous accused Psellos of neglecting their friendship after seizing the professorial throne (Sathas, *MB* 5:15).[16]

The prestige engendered by these positions was enjoyed by Psellos and Xiphilinos for but a short period. Around 1050 a certain Ophrydas

13. Lemerle, *Cinq études*, 216.

14. K. Horna, "Eine unedierte Rede des Konstantin Manasses," *Wiener Studien* 28 (1906), 181.264–65.

15. R. Browning, "Enlightenment and Repression in Byzantium in the Eleventh and Twelfth Centuries," *Past and Present* 69 (1975), 10, reprinted in his *Studies on Byzantine History*, part 15.

16. Weiss, *Oströmische Beamte*, 70f., dates the letter to before 1042, but in all probability it was written later: Ja. N. Ljubarskij, *Michail Psell. Ličnost' i tvorčestvo* (Moscow, 1978), 43f.

brought charges of heresy against Xiphilinos. Psellos immediately went to his colleague's defense, contrasting Xiphilinos, the man of education, an expert in grammar, poetry, rhetoric, and law, with the ignorant Ophrydas, who "moved his tongue like a millstone" (Sathas, *MB* 5: 185.15). But the intellectuals lost. First Xiphilinos and then Psellos was forced to adopt the monastic habit. While the former *nomophylax* accepted vows without resistance and eventually became patriarch, Psellos submitted only unwillingly to tonsure, remaining uncommitted to the spiritual life. At the first opportunity he returned to court to become the tutor of the future emperor Michael VII.

This incident reflects the fragility of the higher educational structures in Constantinople. The offices of *nomophylax* and *hypatos* of philosophers had little autonomy; the insecurity of these positions was aggravated by an inherent, if sometimes only latent, antagonism between intellectuals and the theocentric monarchy. These intrinsic tensions were revealed at the end of the eleventh century, after the military aristocracy led by the Comneni seized imperial power. At that time, John Italos occupied the office of *hypatos* of philosophers, having been appointed under the Doukas dynasty. Among his pupils were representatives of the highest echelons of Constantinopolitan officialdom, including Serblias, Solomon, and others. Anna Comnena described John as a short, sturdy man with a broad chest and a large head (Ex. 24). He wore a rounded beard; his flaring nostrils revealed a fierce temper; he argued with his fists as well as with his words.[17] Born in Italy, Italos had a pronounced Latin accent; his failure to master the Greek idiom was to the culturally biased Constantinopolitans a mark of vulgarity. But while he stumbled over grammar, having not "sipped the nectar" of rhetoric, he had no equal in philosophy and dialectic. Despite, or rather because of, his mental acuity, Italos in his turn was brought before the ecclesiastical tribunal, condemned, and anathematized.

This took place in 1082, just after the Comneni ascended to power, and marked a basic shift in attitude toward higher education that may well have been related to the changed priorities of the new ruling clique. The educational innovations of Constantine IX had furthered the interests of the urban upper class of Constantinople; the purpose of these new institutions had been to train a bureaucratic elite for state and eccle-

17. An. C. 2:33–37; P. Stephanou, *Jean Italos, philosophe et humaniste* (Rome, 1949); P. Joannou, *Die Illuminationslehre des Michael Psellos und Joannes Italos* (Ettal, 1956), 9–31; R. Browning, "Enlightenment and Repression," 11–15; J. Gouillard, "La religion des philosophes," *TM* 6 (1976), 306–15; L. Clucas, *The Trial of John Italos and the Crisis of Intellectual Values in Byzantium* (Munich, 1981).

siastical administration. But with the military aristocracy's rise to power, these schools lost what little support they had had. Italos was succeeded by Theodore of Smyrna, but soon after the office of *hypatos* of philosophers was suppressed altogether. John Italos's condemnation seems to have been a part of Alexios I's program to put education more firmly under church control. To this end he introduced three new ecclesiastical offices: teacher (*didaskalos*) of the Gospels, teacher of the Apostle, and teacher of the Psalter. The church was entrusted not only with the guidance of Constantinopolitan intellectuals but also, according to Alexios's edict of 1107, with their "protection." The *didaskaloi* were, in fact, commissioned to inform the patriarch of any heretical or treasonous idea being publicly expressed, so that secular authorities might intervene if necessary.[18]

These three *didaskaloi* of the Church of St. Sophia formed a special board within the ecclesiastical hierarchy and were subject to the patriarch. Classes were held in several schools, including some, like that at the Chalkoprateia and in the Church of St. Peter, that had been in use in the eleventh century. The *didaskaloi* lectured their students primarily on the Psalms, the Gospels, and Paul's Epistles. They did not, however, ignore the teaching of secular sciences. Michael Italikos, who was one of the most popular instructors in Constantinople during the second quarter of the twelfth century, held in turn the posts of *didaskalos* of the Psalter, *didaskalos* of the Apostle, and finally *didaskalos* of the Gospels, or "universal teacher." But Italikos's interests were not limited to the exegesis of the Holy Scriptures; Italikos taught rhetoric and philosophy, mathematics, and related disciplines. He was devoted, in his own words, to "the material essence," as expressed in mechanics, optics, catoptrics (the study of the refraction of light from mirror surfaces), metrics, gravitational theory, and medicine.[19] Indeed, many literati and scholars in the twelfth century were patriarchal *didaskaloi*, among them Eustathios of Thessaloniki, Nikephoros Basilakes, Michael the Rhetor, and Nikephoros Chrysoberges.

Rhetoric also continued to be part of the curriculum of higher education. For the purpose of rhetorical training, the emperor appointed a master of rhetoric. The man holding this position was a secular official and member of the senate who acted as a court representative to the patriarchal school. Among his official obligations were biannual public ap-

18. J. Darrouzès, *Recherches sur les* ophphikia *de l'Église byzantine* (Paris, 1970), 72–75; I. S. Čičurov, "Novye rukopisnye svedenija o vizantijskom obrazovanii," *VV* 31 (1971), 241.

19. P. Gautier in Mich. Ital. 16–26.

pearances: at the Feast of Lights (Epiphany) on January 6, he presented an encomium on the *basileus* and on Lazarus's Saturday he eulogized the patriarch (exs. 25–26). These public presentations were important vehicles of state propaganda. Like the preambles of imperial chrysobulls, they displayed the official conception of the *imperium*; in them were offered images of the ideal emperor. The ruler's policies were vindicated and his victories, real or imaginary, over his enemies, domestic or foreign, were duly praised.

Despite the extended jurisdiction of the church, tensions continued between the state and the intellectuals. The patriarchal school, like the educational apparatus before it, spawned heresy. In 1156, Michael the Rhetor, master of rhetoric, and Nikephoros Basilakes, *didaskalos* of the Apostle, were accused of heresy, discharged, and banished.[20] Another tack was tried: the office of *hypatos* of philosophers was revived shortly after the scandal, but it was held by a clergyman. In the mid-sixties, Michael, the nephew (?) of the metropolitan of Anchialos and himself previously a high ecclesiastical dignitary, was appointed to the post. In his inaugural address, Michael stated that his primary task was not the teaching of philosophy, but the suppression of rationalist ideas;[21] this was the purpose for which the office of *hypatos* of philosophers, after a long vacancy, had again been occupied. Michael built a splendid career on this platform; in 1170 he ascended the patriarchal throne.

Constantinople was an important focus of intellectual activity at the end of the twelfth century. Even in the West it was regarded as a considerable center of university life. The sorcerer and poet Klingsor, a hero of the *Wartburg War*, a poem written in Germany around 1300, mentioned the Byzantine capital along with Paris and Baghdad as an educational nexus.[22] His description referred to Constantinople before the Latin Conquest of 1204. It cannot be said, however, that even then the city's system of higher schools was a university in the Western sense of the word, that is, a free, self-governing corporation. Its private teachers were supervised by the church and state.[23] The schools were expected to

20. J. Lefort, "Prooimion de Michel neveu de l'archevêque de Thessalonique, didascale de l'Evangile," *TM* 4 (1970), 376; A. Garzya, "Un lettré du milieu du XIIᵉ siècle: Nicéphore Basilakès," *Storia e interpretazione*, part 8, 613–15.

21. R. Browning, "A New Source of Byzantine-Hungarian Relations in the Twelfth Century," *Balkan Studies* 2 (1961), 189.69–84; reprinted in his *Studies on Byzantine History*, part 4.

22. *Der Wartburgkrieg*, ed. K. Simrock (Stuttgart, 1858), 131, no. 102.

23. Weiss, *Oströmische Beamte*, 72, is certainly correct in stressing that the modern distinction between public and private teacher cannot be applied to eleventh-century Byzantium.

propagate official ideology, police the loyalty of the population, and pro-
duce efficient lawyers, administrators, and bureaucrats (Ex. 27). Further-
more the schools were bound to an entrenched curriculum burdened
with archaic textbooks and a dead language. The system was further
weakened by its structural instability. Schools were created, then closed;
professorial chairs were established, eliminated, then reestablished; lec-
tures were transferred from one place to another. Despite these many
impediments, the higher schools remained centers of some ideological
diversity. The concentration of intellectuals, both professors and ardent,
meddlesome student youth, the increased interest in the natural sci-
ences, particularly mechanics, optics, and medicine, and the introduc-
tion of debate as an important vehicle of education all contributed to the
growth of heterodoxy in Byzantium.

INTELLECTUALS IN SOCIETY

The Byzantine intelligentsia in the eleventh and twelfth centuries
formed a particular social stratum associated with the higher schools as
well as with scholarly and literary circles outside academia. It is com-
monly thought that a homogeneous group of intellectuals closely con-
nected with the ruling class of the empire always existed in Byzantium.[24]
But this assumption of ubiquitous uniformity must disappear when the
intellectual circles of different periods are compared. As mentioned ear-
lier, at the beginning of the ninth century monastic figures like The-
ophanes or Theodore of the Studios—both of whom, like many of their
contemporaries, were from their youth active in the monastic move-
ment—dominated the literary life of the Byzantine Empire. From the
middle of the ninth century, however, a new intellectual type prevailed;
these men were for the most part laymen, though some eventually took
places within the ecclesiastical hierarchy. Even the hagiographic com-
pilations of the tenth century were produced primarily by secular au-
thors. From the end of the ninth and the beginning of the tenth century,
the ruling elite was intimately involved in intellectual affairs. Among the
most distinguished writers of this period were two emperors, two lay
administrators who eventually occupied the patriarchal throne, a series
of high-ranking dignitaries, several bishops, deacons, and, with the
single exception of George Hamartolos, no monks at all.

The literati of the eleventh century were still part and parcel of the
ruling group. Only in the late eleventh and in the twelfth century did the

24. H. G. Beck, *Das literarische Schaffen der Byzantiner* (Vienna, 1974), 12f.;
Das byzantinische Jahrtausend (Munich, 1978), 123; see objections in A. Kazhdan,
"Der Mensch in der byzantinischen Literaturgeschichte," *JÖB* 28 (1979), 12f.

literati begin to emerge as a separate professional stratum. Their profession was certainly neither a secure nor necessarily a financially rewarding one, as is shown in the commonplace contrast in twelfth-century literature of the starving intellectual (*sophos*) and the well-to-do leatherworker, stonemason, or similar craftsman. Prodromos, for example, in a poem addressed to Princess Anna Doukaina, openly envied the security of a shoemaker or shepherd:

> O my queen, how desirable is for me the profession of craftsman that would provide me with sufficient means to exist. I wish I could cut hides into hairy portions and make good boots for my own feet. I wish I could be the keeper of a rich herd or milk numerous kine; by so doing I would be satiated with cream and tasty meat.[25]

"Poor" professionals like Theodore Prodromos and John Tzetzes in fact earned their living by flattering powerful patrons. There were also the successful teachers of the higher schools whose activities were frequently rewarded by appointment to positions within the church hierarchy. Michael Italikos, who became the metropolitan of Philippopolis, and Eustathios, who was appointed to the archiepiscopate of Thessaloniki, were among the many intellectuals given ecclesiastical appointments. These men recognized the insecurity of their position, as is perhaps best seen in Eustathios's letter to Patriarch Michael III, in which the talented publicist acknowledged his dependence on the rain of favors poured upon him by his generous benefactor.[26]

Despite the precariousness of their positions, Byzantine intellectuals by no means led an unpleasant life. They formed close-knit circles on the periphery of the higher schools or of the court. One such clique, including Mauropous, Psellos, John Xiphilinos, and Constantine Leichoudes, had a considerable impact on the development of the Byzantine educational system. Despite their differences in temperament and their occasional disagreements, Psellos, Mauropous, and Leichoudes continued to share the same opinions; only Xiphilinos abandoned his youthful views and became the ideological opponent of his former friends. Psellos's correspondence mentions another circle of intellectuals, composed of high-ranking dignitaries such as Choirosphaktes, Aristenos, and others, who were united "by their zeal for wisdom and reason" (Sathas, *MB* 5:452.18–19). The members of this circle represented a second generation of intellectuals, for whom Psellos was a master. Members of the highest nobility, such as the *caesar* John Doukas or the nephews of Pa-

25. *Hist. Ged.* no. 83.68–74. Also see *Poèmes prodr.* 76.70–77.

26. P. Wirth, "Zur Biographie des Eustathios von Thessalonike," *Byz.* 36 (1966), 262–82. Now in his *Eustathiana* (Amsterdam, 1980), 11–33.

triarch Keroullarios, were also acquainted with Psellos through their love of science. During the twelfth century, various literati would associate with literary patrons, especially noblewomen, to whom they dedicated their poetic and scholarly works. In this milieu friendship (*philia*) became a social ideal.

The new appreciation of friendship contrasts with the ambiguity, distance, and even suspicion with which associates were regarded by Kekaumenos or in monastic literature. Psellos was a prime example of this new attitude toward *philia*: his correspondence was full of expressions of care for his friends.[27] In a letter addressed to the theme judge of Thrakesion, he wrote with a tinge of humor: "You know that many are pestering me with their petitions. I cannot guess why: either because everyone likes me or because I love everyone" (*Scripta min.* 2:153.8–10). In contrast, Patriarch Keroullarios did not like anybody—not his relatives, those who had lived with him, his neighbors, nor even those who felt great respect toward him (*Scripta min.* 1:318.8–14). Friendship, furthermore, had its code of behavior. Psellos complained in a letter to Aristenos: "Where are the great features of our mutual friendship and kind disposition—the respectful treatment, the clasping of hands, the kisses on the face, on the breast, and on the hands and even . . . but not a syllable, not a sound more about that" (2:173f.). Psellos was by no means the only scholar to express his feelings for the intellectual community of which he was a part. Michael Italikos exuded satisfaction in a letter to a younger colleague, his "golden nephew," inviting him to the "intellectual feast" he arranged daily for his friends. There he served them philosophical venison, physiological hare, Median peacock, odic partridge, and musical swan—courses untasted by either the inhabitants of Sybaris or by Aristippus, the most effeminate of philosophers. Pythagorases and Platos served as cupbearers, Aristotle and all the Peripatetics were the chief cooks, and members of the ancient and new academies waited upon the guests. For dessert Michael promised the extravagances of the Stoics and Pyrrhon's Skepticism (Mich. Ital. 156–58). Even more poignantly, Gregory Antiochos, who studied under Nicholas Kataphloron (d. 1160), a master of rhetoric, as well as with Kataphloron's successor, Nicholas Hagiotheodorites, remembered the years of his education as a sojourn in a sweet orchard, filled with wonderful trees of knowledge. Consuming the fruit of this paradise, he imbibed knowledge and wisdom. He shared these pleasures with his friends, Euthymios Malakes,

27. F. Tinnefeld, "'Freundschaft' in den Briefen des Michael Psellos. Theorie und Wirklichkeit," *JÖB* 22 (1973), 151–68; Ljubarskij, *Michail Psell*, 117–22.

Michael Choniates, and Eustathios of Thessaloniki, the nephew of Nicholas Kataphloron. Gregory left this garden of delights—books and scholarly discourse—for imperial service, but lamented his destiny in his letters to Eustathios: "You dwell in heaven, while I must crawl on earth."[28]

THE ASSIMILATION OF
THE CLASSICAL TRADITION

BYZANTIUM AND THE AUTHORS OF ANTIQUITY

The emergence of a class of professional intellectuals was also related to a new attitude toward Byzantium's classical inheritance. As discussed in Chapter 1, the tenth century can be called encyclopedic for its reference works, lexicons, and florilegia. This was a time of concern for the maintenance of the classical tradition,[29] and the transmission of texts became exceedingly important. The *Bibliotheke* of Photios marked the beginning of this period; other compilations included Kephalas's *Anthology*, Daphnopates' collection of John Chrysostom's fragments, the *Geoponika*, an agricultural manual derived from antiquity, and the *Souda*, a dictionary of sorts. Epitomatory activity thrived in Constantine Porphyrogenitus's intellectual milieu. Once collected, texts were recopied in minuscule script; thus ancient works were preserved.[30] But concern with the collection and transmission of classical culture does not necessarily imply a Byzantine mastery of the ancient heritage. This seems to have followed only later, in the eleventh and twelfth centuries.

The course of the Byzantines' understanding of the classics has not yet been completely traced. Nevertheless, its main features are identified

28. Escor. Y-II-10, fol. 402; quoted, A. P. Kazhdan, "Grigorij Antioch," *VV* 26 (1965), 80.

29. See Lemerle, *Le premier humanisme*, 267–300, esp. 299f., on the limitations of tenth-century encyclopedism. See also N. G. Wilson, *Scholars of Byzantium* (Baltimore, 1983), 89–147.

30. A. Dain, *Les manuscrits* (Paris, 1949), 122; "La transmission des textes littéraires classiques de Photius à Constantin Porphyrogénète," *DOP* 8 (1954), 41–46; *Les manuscrits*, 2d ed. (Paris, 1964), 126f.; J. Irigoin, *Histoire du texte de Pindare* (Paris, 1962), 123f.; "Survie du renouveau de la littérature antique à Constantinople (IXe siècle)," *Cahiers de civilisation médiévale* 5 (1962), 287–302; A. Diller, "The Age of Some Early Greek Classical Manuscripts," *Serta Turyniana* (Urbana, 1974), 524; G. Zuntz, *An Inquiry into the Transmission of the Plays of Euripides* (Cambridge, 1965), 262.

in Browning's study of the fate of Homer in Byzantium.[31] The oldest complete copy of the *Iliad* is dated to the beginning of the tenth century; that of the *Odyssey* to the mid-tenth century. The early manuscripts are usually accompanied by Hellenistic scholia or commentaries, which provided substance for the compilers of Byzantine lexicons in the tenth century. Original Byzantine exegesis on Homer began only in the eleventh century. Its foundations were laid by Niketas, the older contemporary of Psellos. Niketas sought to reveal the "secret beauty" of the epic by explaining its adventures as moral parables: Ares' binding became a symbol of reason's victory over passion; Odysseus's escape from Circe's island and his return to his homeland represent the mortal seeking the heavenly Jerusalem.

Homeric criticism became more profound and varied in the twelfth century.[32] Though Eustathios of Thessaloniki was familiar with ancient commentaries, now lost, his exegesis was often the fruit of his own consideration. He did not restrict himself to the interpretation of difficult words and grammatical constructions; rather he attempted to understand Homeric heros in terms of contemporary linguistic usage, ethnography, political institutions, and cultural life. Also included in his explanations of the text are popular folkloric elements—dwarfs in England (*Inglika*) who used arrows tiny as needles, inhabitants of Taurika, probably the Kievan Rus, who made wooden books out of boxes.[33] John Tzetzes' *Allegories* as well as his *Verses on the Theme of the Iliad* represent a further exploitation of Homeric material. Tzetzes, following ancient tradition, developed three types of allegory in his interpretation of Homeric epics. In his own words these three modes were elementary, psychological, and pragmatic.[34] Elementary (i.e., "connected with the elements") was the interpretation of mythological persons as physical forces, as cosmic and meteorological elements (e.g., Zeus as air or ether); psychological allegory involved the explanation of mythological persons as the forces or functions of the psyche (e.g., Zeus as reason); and the pragmatic or historical allegory presented the gods as men and women, as kings and queens, as villains and whores. But behind this scholarly game of learned classicism were some contemporary allusions. For in-

31. R. Browning, "Homer in Byzantium," *Viator* 6 (1975), 25f.

32. A. Vasilikopoulou-Ioannidou, *He anagennesis ton grammaton kata ton 12 aiona eis to Byzantion kai ho Homeros* (Athens, 1971–72).

33. Eustathios, *Commentarii ad Homeri Iliadem* 372.22–24, 632.52–61, ed. M. van der Valk, vol. 1 (Leiden, 1971), 588.24–26; vol. 2 (Leiden, 1976), 272.6–12.

34. H. Hunger, "Allegorische Mythendeutung in der Antike und bei Johannes Tzetzes," *JÖB* 3 (1954), 46.

stance, Paris-Alexander was described as a youth brought up according to the prescribed program for a Byzantine prince: riding, javelin throwing, archery, ball playing, "and all other training befitting an emperor." Most notably, the ancient hero was also described by Tzetzes as well versed in rhetoric and even as having authored a book.[35] More complicated is the passage in Tzetzes' *Allegories of the Odyssey* in which he identified the Cimmerians as a tribe living close to the Tauroscythians (Byzantine terminology for the Russians) and the Sea of Maeotis.[36] He insisted that they were ethnically closely related to the Italians. Further, they supposedly dwelt in a region where the sun never shone and where there was a strange lake, Siacha, in which even leaves would sink. This ethnographic detail was apparently very important to Tzetzes; he returned to it, even mentioning the fabulous lake, both in his *Histories* and in his *vita* of the Sicilian St. Lucia.[37] In light of the fact that Tzetzes was writing his *Allegories* during the period approximately between 1146–60, just at the time that the Normans built against the Byzantine Empire a broad alliance that included the prince of Kiev, his emphasis on historical Russo-Norman connections makes good political sense. It was not an arbitrary, arcane observation, but rather an explanation for a contemporary political reality. Thus both Eustathios and Tzetzes tried to interpret ancient writings in relation to their own times, modernizing the text to make it more easily understandable and extracting from it explanations of contemporary habits. These popularizations of Homer may also bespeak a wider literary audience for the classics.

The treatment of other classical texts developed similarly. The tragedies may have been available in the tenth century, but the Byzantines quoted them then only from the excerpts included in Stobaeus and other ancient florilegia, not from the originals.[38] In contrast, in the eleventh century a treatise on tragedy was written; furthermore, Euripides was attentively read by the indefatigable Psellos, perhaps for the first time since George Pisides at the beginning of the seventh century.[39] In the

35. P. Matranga, *Anecdota graeca* (Rome, 1850), 9.235–40.

36. H. Hunger, "Johannes Tzetzes, Allegorien zur Odysee Buch 1–12," *BZ* 49 (1956), 297f.

37. Tzetzes, *Hist.* 835–52; *Vita St. Luciae*, ed. A. Papadopoulos-Kerameus, *Varia Graeca sacra* (St. Petersburg, 1909), 82.

38. A. Tuilier, *Recherches critiques sur la tradition du texte d'Euripide* (Paris, 1968), 132.

39. R. Browning, "A Byzantine Treatise on Tragedy," *Acta Universitatis Carolinae philosophica et historica* 1 (1963), 67f., republished in his *Studies on Byzantine History*, part 11; A. Colonna, "Michaelis Pselli de Euripide et Georgio Pisida judicium," *Studi bizantini e neoellenici* 7 (1953), 16–21.

twelfth century the tragedians and Aristophanes were studied and commented upon by both Tzetzes and Eustathios. Plato was transcribed in the ninth century, but he was not studied until the eleventh, when Psellos read and popularized his work.[40] Aristotle's writings were published in Constantinople about 850, but through the tenth century they were referred to only incidentally.[41] From the eleventh century onward, however, serious commentators on Aristotle proliferated: George Aneponymos, Psellos, John Italos, Michael of Ephesus, Eustratios of Nicaea, Theodore Prodromos, and Tzetzes. Interest in Neoplatonism also revived at this time.[42]

There was a fundamental change in attitude toward ancient culture from the ninth to twelfth centuries. The corpus of classical literature was gathered and transcribed in the ninth and tenth centuries; in the eleventh and twelfth centuries, the process of assimilation and reflection began. But there are further distinctions to be made in the history of Byzantine classicism. Ninth- and tenth-century scholars studied classical texts with curiosity, but also with distance. They used pagan antiquity as a foil for their own times. That Byzantine writers strove for an objective distance from the past was shown in a criticism leveled by Arethas of Caesarea, a collector of ancient texts himself, at Choirosphaktes for ambiguously interweaving the myths of the Hellenic world with contemporary reality.[43] Even the biographer of Emperor Basil I, whether it was Constantine Porphyrogenitus himself or somebody else at court, consis-

40. M. Sicherl, "Platonismus und Textüberlieferung," *JÖB* 15 (1966), 202–5.

41. For a list of commentators on Aristotle, D. Harlfinger, *Die Textgeschichte der Pseudo-Aristotelischen Schrift Peri atomon grammon* (Amsterdam, 1971), 43f. Photios probably used Aristotle in the *Amphilochia*: Lemerle, *Le premier humanisme*, 201. Arethas evidently owned some of Aristotle's manuscripts: ibid., 217f. Also see P. H. Huby, "The Transmission of Aristotle's Writings and the Places Where Copies of His Works Existed," *Classica et mediaevalia* 30 (1969 [1974]), 241–57.

42. L. G. Westerink, "Exzerpte aus Proklos Enneaden-Kommentar bei Psellos," *BZ* 52 (1959), 9; M. Sicherl, "Michael Psellos und Jamblichos de mysteriis," *BZ* 53 (1960), 12, 18. On Proklos's tradition, see H. G. Beck, "Überlieferungsgeschichte der byzantinischen Literatur," *Geschichte der Textüberlieferung* 1 (Zurich, 1961), 457.

43. Arethas, *Scripta minora*, ed. L. G. Westerink, vol. 1 (Leipzig, 1968), 204f. According to Arethas, Homer's works are the products of a senile author (297, 342). In his letters Theodore Daphnopates, an author of the tenth century, used Greek mythology as a mine of allegories primarily for sexual pleasures: Theodore Daphnopates, *Correspondance* (Paris, 1978), nos. 12.16, 17.12, 18.6–8. In Niketas Magistros's letters, mythological figures populate a world quite distinct from that of humanity: Niketas Magistros, *Lettres d'un exilé* (Paris, 1973).

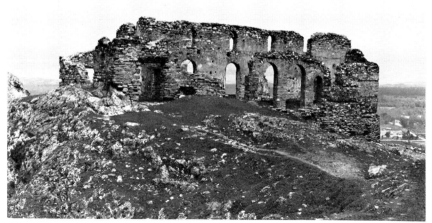

1. Servia, Metropolis, general view of the ruined basilica from the southwest, 11th c. (R. S. Cormack).

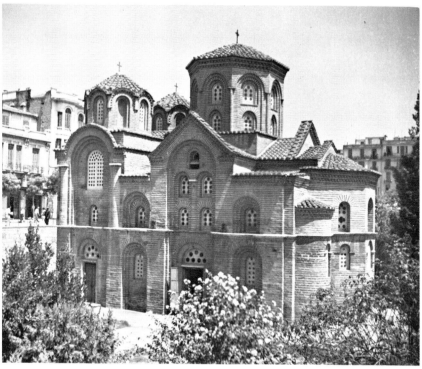

2. Thessaloniki, Panagia ton Chalkeon, general view from the south, 1028 (Dumbarton Oaks, Center for Byzantine Studies).

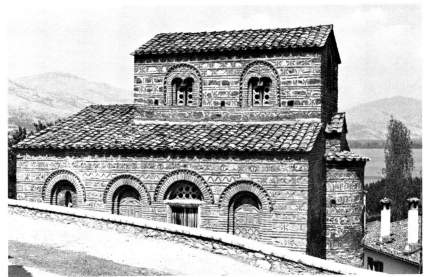

3. Kastoria, Anargyroi, general view of the exterior from the south, early 11th c. (author).

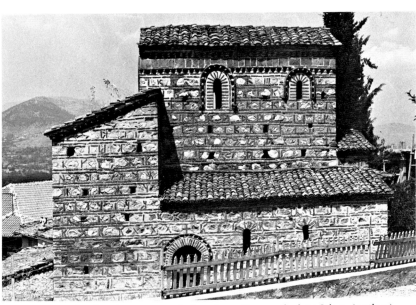

4. Kastoria, St. Stephen, general view from the south, late 9th c. (author).

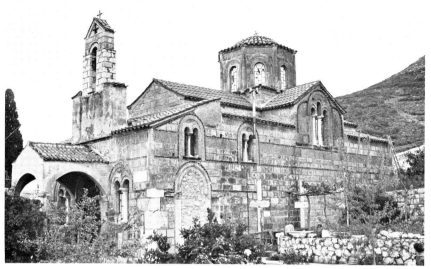

5. Areia, near Nauplion in Argolis, Hagia Moni, general view from the south-west, 1143–44 (author).

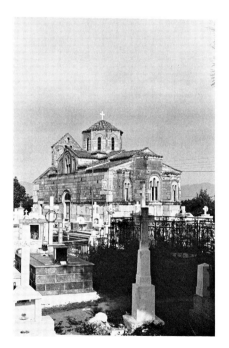

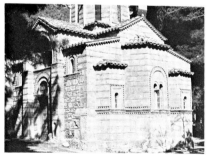

7. Amphissa, in Phokis, Soter, view from the southeast, 12th c. (R. S. Cormack).

6. Merbaka, in Argolis, Koimesis, general view from the southeast, 12th c. (author).

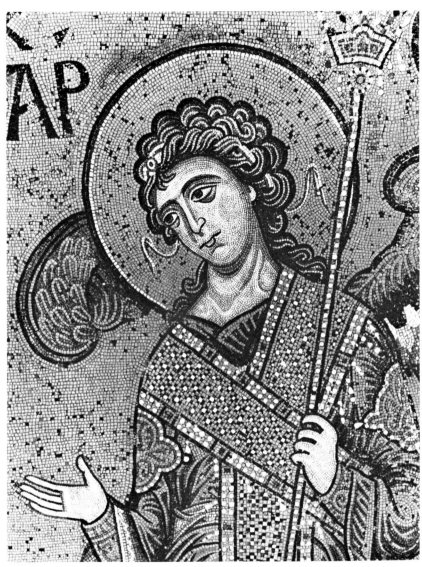

8. Monreale, Cathedral, barrel vault of the sanctuary, detail of the archangel Uriel late 12th c. (Dumbarton Oaks, Center for Byzantine Studies).

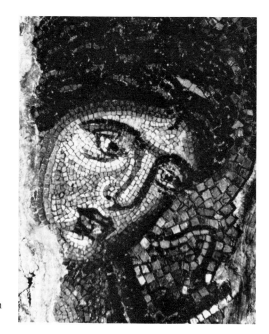

9. Istanbul, Kalenderhane
Camii, fragment of an angel in
mosaic, late 12th c.

10. Madrid, Biblioteca Nacional, cod. 5.3.N.2, Chronicle of Skylitzes, fol. 12v,
12th c. (Biblioteca Nacional).

11. Kakopetria, St. Nicholas tes Steges, proskynesis image of the patron saint, east wall of the nave (author).

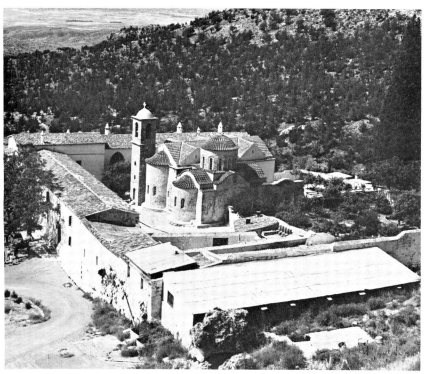

12. Cyprus, near Koutsouvendis, St. Chrysostomos, general view of the complex, late 11th c. foundation (Dumbarton Oaks, Center for Byzantine Studies).

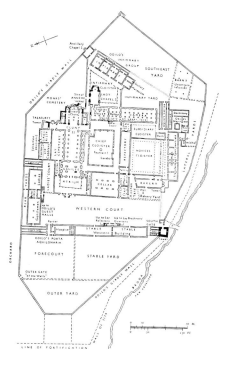

13. Cluny II, plan as in 1050 (K. C. Conant).

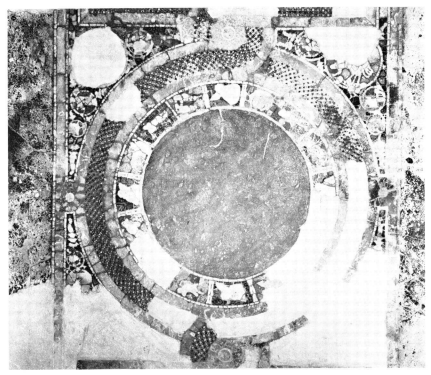

14. Istanbul, Zeyrek Camii, the Pantokrator Monastery, zodiac in the *opus sectile* floor, early 12th c. (Dumbarton Oaks, Center for Byzantine Studies).

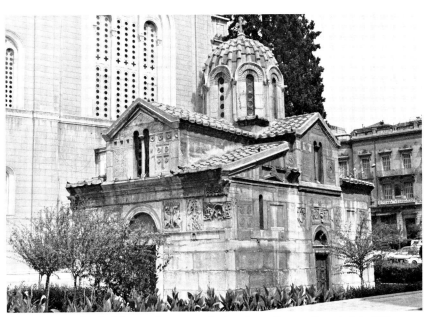

15. Athens, Little Metropolis, general view from the southeast, late 12th c. (author).

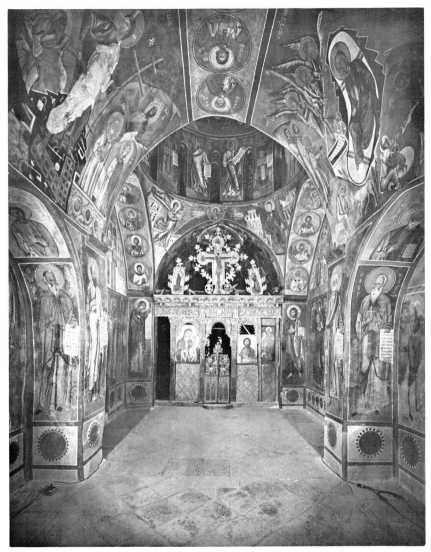

16. Cyprus, Lagoudera, Panagia Arakou, general view of the interior to the east showing the Virgin Eleousa and Christ as *proskynetaria* flanking the apse, 1192; the iconostasis is an early modern addition (Dumbarton Oaks, Center for Byzantine Studies).

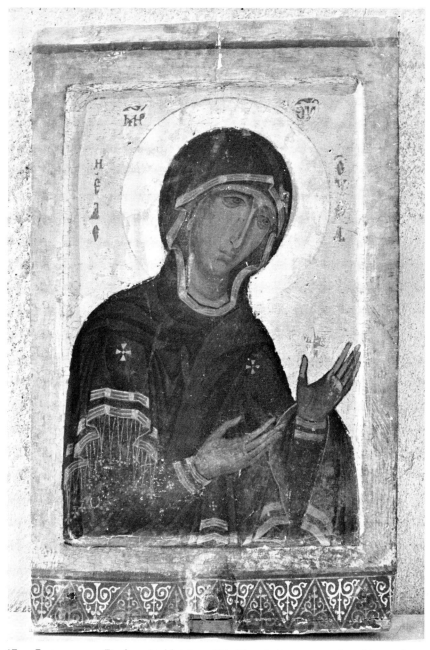

17. Cyprus, near Paphos, Enkleistra of St. Neophytos, processional icon of the Virgin, late 12th c. (C. Mango, Dumbarton Oaks).

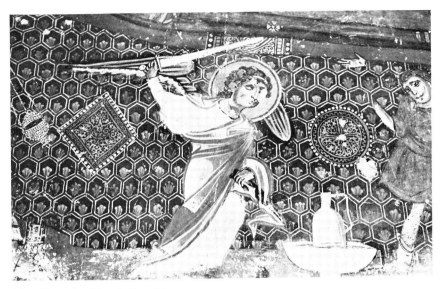

18. Kastoria, Mavriotissa Mon-
astery, detail of the Koimesis on
the west wall of the nave, late
11th c. (R. S. Cormack).

19. Cyprus, Kato Lefkara,
Church of the Archangel, apse,
the infant Christ as the eucha-
ristic sacrifice, third quarter of
the 12th c. (author).

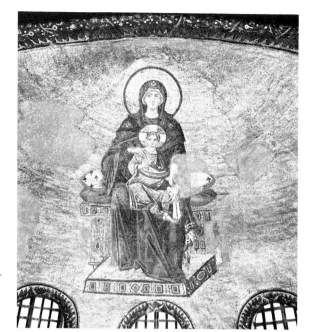

20. Istanbul, St. So-
phia, mosaic, Virgin
and Child in the cen-
tral apse, probably 867
(Dumbarton Oaks,
Center for Byzantine
Studies).

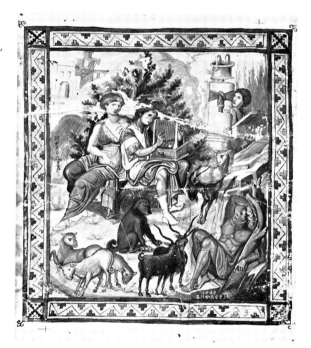

21. Paris, B. N., ms.
grec. 139, David sing-
ing in a bucolic setting,
fol. 1v, 10th c. (Biblio-
thèque Nationale).

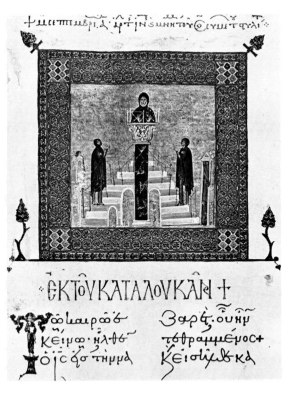

22. Mount Athos, Dionysiou cod. 587, fol. 116r, St. Symeon the Stylite, mid-11th c. (Dumbarton Oaks, Center for Byzantine Studies).

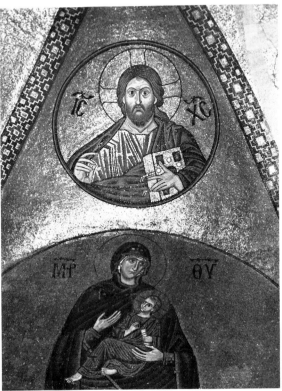

23. Hosios Loukas in Phokis, vault mosaic, Christ and the Virgin, early 11th c. (R. S. Cormack).

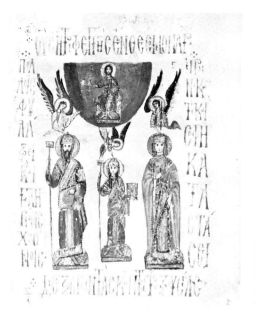

24. Vatican, Barb. gr. 372, fol. 5r, Constantine X Doukas and Eudokia with their son Michael or Constantine, 1060 (Biblioteca Vaticana).

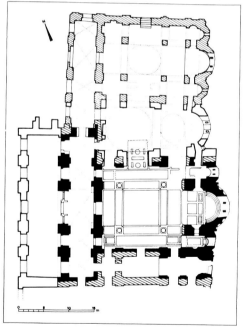

25. Istanbul, Zeyrek Camii, the Pantokrator Monastery, plan, early 12th c. (after C. Mango).

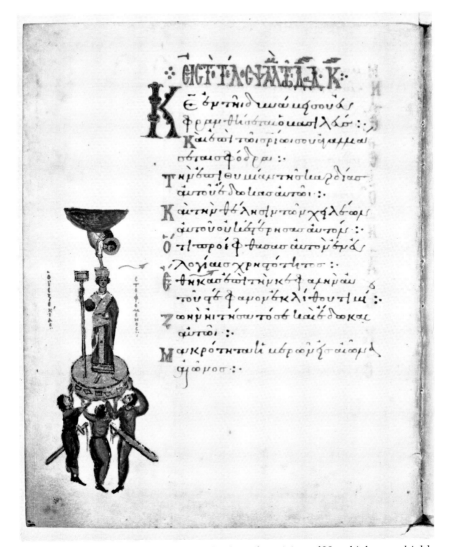

26. Vatican, Barb. gr. 372, Barberini Psalter, the raising of Hezekiah on a shield, fol. 30v, probably 1092 (Biblioteca Vaticana).

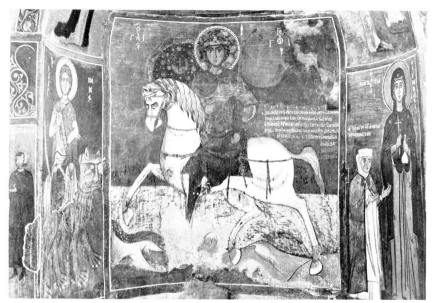

27. Cyprus, Asinou, Panagia Phorbiotissa, south conch of narthex, St. George, late 12th c. (author).

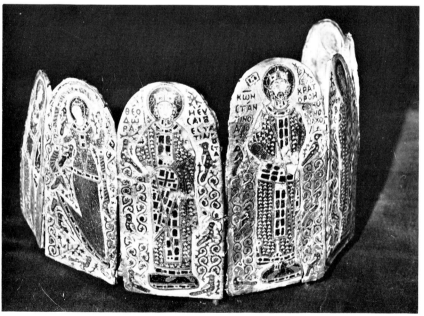

28. Budapest, National Museum, crown with Constantine IX, the empresses Zoe and Theodora, and dancing girls, 1042–55 (National Museum).

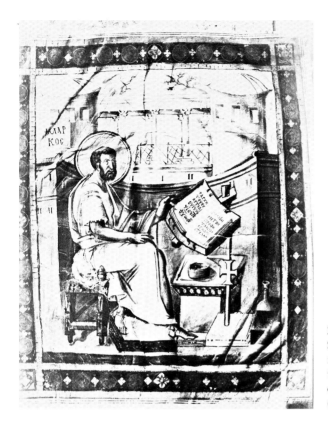

29. Mount Athos, Stauronikita cod. 43, fol. 11r, author portrait of Mark, third quarter of the 10th c. (K. Weitzmann).

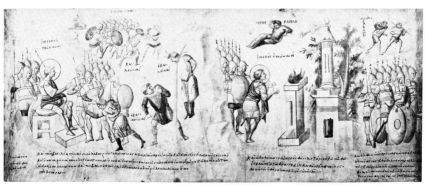

30. Vatican, Pal. gr. 431, Joshua Roll, detail including the personification of Mount Ebal, 960s (?) (Biblioteca Vaticana).

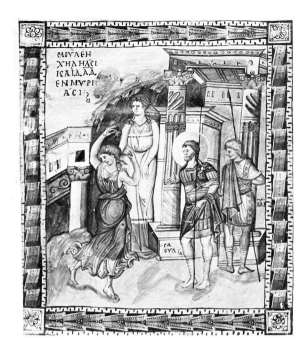

31. Paris, B. N. ms. gr. 139, fol. 5v, David's reception, 960s (?) (Biblioteca Vaticana).

32. Cappadocia, Göreme Valley, Tokalı Kilise, New Church, Peter anointing the deacons, mid-10th c. (author).

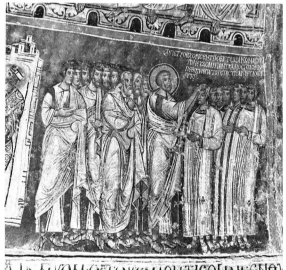

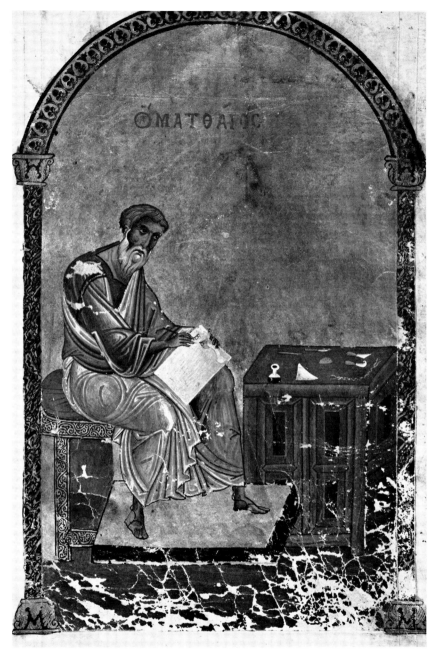

ŌMATΘAIΟC

33. Cleveland, Museum of Art, cod. acc. no. 42, 1512, St. Matthew, mid-
11th c. (Cleveland Museum of Art).

34. Cyprus, Asinou, Panagia Phorbiotissa, west barrel vault of the nave, Pentecost, 1105–06 (Dumbarton Oaks, Center for Byzantine Studies).

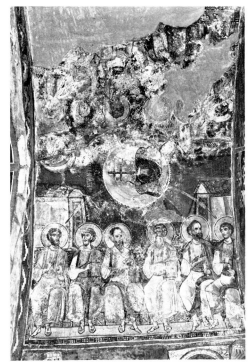

35. Vézelay, Ste.-Madeleine, tympanum of the central portal, relief representing the Pentecost and Mission of the Apostles, ca. 1125–30 (Art Department, University of North Carolina, Chapel Hill).

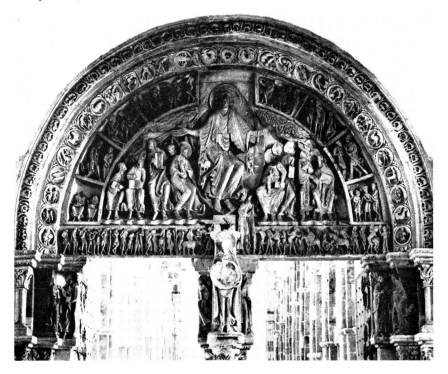

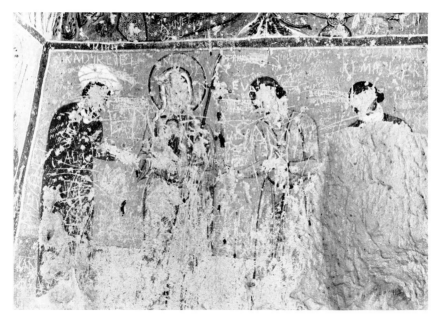

36. Cappadocia, Göreme Valley, Çarıklı Kilise, panel with the donors Theognostos (in a turban), Leo, and Michael, mid-11th c. (author).

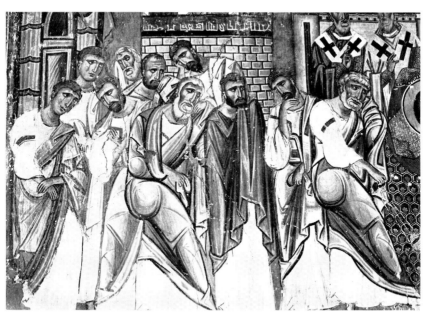

37. Kastoria, Mavriotissa, detail from the Koimesis with pseudo-Kufic, late 11th c. (R. S. Cormack).

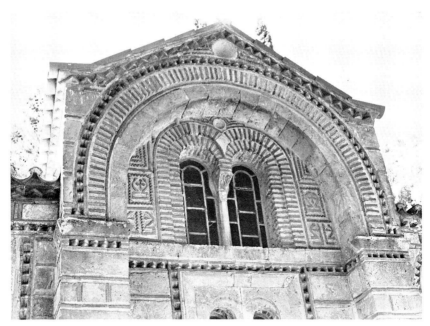

38. Amphissa, Soter, detail of the brickwork from the north façade, 12th c. (author).

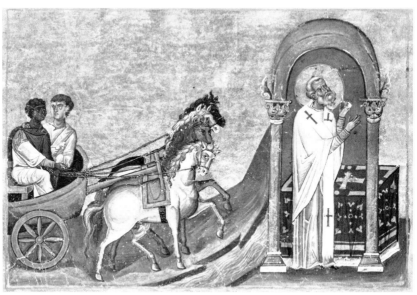

39. Vatican, cod. gr. 1613, Menologion of Basil II, Nestor's conversion of the Ethiopian eunuch, p. 197, c. 1000 (Biblioteca Vaticana).

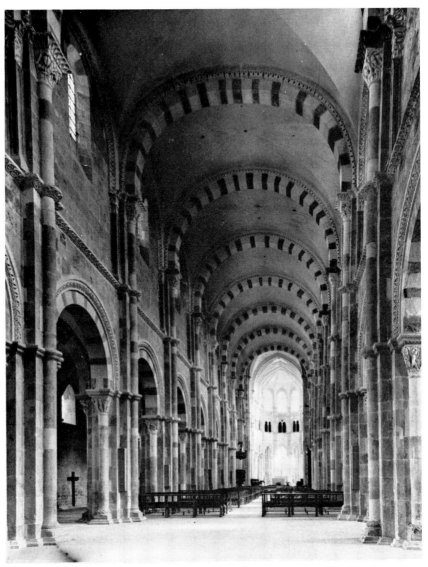

40. Vézelay, general view to the east of the interior, 12th c. (Art Department, University of North Carolina, Chapel Hill).

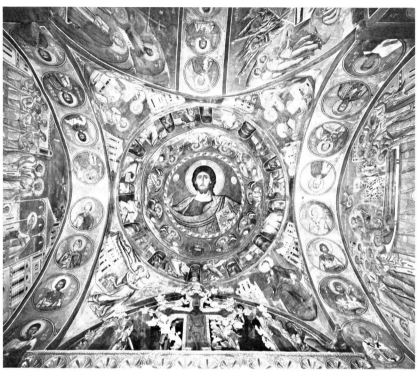

41. Cyprus, Lagoudera, Panagia Arakou, general view toward the dome, 1192 (Dumbarton Oaks, Center for Byzantine Studies).

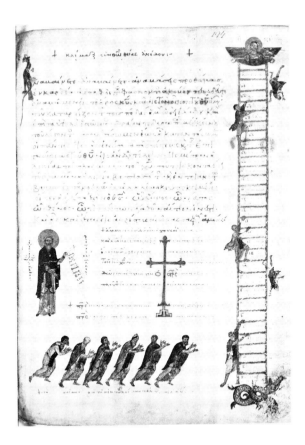

42. Princeton, University Library, cod. Garrett 16, fol. 194r, monks ascending toward heaven, 11th c. (Princeton University Library).

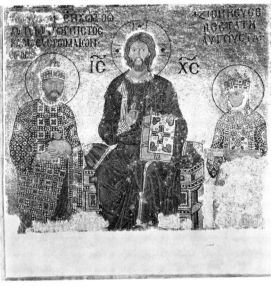

43. Istanbul, St. Sophia, mosaic in the south tribune, Empress Zoe, her consort, and Christ, 1034–42 (Dumbarton Oaks, Center for Byzantine Studies).

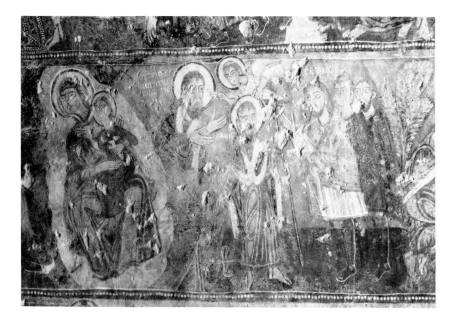

44. Cappadocia, Göreme Valley, Tokalı Kilise, Old Church, John the Baptist preaching, early 10th c. (author).

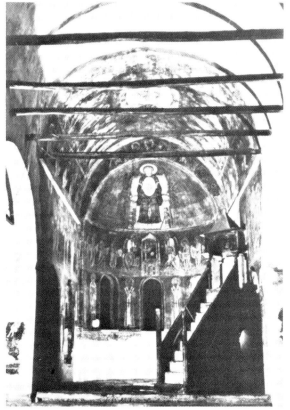

45. Ohrid, St. Sophia, Communion of the Apostles, mid-11th c. (Dušan Tasić).

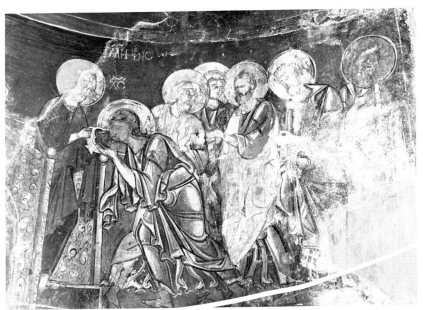

46. Perachorio, Communion of the Apostles, central apse of the church, third quarter of the 12th c. (author).

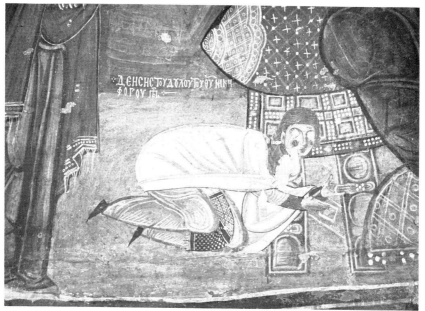

47. Cappadocia, Göreme Valley, Karanlık Kilise, Nikephoros Presbyter, one of
two donors in the conch of the church, mid-11th c. (author).

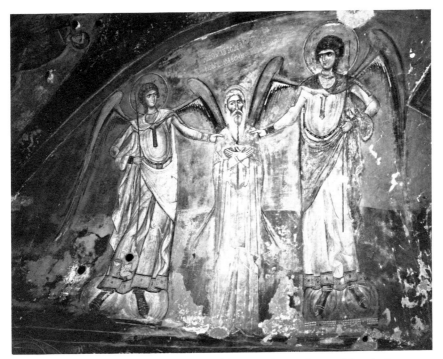

48. Cyprus, near Paphos, Enkleistra of St. Neophytos, bema, Neophytos carried to heaven by archangels, 1183 (Dumbarton Oaks, Center for Byzantine Studies).

49. Cyprus, near Paphos, Enkleistra of St. Neophytos, opening of the passage between the nave of the chapel and Neophytos's retreat, 1196 (Dumbarton Oaks, Center for Byzantine Studies).

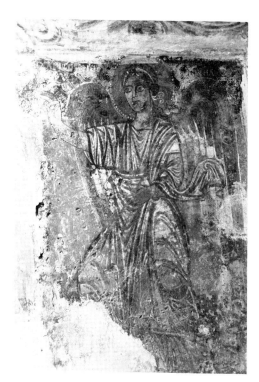

50. Carpignano, SS. Marina and Christina, angel of the Annunciation, 959 (author).

51. Kurbinovo, St. George, angel of the Annunciation, 1191 (David Wright).

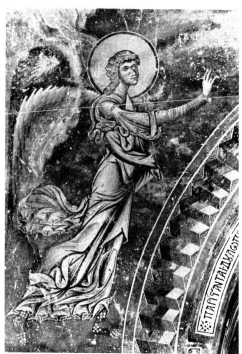

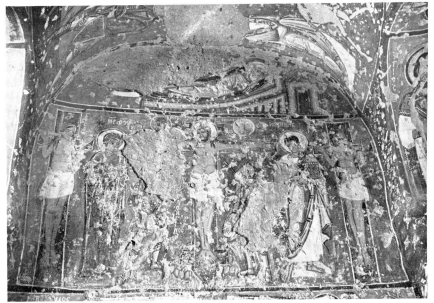

52. Cappadocia, Göreme Valley, Kılıçlar Kilise, Crucifixion, early 10th c. (author).

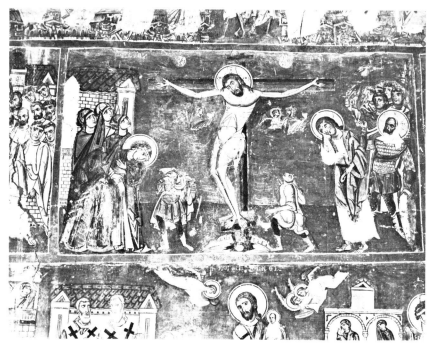

53. Kastoria, Mavriotissa Monastery, Crucifixion, late 11th c. (N. K. Moutso-poulos).

tently contrasted his hero to the personalities of ancient myths or history. For instance, Basil did not need a half-man like Chiron to bring him up, as Achilles had, nor did he have a Lycurgus or a Solon to hand him his laws; yet eventually the emperor established a tribunal more majestic than that of the Areopagus or Heliaia. Similarly, Theodosios the Deacon, in a poem written around 963 describing the capture of Crete, alluded to classical personages only to contrast their insignificance with the importance of contemporary figures. In his opinion, Homer praised worthless events, the generals he depicted were ciphers, the armies involved in the Trojan War were small and unimportant.[44]

The work of Leo the Deacon, which dates from the end of the tenth century, marks a change in attitude toward ancient heros. Leo was not ashamed to compare his beloved Nikephoros Phokas to Herakles or John Tzimiskes to Tydeus (Leo. Diac. 48.17–18, 58.11–12). Similarly, Anna Comnena compared her father both to Herakles and to Alexander of Macedon;[45] her *Alexiad*, moreover, in its title if not in its conception, was modeled on the *Iliad*. Tzetzes was proud of the fact that though he had had to sell his library, he had memorized its texts. In fact, his classical quotations are frequently so far from the original that they are manifestly cited from memory. His intimacy with antiquity is best reflected in his correspondence, which he annotated with a long series of epigrams, creating a previously unexampled literary form. In these epistles, which are addressed both to real and to fictitious people, Tzetzes treated personal concerns and contemporary problems along with details of Hellenic culture. For example, he described his stay in an apartment badly in need of repair. The tenant in the rooms above was a priest who, in addition to having too many children, kept swine; they rained dirt and urine down on the poor writer. This prosaic fact, however, is framed by a series of classical images; for instance, the priest, according to Tzetzes, had fewer children than Priamus or Danaos or Egypt (heros of ancient myths), but they were more numerous than those of Niobe or Amphion; the children and the swine are contrasted with the cavalry of Xerxes: the horses of Xerxes dried up streams, whereas Tzetzes' cohabitants brought forth navigable rivers (Tzetzes, *Ep.* 33.3–16). He also sketched acquaintances, barbarian invasions, and diplomatic envoys, enlivening his im-

44. On the life of Basil I, I. Ševčenko, "Storia letteraria," *La civiltà bizantina dal IX al XII secolo* (Bari, 1978); on Theodosios the Deacon, V. Criscuolo, "Aspetti letterari, stilistici del poema *Halosis tes Kretes* di Teodosio Diacono," *Atti dell'Accademia Pontaniana* 28 (1979), 71–80.

45. Herakles: An. C. 1: 16.6, 36.14; 2: 24.18; 3: 110.24; Alexander: 2: 105.2–3; 3: 217.21–22. See Ja. N. Ljubarskij in *Anna Komnina. Aleksiada* (Moscow, 1965), 44.

ages through comparisons with mythical heros, events from antiquity, or ancient habits. These epigrams as a whole form the so-called *Histories*, an immense poem without any noticeable structure, in which Tzetzes treated everything from history and geography to myths and monuments. He seems to have simply enjoyed the queer tinkling of strange names.

In the ninth and tenth centuries, then, the classical past had been regarded as alluring but alien. By the eleventh and twelfth centuries this ambiguity seems to have been ameliorated. Indeed, in these centuries Byzantine identification with the Hellenic past became firmly rooted.

THE BYZANTINE READING OF
CLASSICAL LITERATURE

That well-educated Byzantines especially of the eleventh and twelfth centuries were thoroughly acquainted with classical literature is well known. But what explains this fascination with a past culture? Beck suggests that this antiquarianism was closely related to the repressive political orthodoxy of the empire, which induced a vacuum between reality and creative activity—classicism was safe and consequently popular.[46] Support for such a thesis may be found in works such as *Timotheos, or About Demons*, which used to be ascribed to Psellos.[47] The piece was written in the form of a discussion between two friends, Timotheos and Thrax, who met in Byzantium (i.e., in Constantinople). Pressed by Timotheos, Thrax described the practices of the Euchites, heretics who indulged in eating excrement, in incest, in the sacrifice of newborn infants, and in devil worship. The conversation was brought to an end only by the threat of rain. In its form, its language, and its concerns, *Timotheos* seems alien to the culture that produced it. The dialogue form was derived from works of Lucian and Plato, which the Byzantines much admired; the subject matter is relevant to the sixth rather than to the eleventh or the twelfth century. The Euchites, the Gnostics, and the savage inhabitants of the British Isles mentioned in the text are all anachronisms. Timotheos and Thrax are placed in an epoch when paganism was still a live issue and when a revival of the excesses of the Dionysiac mystery cults might still be expected.

46. H. G. Beck, *Byzantinistik heute* (Berlin, 1977), 17–19.
47. C. Mango, *Byzantine Literature as a Distorting Mirror* (Oxford, 1975), 10–13. P. Gautier, "Le De Daemonibus du Pseudo-Psellos," *REB* 38 (1980), 105–94, denies Psellos's authorship and redates the work to the twelfth century. He suggests that it may have been written by Nicholas of Methone.

Notwithstanding the fact that the *Timotheos* is not the only piece of Byzantine literature that might be cited to support Beck's supposition, his explanation of the emphasis Byzantines placed on classical literature has weaknesses. Beck himself has recognized in Byzantine political ideology an ambivalence whereby both resistance to autocracy and domination by autocracy were legitimated. The orthodoxy of political thought in Byzantium must not be exaggerated; consequently, concern with antiquity must not be treated simply as a sign of intellectual alienation. Rather it may be suggested that Byzantine dependence on antiquity developed out of a need to find security within an unstable society by creating the illusion of cultural continuity with the Hellenic past. The representation of Timotheos and Thrax (or Achilles or Alexander) as contemporaries was not an inconsequential pastime played to fill a social vacuum, but an attempt to establish constancy amid the insecurities of Byzantine life. Furthermore, Byzantine imitative literature did not avoid vital contemporary questions, but used traditional themes, classical images, quotations, and antique expressions to comment upon social and ideological phenomena in the Byzantine world. Their art was in a sense an art of allusion.[48] Once this is accepted, critiques of Byzantine society become apparent in many Byzantine works. In *War of the Cat and Mice* (*Katomyomachia*), a parody by Theodore Prodromos, the underground existence of the mice stressed by the author may reflect the Byzantines' sense of political oppression. Herbert Hunger even proposed that the king of the mice, Kreillos, represented a typical Constantinopolitan demagogue and usurper (Ex. 28).[49] Antiquity was bound even more tightly in contemporary issues in *Timarion*, a dialogue written possibly by Nicholas Kallikles, a poet and physician at the court of Alexios I, or by another person using the *nom de plume* Lucian (Ex. 29).[50] Certainly it was from Lucian that the author cribbed the plot of his narrative, which involves the hero's journey to the underworld. But the setting (the fair at Thessaloniki), the people of Hell (including Psellos and John

48. A. Garzya, "Topik und Tendenz in der byzantinischen Literatur," *Anzeiger der philologisch-historischen Klasse der Österreichischen Akademie der Wissenschaften* 113, no. 15 (1976), 307. Beck also acknowledges that there are traces of social criticism in Byzantine literature: *Das byzantinische Jahrtausend*, 136–42.

49. H. Hunger, *Die byzantinische Katz-Mäuse-Krieg* (Graz, 1968), 55–65.

50. R. Romano, *Pseudo-Luciano, Timarione* (Naples, 1974), 13–31; R. Romano, "Sulla possibile attribuzione del 'Timarione' pseudo-lucianeo a Nicola Callicle," *Giornale italiano di filologia* 4 (1973), 309–15. H. Hunger admits the possibility of Prodromos's authorship of the *Timarion: Die hochsprachliche profane Literatur der Byzantiner* 2 (Munich, 1978), 154.

Italos), and the events that brought about their downfall were all drawn from contemporary Byzantine life.[51]

The allusive commentary on current affairs that the literary fiction of the empire masked with antiquated vocabulary and traditional subjects was thoroughly understood and appreciated by its readers. The sophisticated knowledge of the classical literary tradition among the educated allowed an author scope for exploiting even subtle modifications of form and substance.[52] Though often lost on modern readers, such manipulation of the familiar texts of antiquity might well rouse emotions or suggest politically sensitive ideas to contemporaries. Of course even in medieval Byzantium such allusions would have had a limited audience; only a small minority would have been able to savor these scholarly innuendos. But the inherent elitism of this mode of expression must have also contributed to its academic attraction.

Classical culture did not remain monolithically intact in its transmission to the Middle Ages. The Byzantines fundamentally modified classicism to conform to their peculiar cultural effort for stability. Instead of analyzing the idiosyncrasies of character through individuals' reactions to events, the Byzantines were concerned with the ideal responses of prototypical or symbolic figures. For instance, *Christ's Passion* (*Christos Paschon*) is similar in form to Greek tragedy.[53] This work, moreover, depends heavily on lines from Euripides and includes also quotes from Aeschylus and from Lykophron. However, the structure of the Byzantine piece differs radically from that of ancient tragedy and especially of Euripides: in *Christos Paschon* the protagonist, the Virgin Mary, reacted passively to the dramatic events announced to her by a series of messengers. Shifts from sorrow to joy occurred as disjointed reactions to the

51. Even in highly derivative erotic romance, images drawn from the contemporary scene are employed time after time: A. P. Kazhdan, "Bemerkungen zu Niketas Eugenianos," *JÖB* 16 (1967), 101–17; H. Hunger, *Antiker und byzantinischer Roman* (Heidelberg, 1981).

52. A. Garzya, "Topik und Tendenz," 306f. H. Hunger has noted both the antinomy of strict *imitatio* and the rich diversity of details in Byzantine literature and the tension between imitation and originality: *Byzantinische Grundlagenforschung* (London, 1973), part 15, 33.

53. On the dating of the *Christos Paschon*, A. Tuilier, *Grégoire de Naziance, La passion du Christ* (Paris, 1969), 72f.; J. Grosdidier de Matons, "A propos d'une édition récente du *Christos paschon*," *TM* 5 (1973), 363–72; more generally, H. Hunger, "Die byzantinische Literatur der Komnenenzeit," *Anzeiger der philologisch-historischen Klasse der Österreichischen Akademie der Wissenschaften* 105, no. 3 (1968), 63–65; S. Averincev, "Vizantijskie eksperimenty s žanrovoj formoj tragedii," *Problemy poetiki i istorii literatury* (Saransk, 1973), 255–70.

narrative of the Lord's passion—the foreboding of Judas's betrayal, the fear of crucifixion, the lamentation over the body after the deposition, and the joy of the resurrection. The outward forms of emotion rather than the dynamics of actions and passions were described. Antique literary devices were absorbed into a purely medieval mode of expression.

ART AND ANTIQUITY

The process of collection and assimilation of the classical inheritance is as evident in art as it is in literature. Here again classical canons were adapted to the contemporary cultural concerns.

The late ninth and tenth centuries were a fertile period in the Byzantine figural arts that perhaps arose from the renewed interest in religious images after Iconoclasm.[54] The scholarly concern for ancient texts apparently resulted in a corpus of Late Antique images representing a variety of subjects, which included authors' portraits and narrative sequences.[55] Of the few surviving fourth- through sixth-century illuminated manuscripts, several have miniatures rendered in an illusionistic style. That is, the artist attempted to capture for his audience the appearance of reality—a specific time and place—by using certain pictorial devices. These conventions include linear and aerial perspective, which impose depth on a flat picture plane by suggesting recession either through the diminution of objects or through a change in atmospheric color from foreground to background. Volume is suggested in the figures by modeling them with highlights and shadows, as though they moved from shade to brightness. Frames might also be used to indicate that the enclosed space was distinct from that occupied by the viewer. Certain masters especially of the mid-tenth century assumed the stylistic habits of the earlier illuminators. There are some extremely competent manuscript illuminations rendered in this classicizing style—full-page windows into space, filled with voluminous, light-contoured figures, such as the author portraits of the Stavronikita Gospels and scenes from the life of David in the Paris Psalter (Fig. 29).[56] Apparently at the same time that antiquarian

54. R. S. Cormack, "Painting After Iconoclasm," in *Iconoclasm*, ed. A. Bryer and J. Herrin (Birmingham, 1977), 147–64.

55. The idea of a revival of classicism is most clearly defined by K. Weitzmann, *Geistige Grundlagen und Wesen der Makedonischen Renaissance* (Cologne, 1962); "Das klassische Erbe in der Kunst Konstantinopels," *Antike und neue Kunst* 3 (1954), 54f. Also see E. Kitzinger, "The Hellenistic Heritage in Byzantine Art," *DOP* 17 (1963), 95f.

56. K. Weitzmann, *Die byzantinische Buchmalerei des 9. und 10. Jahrhunderts* (Berlin, 1935), 23f.; H. Buchthal, *The Miniatures of the Paris Psalter* (London, 1938).

stylistic features began being used, classicizing iconographic elements were also introduced into Christian images.[57] The stance of Christ releasing Adam from Hades may have been remodeled on that of Herakles dragging Cerberus from the netherworld. The boy removing a thorn from his foot (*spinarius*), a well-known *topos* from antiquity, appears to have been metamorphosed into one of the witnesses of Christ's Entry into Jerusalem. Male and female personifications of cities, rivers, and the like proliferate. The well-known Joshua Roll is replete with them (Fig. 30).[58]

All these innovations, both iconographic and stylistic, reflect a remarkable interest in classical prototypes. But questions may be raised about the artistic integrity of these composite images (Fig. 31). Classicizing details and classicizing conventions are put together in such a way that they form a peculiarly unclassicizing whole; there is something essentially eclectic in the classicizing images of the tenth century. Moreover, the traditional equation between naturalism or illusionism and artistic sophistication or quality has affected our view of Byzantine art. We need to be less biased and more critical. It is widely assumed that the Paris Psalter is a great work of art, but while there are masterpieces among the miniatures of the Paris Psalter, there are also compositions such as the Reception of David, in which the attempt to render a convincing depiction of reality is an utter failure.[59] Both figures and space are disjointed. More importantly, the introduction of foreign features sometimes affects the significance of the image. Intrusions from the classical past may add to the decorativeness of the painting or even to its political content, but they do not always contribute to its religious meaning—personifications and antique *topoi*, with their pagan connotations, may well be distracting. One might even suggest that the classicizing style, with its inherent concern with the manipulation of the eye of the beholder, is fundamentally anthropocentric and thus potentially disruptive to a Christian, theocentric image and less appropriate for monumental, communal religious works. In fact, the apparent predominance of a highly classicizing style in the mid-tenth century may be related to the almost complete absence of contemporary monumental decorations. Although a number of churches with mosaic and fresco decorations sur-

57. K. Weitzmann, *Greek Mythology in Byzantine Art* (Princeton, 1951); "The Survival of Mythological Representations in Early Christian and Byzantine Art and Their Impact on Christian Iconography," *DOP* 14 (1960), 43–68.

58. K. Weitzmann, *The Joshua Roll, Work of the Macedonian Renaissance* (Princeton, 1948).

59. H. Buchthal, *Paris Psalter*, esp. 23.

vive from the late ninth and early tenth centuries, it is widely held that
no monumental images exist in a style like that in contemporary manu-
scripts.[60] Indeed, it seems as though relatively few major foundations
were constructed during the middle decades of the tenth century (see
below, p. 198). Nevertheless, the one example of mid-tenth-century wall
painting that may fill this lacuna clarifies our point about classicizing
style. Now that the frescos of the New Church of Tokalı Kilise in Göreme
Valley, Cappadocia, have been cleaned, they can be recognized for what
they are: sophisticated, high-quality works of art with strong metro-
politan connections (Fig. 32).[61] The classicizing figure style of these
frescos is closely related to such works as the Leo Bible. Yet the master of
the New Church avoided introducing into his images any of the other
characteristic elements of contemporary classicizing miniatures, such as
perspective devices or personifications. Apparently, inessential props
and figures were eliminated in order that the Christological narratives
presented in these paintings might be as legible as possible and thereby
better serve their function as church decoration. This evidence confirms
the impression made by luxury codices and ivory boxes that in the mid-
tenth century artistic patronage was dominated by the Constantino-
politan elite. But it also suggests that a simplified, anti-illusionistic treat-
ment of images was regarded as more appropriate for the rendering of
Christological truths in a communal setting.

In contrast to the contrived style characteristic of some tenth-century
manuscripts, style in the following century seems to embody values of a
broader Christian culture: the reality rendered was not natural but di-
vine; the actions represented were not historical but universal. The artist
no longer strove to excite the viewer's interest through illusionistic con-
ventions; rather he attempted to present as clearly as possible the dog-
matic truths he was depicting. Physical space of receding planes and at-
mospheric azure was replaced by a transcendent space of the gold
ground or by the negative space of midnight blue. Bulky figures built up
from shadows to flickering highlights were replaced by austere images
of humanity, abstract in the clarity of their delineation (figs. 33 and 23).
There was a change not only in style, but also in medium. Whereas the
art of the tenth century can best be understood and appreciated from
manuscript illumination and from ivory carving—deluxe works in the

60. E.g., H. Belting, "Problemi vecchi e nuovi sull'arte della cosidetta 'Rina-
scenza Macedone' a Bisanzio," *Corso di cultura sull'arte Ravennate e Bizantine* 29
(1982), 31.

61. A. W. Epstein, *Monks and Caves in Byzantine Cappadocia* (Durham,
N.C., 1983).

minor arts—the art of the eleventh and twelfth centuries is most fully appreciated on a monumental scale in the mosaics and frescos of great foundations of the period. This is not a fortuitous shift. The works of the classicizing illuminators, like those of the classicizing writers, had a limited audience. The monumental art of the eleventh and twelfth centuries was adapted stylistically to a broader community of viewers.

The esoteric style of the mid-tenth-century minor arts was short lived. This is not to say that the artists and patrons of the eleventh and twelfth centuries rejected the artistic inheritance of antiquity; on the contrary, that legacy was absorbed. A new balance between abstraction and naturalism was exploited in the vaults of the great churches and on the illuminated manuscript pages of the period. The mosaic programs of Hosios Loukas, the Nea Moni, and Daphni were all rendered in a distinctive style, but they nevertheless all represented variations of a synthesis of dogmatic abstraction and humanistic illusionism.[62] The isolated figures of the narrative Biblical scenes are flattened by outline and by the geometric treatment of drapery segments. They are set against a shimmering gold ground that defies temporal or topographic localization. Yet the proportions of these figures are consistent with life. Their actions have the clarity and stereotypicality of ancient drama.

The close ties that images of the eleventh and twelfth centuries had to the classical past may perhaps best be demonstrated by contrasting a Byzantine image with a contemporary Romanesque one of the same subject—the Pentecost of Asinou and that of Vézelay (figs. 34–35). Vézelay was a great French pilgrimage church;[63] Asinou was a small Cypriote monastery. Both are, however, decorated with works of high quality of around the year 1100. The figures of Vézelay are superhuman vessels of ecstatic inspiration, pure expressions of divine will. They are not men. Moreover, the whole image is splendidly anti-rational. The relative size of the participants, the relationships between the figures and the space they inhabit, even the framing element, which is a series of pendant scenes, have nothing to do with nature. The Apostles of the Byzantine work, in contrast, are rendered as organically integrated figures. They are individualized men, each with his own hairstyle and beard, each with his own mission. The physical integrity of the figures is

62. E. Diez and O. Demus, *Byzantine Mosaics in Greece, Daphni and Hosios Loukas* (Cambridge, Mass., 1931).

63. A. Katzenellenbogen, "The Central Tympanum of Vezelay. Its Encyclopedic Meaning and Its Relation to the First Crusade," *ABull* 26 (1944), 141–51; C. Beutler, "Das Tympanon zu Vézelay: Program, Planwechsel und Datierung," *Wallraf-Richartz Jahrbuch* 29 (1967), 7–30.

paralleled in the organization of the composition. The painting is eminently legible—the relation between the source of inspiration and the inspired is not only comprehensible, but it also perfectly complements the odd space of the barrel vault in which it is set. The image is fundamentally rational. And it is this rationality of Byzantine art, as much as any formal continuity, that ties it to antiquity.

LAW

It is hard to imagine things more remote from each other than art and literature on one hand and the law on the other: the first two deal with the loftiest emanations of human spirit, the latter with the boring rules of everyday behavior. Nevertheless, the eleventh- and twelfth-century Byzantine approach to the law reveals, in many aspects, the same trends and tendencies that were typical of the development of art and literature: jurisprudence moved from the preservation and compilation of ancient tradition toward commenting on and assimilating them. As discussed in Chapter 1, in the ninth and tenth centuries official or semi-official legal compilations were produced that imposed an order on the inherited corpus of Roman law. The most comprehensive of them were the *Basilika* (*Imperial Books*) by Leo VI, who compiled Justinian's *Digests*, *Code*, *Institutions*, and *Novels* and arranged the material according to subject. The *Basilika* remained the major source of law for the following centuries; it was constantly studied and commented upon. Around 1100 a certain judge named Patzes issued the so-called *Tipoukeitos* (*What Is Placed Where?*), a subject index to the *Basilika*. More reflective of new social developments was a change in the nature of the scholia. The scholia to the *Basilika* written in the tenth century, mostly at the court of Constantine VII, consisted of excerpts from the works of the jurists of the sixth and seventh centuries or from the so-called *Katene* (the *Chain*), compiled by an anonymous writer between 570 and 612. In contrast, the jurists of the eleventh and twelfth centuries wrote their own glosses to the *Basilika*. For example, John Nomophylax reproached the authors of the *Basilika* for their errors in translation from Latin to Greek and gave preference to Justinian's legislative corpus. Sometimes commentators indicated that the rules of the *Basilika* were obsolete. Thus *Basilika* 60:46.1, following Justinian's *Digest* 48:14.1,1, prohibited anyone from currying the *demos*'s favor in order to obtain promotion to the position of *strategos* or of priest. The scholiast indicated that this ruling contradicted the principles of Byzantine law, according to which not the *demos* but only the emperor possessed the right to appoint officials. In the mid-eleventh century a legal collection was produced that included not only

the anonymous *Great Synopsis of the Basilika* but also a register of the imperial laws of the tenth century. This compilation is found in several editions by different authors, some of which reflect considerable care and scholarship in their textual revisions of the emperors' original edicts. Further, several monographs were issued that treated specific legal problems. There are only two recorded legal decisions ascribed to the tenth century: a certain *magistros* Kosmas dealt with problems of land division and with the rights of *paroikoi* on their allotments. In contrast, from the eleventh century onward, a number of juridical treatises appeared, treating a wide variety of subjects ranging from the difference between premeditated and accidental murder to the regulation of agreements, debts, and the separate property of a son under the guardianship of his father. Some of these tracts were anonymous; some preserve the names of their authors, including George Phobenos, Garidas, and Eustathios Rhomaios. A new genre of the eleventh century was juridical textbooks. Michael Psellos's contribution, a deliberation on legal terminology written in verse, is of limited significance. More important to a study of the period is *The Practical Synopsis*, written by the professional judge and historian Michael Attaleiates.[64] This work, dedicated to "the most powerful autokrator Michael [VII]," is a historical survey of the law beginning with the Roman period, "when there was no imperial monarch, but every year two consuls were elected by the senate, that is by the most noble *archons* of Rome, and by the whole *demos*, in order to administer both civil and military affairs" (Zepos, *Jus* 7: 415.20–24). The last legislation taken into consideration by Attaleiates is the *Basilika*. Basically Attaleiates was concerned with ancient Roman law. He even started his work with the traditional statement that "all human beings are either slaves or free persons," adding that free persons have no master above them (Zepos, *Jus* 7: 418.1–2), a principle that overtly contradicted the medieval reality of social dependency. Further, soon after 1034, an anonymous student of the judge Eustathios Rhomaios pub-

64. For a survey of legal works of the eleventh and twelfth centuries, see P. Pieler in Hunger, *Die hochsprachliche profane Literatur* 2, 461–72. On the register of the imperial edicts, see N. G. Svoronos, *La Synopsis major des Basiliques et ses appendices* (Paris, 1964), 173, who connects the creation of several versions of it with the activity of the law school in the mid-eleventh century. His suggestion is hypothetical. W. Wolska-Conus, "L'école de droit et l'enseignement du droit à Byzance au XIe siècle: Xiphilin et Psellos," *TM* 7 (1979), 13–53, in contrast, attributes certain legal works (the scholia to the *Basilika* by John Nomophylax, *Meditatio de pactis nudis*, etc.) to John Xiphilinos. On the treatises of Psellos and Attaleiates, see L. Wenger, *Die Quellen des römischen Rechts* (Vienna, 1953), 710–13.

lished the *Peira*, or *Practice*, a unique collection of cases settled by the judge and recorded in his notes (*hypomnemata*).[65] It contained about 275 decisions made by Eustathios during his long career—his title, variously *protospatharios*, *patrikios*, and *magistros*, reflects the duration of his judicial profession—and is a remarkable source for understanding both the social structure of the Byzantine Empire and its legal practice. Several times Eustathios had to examine cases involving the noble family of the Skleroi. For instance, a group of villagers brought suit against the *protospatharios* Romanos Skleros, alleging that in complicity with the local judge he had forced them to sell their property to him. Eustathios put the burden of proof on the peasants. If they could not demonstrate that they had acceded to the transfer of property under pressure, Skleros would be allowed to pay the price that he promised them in return for their land and in addition interest from the period of their agreement. If, however, they managed to prove that their cession was unwilling, the transfer would be invalidated. Again, certain monks charged Skleros with unlawfully holding a piece of land that belonged to their monastery, and a priest accused Skleros of having struck him with a whip. Maria, Skleros's daughter, was recorded as demanding payment from a certain impoverished *patrikios* Paniberios who was indebted to her. In the end she received the Monastery of St. Mamas in lieu of money. The intricacies of judgment are depicted in another case:

> A bishop died, and the *spatharokandidatos* who was his neighbor [and as a neighbor possessed some rights on the bishop's property] entered [the house] and together with two of the bishop's slaves searched there for gold. He found a bag. When eventually he was asked, he brought it back empty. The slaves, however, informed [officials] that the bag had been full of gold. Thus, the *magistros* and judge [Eustathios] accused him and said in the following way to the *spatharokandidatos*: "Why did you enter alone with the slaves and search for gold?" He retorted: "I brought what I had found." Since the slaves insisted that he had stolen the gold from the bag, the *magistros* decided that the slaves should swear an oath. The *spatharokandidatos* protested saying that slaves, according to law, are not permitted to swear. "I am not condemned," he said. The *magistros* answered: "You took them as witnesses and with them you searched for gold and you trusted them while taking the

65. Published in Zepos, *Jus* 5. On it, see G. Weiss, "Hohe Richter in Konstantinopel. Eustathios Rhomaios und seine Kollegen," *JÖB* 22 (1973), 117–43; D. Simon, *Rechtsfindung am byzantinischen Reichsgericht* (Frankfurt a. M., 1973); S. Vryonis, "The *Peira* as a Source for the History of Byzantine Aristocratic Society in the First Half of the XIth Century," *Near Eastern Numismatics, Iconography and History. Studies in Honor of G. C. Miles* (Beirut, 1974), 279–84.

thing. Since you have accepted them as accomplices and witnesses and co-proprietors, you have to accept their oath that you have taken more gold and not only this amount. Had not you intended this wrongdoing and theft, you would not have entered with slaves into an alien house and ransacked all the things." So he decided, and the slaves swore the oath, and the *spatharokandidatos* was condemned and gave back the rest. (Zepos, *Jus* 5:30.75)

The *Peira* preserves not only the living image of legal practice in the eleventh century but vernacular usages as well. For example, while Eustathios was judging the case of two officials, one of whom was the *protospatharios* Leo, *protonotarios* of the *genikon*, the fiscal department of state, the two adversaries exchanged heated words. While one of the defendants' abuse was relatively mild, Leo called his opponent a swindler and a son of a bitch (61:6). Evidently the secretary of the tribunal did not shrink from recording vulgar expressions.

From the eleventh century onward, canon law, like secular law, was attentively studied. Around 1090, the lawyer Theodore Bestes compiled a new version of the *Nomocanon in Fourteen Chapters*, carefully including the Justinianic code—the Greek edicts in full, the Latin ones in an abbreviated form.[66] Lawyers of the twelfth century commented on the main texts of canon law, the so-called *Rules of the Apostles* and the canons of the church councils as well as the *Nomocanon*. Moreover, obsolete church laws were attacked and refuted, through reference to contemporary secular legislation and to classical writings, by men such as Alexios Aristenos, John Zonaras, and Theodore Balsamon. There was also a move by canonists to exploit the exegeses of ecclesiastic regulations for their own political ends. Utilizing the same material, for instance, Zonaras acted as an ideologue of the senate, demanding limitations on autocratic power, while Balsamon voiced the political position of the emperor, supporting the imperial prerogatives of the Comnenian dynasty. Law, then, also seems to exhibit the typical integration of inherited traditions and contemporary concerns of the eleventh and twelfth centuries.

BYZANTINE SCIENCE

In assimilating the ancient tradition, Byzantine scholarship and art apparently also assumed something of its rationalism. Perhaps the best reflections of this tendency are found in areas that superficially seem utterly opposite: science and theology. In science and mathematics, new studies were added to the received repertoire of classical works. A text

66. H. G. Beck, *Kirche und theologische Literatur im Byzantinischen Reich* (Munich, 1959), 146.

ascribed to Psellos on the four "mathematical" disciplines—arithmetic, geometry, logic, and music—was produced in the eleventh century. Psellos's treatises on algebraic symbols and the mystical significance of numbers also showed this thorough adaptation of antique, often Neo-platonic, ideas to contemporary Christian perspectives.[67] To this end he suggested three applications for mathematics: first, practical; second, abstract—as a medium connecting the worlds of sense and reason; third, theological—as a means of contemplating the divine.[68] Further (though indirect) evidence of Byzantine mathematics may be derived from visitors' descriptions of Constantinople. Leonardo of Pisa, who traveled to the capital around 1200, met several mathematicians who instructed him in devising algebraic problems.[69] One important mathematical innovation also occurred: the introduction of Arabic numerals in the twelfth century. Except for zero, these appear in a commentary on the tenth book of Euclid in the manuscript Vindob. XXXI, 13.[70] While these essays and adoptions do not show a great deal of originality or sophistication, they imply a familiarity with classical methods of problem solving, as well as a modification of the subject to suit contemporary medieval preoccupations.

The new academic interest in mathematics had its counterpart in a revived interest in alchemy and astrology. While the tenth century did not contribute very much to astronomical knowledge, scholars of the eleventh century actively studied both the ancient astronomical tradition and medieval astrology. The *Little Commentary* of the great Greek astronomer Theon was transcribed in 1007–8, and a concise summary of Hephaistion's fourth-century astrological survey was written in the eleventh century.[71] The Byzantines, however, were not restricted to the Greek astronomical tradition; they also appropriated Arabic sources. An

67. J. L. Heiberg, *Geschichte der Mathematik und Naturwissenschaften in Altertum* (Munich, 1925), 46. For a general survey, K. Vogel, "Byzantine Science," *CMH*, vol. 4, part 2, 271–74; and his "Byzanz, ein Mittler—auch in Mathematik—zwischen Ost und West," *Beiträge zur Geschichte der Arithmetik*, ed. K. Vogel (Munich, 1978), 35–53.
68. N. Stuloff, "Mathematische Tradition in Byzanz und ihr Fortleben bei Nikolaus von Kues," *Das Kuzanus-Jubiläum* (Mainz, 1964), 423.
69. Vogel, "Byzantine Science," 273f.
70. P. Tannery, *Mémoires scientifiques* 4 (Toulouse, 1920), 200.
71. D. Pingree, *Hephaistionis Thebani Apostelesmaticorum epitomae quattuor* 2 (Leipzig, 1974), xxv. For general remarks on Byzantine astrology of the eleventh and twelfth centuries, F. Boll, *Sternglaube und Sterndeutung* (Leipzig, 1926), 33, and esp. A. Tihon, "L'astronomie byzantine (du Vᵉ au XVᵉ siècle)," *Byz.* 51 (1981), 610–12.

anonymous scholiast of a Greek manuscript produced in 1032 drew critical comparisons between Ptolemy and "modern" (e.g., Arab) astronomers. Another anonymous Byzantine astronomer, whose tract was published in the 1070s, not only used the work of a certain Habash al-Hâsib (fl. 850) but also applied trigonometrical methods in his calculations for the first time in Byzantium.

Alchemy also thrived. The oldest alchemical manuscript, Marc. 299, dates from the tenth or eleventh century. Psellos addressed to Patriarch Michael Keroullarios a treatise on how to make gold from base metals. Another similar treatise, by a certain Kosmas, seems of later date.[72] By the twelfth century an interest in astrology was quite fashionable. John II had the zodiac prominently represented in the floor of his great monastic church, the Pantokrator (Fig. 14). Manuel I's preoccupation with astrology was so passionate that he was criticized for it by a number of people, including Glykas and Anna Comnena. John Kamateros dedicated to Manuel I a poetic treatise on the twelve signs of the zodiac, the heavenly bodies, and terrestial disturbances such as earthquakes; it noted which constellations were propitious for military campaigns and which ones foretold droughts, civil war, revolt, or a scarcity of wine.[73] Despite its prophetic weaknesses, astrology's monopoly on astronomical knowledge assured its serious investigation. Writers like Psellos and Anna Comnena for the most part hedged their ridicule of astrology with references to the occasional successes of astronomers, whose knowledge was sufficient to predict the movement of celestial bodies (Ex. 30).

Though the prevalent medieval view saw the world as triple-layered, with heaven above, hell below, and earth in the middle, some ancient ideas concerning the universe were retained or, rather, reacquired. Photios had defended the image of the world's spherical structure and later this same idea was developed by Symeon Seth. Moreover, Michael Italikos's encomium on Manuel I, comparing the emperor to the sun as the focus of the universe, even suggests that the ancient conception of a heliocentric system was known to some Byzantines (Mich. Ital. 178.25–30). Italikos's use of this simile points again to the apparent facility with which

72. For developments in alchemy, F. Sh. Taylor, "A Survey of Greek Alchemy," *Journal of Hellenic Studies* 50 (1930), 112f., 122; Hunger, *Die hochsprachliche profane Literatur* 2, 279–82.

73. John Kamateros, *Eisagoge astronomias*, ed. L. Weigl (Leipzig, 1908); M. A. Šangin, "Jambičeskaja poema Ioanna Kamatira 'O kruge Zodiaka' po akademičeskoj rukopisi," *Izvestija Akademii nauk SSSR*, ser. 6, 21, nos. 5–6 (1927), 425–32; Hunger, *Die hochsprachliche profane Literatur* 2, 241–43.

Byzantines appropriated the past for their own use.[74] The spherical image of the universe is preserved in a Byzantine textbook known only from later manuscripts and therefore dated only vaguely to after the eighth century. There the cosmos was presented as an egg: the earth formed the yolk, the air was the thin membrane surrounding the yolk, the sky was the albumen or white, and the heavenly spheres were analogous to the shell.[75] Astrological observations also led to the elaborate description of the cosmos as an internally coherent unit. The earth and heaven were thought to be bound up by causal links, by the "threads of cosmic sympathy," that provided a basis for the belief that constellations and meteorological events such as great storms were reliable predictors of human destinies and political events.[76]

Byzantine geography presents a similar pattern of development. Interest in the physical structure of the world both inside and outside the political frontiers of the Roman Empire was evident in the fourth to sixth centuries, as reflected both in detailed descriptions of pilgrimages and in sober accounts by merchants, such as the *Expositio totius mundi et gentium* of the mid-fourth century, citing the principal harbors and the wares that might be purchased in them. Perhaps most famous is the sixth-century cosmological and geographic treatise by Kosmas Indikopleustes, the *Christian Topography*, based in part on Kosmas's personal observations during his travels and in part on administrative and ecclesiastical lists of provinces and towns in the empire. This interest in geography disappeared after the sixth century, at roughly the same time that urban life declined. Theophanes' indifference toward geography and toponyms is typical of that epoch of contracted horizons.[77] The short itinerary of Epiphanios Hagiopolites, dated to the eighth or perhaps the ninth century, concerning the route from Cyprus via Tyre to Jerusalem and beyond that to Egypt hardly attests a wide or sophisticated interest in geography. But a change in attitude toward the subject became evident in the tenth or perhaps already in the second half of the ninth cen-

74. On this text, see P. Wirth, "Zur Kentnisse heliosatellitischer Planetartheorien im griechischen Mittelalter," *Historische Zeitschrift* 212 (1971), 364f.
75. A. Delatte, "Un manuel byzantin de cosmologie et géographie," *Académie belge, Bulletin de la classe des lettres* 18 (1932), 189–222.
76. On the cosmic sympathy between heaven and earth, M. A. Šangin, "O roli grečeskich astrologičeskich rukipisej v istorii znanij," *Izvestija Akademii nauk, Otdelenie gumanitarnych nauk* 5 (1930), 309.
77. I. Čičurov, "Feofan Ispovednik—kompiljator Prokopija," *VV* 37 (1976), 64–67.

tury, beginning with the collection of ancient geographic texts, especially those of Strabo and Ptolemy. The authorship of Byzantine scholia on Strabo is still disputed; they have been attributed to Photios or to Arethas of Caesarea. In any case, Strabo was frequently used by Byzantine historians of the tenth century.[78] Concurrently, ancient geographic lists were employed for administrative purposes, most notably by Constantine Porphyrogenitus in his work on the themes, a book full of obsolete and antiquated information. The learned Byzantines of the following centuries knew and commented on ancient geographers; thus, many quotations from Strabo are found in Eustathios's commentaries on Homer. Further, antiquarian data might be combined with legends in geographic excursuses such as those by Michael Glykas on the nature of rivers, on India, or on the Nile's floods.[79] There also survives some mention of Byzantine travels to remote countries such as Egypt, India, or Ethiopia (*Scripta min.* 2:10.2–5; also see Sathas, *MB* 5:372.22–24). In Tzetzes and in many historical writings, geographic notes were based on contemporary observations rather than being cribbed from ancient literary traditions. Thus, Tzetzes explained that Lake Maeotis was named "Karmpaluk," which meant "the city of fish" in the "Scythian" language, and indeed the word seems to be of Pecheneg origin.[80] In 1177 a certain John Phokas went on a pilgrimage to Palestine. In his report he described Antioch as a splendid city, the brilliance of which, however, had been tarnished "by time and by the barbarian hand." He also mentioned various sites in the vicinity of Antioch, including the source of Kastalia, the "famous suburb of Daphne," the Black Mountain, Skopelos, and the Orontes (*PG* 133.928f.). The rest of the description is scanty, involving little more than a list of towns: "further is located the so-called Zebelet, and then, the city of Beirut, a large one, with a numerous population, surrounded by many meadows and embellished by a pretty harbor. . . . Further is Sidon and its famous harbor Didymus" (932C–D). Mixed in with this catalogue were also references to the Biblical events associated with specific sites. Travelogues, too, became popular in the twelfth century. Nicholas Mouzalon wrote of his trip to Cyprus from Constantinople, a trip so fortunate that it only took ten days with the help of the Trinity:

78. A. Diller, "Excerpts from Strabo and Stephanus in Byzantine Chronicles," *Transactions of the American Philological Association* 81 (1950), 241–53.

79. K. Dieterich, *Byzantinische Quellen zur Länder- und Völkerkunde* (Leipzig, 1912), XLI.

80. See Gy. Moravcsik, *Byzantinoturcica* 2 (Berlin, 1958), 154.

The Father adjusted the ropes,
The Son guided the tiller,
The Holy Spirit breathed, sending the fair wind,
And so I sailed right to Cyprus.[81]

Less elevated are Nicholas Mesarites' descriptions of his travels: the poor huts of Neakome were built not of stone but of osier covered with clay; the inn in the castellion of the lord George where he and his companions found a "fireplace, beds, blankets, bread, wine, meat, and dried fish" was unfortunately filled with such dense smoke that their eyes suffered. He commented, too, that the small town of Pylae (literally, "gates") was the "entrance to our paradise, planted in the East," for there merchants searched the beach for companions to go to Nicaea, shouting "noisier than roosters." He also mentioned a caravan of mules loaded with dried fish in baskets bound to Nicaea from Neakome and sketched his journey from Nicaea to Constantinople via Nikomedia.[82]

Constantine Manasses described in a poem entitled *Hodoiporikon* (*Guidebook*) his trip from Constantinople to Jerusalem. He went not as a pious pilgrim, but as a political agent. He accompanied the Byzantine diplomat John Kontostephanos, who was sent to prepare the wedding of Manuel I to a relative of Baldwin III of Jerusalem. When Constantine was ordered on the mission, he recounted that he was so shocked, his soul was so mortified, his heart so frozen that he burst into tears.[83] This detail reflects the Byzantine attitude toward traveling—the essential fear of being transferred from home to an alien setting. Manasses provided a list of the places through which he passed: Nicaea, Ikonion, Cilicia, and Antioch. In connection with Antioch he mentioned, as did John Phokas, "the beauty of Daphne" and "Kastalia, abundant with water." Further on he listed Sidon, Tyre, the harbors of Beirut, and Ptolemais. But in addition to place names Manasses repeatedly provided personal observations. For example, on the banks of the Jordan, he was disappointed by the impression made by the famous river:

I saw water mixed with mud,
Not clear at all, not good for drinking,

81. S. Doanidou, "He paraitesis Nikolaou tou Mouzalonos apo tes archiepiskopes Kyprou," *Hellenika* 7 (1934), 119.260–63.

82. Ed. A. Heisenberg, *Quellen und Studien zur spätbyzantinischen Geschichte* (London, 1973), part 2, section 2, 45.8–11, 40.15–20, 39.6–25, 45.21–25; part 2, section 3, 19f.

83. K. Horna, "Das Hodoiporikon des Konstantin Manasses," *BZ* 13 (1904), 327.64–74.

> Its color was the color of milk,
> It moved indolently,
> You might say that the stream of the river had fallen asleep.[84]

His perception of the valley of Jericho was equally personal:

> The heat of the sun was so burning
> That it penetrated even into the brain.

Slowly, the observer's personal perspective found a place next to antiquarian tradition on the written page.

Byzantines also ventured into a study of the natural world. Interest in such observation is seen in Attaleiates' description of Constantine IX's menagerie, which included a giraffe (*kamelopardalis*) and an elephant. The latter had legs like the pillars of Atlas; the joints of its legs were so tight that the animal had to rest by leaning against a tree. The elephant's ears, which were as large as a footsoldier's shield, moved constantly, asserted Attaleiates, for fear of mosquitoes; for if one were to have found its way into the beast's ear, the elephant would have perished from terror. An interest in the material world continued to be complemented with folklore elements. Constantine IX's menagerie made such an impression on contemporaries that it was mentioned also in the eleventh-century edition of Timotheos of Gaza's book *On Quadruped Animals*, written in about 500 on the exotic beasts that lived in India, Arabia, Egypt, and Libya, in which this note was added: "In our time, both these beasts were brought for Emperor Monomachos from India and shown as a marvel to the people in the theater (Hippodrome) of Constantinople."[85]

Not only was nature closely scrutinized, but also a critical, Christianized interest in Aristotle was revived, and causes of natural phenomena were explored and discussed. Psellos's writings contained a number of these expositions. Why does fanning make the body cooler, though motion is supposed to create warmth? Because, explained Psellos, fanning removes the air warmed by the body from its vicinity. Proof: in baths, where all the air is hot, fanning does not produce coolness (*Scripta min.* 2:231.8–25). Again, two kinds of vapors rise from the earth; one is damp and falls back to earth as rain or hail, the other is light and forms itself into meteors and falling stars (*Scripta min.* 2:222.25–223.18). Why is lightning seen before thunder is heard? Because the eye bulges and the ear is hollow. Symeon Seth, Psellos's contemporary gave another an-

84. Horna, "Hodoiporikon," 328.87–88. For the citations that follow in the text: 333.289–93, 333.283–84.

85. M. Haupt, "Excerpta ex Timothei Gazaei libris de animalibus," *Hermes* 3 (1869), 15.10–13.

swer to this last question—sound requires time for its transmission while sight is independent of time.[86] Similarly, Attaleiates ridiculed illiterates for supposing that thunder was generated by a huge dragon, though his "scientific" explanations were hardly more convincing (Attal. 310.19–311.17).

The Byzantine attitude toward medicine changed between the tenth and twelfth centuries, as contemporary correspondence shows. The literati of the ninth and tenth centuries virtually ignored doctors. Among hundreds of letters of the period, only two short ones are to a doctor: Photios twice wrote a medical practitioner, a certain Akakios, "doctor and monk," who may have been a healer of moral ills rather than a real physician. In contrast, twelfth-century writers were continually addressing letters to medical doctors, who were acknowledged as equals within the intellectual sphere. Michael Italikos, for instance, praised one of his medical friends as the most philosophical and the most literate of physicians (Mich. Ital. 204f.). Michael Choniates, in his letter to the doctor Nicholas Kalodoukes, suggests two principles for an honest physician: not to raise his fee too high and not to be negligent or indifferent to the pain of his patients. Doctors should be particularly sensitive to those who suffer simultaneously from grave illness and severe poverty (Mich. Akom. 2:264.9–14).

Byzantine hagiography of the ninth century and of the first half of the tenth century provides little insight into the image of the medical doctor. Although several saints were said to have cured diseases that had been pronounced incurable by doctors, the rendering is vague and impersonal. Toward the end of the tenth century, the attitude changed drastically: hagiographers described in detail the evidence of doctors' greed and lack of skill if they dared to compete with "God's servants." These physicians invariably failed to heal their patients. The *vitae* of the Constantinopolitan Luke the Stylite, Luke the Younger or Steiriotes of the area around Thebes, the Peloponnesian Nikon Metanoeite, Athanasios of Athos, and Nilos of Rossano, all written around 1000, are especially rich in medical information.

Outright animosity toward medical doctors is found later in Kekaumenos. According to him, doctors were universally charlatans, whose primary concern was to fleece their patients; they kept treating their clients until they had robbed them of all their wealth. Kekaumenos advised his readers to avoid physicians and their drugs and rather to eat moderately, keep out of drafts, drink mixtures of Indian rhubarb or

86. Vogel, "Byzantine Science," 284.

wormwood, and bleed themselves every February, May, and September
(Kek. 244f.). Then a change comes. In the twelfth century medicine
might be treated satirically, and it is sometimes hard to distinguish who
was more laughed at—the verbose and pretentious doctor or the gar-
rulous victim. The author of the *Timarion* ridicules the famous medical
authorities of antiquity as well as his medieval contemporaries: Hippo-
crates is presented clad in a funny Arab costume; Galen is described as
hiding in a remote corner, hastily filling in gaps in his book *On Various
Kinds of Fever*; Theodore of Smyrna is caricatured as a holy healer as he
claims to cure "the soul as well as the body," healing his own gout by
dietary self-restraint. But such asceticism is contrary to Theodore's
nature, and at last he asks Timarion to send him his favorite foods. And
Prodromos, in the same vein, described his own sufferings in the hands
of an unskilled dentist (see below, p. 222).

Twelfth-century authors also contrasted ridiculous doctors, the ob-
jects of their mockery, with good physicians. Prodromos, at the end of
his satire, addressed two praiseworthy doctors, providing their names:
one was his close friend Michael Lizix, the other was Nicholas Kallikles,
poet and physician at the imperial court. George Tornikes went even fur-
ther, rejecting the image of the doctor-executioner, contrasting the care-
less hand of the executioner with the philanthropic one of the physician:
the doctor's hand cleans the wound and heals with minimal pain. Tor-
nikes marvels at the skill of the "wise among doctors," who use wonder-
ful tools in operating on people.[87] Unfortunately, few original medical
texts have survived from the period. There remain only Symeon Seth's
treatise on the dietary advantages and disadvantages of a variety of
foodstuffs, Damnastes' *The Care of Pregnant Women and Infants*, Romanos's
work on acute diseases, and several medical musings by Psellos (Ex. 31).[88]

Much more indicative of Byzantine medicine in the twelfth century
is the description of the hospital facilities found in John II's foundation
charter for the Pantokrator Monastery.[89] This monastery hospital had

87. G. Podestà, "Le satire Lucianecthe di Teodoro Prodromo," *Aevum* 21
(1947), 17–21; J. Darrouzès, *Georges et Dèmètrios Tornikès. Lettres et discours* (Paris,
1970), 164f., 225.13–14, 293.27–28. On the *Timarion*, see above, n. 50.

88. M.-E. Brunet, *Symeon Seth, médecin de l'empereur Michel Doucas* (Bor-
deaux, 1939); G. G. Litavrin, "Vizantijskij medicinskij traktat XI–XIV vv.," *VV*
31 (1971), 256. For a survey of medical literature of the ninth through twelfth cen-
turies, see O. Temkin, "Byzantine Medicine: Tradition and Empiricism," *DOP*
16 (1962), 95–115; Hunger, *Die hochsprachliche profane Literatur* 2, 305–10.

89. P. Gautier, "Le Typicon du Christ Sauveur Pantocrator," *REB* 32 (1974),
8–12; P. S. Codellas, "The Pantocrator, the Imperial Medical Center of the XIIth
Century A.D. in Constantinople," *Bulletin of the History of Medicine* 12, no. 2

fifty beds, some of them with special functions: ten in the surgical ward, eight in a ward for severe diseases, and twelve in the women's ward. Every bed was provided with a carpet, a felt mattress, a pillow, a coverlet, and two blankets for the winter. Special mattresses with holes cut in the center were supplied to immobile patients. The patients were provided with mandatory hospital apparel, including shirts (*chitones*) and coats (*himatia*). Their own clothing was washed and returned upon their recovery. Linen was examined every year; worn pieces were mended or given to the poor. Two doctors, three interns, and two attendants were assigned to each men's ward; two doctors, one woman physician, six nurses, and two or three female attendants served in the women's ward. There were also doctors and surgeons for outpatient care. Doctors' salaries were paid both in cash and in kind (i.e., in wheat, barley, hay, and so forth) according to rank and position. While the doctors and assistants got monthly bonuses, for fear of their despoiling the hospital's dispensary they were allowed neither to have a private practice nor to see high officials. The hospital had a special school for doctors' children. The hospital of the Pantokrator was certainly the largest in Byzantium; similar rules for smaller institutions do exist. Such organizational developments indicate an exploratory practicality bordering on innovation, even if within a very limited sphere.

The practice of post-mortem autopsy in Byzantium marks the greater sophistication of medicine in Byzantium than in the contemporary West. Scientific dissection of corpses is attested to by two Byzantine writers of the eleventh and twelfth centuries. In drawing an analogy between a spiritual healer and a physical one, Symeon the Theologian noted approbatively that doctors both in the past and in the present investigated illnesses by cutting open corpses "in order to study the structure of the body, and by so doing they would understand the internal construction of living men and endeavor to cure the sickness concealed within."[90] Again, George Tornikes commented on the practice of dissection in his eulogy of Anna Comnena. Anna was herself interested in medical topics; she vividly described the activities of the doctors at her father's

(1942), 392–410. The hospital may have included a leprosery: A. Philipsborn, "Hiera nosos und die Spezialanstalt des Pantokrator-Krankenhauses," *Byz.* 33 (1963), 227–30; also see A. Philipsborn, "Der Fortschrift in der Entwicklung des byzantinischen Krankenhauswesens," *BZ* 54 (1961), 356f.; E. Jeanselme and L. Oeconomos, *Les oeuvres d'assistance et les hôpitaux byzantins au siècle des Comnènes* (Anvers, 1921), 6–20.

90. *Traités théologiques et éthiques*, ed. J. Darrouzès, vol. 2 (Paris, 1967), 138.267–140.274.

deathbed. Tornikes specifically praised surgeons who dissected human bodies. He described how they separated every organ from its neighbor in order to scrutinize its position, form, and parts and to understand its function in relation to other organs. This study, observed Tornikes, allowed a doctor to appreciate how a particular organ was affected or even destroyed when other sections of the body were diseased.[91]

INTIMATIONS OF RATIONALISM: THEOLOGY AND IDEOLOGY

In the eleventh and twelfth centuries a professional class of intellectuals began emerging, and interest in ancient literature and science grew broader and more intense. These developments contributed to rational skepticism toward inherited doctrines, both theological and political—particularly because, as Orthodoxy was a prerequisite for office, theology and government were in fact functionally as well as theoretically related. Intellectuals often applied their skill in logic to sensitive subjects outside the bounds of politically insignificant, academic areas. Herein lay the grounds for tensions between intellectuals and the establishment. As mentioned above, even Psellos, a relatively conservative scholar, had accusations of heterodoxy directed against him. He was a rationalist, opposed to occultism and magic, demonology and superstitions, astrology and prophecy. He went further, believing that the mind was capable of grasping truth through reason as well as through revelation. In his debate with Keroullarios, Psellos defended scientific investigation of the cosmos.[92] He cautiously avoided, however, any suggestion that logic might be rigorously applied to theological issues. While he might have allowed an occasional theological syllogism, Psellos recognized that God existed above nature and beyond logic. Despite Psellos's circumspection, he lost his academic position because of the religious irregularities of his thought.

Those with less self-restraint suffered even more serious consequences. After Psellos's disgrace, John Italos became *hypatos* of philosophers. Though John is commonly referred to as Psellos's pupil and did, in fact, attend his lectures, he had from the beginning fundamental disagreements with his professor. His succession to Psellos's chair inter-

91. Georges et Dèmètrios Tornikès, *Lettres et discours*, ed. J. Darrouzèo (Paris, 1970), 225.12–19.

92. B. Tatakis, *La philosophie byzantine* (Paris, 1949), 179f.; G. Karahalios, "Michael Psellos on Man and His Beginnings," *The Greek Orthodox Theological Review* 18 (1973), 80, considers Psellos's anthropology "a by-product of his time and place."

rupted rather than continued an academic tradition. His appointment
generated a controversy among his contemporaries, and it remains—
though for different reasons—controversial in current scholarly litera-
ture. Discrepancies in modern evaluations of John Italos may result from
the partisan nature of the sources. On one side are the accusations lev-
eled against him in 1082, which doubtlessly exaggerated the heretical
tenets of his doctrine. On the other side are his own preserved works,
most probably representing only his most benign writings, in which
originality of thought and divergency of opinion is minimal. The charges
against John were serious. First, in his passion for antique philosophy,
he supposedly regarded ancient thinkers more highly than he did the
Church Fathers, elaborating their pagan opinions concerning the soul
and the material universe. Second, he was accused of believing that
secular science possessed a truth in its own right. Third, it was sug-
gested that he employed logic in an attempt to understand the mysteries
of the incarnation and divine *hypostasis*. Fourth, he reportedly scorned
the miracles of Christ and the saints as contrary to nature. Fifth, it was
said that he assumed that ideas and matter were eternal—form being
created by the action of the one on the other, rather than by the will of
God. Finally, he was denounced as having denied the immortality of the
soul and the resurrection of the body.[93] However weak the foundations
for these charges were, it is clear that John Italos was applying logic—
presumably of a Neoplatonic stripe—to theology in a manner unaccept-
able to his more conservative contemporaries.

Italos's pupils were also accused of heresy. Among them was Eu-
stratios of Nicaea, a talented commentator on Aristotle, whose works
were known in Latin translations even to Thomas Aquinas. He was a
didaskalos and an official court theologian, ultimately appointed metro-
politan of Nicaea. Nevertheless, in the Council of 1117 he was accused of
heresy. Despite his renunciation of his works, his plea that his attackers
based their accusations on stolen preliminary drafts, and the support of
Emperor Alexios I, Eustratios, who had earlier denounced Italos, was in
his turn convicted of heresy.[94] Like his master, Eustratios built his thesis
not on quotations from the Holy Scripture, the Church Fathers, and the
canons of the church councils, but on the principles of logic. He went so

93. J. Gouillard, "Le synodicon de l'Orthodoxie," *TM* 2 (1967), 57–61, 188–
202. Anna Comnena and the author of the *Timarion* also felt strong animosity
toward Italus. See above, n. 17.

94. P. Joannou, "Der Nominalismus und die menschliche Psychologie
Christi," *BZ* 47 (1954), 347f.; "Eustrate de Nicée. Trois pièces inédites de son pro-
cès (1117)," *REB* 10 (1952–53), 24–27; "Le sort des évêques hérétiques récon-
ciliés," *Byz.* 28 (1958), 2.

far as to suggest that Christ based his discourses on Aristotelian syl-
logisms.[95] His theological method led him to deny the co-eternity of
Christ and God the Father, according to Niketas Seides.[96] Rationalism
and the theological problems it engendered were not exclusively the do-
main of the intellectual elite. Nilos of Calabria, for instance, emphasized
that he was poorly read and lacked doctrinal sophistication. Under the
influence of Italos, who supposedly was his teacher, and more particu-
larly of Eustratios, Nilos fell into adoptionist heresy, overemphasizing
the human nature of Christ, and intimating that man might obtain di-
vinity, as did Christ, through grace.[97] Nilos was condemned at the end of
the eleventh century.

 In the middle of the twelfth century another theological controversy
was initiated by Nikephoros Basilakes and Michael the Rhetor over litur-
gical formulas representing the consecrated elements—Christ's blood
and body—as being offered to God by Himself, since the Trinity was
perceived as a unity of *physis* (nature), even though divided into three
Persons: Father, Son, and Holy Ghost. These two rationalists regarded
the rendering of Christ simultaneously as victim, officiant, and receiver
as self-contradictory. This position was further elaborated by Soterichos
Panteugenes, a deacon of St. Sophia and later patriarch-elect of Antioch,
who touched on a number of essential dogmatic problems in a Platonic
dialogue. This text, regarded as brilliant even by Soterichos's opponents,
is unfortunately lost. The author's views are accessible only through the
writings of his attackers, most notably Nicholas of Methone, who sub-
stituted abuse for argument in his discussion of Soterichos's opinions.[98]
It is clear, in any case, that Soterichos differentiates the Father and the
Son: through the Crucifixion the Son (as distinct from the Father) offers
a sacrifice to the Father (as distinct from the Son). From this distinction
arises Soterichos's doctrine of humanity's double-staged salvation, first
through the physical incorporation of the Logos-Son, the second by

 95. Joannou, "Der Nominalismus," 373.
 96. J. Darrouzès, *Documents inédits d'ecclésiologie byzantine* (Paris, 1966),
306–8. On Eustratios, see P. Joannou, "Die Definition des Seins bei Eustratios
von Nikaia," *BZ* 47 (1954), 358–65; K. Giocacinis, "Eustratius of Nicaea's De-
fense of the Doctrine of Ideas," *Franciscan Studies* 24 (1964), 159–204.
 97. Gouillard, "Le synodicon," 202–6. On theological disputes of the sec-
ond half of the eleventh century, see S. Salaville, "Philosophie et théologie ou
épisodes scholastiques à Byzance de 1059 à 1117," *EO* 29 (1930), 132–56.
 98. On Nicholas, A. Angelou, "Nicholas of Methone: The Life and Works of
a Twelfth-Century Bishop," in *Byzantium and the Classical Tradition*, ed. M. Mullett
and R. Scott (Birmingham, 1981), 143–48.

means of the self-offering (*prosagoge*) to the Father. If Nicholas is to be believed, Soterichos exchanged the notion of the reconciliation (*katallage*) of mankind with God through divine grace for the notion of an exchange (*antallage*) of substance (*Bibl. eccl.* 388.3–4). The mortal became a partner of God, an idea that particularly infuriated Nicholas (*Logoi dyo* 29.4–5). Finally, Soterichos challenged transubstantiation, the central dogma of the Eucharist; he evidently regarded the partaking of the host simply as the reenactment of the Last Supper.[99] Soterichos was condemned in the Council of 1157. At the same time, Michael Glykas (Sykidites) was imprisoned, blinded, and banished to a monastery for attacking Manuel I's astrological preoccupations. Michael did not accept his fate passively. In addition to *Verses Written in Jail*, a complaint composed in the vernacular and addressed to the emperor, he wrote a treatise on the divine mysteries, in which he denied the imperishability of the eucharistic elements and ridiculed the idea of the resurrection of the flesh.[100]

It may well have been partially in reaction to these heretical developments that certain programmatic changes were effected in the sanctuary decoration of Byzantine churches. In a number of ecclesiastical foundations decorated in the late twelfth century, including St. Panteleimon at Nerezi, St. George at Kurbinovo, the Virgin Eleousa at Veljusa, and St. Nicholas at Prilep, all in Macedonia, and in the Church of the Archangel in Kato Lefkara in Cyprus, the Infant Christ is represented as prepared for sacrifice on the wall of the apse directly behind the altar (Fig. 19).[101] The innocent Lamb of God was depicted literally as the substance of the host. Thus the Orthodox position on transubstantiation was dramatically rendered in the figural ornament of the church. These images complement not only the central eucharistic liturgy, but also the rite of prothesis, in which the specially prepared bread is subjected to the historical passion before its use as host in the service.[102] As previously

99. For the reply by Nicholas of Methone, *Bibl. eccl.* 355.4–6; also *Logoi dyo* 61.4–27.

100. On Glykas, see K. Krumbacher, *Michael Glykas* (Munich, 1895), and an important review by V. Vasil'evskij, *VV* 6 (1899), 524–37.

101. G. Babić, "Les discussions christologiques et le décor des églises byzantines au XIIe siècle. Les évêches officiant devant l'Hétimasie et devant l'Amnos," *Frühmittelalterliche Studien* 2 (1968), 368–86. The church at Kato Lefkara is unpublished.

102. R. Bornert, *Les commentaires byzantins de la divine Liturgie du XIIe au XVe siècle* (Paris, 1966), 227; R. F. Taft, *The Great Entrance. A History of Gifts and Other Preanaphorical Rites of the Liturgy of St. John Chrysostom* (Vatican City, 1977).

pointed out, church dogma was made increasingly explicit in the figural decoration of the church in reaction perhaps not only to theological controversy, but also the rise of popular religiosity in the twelfth century.[103]

Even the tentative theological rationalism of the eleventh and twelfth centuries stimulated a series of fundamental logical questions that challenged a faith grounded solely in tradition. But this variety of heresy was peculiar to intellectuals; it was rarely found outside the academic elite. Another form of heresy, dualism, was more widespread. This prolongation of the Paulician and Bogomil heresies infected all classes in Byzantium—from the educated physician Basil, burned at the stake by Alexios I, to the anonymous soldiers and peasants in the Balkans and Asia Minor.[104] Two important points of distinction between these later appearances of dualism and their earlier occurrences have been suggested, though on little evidence: that it had a more urban character in the eleventh and twelfth centuries and that Bogomil "perfects" were concentrated in certain monasteries.[105]

In 1140, a special council condemned the Enthusiasts and Bogomils.[106] The basic tenets of the heresy were found in the writings of Constantine Chrysomalos, who according to his attackers claimed that government officials worshiped the devil in their obedience to the earthly *archon*. He also denied the validity of the liturgy, proposing that individual salvation was not dependent on the sacraments. The Council of 1143 condemned two Cappadocian bishops;[107] they were accused of preaching pure asceticism, calling on their parishioners to abstain from intercourse, meat, milk, fish, and wine for three years. They evidently insisted that tonsure was the prerequisite for paradise. They rejected the cult of icons; they denied the occurrence of miracles; they allowed women to participate as deaconesses in the liturgy. The suppression of heresy obviously took a

103. R. Browning, "Enlightenment and Repression," 19, counted twenty-five trials against heretic intellectuals during Comnenian rule.

104. M. Loos, *Dualist Heresy in the Middle Ages* (Prague, 1974); G. Ficker, *Die Phundagiagiten* (Leipzig, 1908); D. Obolensky, *The Bogomils* (Cambridge, 1948); D. Angelov, "Der Bogomilismus auf dem Gebiete des byzantinischen Reiches," *Godišnik na Sofijskija universitet. Istoriko-filologičeski fakultet* 44 (1947–48), 1–60; 46 (1949–50), 1–45; M. Loos, "Certains aspects du bogomilisme byzantin des XI^e et XII^e siècles," *BS* 28 (1967), 38–53. D. Gress-Wright, "Bogomilism in Constantinople," *Byz.* 47 (1977), 163–85.

105. E. Werner, "Geschichte des mittelalterlichen Dualismus: neue Fakten und alte Konzeptionen," *Zeitschrift für Geschichtswissenschaft* 23 (1975), 542.

106. *Reg. patr.* 3, no. 1007.

107. *Reg. patr.* 3, nos. 1011, 1012, 1014.

great deal of time; even at the beginning of the thirteenth century, Bogomils were prominent in Philippopolis and some other places.[108]

The Byzantine church actively attacked both the rational and dualistic heresies, employing compendia, treatises, and even monumental art to clarify the history of heretical error and to defend established religious doctrine. The most prominent protagonist of Orthodoxy during the reign of Alexios I was Euthymios Zigabenos. In his voluminous book, *Doctrinal Panoply*, he first briefly reviewed patristic teachings on God, creation, and salvation, then presented the history of heresies and their refutation from early Christian times. His purview included the Armenians, Monophysites, Paulicians, Bogomils, and Moslems. The book also contained contributions from other theologians such as John Phournos. It was, however, original neither in its form nor in its content, drawing entirely on earlier florilegia and anthologies.

A number of polemicists followed Zigabenos.[109] Among them were Niketas Seides and Niketas of Heraclea, who attacked Eustratios of Nicaea, and Nicholas of Methone, who denounced Soterichos. Nicholas, Manuel I's theological advisor, also investigated the ancient roots of medieval heresy. He censured Proklos's philosophy, which had seduced Psellos and his followers. Those pagan philosophers who defended the eternity of matter were also denounced, as their assumptions had been revived in the eleventh and twelfth centuries.[110] Nicholas was not concerned with developing a comprehensive theology, but in protecting the Orthodox inheritance from rationalist (i.e., "pagan") critiques.

RATIONALISM AND THE IMPERIAL IDEAL

Questioning ecclesiastical dogma was tantamount to questioning the political ideology of the state; hence, conversely, Nicholas of Methone's theological position was tied to his political program. Nicholas promoted imperial power in the hope that Emperor Manuel would unite the

108. B. Primov, "Bŭlgari, gŭrci i latinci v Plovdiv prez 1204–1205 g. Roljata na bogomilite," *Izvestija na Bŭlgarskoto istoričesko družestvo* 22–24 (1948), 155f.; also see A. P. Kazhdan, "Novye materialy o bogomilach (?) v Vizantii XII v.," *Byz. Bulg.* 2 (1966), 275–77.

109. J. Darrouzès, "Notes de la littérature et de critique, I: Nicétas d'Heraclée ho tou Serron," *REB* 18 (1960), now in his *Littérature et histoire des textes byzantins* (London, 1972), part 6, 179–84.

110. J. Stiglmayr, "Die 'Streitschrift des Prokopius von Gaza' gegen den Neuplatoniker Proklos," *BZ* 8 (1899), 263–301. See also G. Podskalsky, "Nikolaos von Methone und die Proklosrenaissance in Byzanz," *Orientalia Christiana Periodica* 42 (1976), 509–23.

church (*Logoi dyo* 8). He was outraged that Soterichos dared to publish his "barbarian" theories just at a time when the empire was threatened by barbarian invasion (*Logoi dyo* 44, 70, 72). And certainly church doctrine was not the only subject of rationalist reappraisal in the eleventh and twelfth centuries. The *imperium* also was scrutinized. Byzantines never formulated a theoretical alternative to the monarchy, but criticism of the emperor was an integral part of Byzantine political ideology (exs. 32–34).[111] This criticism, for the most part, took the form of proposing ideal imperial types that, in contrast with a present rule, might well imply a negative assessment. Such an ideal might be derived from a past model, like Constantine the Great in Theophanes, or a near contemporary, like Basil the Macedonian in the milieu of Constantine VII. Often the previous emperor was idealized: Nikephoros III by Attaleiates, Alexios I by Anna Comnena, Manuel I by Kinnamos. But in the eleventh century, another mode of acceptable criticism was introduced: the denunciation of the office of emperor, or of emperors as a caste.

Psellos provides the best example of such criticism. According to him, emperors were addicted to flattery and could not tolerate free speech (Ps. *Chron.* 2:147, no. 18.5–10; see also 1:153, no. 74.21–23); they were guided not by the common weal but by their own will (2:59, no. 179.8–11). While some emperors were good at the beginning of their reign and others at the end, none was good throughout his whole rule (1:130, no. 27.1–4; 131, no. 27.31–32). The evil of some emperors was generated by their own character; in others it grew from their dependence on worthless counselors (1:58, no. 11.3–5; 2:52, no. 163.7–10). The evil inherent in imperial power inevitably led to the corruption of the physical and moral health of him who wielded it. In his *Chronographia*, Psellos wrote as though emperors were predestined to failure—a failure not marked simply by unfulfilled promises and unrealized good intentions, but also by physical decay. Dropsy, gout, and ill humors worked upon the rulers' features–they appeared as corpses before they were dead. Psellos's indignation at imperial pretension betrays his skepticism regarding a divinely chosen *basileus*—emperors were not content with their external signs of power, the crown and the purple, but sought to elevate themselves above humanity; they assumed divine benediction (1:153, no. 74.15–21; 2:83, no. 1.7–10).

Psellos was not the only one to emphasize the emperor's human

111. F. Tinnefeld, *Kategorie der Kaiserkritik in der byzantinischen Historiographie* (Munich, 1971); P. Magdalino, "Aspects of Twelfth-Century Byzantine *Kaiserkritik*," *Speculum* 58 (1983), 326–46.

frailties. John Zonaras, for instance, also questioned the possible existence of an ideal, paradigmatic emperor (Zon. 3: 767.12–19). Once normal weaknesses were ascribed to the emperor, a demand for limitations on his autocratic powers naturally followed. As medieval society was remote from constitutional restrictions, imperial autocracy might be moderated only through ethics and education, advisors and critics. Masters of rhetoric, indeed, composed not only official panegyrics but also critiques aimed at the emperor. Attempts were made particularly by the ecclesiastical hierarchy to modify the imperial position on theological and even on political issues. Ecclesiastics stubbornly opposed Alexios I in an attempt to protect the church's right to dispose of its own property.[112] John Oxeites, patriarch of Antioch, dared to censure Alexios's entire political program.[113] An anonymous churchman, perhaps Niketas, metropolitan of Ankara, demanded that the emperor must be instructed by the bishops, not the bishops by the emperor.[114] Further, he insisted that the prelates' power was above that of the secular ruler.[115] He praised Patriarch Polyeuktos, who opposed emperors, and condemned the emperor who insisted that those resisting his power committed sacrilege (254.12–15; 240.4–5). Finally, he quoted John of Damascus: "Kings are not to legislate in the church" (248.15–16). Where Photios had developed a theory of state control by two equal powers—emperor and patriarch—the anonymous writer of the late eleventh century proposed the creation of a council of metropolitans and high civil dignitaries to guide the emperor for the benefit of the empire (212.30–214.6).

Criticism was implicit even in laudatory speeches. Eustathios of Thessaloniki, a panegyrist and partisan of Manuel I, on several occasions criticized the emperor's action. Around 1166, Eustathios insisted that the capital was crying through his lips for lack of water and demanded that the emperor see to its needs or else endanger its citizens. In many instances, Eustathios called upon Manuel to abandon aggressive military policies, denouncing war as a bloodthirsty evil. To dig pits for enemy cavalry, to poison wells, to sow alien fields with salt, and to scatter iron caltrops over foreign hills he called despicable acts; he suggested it would be more noble to build defensive fortresses. Eustathios even de-

112. A. A. Glabinas, *He epi Alexiou Komnenou (1081–1118) peri hieron skeuon, keimelion kai hagion eikonon eris* (Thessaloniki, 1972).

113. P. Gautier, "Diatribes de Jean l'Oxite contre Alexis Iᵉʳ Comnène," *REB* 28 (1970), 5–55.

114. Darrouzès, *Documents inédits*, 38–42.

115. Darrouzès, *Documents inédits*, 214.5–8.

nounced Manuel's attempt to recognize the God of Islam.[116] A curious document, the record of a dispute between Manuel I and Patriarch Michael III concerning church union with the Latin West, indicates that the emperor not only lost the debate but also acknowledged the prelate's superior argument. This outcome seems so unlikely that one scholar dismissed the text as apocryphal and ascribed it to the following century.[117] But as imperial prerogatives were being questioned in the twelfth century, there is no reason not to accept the text as authentic. It would seem, then, that as the Byzantine image of the emperor was transformed into the noble warrior, it also became somewhat less divinized.

The rediscovery of the antique tradition in the ninth and tenth centuries was followed in the eleventh and twelfth by the assimilation of the classical tradition into the fabric of medieval Byzantine intellectual life. Discrete formal elements of this heritage are recognizable in the art and literature of the age, but perhaps more fundamentally, familiarity with the ancients and their work bred a new rationalism among the urban intelligentsia of the empire. The vigor of the Orthodox reaction to the unorthodox ideas of the academics, like the state's attempts to subject the higher schools to ecclesiastical control, testifies to the strength of the rationalist threat to traditional ideology. But whatever the internal tensions promoted by Byzantium's renewed ties to the antique tradition, the ruling elite of the empire certainly assumed the classical past as their natural inheritance. This cultural tradition allowed the Byzantines to distinguish themselves from their "barbaric" neighbors. The conceptual as well as political relationship between Byzantium and the other medieval Mediterranean states, the subject of the next chapter, is fundamentally influenced by the empire's unique relation to its past.

116. A. P. Kazhdan, "Vizantijskij publicist XII v. Evstafij Solunskij," *VV* 28 (1968), 71f.
117. J. Darrouzès, "Les documents byzantins du XIIᵉ siècle sur la primauté romaine," *REB* 23 (1965), 79–82.

BYZANTIUM AND
ALIEN CULTURES

TRADITIONAL ATTITUDES TOWARD "BARBARIANS"

Medieval society was essentially conservative. Cultural patterns and social perceptions, like political ideology and the economy, evolved slowly. The Byzantines' perception of the contemporary world was thoroughly conditioned by the past. In fact, traditional modes of thought not only were uncritically retained over long periods of time, they also tended to be self-reinforcing. For instance, one culture's contact with and knowledge of another is a great stimulus to change. But in Byzantium one of the strongest inherited prejudices was directed against alien cultures. The Romans regarded themselves as the bulwark of civilization. Their Eastern Christian descendants, still calling themselves *Rhomaioi*—Romans—persisted in believing that their empire was universal, the only true power in the *oikoumene* (exs. 35–36).[1] As mentioned earlier, they bruited Constantinople by representing their capital as the New Jerusalem as well as the New Rome; Constantinople was the Royal City or Queen of Cities.[2] As the new "chosen" people with the special protection of God, their mission was to enjoy and to promote the now-Christianized culture of antiquity.[3] Theoretically, the *basileus* was the

1. The universal empire provided the ideological base of official propaganda throughout the eleventh and twelfth centuries. In 1141 John II Comnenus wrote to Innocent II proposing the reestablishment of a united Roman Empire under the secular authority of the emperor and the spiritual authority of the pope, G. Ostrogorsky, *History of the Byzantine State* (New Brunswick, N.J., 1969), 385.

2. E. Fenster, *Laudes Constantinopolitanae* (Munich, 1968), 326, indicates that this epithet was particularly common in the twelfth century.

3. E. van Ivanka, *Rhomäerreich und Gottesvolk* (Munich, 1968), esp. chap. 1; A. Toynbee, *Constantine Porphyrogenitus and His World* (London, 1973), 346.

only possible heir to the empire of the *augusti*. He was properly the "lord of the entire world" (Skyl. 123.88–89). The reality of the diminished size of the empire was never admitted—the *Basilika*, for example, included rulings relevant to Egypt, North Africa, Scythia, Syria, and Illyricum, regions long lost to Byzantine power.[4]

In the popular imagination as reflected in the *Alexander Romance*, regions beyond the borders of the empire were the breeding ground of monsters and myths. Their populations were unnatural either in their actions or in their appearances. There were Amazons, the fabled warrior virgins; kings whose transportable palaces were drawn by elephants; unicorns so large that thirteen hundred men were unable to move one of their carcasses; as well as men with dogs' muzzles, birds with human faces, and giant centaurs.[5] Hagiographic sources reflect the same imaginative tendencies. According to the Greek *vita* of St. Makarios of Rome, monks passing beyond the frontiers of Persia encountered strange feline beasts, unicorns, tailless apes, men who lived under stones, and ferocious androgynes who wore arrows on their heads instead of wreaths.[6]

Such flights of fancy were rarely found in more sophisticated sources. In these works, ignorance was not robed in rich imaginings, but rather it was simply and prosaically revealed in out-of-date knowledge. Nomenclature, for instance, was woefully anachronistic. Strabo's terms were transmitted from generation to generation without revision. The names of the tribes of antiquity—Scythians, Paeonians, Celts, Ethiopians— were applied indiscriminately and archaistically to contemporary peoples. Thus, the Turks were called Persians; the Hungarians, Turks; Normans, Franks; French, Germans; and all the people living to the northwest, in-

4. A. P. Kazhdan, "Vasiliki kak istoričeskij istočnik," *VV* 14 (1958), 61. Bulgaria, lost in the seventh century, was always regarded as a usurped part of Byzantine territory. V. Tăpkova-Zaimova, "L'idée impériale à Byzance et le tradition étatique bulgare," *Byzantina* 3 (1971), 289f.

5. This aspect of the *Alexander Romance* has been neglected in favor of the tracing of the history of the text. Even the geographical data has been considered a means of establishing sources. F. Pfister, "Studien zur Sagengeographie," in his *Kleine Schriften zum Alexanderroman* (Meisenheim am Glan, 1976), 112–18. The earliest extant manuscript of the Greek *Alexander Romance* of Pseudo-Callisthenes (ca. 200 B.C.), dates to the eleventh century (Par. gr. 1711): K. Mitsakis, *Der byzantinische Alexanderroman nach dem Codex Vindob. theol. gr. 244* (Munich, 1967), 6f.

6. A. Vassiliev, *Anecdota graeco-byzantina* (Moscow, 1893), 135–65; see also J. Trumpf, "Zwei Handschriften einer Kurzfassung der griechischen Vita Macarii Romani," *AB* 88 (1970), 23–26.

cluding Bulgarians, Pechenegs, Polovtsy, and Rus, were Scythians.[7] Even Tzetzes, who was self-consciously Georgian, attempted to link current populations with archaic ethnic names. He associated the Rus with the ancient Taurians, for example.[8] Even when new terms were adopted, they were not obviously consistently applied to the proper population. Tzetzes lumps the Abasges, Iberians, and Alans together as a single people (Tzetzes, *Hist.* 190.588–90). Similarly, the Georgian princess Maria was consistently referred to in Byzantine sources as an Alan.[9]

Though Byzantines for the most part were ignorant about foreigners and basically uninterested in becoming better acquainted with them, more extreme negative reactions are not uncommon. The degree of derision to which non-Greek-speaking peoples were subjected by cultured Byzantines is best exemplified by Theophylaktos, a sophisticated Constantinopolitan politician sent in about 1090 by the patriarch to oversee the Slavic diocese of Ohrid.[10] This city had been the capital and cultural nexus of western Bulgaria until its reconquest by Basil II. The archbishop repeatedly denounced his flock as mindless monsters and toads, slaves and barbarians reeking of sheepskins. How absurd that they dared to mock Zeus's bird, the imperial eagle! Theophylaktos lamented his exile among aliens and his loss of the comradeship of his intellectual equals (*PG* 126.508B, 308A, 541D, 544B, 396B–C). More generally, the Byzantines simply attributed stereotypical vices to foreigners: the Scythians were cruel, the Armenians perfidious, and the Arabs treacherous.[11] Niketas Choniates, for instance, denounced the Latins as greedy, illiterate (literally, as having an "uncultivated eye"), gluttonous, and violent—their hands were always ready to pull out their swords over nothing (Nik. Chon. 602.5–7). He presented them as given to driveling and to gross expressions of arrogance (164.60–61 *et passim*). Even the false

7. V. Tăpkova-Zaimova, "Quelques remarques sur les noms ethniques chez les auteurs byzantins," *Studien zur Geschichte und Philosophie des Altertums* (Amsterdam, 1968), 400f.

8. Tzetzes, *Hist.* 463.872–76. On his origins, see P. Gautier, "La curieuse ascendance de Jean Tzetzès," *REB* 28 (1970), 209.

9. Jo. Ivanov, *Bŭlgarski starini iz Makedonija* (Sofia, 1931; reprint: 1970), 567f.; Nikephoros Basilakes, *Encomio di Adriano Comneno*, ed. A. Garzya (Naples, 1965), 34.203.

10. For his biography, see P. Gautier's preface to his edition, *Théophylacte d'Achrida: Discours, traités, poésies* (Thessaloniki, 1980).

11. Eust. *Opusc.* 75.2–4. A. P. Kazhdan, *Armjane v sostave gospodstvujuščego klassa Vizantijskoj imperii v XI–XII vv.* (Erevan, 1975), 141; V. Christides, "Saracens' *Prodosia* in Byzantine Sources," *Byz.* 40 (1970), 5–13.

etymologies of ethnic names clearly showed this prejudice. Tzetzes, for example, associated Taurians with oxen, which in Greek is *tauroi*.[12]

CONTACT WITH ALIEN CULTURES: THE FRONTIER ZONE

Despite their ethnic pride, the Byzantines did not represent a unified "nation." The tribal diversity so typical of the Late Roman Empire largely disappeared after vast territories were lost to the Arabs in the seventh century. Nevertheless, Byzantium did have several frontier zones with mixed populations with varied beliefs and divergent cultural traditions. The position and importance of these areas changed with fluctuations in political circumstances. In the eleventh century there were three major zones. The eastern frontier sector that stretched from Chaldea along the Euphrates to northern Syria included Arabs and Syrians in the south and Armenians in the north. Much of this area was lost to Byzantium in the last decades of the eleventh century. With the reconquests of the Comneni, Turks were also brought within the boundaries of Byzantium. The second frontier zone encompassed the northern Balkans. Basil II's annexation of the Bulgarian Empire in the early eleventh century carried into the Byzantine fold several groups of southern Slavs, primarily the Bulgarians.[13] In the 1040s the Pechenegs appeared within the frontiers of the empire and received allotments in Bulgaria.[14] Southern Italy formed the third zone, where native Latin- and Greek-speaking populations mixed with Germanic tribes, most notably the Lombards. By 1071, Apulia and Calabria were conquered by the Normans and permanently lost to the empire.

These borderlands were the most vulnerable parts of the empire in respect not only to foreign attack, but also to internal disaffection. The Normans became involved in southern Italy, for instance, at the instigation of the insurrectionary leader Meles early in the eleventh century.[15] The Armenian principalities were also given to revolt. Political leaders

12. See note 8. On a false etymology of the name of the Arabs, V. Christides, "The Names *Arabes, Sarakenoi*, etc., and Their False Byzantine Etymologies," *BZ* 65 (1972), 330.

13. D. Angelov, *Obrazuvane na bŭlgarskata narodnost* (Sofia, 1971), 351–78.

14. P. Diaconu, *Les Petchénègues au Bas-Danube* (Bucharest, 1970). On the date of the first Pecheneg settlement in Byzantium, see A. P. Kazhdan, "Once More about the 'Alleged' Russo-Byzantine Treaty (ca. 1047) and the Pecheneg Crossing of the Danube," *JÖB* 26 (1977), 65–77; J. Lefort, "Rhétorique et politique. Trois discours de Jean Mauropous en 1047," *TM* 6 (1976), 271f.

15. F. Chalandon, *Histoire de la domination Normande en Italie et en Sicile* 1 (Paris, 1907), 42–58.

periodically attempted to create kingdoms for themselves by claiming territories beyond the easy reach of the capital. For example, Richard the Lion Hearted's conquest of Cyprus in 1192 came in the aftermath of the seizure of the island by a certain Isaac Comnenus.[16] The empire attempted to counteract the centrifugal tendencies toward independence by maintaining a centralized bureaucracy and a considerable military force. But it had other means at its disposal for social control. Alien nobility was absorbed into the military or, less frequently, into the civil apparatus of the empire. Foreign chieftains were awarded land grants, often far from their original territories—some Bulgarian nobles were settled in Armenia, for instance. They also received titles and military commands in return for religious orthodoxy and loyalty to the throne. At a lower social level, the Byzantines systematically resettled ethnic groups as a means of preventing urges for independence (exs. 37–38). Armenians were settled in Philippopolis; Alexios I resettled defeated tribes of Pechenegs in the district of Moglena. Some of those Turks who, according to Euthymios Malakes, "by tribes and clans" shifted their allegiance to the Byzantines and accepted "happy serfdom" under the emperor evidently received land around Thessaloniki (Ex. 39).[17] There they established a "new Persia" (*Fontes* 1:77.30–79.6).

The church was another effective tool of acculturation. Re-hellenizing the reconquered areas of the Balkan peninsula seems to have begun with the imposition of the Greek liturgy.[18] In southern Italy, the Byzantines' attempts to control Apulian as well as Calabrian dioceses mark the importance of ecclesiastics as agents of state power.[19] An individual example of how the state might use the church to advance its interests is provided by a certain Nikephoros. Nikephoros, probably a hellenized Armenian, was sent to the theme of Charsianon in 1001, i.e., immediately after David Kouropalates, prince of Taiq, had died and his princedom was annexed by Basil II. Nikephoros worked in the province near the newly annexed land and contributed to the expansion of Christian-

16. W. H. Rudt de Collenberg, "L'empereur Isaac de Chypre et sa fille (1155–1207)," *Byz.* 38 (1968), 123–79.

17. On Turkish settlements in Byzantine Asia Minor, H. Ahrweiler, "L'histoire et la géographie de la région de Smyrne," *TM* 1 (1965), 22. Also see Euthymios Malakes, "Dyo enkomiastikoi logoi eis ton autokratora Manuel I Komnenon," *Theologia* 19 (1941–48), 541.

18. A. W. Epstein, "The Political Content of the Bema Frescoes of St. Sophia in Ohrid," *JÖB* 29 (1980), 315–29.

19. A. Guillou, "L'Italie byzantine du IX^e siècle. État des questions," in E. Bertaux, *L'art dans l'Italie méridionale, aggiornamento dell'opera*, ed. A. Prandi, vol. 4 (Rome, 1978), 11–13.

ity for thirty-six years. As a reward, his retirement within the church was provided for: in 1037 he was settled on Athos; he received the privilege of eating at *Protos* Theoktistos's table, or, if he preferred, he would be served in his own cell from the *protos*'s kitchen. His servant was fed with the brethren. After the death of the *protos* (who was of Armenian stock), Nikephoros would be bequeathed an estate.[20]

These attempts to integrate the borderlands were never entirely successful. Both the settled populations of these frontier zones and the newly introduced aliens maintained their ethnic identity.[21] Large parts of Bulgaria retained their Slavic languages, their own churches, and even their own literary cultures despite Byzantium's efforts to subsume the new territory. Similarly, the Italians and the Armenians remained religiously and linguistically distinct from their Greek overlords, continuing to harbor a desire for political independence. While the aristocracies of a subject people might be hellenized and lose their cultural associations with their tribes of origin, the mass of people stubbornly maintained their traditional customs.

CONTACT WITH ALIEN CULTURES: THE CENTER

In Byzantium, the opportunities for exposure to foreign habits were varied. The military probably represented the single greatest institutional invitation to cultural agglomeration, although such integration was neither high-level nor very effective. But certainly within the army members of different ethnic groups were brought together. Further, these groups included not only peoples within the borders of Byzantium, but also mercenary troops from all over Europe. Moslem chroniclers recorded Greeks, Rus, Khazars, Alans, Uzes, Pechenegs, Georgians, Armenians, and Franks within the ranks of Romanos IV's army.[22]

20. *Actes d'Esphigménou* (Paris, 1973), no. 2. On this affair, see A. P. Kazhdan, "Esfigmenskaja gramota 1037 g. i dejatel'nost' Feoktista," *Vestnik Erevanskogo universiteta*, 1974, no. 3, 236–38.

21. Ja. Ferluga, "Quelques problèmes de politique byzantine de colonisation au XIᵉ siècle dans les Balkans," *Byz. Forsch.* 7 (1979), 55f. On the problem of borderlands, see H. Ahrweiler, "La frontière et les frontières de Byzance en Orient," *Actes du XIVᵉ Congrès international d'études byzantines* 1 (Bucharest, 1974), 209–30, with comments by Z. V. Udal'cova, A. P. Kazhdan, R. M. Bartikian, A. Pertusi, N. Oikonomidès, D. Obolensky, 231–313. J. F. Haldon and H. Kennedy, "The Arab-Byzantine Frontier in the Eighth and Ninth Centuries: Military Organization and Society in the Borderlands," *ZRVI* 19 (1980), 116, also emphasize that frontier regions were different in character from the central territories of the empire.

22. C. Cahen, "La campagne de Mantzikert d'après les sources musul-

In a contemporary Greek history, further ethnic divisions were recognized—Macedonians, Cappadocians, Bulgarians, and Varangians (Skyl. Cont. 125.5–7). Turks abandoned Islam to serve in John II's army; Ibn Ğubair counted forty thousand Turkish horsemen riding in the ranks of the imperial forces at the time of Andronikos I.[23] Some insight into the variety of nations found among the specifically mercenary corps may be provided by eleventh-century chrysobulls exempting certain monasteries from the billeting of foreign troops (Ex. 40). In the chrysobull of 1060, only Varangians, Rus, Saracens, and Franks were listed. In that of 1079, Bulgarians and Koulpingoi (?) were added. Later English and Germans (Nemitzoi) appeared, and finally in the chrysobull of 1088 also the Alans and Abasges.[24] Apparently throughout the eleventh century, the Byzantine army became increasingly ethnically diverse.[25]

Within this multiracial body, different groups seem to have been dominant at different times. Under Basil II, Rus warriors were prominent among the mercenaries.[26] By the middle of the eleventh century this position had to be shared with the Scandinavians (Varangians), Arabs, Franks (Normans), and Bulgarians.[27] The Sicilian Normans were most successful in obtaining high positions with the army.[28] Hervé, known as

manes," *Byz.* 9 (1934), 629.

23. W. Hecht, *Die byzantinische Aussenpolitik zür Zeit der letzten Komnenenkaiser* (Neustadt/Aisch, 1967), 32f. On the Seljuks in the army of John II, H. A. Gibb, *The Damascus Chronicle of the Crusades* (London, 1932), 249.

24. A. P. Kazhdan and B. L. Fonkič, "Novoe izdanie aktov Lavry i ego značenie dlja vizantinovedenija," *VV* 34 (1973), 49.

25. The Iberians are also mentioned: Eust. *Esp.* 88.23. Iberians in iron coats (chain mail) are described by Nicholas Mesarites as supporters of the usurper John the Fat in 1200: A. Heisenberg, *Nikolaos Mesarites. Die Palastrevolution des Johannes Komnenos* (Würzburg, 1907), 33.3–5.

26. G. G. Litavrin, "Psell o pričinach poslednego pochoda russkich na Konstantinopol' v 1043 g.," *VV* 27 (1967), 75f.; J. Shepard, "Some Problems of Russo-Byzantine Relations c. 860–c. 1050," *Slavonic and East European Review* 52 (1974), 10–33.

27. A. Poppe, "La dernière expédition Russe contre Constantinople," *BS* 32 (1971), 21–29. J. Shepard, "The English and Byzantium: A Study of Their Role in the Byzantine Army in the Later XIth Century," *Traditio* 29 (1973), 53–92; S. Blöndal, *The Varangians of Byzantium* (Cambridge, 1978); P. Tivčev, "Za učastieto na bŭlgari vŭv vizantijskata vojska prez perioda na vizantijskoto igo," *Istoričeski pregled* 19 (1963), 81–89.

28. R. Janin, "Les Francs au service des Byzantines," *EO* 29 (1930), no. 157.61–72; Marquis de la Force, "Les conseillers latins du basileus Alexis Comnène," *Byz.* 11 (1936), 153–65.

Frankopoulos ("son of the Frank"), was appointed commander (*strate-lates*) of the Orient, made a *magistros*, and granted estates in Armenia-kon; eventually he was executed by Constantine X. Robert Crespin was accused of attempted mutiny by Romanos IV, but Michael VII brought him back from exile and made him commander of the "Frankish" mer-cenaries; Crespin was succeeded as commander by Roussel de Bailleul, who betrayed his Byzantine lord and attempted to carve out a prince-dom for himself in Lycaonia and Galatia. Germans were important in the 1070s and 1080s; Anna Comnena recognized their long tradition of service among the ranks of the Rhomaioi (An. C. 2:92.5–7). Finally, dur-ing the twelfth century the Scandinavians and Anglo-Saxons are men-tioned most frequently as seeking new fortunes in Byzantium, espe-cially the latter, who had lost their inheritances to the Normans in 1066; time and again they are referred to by the Byzantines as "the barbarians bearing the double-edged sword on their shoulders." The prominence of Latins, too, within the Byzantine army lends some credibility to William of Tyre's comment that Manuel I disdained the coddled, effeminate Greeks and depended only on Latins in difficult military situations (*PL* 201.857D). Others made much the same observation though with a dif-ferent bias. Odo of Deuil commented that the Byzantines would have lost their empire had it not been defended by hired knights from foreign countries;[29] more sympathetically, Benjamin of Tudela observed that the Greeks were not warlike and therefore hired soldiers from other nations to fight their battles (Ben. Tud. 13).

Latin expansion in the late eleventh and twelfth centuries brought the Byzantines into vital contact with Westerners. The Normans under Robert Guiscard conquered Dyrrachium and invaded mainland Greece. Their occupation was short lived, but some Norman followers of Guis-card and his son Bohemond may well have remained in Byzantine ser-vice even when the main force returned to Italy: after the recapture of Kastoria, Alexios I offered the defeated knights either free retreat or ac-ceptance into the imperial service (An. C. 2:43.11–20). The Crusades again introduced Western Europeans to the Byzantine population. Cer-tainly, the arrival of the crusading hordes—women, children, and mili-tant churchmen, as well as knights—was traumatic for the empire (An. C. 2:207.29–208.6).

Less numerous than mercenaries or Crusaders, but at least as influ-ential, were the merchants of the Mediterranean basin who lived and traded in the major urban centers of the empire. During the eleventh

29. Odo of Deuil, *De profectione Ludovici VII in Orientem*, ed. and transl. V. G. Berry (New York, 1948), 88.

and twelfth centuries in the West trade grew enormously. The great centers of cloth production were established and banking enclaves began to emerge. Western European commercial growth had a significant impact on Byzantium. The flow of goods in commerce and people in pilgrimage during the eleventh and twelfth centuries resulted in the increased visibility of foreigners in the cities and even the towns of Byzantium, as is clear from the description of the annual fair of Thessaloniki discussed in Chapter 2. Concessions of trading privileges were greatly sought after. In the eighth and ninth centuries trade was developed predominantly on the frontiers. The Bulgarians were very active traders with the empire; the denial of their trading privileges was even a pretext for war in 894. From the tenth century on, trade with Kievan Rus acquired special importance, and a series of Russo-Byzantine treaties were concluded, the latest-known being signed in 1046.[30] Rus had their own quarter, their own church, even a cult of their own saint, St. Leontij, in Constantinople.[31] Their affinity with the Byzantines is reflected in the Russian pilgrims' descriptions of the New Rome, and by their establishment of one of the most influential monasteries on Athos—St. Panteleimon.[32]

Culturally more intractable were the mercantile states both to the east and west that sought trading rights within the cities along the principal trade routes. The Arabs had special quarters for their merchants in small towns as well as in major centers such as Thessaloniki and Constantinople. Archaeological evidence suggests, for instance, that a mosque existed in the Middle Ages in Athens.[33] A large mosque was opened for Moslem worship in the capital in 1027.[34] A description preserved from 1189 remarked on the great number of worshipers who gathered there.[35]

30. R. Browning, *Byzantium and Bulgaria. A Comparative Study across an Early Medieval Frontier* (Berkeley and Los Angeles, 1975), 58–59; I. Sorlin, "Les traités de Byzance avec la Russie au Xe siècle," *Cahiers du monde russe et soviétique* 2 (1961), 313–60, 447–75; A. S. Sacharov, *Diplomatija drevnej Rusi* (Moscow, 1980).

31. Antonij, "Kniga palomnik," *PPSb* 17, no. 3 (1899), 29f. On Leontij, A. I. Jacimirskij, "Novye dannye o Choždenii archiepiskopa Antonija v Car'grad," *Izvestija Otdelenija Russkogo Jazyka i Slovesnosti* 4, no. 1 (1899), 245–49.

32. On St. Panteleimon, see V. Mošin, "Russkie na Afone i russko-vizantijskie otnošenija v XI–XII vv.," *BS* 9 (1947), 55–85; 11 (1950), 32–60, and P. Lemerle's introduction to *Actes de Saint-Pantéléèmôn* (Paris, 1982), 8–10.

33. G. C. Miles, "Byzantium and the Arabs: Relations in Crete and the Aegean Area," *DOP* 18 (1964), 19f.

34. N. Mednikov, "Palestina ot zavoevanija ee arabami do krestovych pochodov," *PPSb* 17, no. 2 (1903), 859. Abulfeda, *Annales muslemici*, ed. Io. Ia. Reiske, vol. 3 (Copenhagen, 1794), 131.

35. Baha ud-Dīn, *The Life of Saladin* (London, 1897), 198f.

Best known of these commercial enclaves within Byzantium, however, were those established by the Latins, most notably the Italians. Although contemporary figures may be exaggerated,[36] the Latin communities in Constantinople itself were very sizable: Eustathios of Thessaloniki counted sixty thousand Latins in the city (Eust. *Esp.* 34.2). Abu al-Faraj calculated the number of "Frankish" merchants in the capital as in excess of thirty thousand.[37] According to Western documents, twenty thousand Venetians fled the Constantinopolitan hostilities of the 1160s; supposedly more than ten thousand Venetians were arrested in Byzantium in 1172.[38] The Genoese annals of Caffaro relate more modest figures, numbering the Pisans and Genoese in the "royal city" as one thousand and three hundred respectively (*MGH SS* 18:33). That the number of Westerners in the empire was significant in the eleventh and twelfth centuries is plausible; the extent of their cultural impact on their hosts is less easily measured.

These Italian mercantile communities received concessions in return for military and naval assistance far later than the Rus. First Venice obtained a favored position, with a privilege of about 1082 (the exact date is not proven; *Reg.* no. 1081); its merchants were exempted from all customs and were provided a quay and several warehouses in Constantinople.[39] Slowly, privileges of this sort were conceded to other Italian cities. Their communities certainly had their own Latin-rite sanctuaries.[40] Scholars generally assume that these concessions had a crippling effect on the Byzantine economy, but by so doing they tend to impose on the eleventh and twelfth centuries the economic perspective of the fourteenth century, when the Venetian and Genoese indeed exercised political and economic domination of Constantinople through their control of the Straits. In the eleventh and twelfth centuries the Straits were still under the *imperium*'s control. During that same period Italian trade and

36. W. Hecht, *Die byzantinische Aussenpolitik*, 35; C. Brand, *Byzantium Confronts the West* (Cambridge, Mass., 1968), 6, assumes that this figure cannot be trusted.

37. *The Chronography of Gregory Abu'l Faraj*, transl. E. A. W. Budge, vol. 1 (Oxford, 1932), 358. Abu'l Faraj added, "On account of the great size of the city they were not conspicuous therein."

38. "Historia ducorum Veneticorum," *MGH SS* 14, 78; H. F. Brown, "The Venetians and the Venetian Quarter in Constantinople to the Close of the XIIth Century," *Journal of Hellenic Studies* 40 (1920), 82.

39. A. Pertusi, "Venezia e Bisanzio nel secolo XI," *La Venezia del mille* (Venice, 1965), 138–42.

40. R. Janin, "Les sanctuaires des colonies latines à Constantinople," *REB* 4 (1945), 163–77.

military assistance was beneficial if not crucial for the Byzantines. Alexios I's privilege of about 1082 and those that followed did not differ fundamentally from the Russo-Byzantine treaties of the tenth century, which have never been judged so harshly. Byzantine landowners seem to have profited from commercial relations with Italian communes by selling such produce as grain, meat, and wine. Craftsmen and merchants were more hostile toward Westerners, although their competition was not yet damaging or even dangerous. Imperial favors shown to these aliens might exacerbate the enmity of the emperor's subjects, but probably discrepancies in custom and creed did more to cause mutual intolerance. The fruitfulness of Italo-Byzantine interchange was, however, delicately balanced. A significant loss of equilibrium occurred only under Andronikos I.

BREAKDOWN OF SOME OF THE TRADITIONAL BARRIERS

The increased social, military, and commercial contacts between Byzantium and alien cultures during the eleventh century seem to have led to the breakdown of some of the traditional barriers dividing Byzantine society from the cultures beyond its borders. Perhaps the most tangible evidence of this change in attitudes toward aliens is in marriage practice. In the tenth century Constantine VII had prohibited marriage between Byzantine princesses and foreign rulers;[41] exceptions were made only under duress. In 927 the Byzantines were forced to sign a peace treaty with Bulgaria in which the Bulgarian czar was to receive Maria, Romanos I Lakapenos's granddaughter, as his wife. In 989 the imperial family was again obliged to dispatch one of its members, the unwilling Princess Anna, Basil II's sister, to Vladimir of Kiev in return for his military assistance. In the middle of the same century, Theophano, another princess, was married to the German emperor Otto II. Through the eleventh century the emperors still sought their spouses from within the empire. Maria-Martha, the so-called Alan, a Georgian princess who was the wife of two rulers, was the only exception.[42]

41. Constantine Porphyrogenitus, *De administrando imperio*, ed. Gy. Moravcsik and R. J. H. Jenkins (Washington, D.C., 1967), chap. 13.107–94. See commentary to it, vol. 2 (1962), 67. Certainly such marriages had been occasionally condoned by several of Constantine's predecessors: D. Obolensky, *The Byzantine Commonwealth* (London, 1971), 196; A. Guillou, *La civilisation byzantine* (Paris, 1974), 162. There were, nevertheless, strong feelings against such alliances.

42. I. Nodija, "Gruzinskie materialy o vizantijskoi imperatrice Marfe-Marii," *Vizantinovedčeskie etjudy* (Tbilisi, 1978), 146–55.

From the end of the eleventh and through the twelfth century for-
eign dynastic alliances became gradually more common. Although it
never took place, the wedding of Constantine Doukas to Robert Guis-
card's daughter had been arranged; a close relative of Nikephoros III was
betrothed to a Hungarian king or magnate;[43] John II's wife, Eirene-
Piriska, was a Hungarian princess; their son Manuel I married Bertha of
Sulzbach, sister-in-law of the German king Conrad III; Manuel I's second
wife was Maria of Antioch, a Latin princess; his heir, Alexios II, married
Agnes-Anna, a daughter of the French king. Conversely, numerous
women with imperial connections were betrothed to Latin nobles from
the middle of the twelfth century to its close. Manuel I's daughter Maria
married Ranier of Montferrat, the emperor's niece Theodora wedded
Henry of Austria, another niece was given to Baldwin III of Jerusalem, a
third niece married Stephen Arpad, and a fourth niece went to William
VIII of Montpellier (Ex. 41).[44] John, Manuel's nephew, had two daughters
who married the Latin lords Amory of Jerusalem and Bohemond III of
Antioch. The Angeloi dynasty continued this new trend. Isaac II chose
as his second wife Margaret of Hungary and betrothed two of his daugh-
ters to the foreign princes Tancred of Sicily and Roger of Apulia. One
can easily attest a shift in attitude toward foreign alliances by comparing
Grumel's genealogical tables for the Macedonian (867–1056) and the
Comnenian (1081–1185) dynasties.[45] Of the fifteen marriages noted on
the first chart, only two represent the alliances of Byzantine princesses
with foreign rulers. The second table includes twenty-six marriages, of
which eight are between Byzantine princesses and foreign lords (31 per-
cent) and six are between Byzantine princes and foreign ladies (23 per-
cent). Even if Grumel's data are incomplete, a radical change of Byzan-
tine policy is evident. Not only had marriage become a fundamental
instrument of Byzantine diplomacy, but many of the prejudices against
alien cultures had been mollified.

More complex and less successful was the attempt of the empire to

43. H. Bibicou, "Une page d'histoire diplomatique de Byzance au XIᵉ siècle,"
Byz. 29–30 (1959–60), 43f.; A. P. Kazhdan, "Iz istorii vizantino-vengerskich
svjazej vo vtoroj polovine XI v.," *Acta Antiqua Academiae scientiarum Hungaricae* 10
(1962) 163–66.

44. K. J. Heilig, "Ostrom und das Deutsche Reich um die Mitte des 12. Jahr-
hunderts," *Kaisertum und Herzogsgewalt im Zeitalter Friedrichs I* (Stuttgart, 1973),
229–71; V. Laurent, "Le sceau de Theodora Comnène, reine latine de Jérusalem,"
Académie Roumaine. Bulletin de la section historique 23 (1943), 208–14; W. Hecht,
"Zur Geschichte der 'Kaiserin' von Montpellier Eudoxia Komnena," *REB* 26
(1968), 161–69.

45. V. Grumel, *La chronologie* (Paris, 1958).

cast its net of titles over Western princes. In the mid-eleventh century even the title *magistros* seems to have been attractive to Westerners. The Venetian doge Domenico Contarini had this title, and the influential Norman commander Hervé requested it, only to have it disdainfully denied by Michael VI (Skyl. 484.41–47). The value of Byzantine titles soon depreciated. The next doge, Domenico Silvo, received a higher title, that of *protoproedros*, and Alexios I's privilege for Venice of about 1082 adorned the Venetian doge with the new title *protosebastos*, introduced for the highest members of the emperor's family. At the same time, the patriarchs of Grado became *hypertimoi*. By the later eleventh century, the attractiveness of Byzantine titles began to fade. Occasionally they were rejected by Western lords. The Norman prince Robert Guiscard would not accept the title of *kouropalates* offered to his son, and Roussel de Ballieul did not allow the same title to be bestowed upon him by Michael VII.[46]

Foreign nobles did, however, actively enter the ranks of the Byzantine aristocracy. These new members of the ruling elite were sometimes recruited from conquered peoples: for instance, the descendants of the last Bulgarian czar, Ivan Vladislav, intermarried with the Comnenus and Doukas families. More commonly they came from independent neighboring states. Rus nobles who sought refuge in Byzantium were occasionally granted lands and took their place in the ranks of the aristocracy (exs. 42–46).[47] Numerically more significant in the empire were the noble families of Armenian origin; during the Comnenian period, however, fewer Armenians than before were introduced into the Byzantine elite,[48] perhaps because by that time they had their own princedoms in Cilicia. There they could follow their own branch of Christian creed rather than the Orthodox Chalcedonian one foisted on them by the emperor. Georgia also contributed to the aristocracy of the empire.[49] The families of the Iberoi, Iberitzes, and Iberopouloi were known in Byzantium; descendants of the powerful ruler Liparit IV of Trialeti were Byzantine functionaries in the twelfth century.[50] Other important families, the Tornikes, Pakourianoi, Vihkatzes, and Apuhaps, are identified in the sources as

46. R. Guilland, "Études sur l'histoire administrative de l'empire byzantin. Le curopalate," *Byzantina* 2 (1970), 220.

47. A. P. Kazhdan, "Slavjane v sostave gospodstvujuščego klassa Vizantijskoj imperii v XI–XII vv.," *Slavjane i Rossija* (Moscow, 1972), 32f.

48. Kazhdan, *Armjane*, 146–56.

49. Aristakes de Lastivert, *Récit des malheurs de la nation arménienne* (Brussels, 1973), 27.

50. A. P. Kazhdan, "Vizantija i Liparity," *Vizantinovedčeskie etjudy*, 91f.

either Armenian or Iberian; in all probability they originated among the Georgian or Armenian followers of the Chalcedonian Creed. Among the Westerners, only the Normans managed to secure for themselves a significant niche within the ruling class of Byzantium. By the twelfth century several Norman families, including the Rogerioi, the Petraliphas, and the Raul, had allied themselves with the Comneni through marriage. They became great landowners, obtained high titles (*caesar* and even *sebastokrator*), and served as trusted military leaders. Even Turks and Arabs were represented in the ranks of the Byzantine nobility. Alexios I, for example, favored a Turkish slave who was appointed as a grand *domestikos* by John II. This slave's son, the *protostrator* Alexios Axouch, who married John II's granddaughter, was one of the wealthiest magnates in the empire. His offspring, John Comnenus the Fat, even attempted to seize the imperial throne in 1200. The noble family of the Tatikioi, founded by a servant of Alexios I, was of Turkish or Arab origin. The Chalouphes also may have been of Turkish or Arab origin; the Samouch (Camuha) and Prosouch (Borsuq) certainly were Turkish. Finally, Gautier has suggested that the aristocratic family of Kamytzes was founded by a Turk who had defected to Alexios I.[51] Certainly all these noble scions of "barbarian" tribes were converted to Orthodoxy and hellenized before they took their places within the Byzantine social hierarchy.

The increasing prominence of foreigners in the ruling elite stimulated some reaction among native Byzantines. There was considerable resentment over the devaluation of Byzantine titles by their appropriation by outsiders. Kekaumenos (278.8–284.7), though himself of hellenized Armenian stock, insisted that no barbarian, with perhaps the exception of those of royal blood, should ever be granted an important title. Psellos, too, was filled with indignation at the barbarian slaves, contemptible "Spartacuses," who presumed to wield power and influence in Byzantium (Ps. *Chron.* 2:35, no. 134.4–17). Niketas Choniates was disgusted by the spectacle of pompous, half-civilized manikins receiving imperial gifts and taxes that the emperor's true subjects had to subsidize through their labor (Nik. Chon. 209.45–47). Despite such lamentations, however, the growing number of foreign aristocrats in Byzantine society demonstrated an impressive capacity for assimilation.

EFFECTS OF FOREIGN INFLUENCE

The numbers of aliens coming into contact with Byzantium and their increasing status in the society were bound to influence the host culture.

51. P. Gautier, "Le synode de Blachernes (fin 1094)," *REB* 29 (1971), 259.

Most influences that can be detected were superficial: chivalric games became more common among the aristocracy; clothing styles may also have been affected. The Iberian wide-brim felt hat became fashionable among Byzantine aristocrats in the twelfth century. Breeches became popular probably under Latin influence. The turban is increasingly found depicted in donor panels in the twelfth century, indicating adoption of the Eastern custom (Fig. 36).[52] The visual arts also show external influence. In the eleventh century, for instance, pseudo-Kufic decoration, derived from the Arab use of script in both the minor and monumental arts, became commonplace not only in wall painting from Cappadocia to southern Italy, but also in brick decoration, particularly in Hellas (figs. 37–38).[53] Mango and others have suggested that Armenian church plans were used as models for the Byzantine churches in Constantinople, Athos, and elsewhere.[54] But even where foreign ornament made its decorative appearance or where an Armenian-looking plan was used in a Byzantine setting, the impact of outside traditions had very little substantive effect on Byzantine art. Secular architecture may have been more fundamentally affected by Eastern modes. Manuel I's so-called Persian House in the Great Palace evidently had a muqarnas (stalactite) roof[55] of the sort that still survives in Roger II's Cappella Palatina in Palermo—a form of construction that had its origins in Islamic architecture. So little survives of secular architecture, however, that it is impossible to draw broad conclusions.

Related to the new Byzantine fascination with foreign decorative and architectural features was an interest in foreign literature. The influence of Greek literature on the West in the twelfth century is a familiar theme. Scientific knowledge collected by the Byzantines was slowly diffused through Europe. A number of Greek manuscripts were translated in Sicily. For example, Abelard of Bath apparently translated Ptolemy and the *Institutio physica* of Proklos, Aristippus the so-called fourth book of Aristotle's *Meteorology*, while Burgundion of Pisa, who frequently vis-

52. The mention of light turbans is found in earlier narrative sources: C. Mango, "Discontinuity with the Classical Past in Byzantium," *Byzantium and the Classical Tradition*, ed. M. Mullett and R. Scott (Birmingham, 1981), 51f.

53. R. Ettinghausen, "Kufesque in Byzantine Greece, the Latin West and the Muslim World," *A Colloquium in Memory of George Carpenter Miles* (New York, 1976), 28–47.

54. C. Mango, "Les monuments de l'architecture du XIᵉ siècle et leur signification historique et sociale," *TM* 6 (1976) 251–65; *Byzantine Architecture* (New York, 1975), 231.

55. R. Guilland, *Études de topographie de Constantinople byzantine* 1 (Berlin, 1969), 159f.

ited Byzantium, produced a Latin translation of the section on vini-
culture from the *Geoponika*.[56] It would, however, be wrong to suppose
that scientific observation moved only in one direction. The rapidity
with which ideas concerning nature circulated can be imagined from the
hysteria that spread across the Mediterranean basin just before 1186. As-
tronomers forecast that on the fifteenth or sixteenth of September of that
year all seven planets would unite under the sign of the Balance, causing
catastrophes on earth. Latin chroniclers relate that Spanish, Sicilian, and
Greek astrologers, as well as Jews and Saracens, sent letters throughout
the world warning of the coming disaster.[57] Niketas Choniates com-
mented with considerable disdain on how the emperor and the cour-
tesans of Constantinople prepared for the holocaust by digging holes in
the ground like ants or by removing windowpanes from their houses
(220.23–221.43). Less dramatically, Arabic cures were quoted by Symeon
Seth in his dietary book.

Byzantines began taking an interest in non-scientific foreign works
also. Symeon Seth, again, modeled his fable *Stephanites and Ichnelates* on
the Arabic book *Kalila wa Dimnah*. This work, concerned primarily with
the sly jackals Stephanites and Ichnelates and their intrigues against the
credulous and cowardly King Lion and his retainers, is supposedly a
parable for the instruction of Byzantine courtesans.[58] At the end of the
eleventh century, Michael Andreopoulos, perhaps like Seth from one of
the eastern border provinces of the empire, translated into Greek the so-
called *Book of the Philosopher Syntipas*, a collection of oriental moralizing
tales.[59] Again, Arab and Armenian elements are noticeable in the Di-
genis Akritas epic as well. While Arab sources had previously been used
almost exclusively to fill scientific and philosophic gaps in the Byzan-
tines' knowledge of their own cultural inheritance, specifically oriental
genres and subjects interested the Byzantines in the eleventh and twelfth
centuries. Certainly, scientific and descriptive works like the Arab *Viati-
cum*, a manual for travelers written by the geographer Abu Jafar Ahmad

 56. K. Vogel, "Byzantine Science," *CMH*, vol. 4, part 2, 273, 281, 286;
Ch. Haskins, *The Renaissance of the Twelfth Century* (Cambridge, 1939), 291–302.
 57. Roger of Hoveden, *Chronica*, 4 vols., ed. W. Stubbs (London, 1868–71),
vol. 2, 290–98; Benedictus abbas Petroburgensis, *Gesta Henrici II et Ricardi I*, 2
vols., ed. W. Stubbs (London, 1864), vol. 1, 324–28. Also see Rigordus, "Gesta
Philippi Augusti," *Recueil des historiens des Gaules et de la France* 17 (Paris, 1878),
22. On the oriental influence on Byzantine astronomy, see above, Chapter 4
and n. 71.
 58. L.-O. Sjöberg, *Stephanites und Ichnelates* (Stockholm, 1962).
 59. V. Ernštedt, "Michaeli Andreopuli liber Syntipae," *Zapiski Akademii
nauk.*, ser. 8, 11, no. 1 (1912).

ibn Ibrahim ibn Ğubair (d. 1009), were translated during this period.[60] But mythological tales seem to have enjoyed the most lively interest.

While folklore was gathered on the eastern frontiers, hagiographic material came from the western borderlands. Despite Theophylaktos's disdainful attitude toward his Slavic flock, this archbishop of Ohrid composed a eulogy in honor of the Bulgarian Christian martyrs of Tiberiopolis.[61] Further, in his *vita* of St. Clement of Ohrid, Theophylaktos documented the highly developed Slavic culture flourishing in the region.[62] Later, in the third quarter of the twelfth century, George Skylitzes, who served for a time as governor of Serdica-Sofia, compiled the *vita* of another Bulgarian saint, John of Rila. He also wrote a canon for John of Rila's memorial services.[63]

Although the most detectable foreign influences are superficial, more practical or substantive reactions to the presence of foreigners may also be identified. For instance, the Byzantines seem to be increasingly aware of the advantages of knowing foreign languages. Tzetzes insisted that he was capable of greeting Latins, "Persians," Alans, Rus, Arabs, "Scythians," and Jews all in their own languages (Ex. 47). Whether he was able to converse with them further is another question. It does seem, however, that bilingual Byzantines of high rank became increasingly numerous. Attaleiates mentioned the *magistros* Peter Libellisios, an "Assyrian" of Antioch who had had both a Byzantine and a Saracen education (Attal. 110.22–23). Gregory Pahlavuni, an Armenian polymath of the mid-eleventh century, mastered the refinements of both the Armenian and the Greek cultures. Anna Comnena remarked that a certain Adralestos, quite probably a Greek, knew the "Celtic" language (An. C. 3:117.25–26).

Although a concern with alien tongues may have emerged in the eleventh and twelfth centuries, language remained perhaps the greatest single impediment to real cultural interchange and mutual understanding. The linguistic problems faced by the Byzantines, even at the court of the emperors, are seen in an episode recorded by Niketas Choniates. For a reception of Western envoys, Manuel I employed a certain Isaac Aaron

60. Vogel, "Byzantine Science," 290.

61. G. G. Litavrin, *Bolgarija i Vizantija v XI–XII vv.* (Moscow, 1960), 369f.

62. Doubts concerning Theophylaktos's authorship are rejected by A. Milev, "Za avtorstvo na prostrannoto Klimentovo žitie," *Izvestija na Institut za bŭlgarskata literatura* 5 (1957), 405–34.

63. B. St. Angelov, "Novi vesti za knižovnoto delo na Georgi Skilica," *Literaturna misŭl* 12, no. 2 (1968), 113–18; "Un canon de St. Jean de Rila de Georges Skylitzès," *Byz. Bulg.* 3 (1969), 171–85.

as an interpreter. He was a Corinthian who had learned "Latin" (probably vernacular Italian) while in Norman captivity. Apparently assuming that no one would understand him, Isaac Aaron gave malicious, self-serving advice to the envoys. His scheme evidently failed only because Empress Bertha, being of Western origin, realized the culprit's intentions and brought his treacherous behavior to the attention of the *basileus* (Nik. Chon. 146f.).

Still, a growing liberalism may be discerned in the Byzantines' attitudes toward foreigners. The strength lent to the empire by alien forces was on occasion appreciated by the Greeks. Eustathios of Thessaloniki, for instance, applauded the foreign troops in the Byzantine army. No realm, he said, remained that had not contributed its noblest fruit to Manuel I's retinue. Elsewhere he remarked that every known race had commingled with the Rhomaioi and made a second homeland in Byzantium. Migrants who had previously dwelt in Byzantium as slaves dreaming of escape and vengeance on their lords were now transformed into loyal warriors (*Fontes* 1:81.5–11; Eust. *Opusc.* 200.11–20, 33–37, 45–47). These were the "pearls" that Manuel collected from all the world to adorn the imperial crown.[64] Close and objective observation of aliens in eleventh- and twelfth-century accounts also indicates this change of attitude. Best known, perhaps, is the brilliant depiction of Robert Guiscard rendered by Anna Comnena—so much more detailed a picture than any presented by contemporary Western writers (An. C. 2:59.26–60.10). Even Choniates, whose experience with the Latins through the capture of Thessaloniki in 1185 and the sack of Constantinople by the Fourth Crusade disposed him ill toward Westerners, thought undifferentiated hatred of those barbarians rather stupid, a stupidity worthy only of a mob incapable of distinguishing a friend from an enemy (Nik. Chon. 552.81–82). He was even able to identify in Latins a few positive characteristics, notably piety and courageousness (598.88–89, 644.33–35); he sympathized with those Crusaders who perished in Palestine for the love of Christ (395.53–56); he admired Frederick I Barbarossa's noble origins and obedience to God, comparing him even to the Apostle Paul (416.24–45, 413.57–58). He also lauded other Latin lords: Baldwin, who died bravely at Myriokephalon (181.7–13); Conrad of Montferrat, who was handsome, sagacious, and manly (201.93–95, 382.62–67, 395.56); Raymond of Poitiers, prince of Antioch (116.58–59); and Peter of Bracieux (601.85–86, 623.55–56, 641.50–52). Further, Choniates recognized

64. *Fontes* 1: 94.22–25; see A. P. Kazhdan, "Vizantijskij publicist XII veka Evstafij Solunskij," *VV* 28 (1968), 64.

that the Byzantines had to share with the armies of the Second Crusade the blame for the skirmishes between them.[65]

The new sensibility for the distinctive traits of individual foreigners found in literature has some parallels in the figural arts. When aliens are portrayed as such they may be rendered with a surprising specificity, reflecting the artist's sensitivity not only to distinct customs and clothing but also to characteristic features. For instance, the Ethiopian in the scene with St. Nestor in the Menologion of Basil II, which dates to about 1000, shows a careful delineation of black physiognomy (Fig. 39). Blacks are also depicted in the Pentecost, along with other personifications of the nations to which the apostles were sent, though here ethnic features are more schematically realized.[66] Further, in politically sensitive contexts an artist might caricature the opponent, as seems to have been the case with the Arabs.[67] It appears that the Byzantines were cognizant of racial differences, and could treat them positively or negatively as circumstances required.[68] In all, it seems that by the twelfth century the Byzantine world view had been subtly modified. The "barbarians" were differentiated and individualized; they had positive as well as negative characteristics. They might even be considered useful to the empire as warriors, merchants, and diplomats.

UNBREACHABLE BARRIERS

While the inherited prejudices of Byzantium seem to have been shaken by the economic and military realities of the eleventh and twelfth centuries, the impact of alien cultures on the old empire should not be overestimated. Shifts that took place in the upper reaches of the society do not seem to have fundamentally influenced the broader rhythms of life in Byzantium. Among the populace the traditional world view was largely unaffected by the changes wrought by circumstances on the state

65. F. I. Uspenskij, *Vizantijskij pisatel' Nikita Akominat iz Chon* (St. Petersburg, 1874), 87f.; A. P. Kazhdan, "Ešče raz o Kinname i Nikite Choniate," *BS* 24 (1963), 25f.

66. J. Devisse, *The Image of the Black in Western Art* 2 (New York, 1979), 104–6. For the redating of the Menologion, see A. Cutler, "The Psalter of Basil II," *Arte Veneta* 30 (1977), 9–19; 31 (1978), 9–15. For the Pentecost, A. Grabar, "Le schéma iconographique de la Pentecôte," *L'art de la fin de l'Antiquité* 1 (Paris, 1968), 615–27.

67. V. Christides, "Pre-Islamic Arabs in Byzantine Illuminations," *Le Muséon* 83 (1970), 167–81.

68. Political opponents might also be caricatured. The most evident example is the volume of forged minutes produced by Photios of the church council in which Patriarch Ignatios is caricatured: *PG* 105.540C–541A.

bureaucracy and military nobility. Perhaps this conservatism is best re-
flected in Byzantine theology. Because religion was an essential part of
everyday life in the Middle Ages and because religious concerns are so
well documented during that period, discussions on doctrine may be
scrutinized for evidence of cultural biases. In other words, theological
debates have an important ideological dimension. Such a consideration
of the cultural content of religious differences must, however, be set
against a background of the issues of the controversies and the nature of
the adversaries.

In relation to the Arab East, Byzantium's theological position was
well defined:[69] God by any other name was not God. In the early twelfth
century, Manuel I attempted to defuse religious hostility directed to-
ward the "heathen" Arabs in order to foster military rapprochement. To
this end he suggested modifications in the oath of abjuration admin-
istered to Moslems converting to Christianity so they need not anathe-
matize Allah, a God who, according to the Prophet Muhammed, "nei-
ther had borne nor had been born." Manuel went so far as to defend the
Prophet's God as being the same omnipotent power worshiped by the
Christians. After a long and bitter debate with the clergy of the Great
Church, led by Eustathios of Thessaloniki, a compromise solution was
found. As long as the convert anathematized Muhammed, his teaching,
and his followers, he need not renounce his God.[70] Despite such shifts of
attitude among the secular and ecclesiastical elite, anti-Moslem feeling
probably was as virulent among the Byzantine clergy and laity at large as
it was in Euthymios Zigabenos.[71] Zigabenos began his *Doctrinal Panoply*,
a rabid polemic in refutation of Islam, with a mocking biography of the
"pseudo-prophet Moameth," whom he presented as an orphan who
served and eventually married a widow. After he had taken possession
of all her belongings, Muhammed often went to Palestine to trade; there

69. J. Meyendorff, "Byzantine Views of Islam," *DOP* 18 (1964), 113–32;
A. Th. Khoury, *Polémique byzantine contre l'Islam (VIIIᵉ–XIIIᵉ s.)* (Leiden, 1972).
For an anthology of sources, A. Ducellier, *Le miroire de l'Islam. Musulmans et Chré-
tiens d'Orient au Moyen Age* (Paris, 1971), esp. chap. 4. Until the eleventh century
the Byzantine attitude toward Islam was based on the traditional antithesis
between the New Rome and the barbarian world. It was overtly aggressive.
S. Vryonis, "Byzantine Attitudes towards Islam during the Late Middle Ages,"
GRBS 12 (1971), 264f. Also see Nikephoros II Phokas's letter of 967: G. E. von
Grunebaum, *Islam and Medieval Hellenism* (London, 1976), 53–59.

70. H. G. Beck, *Kirche und theologische Literatur im Byzantinischen Reich* (Mu-
nich, 1959), 622; M. Darrouzès, "Tomos inédit de 1180 contre Mahomet," *REB* 30
(1972), 187–97.

71. On Zigabenos, see Chapter 4.

he met Jews, Arians, and Nestorians (*PG* 130.1333B). Thus from the very beginning, Zigabenos attempted to create the impression that Muhammed's tenets were nothing but distortions of Jewish and Christian creeds. When Muhammed's wife complained that her husband turned out to be not only poor, but also sickly, he managed to convince one of his friends, a heretical monk banished for his wrong beliefs (*kakopistia*), to reveal to the indignant woman that her spouse's illness was by no means a common one, but rather a malady resulting from visions of the archangel Gabriel, God's envoy to major prophets. The woman believed the fiction, changed her mind about her husband, and proclaimed to other women that she was married to a great prophet. "In this way," wrote Zigabenos, "the gossip spread from feminine talk to the men and acquired the image of certainty." Zigabenos refuted the principles of Islam as misinterpretations of Christian teaching, "full of hair-splitting and marvel-mongering," and borrowings from the Old and New Testaments. "He presents Maria as Moses and Aaron's sister, who delivered Christ under a date palm and lost her spirit because of the sufferings [of childbirth]. And he presents Christ as speaking to her from her belly and ordering her to shake the palm and to eat some of its fruit" (1348C). Among the moral precepts of Islam, it was marriage practice that most aroused the indignation of the Byzantine polemicist: "He legislated that everyone could take four wives and a thousand concubines, as many as he could feed" (1349C). For the apologist of Byzantine monogamy, this was a swinish or canine lewdness. The idea of a holy war against the Christians was labeled by Zigabenos "a murderous tendency of a murderous prophet of a murderous people" (1352A). Further, he rejected both the Moslem prohibition on drinking wine and the Moslem picture of the universe.

The theological questions raised in dealing with non-Orthodox Christians were much more complex and consequently much more indicative of Byzantine ways of thinking. Historians have traditionally focused on the dramatic events of 1054 as the culmination of East/West theological controversies. In that year, the emissary of the pope, Cardinal Humbert, disappointed at the progress of negotiations in Constantinople, placed a bull excommunicating Patriarch Keroullarios on the altar of Saint Sophia; Keroullarios in his turn excommunicated the legate of the pope along with his companions (Ex. 48). This exchange lent a new bitterness to anti-Roman polemics, though denunciations of the Latin church had been commonplace since the days of Patriarch Photios. The Byzantines' list of Latin heresies was a long one. It included using unleavened bread for the Eucharist, fasting on Saturdays, shaving the

face, prohibiting marriage among the lower clergy, rejecting the venera-
tion of images, holding that only three languages—Latin, Greek, and
Hebrew—were appropriate for the liturgy (Trilingualism), and, perhaps
most important, adding "and from the Son" (*Filioque*) to the Creed.[72] But
evidently the dispute of 1054 seemed less momentous to contemporaries
than it has to historians.[73] Psellos did not even mention it in the *Chro-
nographia*, although he praised Keroullarios for his attacks on the false
doctrines of the Latins in his funeral oration for the patriarch.[74] It did,
however, stimulate theological interchange between Eastern and West-
ern Christendom.

In 1112 Peter Grossolanus, archbishop of Milan, came to Constan-
tinople.[75] He met two of Byzantium's most conservative theologians, John
Phournos, the *protos* of Mount Ganos, and the rhetorician Niketas Seides,
in the presence of Alexios I to discuss East/West differences. Theodore of
Smyrna, the *hypatos* of philosophers, may also have been present. The
debate ended amicably, with Phournos rhetorically inviting Grossolanus
to move permanently to Byzantium (*Bibl. eccl.* 1:46.27–47.6). According
to Seides, the debates had centered on only three substantive differ-
ences: fasting on Saturday, unleavened bread, and the *Filioque*.[76] In his
discussion of the events, Theophylaktos of Ohrid narrowed the range of
critical issues even further, to the *Filioque* alone (*PG* 125.225A).

The Nicene Creed, as formulated by the ecumenical council of Con-
stantinople in 381, contained the phrase "[I believe] in the Holy Spirit
. . . who proceeds from the Father." The addition "and from the Son" is
first documented in 796 in the proceedings of a local synod held in Fré-
jus. The innovation does not seem to have been introduced into the

72. *Reg. patr.* 3, nos. 870–72. Keroullarios developed the same range of
ideas in other works, particularly a collection conventionally entitled *Panoply
against the Latins*: A. Michel, *Humbert und Kerullarios* 2 (Paderborn, 1930), 208–81.

73. P. Lemerle, "L'orthodoxie byzantine et l'oecuménisme médiévale," *Bul-
letin de l'Association G. Budé*, ser. 4, no. 2 (1965), 228–46; republished in his *Essais
sur le monde byzantin* (London, 1980), part 8.

74. S. Runciman, *The Eastern Schism* (Oxford, 1955), 64.

75. V. Grumel, "Autour de voyage de Pierre Grossolano," *EO* 32 (1933),
22–33. J. Darrouzès, "Les documents byzantins du XIIe siècle sur la primauté
Romaine," *REB* 23 (1965), 51–59.

76. Concerning unleavened bread, Ja. Pelikan, *The Christian Tradition*, vol. 2:
The Spirit of Eastern Christendom (600–1700) (Chicago and London, 1974), 177:
"Azymes became so important in the controversy as the justification for the 'real
differences.'. . . Azymes became both a useful pretext for the political and per-
sonal conflict and at the same time an appropriate expression for the religious
and doctrinal differences."

mass at Rome until the early eleventh century, although the legitimacy of the doctrine was recognized much earlier.[77] The Byzantines objected to this Western adulteration of sacred tradition. Bishop Anselm of Havelberg visited Constantinople at least twice, in 1136 and 1154, for debates with Basil of Ohrid, metropolitan of Thessaloniki, and then with Niketas of Nikomedia.[78] Basil defended the official Byzantine position on the *Filioque*, unleavened bread, and the theory of papal supremacy both in his discussions with Anselm and in his letter to Pope Hadrian IV.[79] But there is some evidence of a softening in the Byzantine position. According to Anselm, Niketas of Nikomedia was prepared to compromise by suggesting the formula, "through the Son," rather than "from the Son."[80] Furthermore, in the middle of the twelfth century, Niketas of Maronea, metropolitan of Thessaloniki, seemed prepared to accept the Latin wording. Niketas, Bessarion of Nicaea said much later, fought for donkey's shade, for he allowed the *Filioque* but at the same time regarded the addition to the Creed as unnecessary (*PG* 161.329A). In other words, Niketas's position was a political rather than a theological one, as he implied in the preamble of the dialogues he wrote "to solve the contradictions that arose between us and the Latins."[81] His theology smacks of the rationalism of the late twelfth century, admitting the possibility of accepting notions either not found in the Holy Scriptures or even those used by the heretic Latins. Niketas went so far as to recognize the hierarchical structure of the Trinity and quoted the Latin as saying that he was not going to introduce two principles, but rather he assumed that everything proceeded from the One, from the Father, while the Son played an intermediate role, linked directly to the Father and acting as the intervening medium between the Father and the Holy Spirit. In this connection Niketas employed several similes, one of which reveals the earthly essence of the *Filioque* dispute. The Latin was made to ask rhetori-

77. For a general discussion of the *Filioque*, Pelikan, *The Christian Tradition* 2, 183–98.

78. J. Dräseke, "Bishop Anselm von Havelberg und seine Gesandschaftsreisen nach Byzanz," *Zeitschrift für Kirchengeschichte* 21 (1901), 167–85; N. Russell, "Anselm of Havelberg and the Union of Churches," *Sobornost*, vol. 1, part 2 (1979–80), 19–41.

79. J. Schmidt, *Des Basilius aus Achrida, Erzbischofs von Thessalonich, bisher unedierte Dialoge* (Munich, 1901), 16–23.

80. H. G. Beck, *Kirche und theologische Literatur*, 313f.

81. *PG* 139.169A; on him see C. Giorgetti, "Un teologo greco del XII sec. precursore della riunificazione fra Roma e Costantinopoli: Niceta di Maronea, arcivescovo di Tessalonica," *Annuario 1968 della Biblioteca Civica di Massa* (Lucca, 1969), no. 117.

cally if the relationship between the *basileus*, taxiarch, and *stratiotes* implied a diarchy. Of course it does not, as the *stratiotes* obeys both the emperor and the taxiarch: while the taxiarch is subject to the emperor, the taxiarch remains the source of action and an authority for the *stratiotes*.[82] Niketas apparently accepted, for the sake perhaps of a political solution, the occidental perception of hierarchical structures, as sanctified by pseudo-Dionysios. Niketas of Maroneia was not alone in his pro-Latin religious feelings: his younger contemporary Niketas Choniates did not regard the Latins as heretics.[83]

The dialogues of Niketas of Maroneia provide some indication of why the question of the *Filioque* became the center of a heated controversy in Byzantium. The nature of the Trinity had been the focus of controversy in the Christian church since its foundation. Interpretations of the interrelationships of the three members of the Godhead formed the substance of heresies from Arianism to Iconoclasm.[84] The emphasis on subtle definition in these theological debates, including the *Filioque* question, has appeared obscurantist to some modern historians. Early scholars concerned with Byzantium tended to deride the culture for expending so much intellectual energy on such trifling issues. Beginning in the nineteenth century, these problems were treated more seriously— doctrinal controversies tended to be regarded as symbolic images of specific political concerns. Certainly the *Filioque* represented a power struggle between the Greeks and Latins concerning papal prerogatives in regard to doctrine.[85] But it might be further suggested that these disputes reflected differences in fundamental cultural values. The Latin

82. N. Festa, "Niceta di Maronea e i suoi dialoghi sulla processione dello Spirito Santo," *Bessarione*, ser. 3A, 9, no. 119 (1912), 101.28–33.

83. He uses terms such as *homopistoi* (Nik. Chon. 66.25, 70.20), *tautopistoi* (238.8), or *homodoxon* (576.94) and, as a matter of fact, ignores the disputes against the Latins.

84. H. A. Wolfson, *The Philosophy of the Church Fathers* (Cambridge, Mass., 1964), 308f.; J. Meyendorff, *Byzantine Theology* (New York, 1974), 183.

85. Recent historiography emphasizes the political substance of religious conflict. E.g., M. Ja. Siouzioumov (Sjuzjumov), "Le schisme de 1054," *Recherches internationales à la lumière du marxisme* 6 (1958), 64–68; Runciman, *The Eastern Schism*, 28–54; H. G. Beck, in *Handbuch der Kirchengeschichte*, ed. F. Kempf, H. G. Beck, et al., vol. 3, part 1 (Freiburg and Basel, 1966), 467–76; K. Böhmer, "Das Schisma von 1054 im Lichte der byzantinischen und frankisch-deutschen Beziehungen," *Sapienter ordinare. Festschrift F. Kleineidam* (Leipzig, 1969), 317–36; O. Jurewicz, *Schisma wschodnia* (Warsaw, 1969). An opposing approach, in which the "Eastern schism" is considered to be a purely philosophical and theological problem, is represented by P. Sherrard, *The Greek East and the Latin West* (London, 1959), 48–87.

dogma suggested a sequential order of descending power. This conception of the relationship among the members of the coequal and coeval Trinity mirrored the feudal mediation of power. The Greeks held that the Son and Holy Spirit both proceeded directly from the Father; this perception seems modeled on the autocratic structure of the Byzantine state. The comments made by Byzantine theologians on the matter lend credence to this parallel between the nature of power in a culture and its religious dogma. Michael Keroullarios wrote: "O Latin, cease and desist from saying that there are many principles and many causes, and acknowledge that the Father is the one cause."[86] At the beginning of the twelfth century, John Phournos wrote explicitly that the Byzantines believed in monarchy and not in diarchy (*Bibl. eccl.* 1:40.7–9; 46.1–2). To John, the Father appeared not as *one* of the Persons, but rather as a source of the Trinity and as the pledge of its unity.

While basic cultural differences between the East and the West made the religious schism between them ultimately unbridgeable, there were congruences in their ways of thinking. Most notably, an emergent rationalism is apparent in the arguments of both the Latins and the Greeks. The conservative reaction to the more daring Byzantine thinkers suggests that rationalism and its tenets might have been ascribed to Western influence. Nicholas of Methone charged Soterichos with heretically accepting "the doctrines of alien tribes." Soterichos was further denounced as having smitten the church with the dogmas of alien peoples, like stones from a sling (*Logoi dyo* 2.16–17). Nicholas further alluded to Soterichos's foreign connections when he associated the destruction of the hated theologian with Manuel's predicted victories over the barbarians (44.27–45.1; also see 72.6–9). Unfortunately, as Soterichos's dialogue is lost, it is impossible to determine to what degree his rationalism might be connected with Latin scholasticism.

There is also some evidence that Byzantine theological debate was affected by Western controversies. In the West in the 1160s, Gerhoh of Reichersberg repudiated the teachings of Gilbert de la Porrée, who held that Divine Nature was a concept of the human mind and that only the Persons were real. Demetrios of Lampe, a Byzantine diplomat in Europe, wrote a treatise, now lost, concerning this debate, relating that there were Latins who regarded Christ as both equal and unequal to the Father. This treatise seems to have given impetus to Byzantine theological discussions, particularly those of the Council of Constantinople of

86. *Panoplia*, ed. A. Michel, in *Humbert und Kerullarios* 2, 62.1; quoted in Pelikan, *The Christian Tradition* 2, 197.

1166, which focused on the interpretation of the Gospel phrase "My Father is greater than I" (John 14:28). Those explanations of this text that held that Christ was "less" than the Father because of his capacity to assume human form in the incarnation and to co-suffer with humanity were found to be orthodox, while those that emphasized the divine in Christ and the coequality of the Father and the Logos and insisted on the conventional rather than substantial link of Christ to humanity were found to be heterodox.[87]

The twelfth century was not just a period of schism, but also one of revived theological contacts. It was by no means fortuitous that John of Damascus was discovered by the West in the twelfth century, nor that numerous translators of Greek appeared at that time, including Moise of Bergamo, Jacob the Venetian, Burgundion of Pisa, and others.[88] These contacts were not limited to sophisticated theologians. Dualistic heresies in the West may have been stimulated by adherents in the Byzantine East. Paulicians, Bogomils, Phoundagiagitai, and others had had a place in Byzantium. Further, Western heretics were known by the Greek word cathars (literally, "the pure"). Émigrés from Byzantium were recognized as having played an important role in the Cathar movement: for instance, the Cathar "bishop" Niquinta (Niketas), who appeared as the supreme authority at the assembly of Cathars held in the town of St. Félix de Caraman in 1167, came from Constantinople. Some of the mysterious "seven churches of Asia," which the European Cathars considered as models, were located in Philadelphia, Bulgaria, and Dalmatia. Other churches mentioned bear Slavic names, such as Dragometia (Dragovitia in the region of Thessaloniki) and Melengyia (evidently connected with the Slavic tribe of the Melingoi in the Peloponnese).[89]

Despite these contacts, fundamental societal differences between the East and the West gave rise not only to theological distinctions, but also to more functional disagreements in religious practice and religious thought. The Western church was a potent political body with wealth,

87. On the Council of 1166, P. Classen, "Das Konzil von Konstantinopel 1166 und die Lateiner," BZ 48 (1955), 339–68, and also A. Dondaine, "Hugues Ethérien et le Concile de Constantinople de 1166," Historisches Jahrbuch 77 (1958), 473–83.

88. A. Dondaine, "Hughes Ethérien et Léo Toscan," Archives d'histoire doctrinale et littéraire du Moyen Age 19 (1952 [1953]), 79. See also Ch. Haskins, "The Greek Element in the Renaissance of the Twelfth Century," American Historical Review 25 (1920), 603–15, and especially M. V. Anastos, "Some Aspects of Byzantine Influence on Latin Thought," Twelfth-Century Europe and the Foundations of Modern Society (Madison, Milwaukee, and London, 1966), 137–63.

89. M. Loos, Dualist Heresy in the Middle Ages (Prague, 1974), 127–29.

power, a well-organized bureaucracy, and a considerable degree of independence. In the East, in contrast, the patriarch was inevitably in the shadow of the emperor. The Orthodox church never adopted the apparatus of the secular state. Further, it seems that the Roman church tended to compensate for its widespread assumption of secular functions by emphasizing its priestly nature and by insisting on its separation from the laity. During the eleventh and twelfth centuries celibacy was forced upon the clergy of the West; in the East only monks and bishops had to remain unmarried.[90] The clergy in the West reserved the eucharistic wine for themselves from the twelfth century, a custom challenged during the Reformation. In the East, the laity continued to receive both elements of the sacrament. The church in the West appropriated the seven sacraments as the principal means to salvation. Such doctrine was introduced under Western influence in the East only in the thirteenth century.[91] Even more obvious an instrument of church control over the gates of heaven was the indulgence, whereby the sinner could redeem his sins and insure a place in paradise by paying the price required by the temporal church. While the efficacy of good works and the prayers of others was certainly recognized by the Orthodox, indulgences were unheard of. The Western, quantitative attitude toward judgment was also reflected in the concept of purgatory as a place of account settling;[92] such a region is absent from the Byzantine vision of the hereafter. Perhaps the most fundamental of the Western church's means of self-segregation was its insistence on Latin as the sole vehicle of liturgy in areas under its jurisdiction. Vernacular language was anathema. Language and not the rood screen separated the officiating priest from his people. The Orthodox church, in contrast, accepted translation of sacred texts as a necessary adjunct of conversion. The liturgies of St. John Chrysostom and St. Basil are found in Coptic, Syriac, Georgian, Armenian, Old Church Slavonic, and other languages. While the Byzantines may well have regarded Greek as the best of liturgical languages, given as they were to cultural snobbery, they never embedded their prejudice in dogma. Finally, the Latin sense of political preeminence was embodied in the con-

90. B. Kötting, *Der Zölibat in der alten Kirche* (Münster, 1968).

91. On Eastern ecclesiastical doctrine, K. Onasch, *Einführung in die konfessionskunde der orthodoxen Kirchen* (Berlin, 1961); J. Meyendorff, *Byzantine Theology* (New York, 1974).

92. J. Le Goff, *La naissance du Purgatoire* (Paris, 1981), argues that purgatory was an idea generated in the twelfth century in connection with the radical changes in jurisprudence (esp. p. 285f.). In contrast, A. Gurevič, *Problemy srednovekovoj narodnoj kul'tury* (Moscow, 1981), assumes that the general pattern of purgatory can be discovered even in some early medieval visions.

cepts of the universal church and of papal primacy: Christendom was to be overseen from the throne of St. Peter. Indeed, this conception of papal power is the spiritual and Western equivalent of the secular and Eastern ideology of *imperium*. Not surprisingly, the Orthodox church had a different view of ecclesiastical authority. It enjoined a pentarchy, the rule of the five patriarchs of the church, the bishops of Rome, Constantinople, Antioch, Alexandria, and Jerusalem.[93]

The Western church's tendency to assert its power by separating itself from the people and ritualizing access to the divine has a physical correspondent. The great religious edifices of the eleventh and twelfth centuries in the West impose a certain anonymity on the worshiper as well as inspire awe in the individual. The very size of these monuments dwarfs the laity into insignificance (Fig. 40). Even with the richness of their original liturgical furnishings reconstructed in one's imagination, these structures are not intimate personal spaces. Similarly, Romanesque decoration is large-scale, its bold, simplified forms perfectly suited to its characteristic medium, stone. A viewer may feel horror and pity, even amusement and revulsion mixed with an admiration of craft, when confronting Romanesque cloister sculpture or a great portal such as that at Vézelay (Fig. 35). St. Bernard makes this point in his famous denunciation of images:

> But in the cloister, under the eyes of the Brethren who read there, what profit is there in those ridiculous monsters, in that marvelous and deformed comeliness, that comely deformity? . . . In short, so many and so marvelous are the varieties of diverse shapes on every hand, that we are more tempted to read in the marble than in our books. . . . (*PL* 182.914–16)

The marvelous monstrosities of the West express a faith in unknowable, suprarational power. God is above nature and cannot be rendered as human, but only as ecstatic creative power. In contrast, God is more accessible in a Byzantine church. The scale of these monuments is diminutive, even when lavishly patronized. In contrast to the great, broad rhythms of the many-bayed Romanesque basilica, the varied vaults of a centralized Byzantine church reach a crescendo not too far above the worshiper. Not only is the space intimate, but the diversity of its curvilinear planes and the irregularity of its parts make its proportions more human (figs. 16 and 41). The screen (*templon*) between the congregation and the officiant remained low—a physical but not a visual

93. H. M. Biedermann, "Zur Frage der Synode in der orthodoxen Theologie," *Ostkirchliche Studien* 16 (1967), 121f.; C. Papoulidis, "La place de l'empereur à Byzance pendant les conciles oecuméniques," *Byzantina* 3 (1971), 130.

barrier between the laity and the sacraments.[94] The imagery of the decorative program is recognizably rational, representing an unraveling of the divine scheme. Christ Pantokrator, the Almighty, is depicted usually as a bust in a great medallion in the central dome, "leaning and gazing out as though from the rim of heaven" (Nic. Mesar. 869). God is superhuman but still clearly the prototype of our own image. Below in the real spatial hierarchy of the church are the ordered ranks of the spiritual elite: the Virgin, prophets, apostles, and familiar saints. The style of these icons, like their arrangement, is reassuringly understandable. Although idealized through abstraction, the figures in Byzantine art are recognizably human in their proportions, expressions, and interactions (Fig. 33). Icons never appeal to base emotions. Secular art might be criticized in Byzantium, but there was nothing in Eastern religious images to inspire such spectacular denunciations as Bernard of Clairvaux's.

What do these differences in religion show about their respective cultures? There were, to be sure, different relations between the pious believer and God in the East and in the West. Latins tended toward the institutionalization of spiritual life, just as they tended toward strong communal structures in their material and political existence. This institutionalization in the church ultimately became oppressive, just as did outmoded political and social forms of organization. Old modes were shattered and restructured under the Protestantism of the Reformation and the Catholicism of the Counter-Reformation. The absence of *vincula* within religious life in the East perhaps meant greater individualism.[95] But because of this relative flexibility of the state religion to accommodate the individual, the reaction to traditional practices, when it came in the fourteenth century, was both less dramatic and less effective than that in the West.

By the twelfth century there was a rift between the orthodoxies of the East and the West, though not so sharp as it seemed during the confessional disputes of the nineteenth century. Efforts were made to close

94. C. Mango, "On the History of the Templon and the Martyrion of St. Artemios at Constantinople," *Zograf* 10 (1979), 40–43; A. W. Epstein, "The Middle Byzantine Sanctuary Barrier: Templon Screen or Iconostasis?" *Journal of the British Archaeological Association* 134 (1981), 1–28.

95. On the access of the individual to God in Orthodox Christianity, V. Lossky, "The Problem of the Vision Face to Face and Byzantine Patristic Tradition," *The Greek Orthodox Theological Review* 17 (1971), 253f.; *Vision de Dieu* (Neuchatel, 1962), 118–25; *The Mystical Theology of the Eastern Church* (London, 1957); *In the Image and Likeness of God* (New York, 1974). Also see M. Lot-Borodine, *La déification de l'homme selon la doctrine des Pères grecs* (Paris, 1970), 177–82.

the gap, but typically these exercises were undertaken by the emperors and their minions. Political purposes molded the theology of these men, or at least so it seemed to their more conservative contemporaries. But as the cultural differences lying behind the religious ones remained unchanged, these attempts at reconciliation came to nought. In religion, as in other areas of society, the influence of foreign cultures was largely felt only by an intellectual and political elite at the core of the empire and, through direct contact, by the provincials at its periphery. Despite the economic and political pressures on the Byzantines to become integrated into the European system in the eleventh and twelfth centuries, the traditional prejudices against foreigners persisted. This residual disdain toward other cultures is nowhere more clearly articulated than in the conservative position maintained by Eastern Christian theologians.

· VI ·

MAN IN LITERATURE AND ART

ARTIST, AUDIENCE, AND OBJECT

A modified position of man in literature and art also reflects fundamental changes in Byzantine society from the seventh through the twelfth centuries. As in so many other areas of Byzantine culture, this is not a revolutionary development; it evolves from the conservative to the less conservative. Nevertheless, the shift provides a rare, intimate insight into the consciousness of the individual in Byzantium, as obviously embodied in the works of exceptional writers and artists. But the subtle changes of attitude found in the best literature and art of the period are not simply expressions of the genius of their creators. The artists' perceptions were affected by shifts in their relationships to both their subjects and their audiences.

The literary audience may have significantly expanded during the twelfth century. Works seem to have been written to establish reputations as well as to please patrons. A treatise by Michael Choniates, metropolitan of Athens, rhetor and epistolographer, not only reflects the ambiguous attitude an artist might have toward his public, but also indicates something of the nature of his constituency. Michael put forward two perspectives on the artist's obligations to his audience. According to the first the artist should present his work for the judgment of the thousand-eyed throng that will applaud its perfection or censure its ineptitude (Mich. Akom. 1:12.16–17). Those who refrain from public displays of their creations will, lacking stimuli, lose their ability to mold masterpieces (13.12–13). But Michael actually prefers the second, opposing, position. Public exhibition of one's work is without purpose. Genuine wisdom is never inspired by vain applause. Would noisy praise draw from a swan a more beautiful song? Would eulogies increase the strength of the lion? Similarly, human genius is not stimulated by praise or

criticism, but arises from virtue and a knowledge of good (21.16–22; 22.9–11).

While the literary audience of the twelfth century may have expanded somewhat, it must have remained small in relation to the population. Such considerations as the cost of book production and the expense of education kept the reading public a select few.[1] Any conclusions drawn about the nature of self-consciousness from change in literature alone leaves open a basic question: does this shift represent a development within an exclusive, elite group or does it evidence a broader cultural phenomenon? The consideration of a second medium—art, particularly monumental art—might provide a measure for the first. The number of patrons of religious painting throughout the empire was relatively large. Not only emperors and lords, archbishops and abbots built and decorated churches, but also minor provincial officials, local holy men, and even conglomerates of peasants founded and frescoed ecclesiastical structures.[2] Perhaps more importantly, monumental religious art that was produced on behalf of patrons of whatever social order often had a broad audience. The works of the court historians and poets are fundamentally elitist; the monumental paintings of monasteries and congregational churches are less so. One observation is, consequently, worth making. A large number of luxury manuscripts, including the famous Joshua Roll (Vat. Palat. gr. 431), the Paris Psalter (Páris. gr. 139), and the Leo Bible (Vat. Reg. gr. 1), may be dated to the middle of the tenth century, but very few major monuments with figural programs seem to have been constructed during that period. In the eleventh century, however, numerous large decorated buildings appeared both in the provinces and in the capital; new or refurbished works such as St. Mary Peribleptos, SS. Kosmas and Damian, and St. George of the Mangana in Constantinople and Hosios Loukas in Phokis, the Nea Moni on Chios, St. Sophia in Ohrid, and Daphni near Athens in the provinces. This apparent change of artistic emphasis from the minor to monumental arts may, then, be related to a broadening of the audience for art similar to that for literature.

1. On the book as a luxury object, K. Treu, "Griechische Schreibernotizen als Quelle für politische, soziale und kulturelle Verhältnisse ihrer Zeit," *Byz. Bulg.* 2 (1966), 139; N. G. Wilson, "Books and Readers in Byzantium," *Byzantine Books and Bookmen* (Washington, D.C., 1975), 3.

2. On monasteries built by or with the help of peasants, N. A. Skabalanovič, *Vizantijskoe gosudarstvo i cerkov' v XI veke* (St. Petersburg, 1884), 433f. Also A. Guillou, "L'organisation ecclésiastique de l'Italie byzantine autour de 1050: de la métropole aux églises privées," *Le istituzioni ecclesiastiche della "Societas Christiana" dei secoli XI–XII* (Milan, 1977), 314–15.

If literature and art reflect a change in the relationship between artist and audience, they also embody a shift in attitude toward the object. Writers continue to subscribe to the Neoplatonic, pseudo-Dionysian concept of the imàge as a means of access to its divine prototype. This theory of images had been formulated and thoroughly inculcated among the Orthodox during the Iconoclastic controversy.[3] There was, however, an increasing interest in the relationship between the image and its physical model. These two distinct interpretations of the generation of an image were reconciled easily by Psellos.[4] The first mode was intellectual and interpretive; it revealed the symbolic content of the image (*Scripta min.* 2.208.5–19). The second mode of perception was direct sensation. Psellos wrote, "I am a great connoisseur of icons, one of which [an image of the Virgin and Child] particularly ravishes me; as a bolt of lightning, it strikes me with its beauty, depriving me of strength and reason. . . . I do not know," he continued, "whether or not the image reveals the identity of its supersubstantial original; I behold, nevertheless, that the layering of paints reproduces the nature of flesh" (*Scripta min.* 2.220.19–221.13).

Michael Choniates showed a similar appreciation of physical reality in reviving Zeuxis's ancient formula for artistic production: the gifted sculptor fashioned the image of an ideal woman from the best features of local beauties. Through careful selection from nature, the artist contrived perfection (Mich. Akom. 1:171.17–23). While this notion of creation was obviously a *topos* drawn from antiquity, its revival in Michael's work must reflect something of his own attitude toward artistry. That Byzantine writers drew parallels between the visual media and literature is perhaps most touchingly demonstrated in St. Neophytos's preface to his ascetic canons, in which he compares his words to the painter's pigments being built up to form the image of God:

> You, brethren, in my desire for you to be ascetics by practice and by word, remember the work-loving painters who, desiring to complete the drawn image, not sparing colors but laying these on thinly, enlighten the image, even binding in the colors. And I, according to the similarity of these [things], [find] many resemblances between colors and words, arising from the festal signs, from the catechism, from the letters, from penance, and from the constitution of the *typikon*. So in place of pigments, presenting a depiction by means of the canons, in

3. J. Meyendorff, *Byzantine Theology* (London, 1974), 42–53; L. Bernard, "The Theology of Images," *Iconoclasm*, ed. A. Bryer and J. Herrin (Birmingham, 1975), 7–13; L. Ouspensky, *Theology of the Icon* (Crestwood, N.Y., 1978).
 4. V. V. Byčkov, *Vizantijskaja estetika* (Moscow, 1977), 35–41.

this manner we ascend anew with the aid and grace of Christ to the beautiful archetype through the image of God, from whom we will not be separated.[5]

And again in the *vitae* of SS. Christopher and Makarios of Sicily, written by Orestes, patriarch of Jerusalem (968–1005/6), the art of painting was used as a simile for monastic life: "Painters, while they are compiling images on icons, look intently at ancient models. The brethren acted in the same way: when they would create the beauty of virtue in themselves, they gazed at St. Christopher."[6]

An eloquent suggestion of the artists' interest in real models is found in the anonymous biography of the Peloponnesian saint Nikon the Metanoeite. This holy man died during Basil II's reign, but his *vita* appears to have been written a couple of generations later.[7] The story goes that a certain John Malakenos, member of the Constantinopolitan senate, desired an icon of the deceased Nikon. He commissioned a skilled painter to make the icon, but since the artist had never met Nikon, John had to describe the saint's appearance. Despite his efforts, the painter could not produce a satisfactory image. "Even though he was highly experienced in his vocation, he was unable to make with precise similarity the image of the man, whom he had never seen, only on the basis of a description." He was frustrated in his efforts until aided by a miracle: a monk entered his house and asked the cause of his distress. After the artist explained his problem, the monk declared, "Look at me, brother. I quite resemble the man whom you are to depict." The artist looked at his guest, and indeed, he was amazed by the identity of the monk's face and John's description. He rushed to his panel to draw the features of the thrice-blessed, but when he stopped for a moment and looked around, the monk had vanished.[8] There was, then, evidently a new interest in natural reality, as is reflected in elaborate description and in the effort to find a concrete means of conveying impressions.[9]

Not only did the treatment of the object in literature change; subject matter did also. Hagiography, the leading literary genre in the ninth and

5. I. P. Tsiknopoullos, ed., *Kypriaka typika, Pegai kai meletai tes Kypriakes historias* (Nicosia, 1969), 94.

6. *Historia and Laudes SS. Sabae et Macarii*, ed. G. Cozza-Luzi (Rome, 1893), 84.29–36. See also C. Van de Vorst, "La vie de S. Evarist, higoumène à Constantinople," *AB* 41 (1923), 295.7–9; 296.3–6.

7. *Vita* of S. Nikon, ed. S. Lampros, *Neos Hellenomnemon* 3 (1906), 189.27–31.

8. *Vita* of S. Nikon 179f.

9. The resemblance between a real saint and her icon is also emphasized in the life of Eirene of Chrysobalantos: *AASS* Julii VI, 629A–630D.

tenth centuries, lost its vitality from the second half of the eleventh cen-
tury. The last great example of eleventh-century hagiography is the *vita*
of St. Lazarus of Mount Galesios (d. 1054), compiled by his pupil, the
kellarites Gregory.[10] It consists of a set of short fabliaux full of insight into
contemporary monastic life. The *vita* was designed to demonstrate the
triumph of piety over demons and crooks, but it simultaneously pre-
sents the variegated characters of the many brethren at their chores. It
also reflects upon their naive beliefs and superstitions.

Ossification of hagiography sets in despite the fact that literary fig-
ures such as Psellos, Nicholas Kataskepenos, Prodromos, Nicholas of
Methone, Eustathios of Thessaloniki, and John Tzetzes worked in the
genre.[11] Kataskepenos's *vita* of Cyril Phileotes, written soon after the
saint's death at the beginning of the twelfth century, is typical. Every fact
in the biography is presented amid numerous patristic quotations: sche-
matization squeezed all the life out of the essay. Moreover, hagiography
was scorned under the Comneni (see Chapter 3). Leontios of Jerusalem
seems to have been the only twelfth-century saint whose contemporary
vita has survived in Greek (apart from Greek monastic saints of Norman
southern Italy). Similarly, hymnography declined somewhat in quality
in the twelfth century. Few hymns were written; those that were, includ-
ing some by John Mauropous,[12] tended to lack expressiveness. This may
be explained partially by the fact that the liturgy was "canonized"
in the eleventh century:[13] further ornament was evidently considered
unnecessary.

While hagiography and hymnography grew less effective as genres,
romance became increasingly popular. Byzantine writers of the twelfth
century developed their themes in accordance with antique tradition,

10. On this life, I. Ševčenko, "Constantinople Viewed from the Eastern
Provinces in the Middle Byzantine Period," *Harvard Ukrainian Studies* 3–4, part 2
(1979–80), 723–26, now in his *Ideology, Letters and Culture in the Byzantine World*
(London, 1982), part 6.

11. A survey is found in H. G. Beck, *Kirche und theologische Literatur im Byzan-
tinischen Reich* (Munich, 1959), 587–91, 638–41. To add to his list are the newly
published E. Sargologos, *La Vie de Saint Cyrille le Philéote moine byzantin* (Brussels,
1964), and P. Joannou, *Démonologie populaire—démonologie critique au XIe siècle. La
vie inédite de S. Auxence par Michel Psellos* (Wiesbaden, 1971). The life of Leontios
of Jerusalem was composed by Theodosios of Patmos at the beginning of the
thirteenth century: W. Hecht, "Der Bios des Patriarchen Leontios von Jerusalem
als Quelle zur Geschichte Andronikos' I. Komnenos," *BZ* 61 (1968), 40–43.

12. On Mauropous, A. Karpozelos, *Symbole ste melete tou biou kai tou ergou
tou Ioanne Mauropodos* (Ioannina, 1982).

13. H. J. Schulz, *Die byzantinische Liturgie* (Freiburg i. B., 1964), 131.

unlike their Western counterparts, to whom myth and legend were much more important. Ancient erotic romances had long been read in Byzantium and had been cautiously interpreted as allegories of the soul's longing for God.[14] In the twelfth century, however, contemporary romances began to be written in greater numbers. But the evolution of the Byzantine romance in the twelfth century is difficult to trace in detail, as no precise chronological sequence can be established. One of the earliest of these romances seems to have been Eumathios Makrembolites' prose tale *Hysmine and Hysminias*.[15] Prodromos's *Rodanthe and Dosikles* and the romances of Niketas Eugenianos and Constantine Manasses probably came later. The romancelike plot of Nikephoros Bryennios's *Memoirs* might, in fact, have been the first of the series. Although *Memoirs* (written in the first quarter of the twelfth century) was presented as a history of the late eleventh century, it was cast externally in the form of a conventional Greek romance. The marriage of the future emperor Alexios Comnenus and Eirene Doukaina forms the core of the tale. After overcoming many obstacles set in their way by their families, "the comeliest youth wedded the comeliest girl" (Bryen. 223.5). Thus even an aristocratic chronicle was part of the developing genre. A new sensuousness, too, if not eroticism, appeared in Byzantine literature, corresponding to the new popularity of literary romance. For instance, *What Did Pasiphaë Say When the Bull Fell in Love with Her* is a *progymnasma* written, surprisingly, by an anonymous cleric at St. Sophia.[16]

The plot of Prodromos's *Rodanthe and Dosikles* depended in part on the ancient novel by the third-century Heliodorus of Emesa and in part on Makrembolites. When Dosikles met the beautiful Rodanthe, she was already betrothed to another man, and her parents did not wish to break their promise to him. Here again, as in Nikephoros Bryennios's tale, family obstacles formed the pivot of the romance. Dosikles kidnaped his beloved and fled with her from Abydus to Rhodes, only to be captured there by pirates. The pirate ship on which Rodanthe was carried away

14. S. V. Poljakova, *Iz istorii vizantijskogo romana* (Moscow, 1979), 36–55. The dates of Philip the Philosopher, who composed an allegorical interpretation of Heliodorus's *Aithiopika*, are disputed. B. Lavagnini, "Filippo-Filagato e il romanzo di Eliodoro," *EEBS* 39–40 (1972–73), 457–63, identifies him with Philagathos, the Greek writer of the twelfth century from southern Italy. H. Hunger, *Die hochsprachliche profane Literatur der Byzantiner* 2 (Munich, 1978), 121, dates him to the fifth century.

15. S. V. Poljakova, "O chronologičeskoj posledovatel'nosti romanov Evmatija Makremvolita i Feodora Prodroma," *VV* 32 (1971), 104–8; Hunger, *Die hochsprachliche profane Literatur* 2, 137–42.

16. H. G. Beck, *Das byzantinische Jahrtausend* (Munich, 1978), 146.

capsized; she was rescued from the wreckage to which she clung, only to be sold into slavery in Cyprus. Dosikles in the meantime was to be offered as a sacrifice to the gods, but was saved by a miracle. He arrived in Cyprus, found Rodanthe, but her owner, Myrilla, who had fallen in love with Dosikles, frustrated his attempt to free her. Myrilla, in jealousy, poisoned Rodanthe, but, again miraculously, Dosikles discovered an herb and cured her. While all this was happening, the Delphic oracle advised the lovers' fathers to travel to Cyprus; there they delivered the pair from their trials and arranged a gala wedding. As in other Byzantine romances, the action in *Rodanthe and Dosikles* occurs in a two-dimensional space. Throughout the genre, even when real places provide the stage for events, they have no distinctive character. For instance, Makrembolites' romance begins with a description of the city of Eurykomis, which, wrote the author, "is rather lovely, since it is surrounded by the sea, and rivers flow along and meadows bloom and it abounds with various pleasures. The city is also very pious, even more than the golden Athens—it is a perfect altar, a perfect sacrifice, a present to the gods."[17] The time is conventional as well: the story is a mechanical sequence of episodes, adventures, miracles, dangers, and so on, that could as readily be added to as subtracted from, because nothing affected the characters in any way. The hero and heroine are flatly rendered. From the moment they are inflamed with love for one another no change occurs.

Within this conventional scheme, however, twelfth-century concerns and problems were represented. Some details come to life; for example, Prodromos's description of a naval battle. Bryaxes, one of the commanders, ordered "courageous divers" to attack the enemy vessels from below:

> And the divers whom I have mentioned above,
> They swam under the ships with their hammers
> And they damaged the joints underneath,
> And many perished without hope.[18]

This probably reflects tactics actually used in Byzantium.[19] Further, the social milieu presented in Prodromos's romances was the same as that eulogized in his poems and speeches, as well as in Bryennios's *Memoirs*. The heros were noble and military. Dosikles' father was titled a great *strategos*, and Dosikles himself was described as having been brought up

17. *Erotici scriptores Graeci*, ed. R. Hercher, vol. 2 (Leipzig, 1859), 161.1–5.

18. *Erotici scriptores* 2, 370, chap. 6.32–35.

19. H. Hunger, "Byzantinische 'Froschmanner'?" *Antidosis. Festschrift für W. Kraus* (Vienna, Cologne, and Graz, 1972), 184f.

in battles. The *"basileus"* Bryaxes offered a warrior's moral code: victory never quenches a true soldier's thirst for new conquests; internal quarrels must be avoided; the enemy's stratagems must be guarded against, although a genuine knight would not himself stoop to military trickery; flight from a battlefield is unimaginable—it is better to be bravely slain than to escape in a cowardly manner, only to live miserably in shame and derision. Bryaxes even spoke of a just war and prohibited his soldiers from plundering.[20]

Historiography was transformed. During the ninth and tenth centuries, history was largely a matter of compiling events from the beginning of time to the present. Theophanes, the greatest historian after the murky gap of the eighth century, continued Synkellos's chronicle, which began with Adam and chronicled the main occurrences in Byzantine history year by year from 284 to 813. The events recorded within annual entries were often connected to each other randomly; the chronological sequence was assumed to have determined the inner order of the story; earthquakes and births of monsters were duly inserted into the story of wars and religious disputes. This dry, factual recording predominantly of remote events was ultimately superseded by narratives of the personally experienced, recent past. The first of these personal histories was the *Chronographia* of Psellos. Quite probably Psellos began writing a conventional chronicle covering the period from Romulus to Basil II's reign. As he came close to the date of his birth (1018), however, he changed his style. The *Chronographia*, which strangely enough has no traditional proem (perhaps Psellos meant it to be attached to the earlier chronicle), was freely structured—not according to the stream of time but around major characters: Psellos aimed not to reveal the sequence of political and military happenings but to create images of heroes. Even though emperors and empresses occupy central positions in his narrative, Psellos was detailed and eloquent in his descriptions of lesser personages as well.[21]

The close connection between the narrated past and the experienced present was exposed in an exceptional letter written by Psellos to a certain Machetarios, *droungarios* of the *vigla* (guards). "I compiled my *Chronographia*," wrote Psellos, "and mentioned there noble men, among

20. Braxes' speech, *Erotici scriptores* 2, 357–66, chap. 5.115–414.

21. On the *Chronographia*, Ja. N. Ljubarskij, *Michail Psell. Ličnost' i tvorčestvo* (Moscow, 1978), 175–229. Also R. Anastasi, "Sulla *Chronographia* di Psello," *Studi di filologia bizantina* 1 (1979), 27–36; St. Linner, "Literary Echoes in Psellus' *Chronographia*," *Byz.* 51 (1981), 225–31.

whom you've got first place, as a man of lofty mind and of open speech, and as my friend. But you are offending me. What should I do now? Should I write something different? Certainly not; our friendship is a pledge—but you must stop your assaults" (Sathas, *MB* 5:352.11–14 and 25–29). We have the means of judging Psellos's sincerity: Machetarios is not mentioned in the text of the *Chronographia*. His name was deleted; apparently he did not cease in his offenses to the author.

Paradoxically, Psellos's work does not seem to have influenced his near contemporaries Zonaras and Skylitzes. In fact, Skylitzes proclaimed himself to be Theophanes' successor. Like Theophanes, Skylitzes recorded the battles, earthquakes, and plagues that beset Byzantium. Only at the end of the *Historical Synopsis* did he compose several excursuses on various topics, including, for instance, the ethnography of the Pechenegs and the Seljuks. The figures of his narrative are in any case two-dimensional; they are presented flatly as either good or bad. Zonaras's *Historical Epitome* was more ambitious and more learned than Skylitzes' work, covering the world's development from the Creation to 1118 A.D., with numerous references to ancient authors; it lacks, however, a critical historical framework. But the annalistic approach to history of the chroniclers who wrote after Psellos was already outmoded.[22] After Zonaras in the twelfth century, universal chronicles were no longer a serious genre but a literary pastime. Events were versified, as in Constantine Manasses' *Historical Synopsis*, or they were intermingled with didactic or theological discourses, as in Michael Glykas's *Chronicle*. Eventually Psellos's "new history" was accepted by Byzantine historians of the twelfth century.

As in literature, an evolution in art took place within a relatively narrow spectrum of formal possibilities. The content or iconography of monumental images was carefully circumscribed by tradition. Nevertheless, painting does seem to offer at least crude parallels to contemporaneous developments in literature. For instance, secular themes, as discussed in Chapter 3, became increasingly prominent. Unfortunately, because of the vicissitudes of history, virtually nothing remains of the monumental frescos and mosaics that once decorated palaces and public buildings. Although from the written sources it appears that the figural elaboration of secular structures became important, especially in the twelfth century, it goes without saying that the enrichment of religious

22. The influence of the city annals of Constantinople can be traced in Byzantine historical writing until Skylitzes: P. Schreiner, *Studien zu den Brachea Chronika* (Munich, 1967), 123f.; *Die byzantinischen Kleinchroniken* 2 (Vienna, 1977), 45.

foundations both artistically and architecturally remained as always a central object of patronage.[23] Consequently, we must depend on traditional forms of church decoration and religious art to provide the stylistic and iconographic reflections of social change in Byzantium. The changing relationships between the artist, his audience, and his object modified the form and subject matter of both art and literature in the eleventh and twelfth centuries. These modifications may be most clearly discerned by analysis of three overlapping categories of change: from the ideal to the ordinary, from the impersonal to the personal, and from the abstract or conventional to the natural.

FROM THE IDEAL TO THE ORDINARY

The didactic literature of the ninth and tenth centuries was predominantly characterized by two images—that of the emperor and that of the holy man. They presented for imitation the extraordinary ideal, although that ideal was unobtainable. The stereotypical renderings of types were meant as unambiguous portrayals of good and evil. There was no sympathy for the everyday emotions and problems of the average human being. Ideal behavior was represented in remote and unapproachable types. While prose may have impressed its audience with the moral superiority of its heros, it did not invite emulation. Even in hagiography, which supposedly provided a model for living, figures were superhuman in their proportions. The writer taught his reader only how to be an ideal hermit or an ideal king. Three princely mirrors of this period are connected with the person of Basil I, a Thracian peasant of Armenian stock who wormed his way to imperial power—a typical figure of Byzantine society of the ninth century. One of them is falsely ascribed to Basil himself, another is the funeral speech in his honor produced by his educated son and successor, Leo VI, and the third is Basil's biography written by his grandson Constantine VII or by one of Constantine's aides.

Although the genre of princely mirrors did not vanish—Theophylaktos of Ohrid addressed his treatise on the qualities of the ideal ruler to the heir apparent—from the eleventh century on, the addressee of didactic admonitions changed: attention was paid to the norms of behavior of ordinary people. Symeon the Theologian, the first in a series of social instructors, worked still within the framework of tradition; in his sermons he addressed monks and dwelt primarily on the topic of salva-

<hr />

23. P. Magdalino and R. Nelson, "The Emperor in Byzantine Art of the Twelfth Century," *Byz. Forsch.* 8 (1982), 123–81.

tion. But the intensity of his moral inculcations was so exceptional and the principles of human demeanor as it was presented by Symeon so closely resembled the admonitions of secular authors his junior that we may regard Symeon as the founder of a new approach. Symeon's moral doctrine stressed the individual way of salvation and the rejection of such social ties as the family and friendship; he required also a complete self-subjugation to God and—on the earth—to one's spiritual father.

A generation later appeared Kekaumenos's *Advice and Admonitions* and Symeon Seth's *Stephanites and Ichnelates*, supposedly directed at courtly courtesans, and at the beginning of the twelfth century the anonymous versified *Didactic Admonitions*, known commonly as *Spaneas* (the meaning of this title is unclear), written for a yet-unidentified Byzantine aristocrat. These works were by no means radically innovative in their form or in their content, but their attention to the problems of individual behavior provides some evidence of a change in social consciousness. The *Spaneas* perhaps most directly addressed lay persons, admonishing them to appreciate wisdom and wealth, to be indulgent with friends, relations, and paupers. The basic philosophy was the simple medieval wheel-of-fortune one—be kind to the poor, for soon you may be counted among them. But virtue here does seem to have taken on a new dimension. It was no longer simply a matter of proper actions: virtue, for the anonymous author of the treatise, seems to have been equated with learning, though in a prosaic, pragmatic manner. Learning cannot be taken away from you; learning might allow you to resolve a difficult problem and thereby bring you acclaim.[24] Indeed, much of the advice provided in the *Spaneas* was banal: be merciful to your own adversaries, but punish those who injure someone else; praise honesty, but never flatter; avoid excessive drinking as it upsets the stomach, makes the soul gloomy and the body puny; abstain from raucous laughter. Byzantine reality is better seen in the *Spaneas*'s advice to denounce others: those who hear blasphemy or slander of the emperor and do not inform the authorities should be punished. Further, the *Spaneas* advised its readers not to be critical but rather to praise people in the hope of acquiring friends.[25] Human relations as conceived in the *Spaneas* are informed by caution and ritual, not by frankness and feeling. Certainly the relationship between the individual and God was still much

24. W. Wagner, *Carmina graeca medii aevi* (Leipzig, 1874), 8.172–77; E. Legrand, *Bibliothèque grecque vulgaire* 1 (Paris, 1869), 4.106–11.
25. Wagner, *Carmina* 4.76–78, 12.270; Legrand, *Bibliothèque* 1, 1.15–21, 5.138–39.

more important than that between people, and the emperor was revered as the living image of God.[26] Nevertheless, the *Spaneas* indicates that human behavior had become a subject worthy of literary consideration by the eleventh century.

Kekaumenos's *Advice and Admonitions* advanced the humanizing tendencies of eleventh-century literature. The etiquette of this treatise is indistinguishable from that of other moralizing works, but in contrast to theirs, its stereotypical admonitions seem to have been informed by the author's experience. The work certainly did treat the emperor and the patriarch, but in fact it primarily considered the laity—courtiers, civil servants, military leaders, and provincial landlords. Kekaumenos repeatedly warned such figures of perils that continually threatened them. If conversation turns to the imperial couple, be silent lest you be accused of defamation (Kek. 122.24–30). Avoid revelries and drunken conversations, for it is better to be regarded as unsociable then to be denounced for slander (124.14–20). Beware of intimacy—social or physical—with women (226.27–29). Take nobody into your confidence (230.4–6; also see 226.22–23).

Kekaumenos's attitude toward friendship was very cautious.[27] Foreigners can never be friends; their background makes them incompatible (242.22–28). Never act as a guarantor, even for a friend (218.17–18). If a friend arrives in your hometown, never invite him to stay with you, lest he mock your domestic habits or try to seduce your wife (202.14–204.1). Have friends, certainly, but never get too involved. After all, he reminded his readers, many have lost their property or even their lives because of friends. He even admonished, "Beware more of friends than of enemies" (Kek. 306.11–12) and clearly took his own advice: "I never wanted a companion; I never sat at a table with an equal unless I was forced to" (242.12–14). In any case, a man in trouble will find himself without friends (242.22).

Kekaumenos was not, however, entirely isolated. He lived not only for himself, but also for his family. In contrast to loose connections with friends, the author advocated the closest of ties with immediate family

26. Wagner, *Carmina* 4.65–66; Legrand, *Bibliothèque* 1, 1.12–14. On the *Spaneas*, H. G. Beck, *Geschichte der byzantinischen Volksliteratur* (Munich, 1971), 105–8; N. Papatriantaphyllou-Theodoride, "'Spaneas' kai 'Logoi didaktikoi' tou Phalierou," *Hellenika* 28 (1975), 92–101.

27. Kek. 208.21–28, 218.21–22. Kekaumenos often uses the word "friends" (*philoi*) to designate vassals (242.7–9), subordinates (298.21), or allies (166.20–21). These "friends" are not, however, to be trusted (270.14–15, 306.7–11).

members. For its protection, the family was segregated from society and highly disciplined.[28] He insisted that children must love and respect parents (244.23–246.12). He worried continuously about familial honor (220.5–11, 226.24–25, 228.29–30, 244.3–4). "Do not forget your relatives," he admonished his readers (222.32). "Pray, lest your son, your son-in-law, or brother becomes your enemy" (220.5; see also 244.1).

All in all, Kekaumenos's concern for the family was conventional. Equally traditional was his conception of the individual's position in relation to God and to the emperor: all stand submissively before both divine and secular authority. But the intensity of Kekaumenos's emphasis on the individualistic self-isolation, on the escape from the dangerous world, on the rejection of trustless and unfaithful humanity for the sake of the safe microcosm of the nuclear family was determined by both the author's personality and the social tendencies of the period. As literary pieces Kekaumenos's *Advice and Admonitions* and Symeon's sermons are of a significantly higher literary level than other works of the genre: side by side with trite indoctrinations they include short stories and edifying episodes; Kekaumenos was very fond of tricks and ruses that, in his presentation, resembled the stories told by his contemporary, the historian Skylitzes. The shaping of characters, however, remained traditionally flat—life was considered to be an interplay of good and evil, clever and dull people, and there was no place for hesitation and inner evolution.

The interest in human behavior reflected in literary works had some correspondent in the visual arts, especially in manuscript illumination. Gospels and lectionaries illustrated with narrative scenes from the life of Christ became increasingly popular in the second half of the eleventh century.[29] It has been established that the rich cycles of the eleventh- and twelfth-century Octateuchs were contemporary inventions rather than revivals of now-lost Late Antique archetypes.[30] Illustrated copies of the popular seventh-century treatise on monastic life by John Klimakos pro-

28. Kek. 226.7–8. "Do not be cruel in your house, but let all those who live within be in awe of you" (Kek. 240.15–16).

29. K. Weitzmann, "The Narrative and Liturgical Gospel Illustrations," *New Testament Manuscript Studies*, ed. M. Parvis and A. Wikgren (Chicago, 1950), 151–74, reprinted in his *Studies in Classical and Byzantine Manuscript Illumination*, ed. H. Kessler (Chicago, 1971), 247–70; "Byzantine Miniature and Icon Painting in the Eleventh Century," *Proceedings of the XIIIth International Congress of Byzantine Studies, Oxford, 1966* (Oxford, 1967), 207–24, reprinted in his *Studies*, 271–313.

30. J. Lowden, "The Vatopedi Octateuch and Its Source," *Abstracts of the Sixth Annual Byzantine Studies Conference, Oberlin, Ohio* (Oberlin, 1980), 22–23.

liferated in the eleventh century (Fig. 42).[31] In icons, saints began to be enframed by scenes from their lives and of their posthumous miracles. Even a history, John Skylitzes' chronicle, was elaborately illustrated in the twelfth century.[32] Again, the ideas visually expressed in these works were not necessarily new ones; but there was a new desire to visualize and explain traditional concepts.

The full consequences of this shift of concern from conventional ideality to normative didacticism are found contemporaneously in the works of Christopher of Mytilene.[33] Christopher was a prominent functionary in the court of Constantine IX, writing both panegyrics for the emperor and religious poetry.[34] At the same time he was extremely sensitive to the inequities of the existing social order. Why do people who were created from the same dust live so unequally? He addressed this question to God:

> Are not we all created by your fingers?
> Why then do some of us dwell in overabundance,
> Having enough and even more than enough,
> Beyond what is necessary, beyond any measure,
> While others possess no more than a crust of bread
> Or a few crumbs from another's feast?
> O Ever Just, is that just whatever?[35]

Christopher of Mytilene's critique of the human condition seems to have been inspired by his interest in affecting actions. Indeed, the didactic tendencies identifiable in Byzantine literature evolved along with a new concern for humanity, both the individual and society. This same revival of anthropomorphic values was reflected in a developing interest in the palpable reality of physical surroundings.

ABSTRACTION TO NATURALISM

Between the seventh and tenth centuries literary heros and antiheros were stereotypical personifications of virtues and vices. Drawn

31. J. R. Martin, *The Illustration of the Heavenly Ladder of John Climacus* (Princeton, 1954).

32. See above, Chapter 3, n. 7.

33. On him, E. Follieri, "Le poesie di Cristoforo Mitileneo come fonte storica," *ZRVI* 8/2 (1964), 133–48; Th. Xydes, "Ho byzantinos poetes Christophoros ho Mytilenaios," *Deltion tes Christianikes archaiologikes hetaireias*, ser. 4, 4 (1964–65 [1966]), 245–52.

34. E. Follieri and I. Dujčev, "Il calendario in sticheri di Cristoforo di Mitilene," *BS* 25 (1964), 1–36; J. Darrouzès, "Les calendriers byzantins en vers," *REB* 16 (1958), 65.

35. Chr. Mityl. no. 13. A. Cosattini, "La 'poesie varie' di un bizantino," *Atene e Roma* 7 (1904), col. 259.

as either good or bad, these figures lacked the depth and ambiguity of experience. The two-dimensional nature of the characters was fostered by social separation: the subjects were drawn from the political and spiritual elites of the society—emperors, patriarchs, or saints with, respectively, foreign adversaries, heretical opponents, or demonic persecutors. Perhaps because of the popularizing tendencies of the culture, as well as because of its new materialism and intimations of rationality, writers from the eleventh century onward concerned themselves more with humanity and its setting. For instance, the prominent merchant of Seth's *Stephanites and Ichnelates* defined life's essentials in terms of his economic independence, of success in his undertakings, and of the recognition of that success by his contemporaries. Give alms and avoid disasters—that was the formula for a comfortable life.[36] Familiar everyday sentiments, his prescriptions for happiness seem particularly appropriate for a merchant. Thus Seth not only concerned himself with worldly characters but also attributed to them attitudes entirely fitting their estate.

Psellos perhaps best displayed these new attitudes toward subject matter. His sensuosity and his appreciation of material life led him to write of the charms of a beautiful landscape (*Scripta min.* 2:219.2–12; see also his *ekphrasis* of Olympus, Sathas, *MB* 4:442.13–443.27). He went so far as to express his delight in the physical loveliness that God could create out of dust (Sathas, *MB* 5:76.26–28). For Psellos, the soul and the body rivaled each other in beauty, each having its singular delights. He even argued that people, having originated in matter, should not disdain corporeal things (Sathas, *MB* 4:308.12–309.9). Further, he criticized those "extreme philosophers" who dedicated their entire attention to the disembodied spirit, discounting entirely the physical form. And in fact Psellos devoted considerable attention to the physical description of his characters.

His lengthy portrait of his daughter Styliane is typical: her head was neither too large nor too small; her face was round; her eyebrows were not too arched or too long; her beautiful eyes shone like stars, were very large and a little slanted, resembling buds planted near her nose; her eyelids were as fine as pomegranate peel; her nose was delicate with pleasingly proportioned nostrils; her mouth was framed by lips as brilliant as precious stones catching the rays of the sun; her seemly smile exposed snow-white teeth that resembled pearls and glittered like crystal; her cheeks' color was that of a rose that withered neither in the winter nor in the fall; her exquisite neck was the hue of ivory; her curling

36. L.-O. Sjöberg, *Stephanites und Ichnelates* (Stockholm, 1962), 151.4–152.5.

hair fell in golden locks down to her ankles. The rest of Styliane's body was treated somewhat more briefly. She had beautifully proportioned hands, pure as newly carved ivory, and tapering fingers; she had well-developed breasts, a narrow, tightly belted waist, and hips like the Aphrodite of Knidos; finally, she had shapely knees and legs and comely ankles (Sathas, *MB* 5:68.26–72.17).

The naturalness of Psellos's physiognomies should not be exaggerated. Psellos's own conception of beauty was nominally derived from antique canons of proportion and harmony of parts, but most elements in his descriptions are, in fact, strikingly similar to medieval artists' conception of the human figure. Comparing Styliane's description with the portrait bust of Empress Zoe in the south tribune of St. Sophia in Constantinople (Fig. 43), one may recognize the same exaggerated concern with the subject's eyes, the same sense of geometric precision, the same clear definition of the various parts of the physiognomy. Further, in both the mosaic and the literary images, as even in contemporary narrative scenes, the figures are frozen in time, unmoving.

Though Psellos may not actually have been looking at Styliane when he wrote his canonical description of her, she is no more idealized than the literary heroines of most ages. Some of his male figures, also, are conventionally idealized. Certainly this is true of his portrayal of Basil II in the *Chronographia*:

> His eyes were light-blue and fiery, his eyebrows did not sullenly overhang his eyes nor did they extend in a straight line, like a woman's but rather they were well-arched and indicative of his pride. His eyes were neither deep-set (a sign of knavishness) nor were they too prominent (a sign of frivolity), but they shone with a brilliance that was manly.[37]

In these instances, it is not the originality of the description that is significant, but rather its prominence in the narrative. Psellos was actually more naturalistic in his portrayals of sickness and deformity, where he finally evaded the limitations of physical stereotypes. The seriously ill Constantine Leichoudes was marked by "the signs of death"—his temples grew sunken, his nose pinched, his eyes hollow, his breath short and erratic (Sathas, *MB* 4:417.23–25). Romanos III, too, was transformed by illness. He resembled a dead man: his face was swollen, his breathing fast, his hair falling out (Ps. *Chron.* 1:50, no. 25.3–9).

More important than Psellos's interest in his subjects' physical ap-

37. Ps. *Chron.* 1: 22, no. 35.2–15. Translated by E. R. A. Sewter (Baltimore, 1952), 27.

pearance was his attempt to explore individual personalities. Perhaps his inchoate rationalism and his respect for humanity led him to a more complex concept of character. In any case, his delineations of personality were often more subtle than his physical depictions: for all his stereotypical good looks, for example, Emperor Basil II's nature was defined less conventionally, as severe, crude, stubborn, and suspicious. Psellos even invested his heros with contradictory features; a brilliant example of such characterization is his depiction of John Orphanotrophos in the *Chronographia*. At the onset, Psellos stated that "some of John's deeds are praiseworthy," although "there are other things about his life that cannot meet with general approval." John was meticulous in the execution of his duties; he went to extremes of industry in the performance of his obligations. Nothing escaped his notice. But at the same time, according to Psellos, he was a heavy drinker and a buffoon. Furthermore, despite his monastic vocation, he cared nothing for decent behavior. He persecuted those who lived respectably, who passed their time in the exercise of virtue, or who enriched their minds with classical learning. These monstrous traits were worse in combination. John was more vengeful and suspicious when he had had a few glasses of wine: "he would carefully watch how each of his boon companions behaved. Afterwards, as if he had caught them red-handed, he would submit them to questioning, and examine what they had said and done in their drunken moments. So that they came to dread him drunk even more than they dreaded him sober."[38]

The images of emperors and empresses conjured up in the *Chronographia* possess neither the epic grandeur of the pseudo-antique heros of the ninth- and tenth-century histories nor the spiritual grandeur of the martyrs and wonder workers of the hagiographic tradition; they emerge as believable human beings. Those at the apex of political power were demythologized through a detailed account of their weaknesses. For instance, Constantine IX Monomachos was portrayed as an inadequate statesman, flippant and unbalanced. But those same qualities— good nature, joviality, accessibility, womanizing (discussed in unusual detail for a Byzantine work)—insured him a sympathetic treatment from Psellos, who refrained from passing judgment on him. The writer's vagueness in his assessment of the emperor appeared to be characteristic of a new, less simply judgmental attitude toward humanity. Constantine's weaknesses may have been exposed to the readers' ridicule,

38. Ps. *Chron.* 1: 59–61; R. Jenkins, "The Classical Background of the Scriptores post Theophanem," *DOP* 8 (1954), 15.

but displaying the emperor's sensibilities contributed to a deeper appreciation of the tasks of the empire.[39]

Psellos's characterizations of more lowly personages were no more stereotypical than those of the elite. We find vivid descriptions of this sort particularly in Psellos's correspondence; for example, the monk Elias appears in about a dozen different letters (exs. 11–12). Elias seems to have been a parasitic friend of the author's; he was, in any case, rather unflatteringly presented by the author as a glutton and philanderer, a man who knew the locations of all the brothels in Constantinople; Psellos tolerated him for his joviality and homespun wisdom. He could be immensely entertaining, embroidering in a most shocking manner accounts of his travels or of his theatrical appearances. Psellos remarked that he was flabbergasted that such a blasphemous person was not swallowed by a sea monster.[40]

Nikephoros Bryennios and even more so his wife, Anna Comnena, continued Psellos's pursuit of character.[41] Anna's book on her father belongs to the tradition of encomiastic imperial portraits. Alexios Comnenus was endowed with all the qualities of a perfect ruler. He pours out his "imperial sweat" for the sake of the Roman people, a traditional *topos* of imperial panegyrics. He possessed military courage, reason, and keen insight. He knew how to endure illness and how to reverse defeat. Anna typified her father's character with a single word—the *mesotes*, the middle way, harmony. Similarly, her favorite female characters were highly idealized. Anna's mother, Eirene Doukaina, was mild, loving, solicitous. Maria the Alan, like Psellos's daughter in his above-mentioned description, was presented as a construction of separate, perfect parts. She was tall and slender as a cypress, her skin was white as snow, her eyebrows were golden, and her eyes were brilliant blue. Neither Phidias nor Apelles could have chiseled a statue of such beauty (An. C. 1:107.28–108.9).

As in Psellos's work, stereotypical heros were given some depth through recounting their weakest as well as their strongest moments. Alexios occasionally appeared depressed by the innumerable calamities of the state, by his own failures, or by a stricken conscience. In overcoming his weaknesses, of course, Alexios emerged as greater than those simple paradigms of strength such as Katakalon Kekaumenos in Skylitzes or Nikephoros Botaneiates in Attaleiates' *History*. Perhaps

39. Ljubarskij, *Michail Psell*, 204–29.
40. Ljubarskij, *Michail Psell*, 76–79.
41. Hunger, *Die hochsprachliche profane Literatur* 1, 394–409.

more importantly, the villains of her narrative were endowed with depth of character even when they were shown with virtually no redeeming features: as mentioned earlier, Robert Guiscard, who attacked the empire in the 1080s,. was described as an adversary worthy of Alexios. Anna's narrative was also enlivened by the enemy's plots. At one point, for instance, Robert Guiscard's son Bohemond evaded capture by the Byzantines by feigning death (Ex. 49). To make his deception realistic, he had the stinking carcass of a cock placed in his coffin alongside him.[42] Bohemond's ingenuity was matched by his greed for power, wealth, and military success. Significantly, Anna attempted to provide even her villains with motives for their actions—Bohemond's covetousness of the throne of Byzantium stemmed from his lack of possessions in Italy.

Eleventh- and twelfth-century painting also shows increasing interest in the physical world. During the late ninth, early tenth, and early eleventh centuries, monumental art was characteristically abstract. Two-dimensional figures occupied an equally flat picture plane. A detailed analysis of one example must suffice: the Preaching of John the Baptist in the Old Church of Tokalı Kilise, Göreme, painted in the early tenth century (Fig. 44). This image appears as part of a dense Christological narrative set in sequential registers in the barrel vault of the nave. The scale of the figures was limited by the height of the register and the lack of depth of the stage space. In contradiction to the common medieval convention that dictates that size correspond to social status, John was depicted as smaller than the people to whom he preaches because he occupies the same plane as the angel of the previous scene. The depth implied by the overlapping of the three figures of John's audience is eliminated by the placement of their five legs. Further, both John and his audience lack substance. Their physical forms are generalized and highly simplified. For example, elongated ovals serve as heads. Individuals are not distinguished by their features—they all have very large eyes and elongated noses—but only very minimally by beards and hairstyles. The patterns of white highlights on the drapery do not model the figures, but simply decorate and flatten them. The limited palette—gray and gray-green with earth colors—is so homogeneous in its value that it too contributes to the elimination of space. The gray ground is no less on the surface than the dull ochre. A similar attitude toward space is found in the other paintings and mosaics of the late ninth and early tenth cen-

42. On this episode, H. Hunger, "Die byzantinische Literatur der Komne-nenzeit," *Anzeiger der philologisch-historischen Klasse der Österreichischen Akademie der Wissenschaften* 105, no. 3 (1968), 65f.

turies, including St. Sophia in Thessaloniki, Hosios Stephanos in Kastoria, and St. Pietro in Otranto. When monumental art became prominent again in the early eleventh century, images were schematically and flatly rendered, as shown in such monuments as the Panagia ton Chalkeon in Thessaloniki, Hosios Loukas in Phokis, or Direkli Kilise in Cappadocia.

In the later eleventh century, the artistic treatment of figures in both monumental and small-scale works altered. The modeling of these figures became more dramatic. Even more noticeably, the figures began to have the appearance of movement, though still in a carefully choreographed manner, and to interact. One may perceive this change by comparing the mid-eleventh-century file of apostles in *Proskomide* in the apse of St. Sophia in Ohrid with the disciples of the Communion in the Holy Apostles in Perachorio on Cyprus, from the second half of the twelfth century (figs. 45–46).[43] In the later fresco, the Apostles are clustered; they relate to one another as well as to the Godhead. There is even a sense of double file, one moving toward Christ, the other moving behind the first, away from Him. It is tempting to relate this new sense of human interaction not only to an increased appreciation of physical reality, but also to a concurrent development of broader social ties.

In later twelfth-century literature, the interest in naturalistic detail characteristic of Psellos's and Anna Comnena's writing expanded into a spatial and social dimension. This is particularly clear in the works of Eustathios of Thessaloniki. Initially, Eustathios appears an unlikely source of literary innovation: a high-ranking functionary of the patriarchate and later a metropolitan, Eustathios was an official orator and preacher. Most of his surviving work consists of sermons (*logoi*) on temporal and spiritual subjects; his few attempts at poetry are of indifferent quality.[44] Though his rhetoric is often conventional, Eustathios had a lively literary imagination. He conjured up concrete images not only of the individual, but also of specific social groups. His description of the fall of Thessaloniki to the Normans at the end of the twelfth century is

43. A. Grabar, "Les peintures murales dans le choeur de Sainte-Sophie d'Ochrid," *CA* 15 (1965), 257ff.; A. H. S. Megaw, "The Church of the Holy Apostles at Perachorio, Cyprus, and its Frescoes," *DOP* 16 (1962), 277–348.

44. P. Wirth, "Ein bisher unbekannter Demetrioshymnos des Erzbishofs Eustathios von Thessalonike," *BZ* 52 (1959), 320, now in his *Eustathiana* (Amsterdam, 1980), 47; see also his *Untersuchungen zur byzantinischen Rhetorik des XII. Jahrhunderts mit besonderer Berücksichtigung der Schriften des Erzbishofs Eustathios von Thessalonike* (Munich, 1960); T. Hedberg, "Das Interesse des Eustathios fur die Verhältnisse und die Sprache seiner eigenen Zeit," *Eranos* 44 (1946), 208–18; A. P. Kazhdan, "Vizantijskij publicist XII v. Evstafij Solunskij," *VV* 29 (1968), 188–90.

extremely evocative, offering vivid portrayals of the suffering of an en-
tire city. He gave this depiction unusual intensity by focusing on detail
(Ex. 50). In the midst of describing the horrors of massacre and enslave-
ment, Eustathios turned to the city's dogs. Most of these had been
slaughtered by the Normans, but those that survived crawled fawning
and whining to their new Latin overlords, growling only at their former
Byzantine masters. Eustathios concluded that "even dogs understood
the full measure of the disaster" (Eust. *Esp.* 113.6–9). In this feeling for
concrete detail, Eustathios continued the literary tradition established
by Psellos. In fact, Eustathios's love of minutiae reveals an even greater
fondness for life on his part—he saw and recorded the deep shadow
thrown by his weary teacher resting on a fallen column by the road and
as well the joyous dance of an audacious mouse that had managed to
steal the author's wine (Eust. *Opusc.* 111.78–91 and 313.57–69). Further-
more, Eustathios delighted in describing the physical pleasures of life,
such as feasts and good fellowship. He wrote with enthusiasm of lavish
meals he had enjoyed and of delicacies he had sent to friends (Eust.
Opusc. 311.42–54 and 311.81–90, 312.20–28). He depicted in a lively
manner the festivities that he had attended—for instance, the celebra-
tion of Alexios II's wedding to Agnes of France, for which the Hippo-
drome was filled with wooden tables, the stables were converted to
kitchens, and the cisterns flowed with sweet wine.[45] At the same time,
Eustathios castigated asceticism and the illiterate and idle monks who
wallowed in their bodily needs. He also criticized those who substituted
strict observances for virtue. He exclaimed at the end of a diatribe
against hypocritical fasting, "It would be better to fill the mouth with
meat and be called flesh-eating, than to be filled with evil and be known
as man-eating."[46] Eustathios's sarcasm and sense of detail are most
pointedly applied to men he disliked. David Comnenus, governor of
Thessaloniki, was "little in his qualities, but great in his unfitness"
(Eust. *Esp.* 8.32). During the siege of the city, this commander neither
mounted a horse nor grasped a sword, but rode on a mule through the
streets of the hard-pressed city in an odd foreign costume—trousers,
boots, and a Georgian felt hat to protect himself from the sun. His
foolish behavior matched his preposterous appearance: David did noth-

45. A. P. Kazhdan, "Neizdannye sočinenija Evstafija Solunskogo v Esku-
rial'skoj rukopisi Y-II-10," *Polychronion. Festschrift Franz Dölger*, ed. P. Wirth (Hei-
delberg, 1966), 343.
46. Escor. Y-II-10, fol. 40v; quoted, A. P. Kazhdan, "Vizantijskij publicist,"
180. On Eustathios's pamphlet, *Notes [episkepsis] on the monastic life*, Beck, *Kirche
und theologische Literatur*, 635.

ing to better the precarious position of his city, leaving unattended a leaking cistern, inferior catapults, and a dearth of arrows for the defending archers. At the same time, David bragged of his victories—in reality the capture of a poor footsoldier and the seizure of a helmet and a pair of horses—in dispatches to the capital (Eust. *Esp.* 82.6–12, 74.29–76.5, 68.20–32). When finally the Normans captured the city, David fled immediately to the citadel without ever touching a weapon or confronting a Norman (102.3–10). Eustathios's David exhibited the general features of Byzantine officialdom, but the detail in which he was rendered lent him a realism unusual in Byzantine literature.

Eustathios was one of the best-educated scholars of his time, an excellent representative of the self-conscious, intellectual elite of twelfth-century Byzantine society. Like Psellos, Eustathios had the highest regard for friendship, maintaining close ties with his pupils and friends. Included within the circle of his intimates were Gregory Antiochos and the brothers Michael and Niketas Choniates. Eustathios's influence on his associates is evident in their quotations from his works and in their imitations of his literary style. Niketas retold many episodes from Eustathios's narrative of the capture of Thessaloniki in his own history; Antiochos's descriptions of his provincial environment in his letters to Eustathios—the poor quality of imported and local produce that he had to endure and the strenuousness of his work, which caused him to fall asleep over his beloved books—have the same concreteness of detail that marks Eustathios's own writing.[47]

Nicholas Mesarites, an orator and church leader on the threshold of the thirteenth century, also wrote in graphic images. The particular character of Mesarites' literary style can readily be appreciated through contrast with the works of some of his contemporaries. One of his pieces, a speech celebrating the suppression of John Comnenus the Fat's rebellion in 1200, is essentially different from the other surviving writings on the same theme.[48] In pieces by Nikephoros Chrysoberges, Niketas Choniates, and Euthymios Tornikes, John is presented in a conventional, highly abstract manner (exs. 51–52). Tornikes depicted the usurper as an unpleasant, obese Persian who never gave up his oriental habits; he was apelike in his actions, a rebellious slave attracting a foolish following, a

47. J. Darrouzès, "Deux lettres de Grégoire Antiochos écrites de Bulgarie vers 1173," *BS* 23 (1962), 279; Escor. Y-II-10, fol. 400v; quoted, A. P. Kazhdan, "Grigorij Antioch," *VV* 26 (1965), 94.
48. A. P. Kazhdan, "Nikifor Chrisoverg i Nikolaj Mesarit," *VV* 30 (1969), 106–12.

beheaded Empedoclean monster.[49] According to Choniates, John was a
bag packed with flesh; his bulk required a chariot drawn by eight horses;
he was a brazen calf worshiped by an unthinking mass (Nik. Chon.
Orat. 104.12–27, with an allusion to Exod. 32:8). The author insisted that
it would be easier for a camel to go through the eye of a needle than for
this "many-ribbed [*megapleuros*, a neologism] ox" to master the empire
(105.2–8, with an allusion to Matth. 19:24). Chrysoberges also wrote in
the cliché images and rhetorical *topoi* of evil: "Just as a mighty cedar of
Lebanon, O Lord, John fell when he was struck by your axes [a hint of
the Varangian guards' poleaxes]; like the Empedoclean monster, he per-
ished by your swords."[50] Chrysoberges alluded also to the classical fable
in which monkeys busy attempting to elect a king were surrounded and
captured by hunters (5.10–6.5). The similarity of the images in these
three works is striking. The authors speak of the fatness of the villain, of
an Empedoclean monster, of monkeys, of the foolish crowd. Although
glimpses of actual events are occasionally afforded, these accounts are
deprived of concrete, graphic renderings of time and place.

Mesarites' description of John the Fat's revolt differed markedly
from these traditionally rhetorical treatments of a political event. While
Nikephoros Chrysoberges, Niketas Choniates, and Euthymios Tornikes
provided the facts of the occasion, Mesarites' account invested the scene
with the immediacy of reality. He mentioned specific people involved in
the actions and gave ethnic names and related topographic information.
Characters were vividly depicted: a vagrant oriental monk in a ragged
sheepskin cloak and frayed shift attempted to cut down the imperial
crown hanging below the cupola in the splendid Church of St. Sophia;
mint laborers with their sooty visages, dusty feet, and stained tunics
produced the golden stream that spread throughout the empire.[51] Mesa-
rites was alive to the strange juxtapositions that life offers the careful ob-
server; his people have a palpable reality entirely absent in Tornikes' or
Choniates' "foolish crowd." Similarly, Mesarites' portrait of the villain
has far more substance than the fat but flat antihero of his contempo-
raries. He saw John at the peak of the mutiny in a specific setting, the
tricilinium of Justinian in the Great Palace of the Byzantine emperors. In

49. J. Darrouzès, "Les discours d'Euthyme Tornikès," *REB* 26 (1968), 66.19–
20, 67.4–11, 68.16.

50. Nikephoros Chrysoberges, *Ad Angelos orationes tres*, ed. M. Treu (Breslau,
1892), 5.1–5.

51. A. Heisenberg, *Nikolaos Mesarites. Die Palastrevolution des Johannes Kom-
nenos* (Würzburg, 1907), 22.18–26, 25.32–34.

defiance of the canons of Byzantine iconography, he portrayed the usurper from the rear; he noted John's black, wiry hair, his fat shoulders, the fleshy nape of his neck and lamented the imperial throne's unhappy burden (27.11–13). Approaching the seat of power, Mesarites realized that the rebel was exhausted, with his head slumped over his flabby chest, and that he was unable to answer the questions put to him (28.11–13). Mesarites' final description of John has a note of pathos in it. John was already defeated, hiding himself in the palace of Moukhroutas. The usurper sat on the floor; he had laid aside his imperial raiment but still wore the crown. He inhaled noisily and perspired heavily, mopping himself continuously with a towel (45.11–18). In Mesarites' writings, as in none of his contemporaries' works, John the Fat's epithet was lent an unpleasant tangibility.

IMPERSONAL TO PERSONAL

The development of a new "naturalism" in literature and art was intertwined with the growing prominence of the artist's personality in his work. Art and literature assumed a greater emotional content. During the ninth and tenth centuries, the authors' intention to minimize their place in their narratives was expressed in the prefaces of their works.[52] They proclaimed themselves unworthy of their subjects in order to emphasize the objectivity of their productions and depicted themselves as simple vessels of the Holy Spirit, from whom the text flowed. There seems to have been a deliberate rejection of the writers' personal involvement, a denial of their independence and importance. Of course, in practice the authors' personalities were revealed in their writing and in their choice of material, in their structuring of their stories, in their sympathies and in their antipathies. Nevertheless, authors regularly insisted on their personal separation from their subjects. Similarly, neither the artist nor the patron figured very prominently in the programs of ninth- and tenth-century churches.

This situation changed. Especially in the twelfth century, masters began to sign their works. Theodore Apseudes, who painted the cell and the bema of the Enkleistra of St. Neophytos near Paphos, not only signed his work there but may also have left a dedicatory inscription at the Church of the Virgin tou Arakou at Lagoudera.[53] Certainly the style

52. I. S. Čičurov, "K probleme avtorskogo samosoznanija vizantijskich istorikov IV–IX vv.," *Antičnost' i Vizantija* (Moscow, 1975), 203–20.
53. D. Winfield, *Panagia tou Arakos, Lagoudera. A Guide* (Nicosia, 1978), 16–17; C. Mango and E. Hawkins, "The Hermitage of St. Neophytos and Its Wall-Paintings," *DOP* 20 (1966), 122f.

of painting in the two churches is so similar that it may well be by the same hand. Unfortunately, the artistic personality of one of the most famous Byzantine masters of the period, Eulalios, is impossible to reconstruct, as no work survives that might be ascribed to him with any certainty. Even the now-lost image in the Church of the Holy Apostles in Constantinople, which Nicholas Mesarites described as Eulalios's self-portrait, seems in fact to have been a typological representation of King David.[54] Nevertheless, the very fact that Nicholas could assume that a painter depicted himself prominently in mosaic indicates the change in the artist's attitude in the twelfth century.

Patrons, whose participation in artistic production was much more intimate in the Middle Ages than it is today, became increasingly prominent in the eleventh and twelfth centuries. Even individuals of a relatively low social status began to appear portrayed in the naves of the churches that they had subsidized. The priest Nikephoros and the layman Basil, for instance, were depicted in the conch of the rock-cut church of Karanlık Kilise in Cappadocia in the middle of the eleventh century (Fig. 47); two provincial *magistroi* (a title deflated in value by the end of the eleventh century and unused at court in the twelfth), both named Nikephoros, were represented with their families in their respective churches in Asinou in Cyprus (1105/6) and Kastoria in Macedonia (1160s/70s).[55] Perhaps most notorious was the case of St. Neophytos, who in the late twelfth century had himself portrayed at least twice, but perhaps even three times in the decoration of his enkleistra near Paphos on Cyprus (Fig. 48). One of these portraits, an image depicting Neophytos being carried to heaven by the archangels, is unique in its hybris (Fig. 49). Moreover, Neophytos had even arranged his rock-cut church in such a way that by using an excavated passage connecting his retreat to the vault of the chapel he could physically appear next to Christ in the scene of the Ascension.[56]

Self-portraiture is even more evident in literature. Theodore Prodromos's portrait of himself after a long illness shows a wit and self-understanding rare in medieval writing. Having lost all his hair, he was

54. O. Demus, "'The Sleepless Watcher': Ein Erklärungsversuch," *JÖB* 28 (1979), 241–45.

55. G. de Jerphanion, *Une nouvelle province de l'art byzantin: les églises rupestres de Cappadoce*, vol. 1, part 2 (Paris, 1932), 397–99; A. and J. Stylianou, "Donors and Dedicatory Inscriptions, Supplicants and Supplications in the Painted Churches of Cyprus," *JÖB* 9 (1960), 97–99; A. W. Epstein, "The Middle Byzantine Churches of Kastoria in Greek Macedonia: Their Dates and Implications," *ABull* 62 (1980), 198–99.

56. Mango and Hawkins, "The Hermitage of St. Neophytos," 140, 200.

bald as a pestle, but at the same time his beard had grown enormously, blooming like Alkinos's orchard (an allusion to *Odyss.* 7.112–16; *PG* 133.1251B–1252B). In Prodromos's writings, the author's sensibilities dictated the subject matter (Ex. 53). Sometimes his observations were amusing: he mocked a dentist who promised to deliver him from a toothache; the dentist slit Prodromos's gums, attached to his tooth a tool large enough to extract an elephant's tusk, and broke the tooth in half. Prodromos called him an executioner rather than a doctor; though small as one of Demokritos's atoms, he looked like an ogre to his wretched patient.[57] But Prodromos could also write with intense feeling.[58] In his monody on Stephen Skylitzes, metropolitan of Trebizond, Prodromos gave a moving account of his reunion with his old friend Stephen, who returned to Constantinople from his see so desperately ill that Prodromos at first did not recognize him on his litter. Realizing who it was, Prodromos cried, "your beautiful soul has cast away its former charming body and attired itself in a new one!" and began to sob. Stephen, barely able to speak, told Prodromos of his "arduous Iliad," and finally of his return to the Queen of Cities to be healed by the best physicians available or to die among friends in the motherland.[59] Prodromos's personality shows through in his writings. Moreover, he perceived reality in light of his personal experience. He even humorously suggested that the emperors had won their victories in order to provide him the opportunity to traverse the world in safety.[60]

A pervasive sense of personal involvement, as in Prodromos's work, was also found in other authors' writings. Prodromos's contemporary Michael Italikos began to describe his pet partridge in a traditional manner by classifying the species. But he broke off his objective analysis with an exclamation: "Who cares about all these zoological details? My own poor partridge is dead!" (Mich. Ital. 103); he then gave vent to his feelings in relating the sad tale of the bird's demise. But it was Psellos who best demonstrated how high an author's ego might aspire. He

57. S. D. Papadimitriu, *Feodor Prodrom* (Odessa, 1905), 268–70; G. Podestà, "Le satire Lucianesche di Teodoro Prodromo," *Aevum* 21 (1947), 12–25.

58. E. Legrand, "Poésies inédites de Théodore Prodrome publiées d'après la copie d'Alfonse l'Athénien," *Revue des études grecques* 4 (1891), 72.

59. L. Petit, "Monodie de Théodore Prodrome sur Etienne Skylitzès métropolitain de Trébizonde," *IRAIK* 8, no. 1–2 (1902), 13.211–34.

60. *Hist. Ged.* 305, no. 18. Note also his words addressed to John II: "You, the emperor, were starved for my sake, for the sake of a slave, you were starved and I fattened, you were frozen and I lived in warmth, you dwelled in the open and I under a roof. The mighty Comnenus would toil, while wretched and humble Prodromos lived luxuriously" (315.185–91).

boasted of his eloquence (*Scripta min.* 2:81.18–20, 160.3), of his promi-
nence among the literati (289.3–6), and of the extent of his fame. Celts,
Arabs, Ethiopians, and Persians all admired him (Sathas, *MB* 5:508.11–
19). A similar vanity was also evident in his historical narratives. Psellos
lacked earlier historians' pretense of objectivity; he not only put himself
in the *Chronographia* as an active participant in the events he described,
but he also voiced his opinions in his incidental discussions of religion,
philosophy, ethics, and the like. Psellos probably aggrandized his role in
contemporary affairs. While he held important if not powerful positions
in the courts of Constantine IX and Isaac I, he is unlikely to have been so
intimate an advisor to the emperors as he claimed. But his presenting
himself as an integral part of his history reflects an unprecedented self-
consciousness among Byzantine writers in his time.

Psellos's most paradoxical self-revelation occurs in his biography of
St. Auxentios, a Constantinopolitan holy man of the fifth century. Not
only has Psellos's text been preserved,[61] but the Metaphrastian *vita*, the
source of his information, has also survived; consequently, it is possible
to recognize Psellos's additions and corrections to the text. Psellos com-
pared himself to his hero—they were both, for instance, very fond of
music—and consistently remodeled features of both Auxentios and of
his companions according to his own self-image and the images of his
friends. One of Auxentios's associates became the *phylax* of imperial
epistles, like Leichoudes in real life; another was a teacher who ascended
the patriarchical throne, as had Xiphilinos; and a third lived on a rock
(*petra*)—an allusion to John Mauropous, the fourth member of Psellos's
eleventh-century intellectual clique, who was a monk in the monastery
at Petra. Further, Auxentios was given traits that Psellos imagined him-
self as possessing. Auxentios, a modest preacher and wonder worker,
was transformed into a counselor of emperors, an economist of genius
who saved Constantinople's trade from a depression, a reformer and
philosopher whose ideas were remarkably similar to those held by the
author. Even some expressions used in the *Chronographia* to describe
events in Psellos's own career were introduced into the life. But such
self-indulgence was not limited to the *vita* of St. Auxentios. In his en-
comium on Symeon Metaphrastes, also, Psellos drew parallels between
himself and his subject. In another encomium, on John Xiphilinos, he
expressed his fear that his audience might blame him for indulging in
self-appraisal while writing of another man: "I am afraid that they will

61. Ed. P. Joannou, *Démonologie populaire—démonologie critique au XI^e siècle*
(Wiesbaden, 1971).

call me selfish [*philautos*]. But I just cannot help returning to myself time and again" (Sathas, *MB* 4: 430:22–26).

Nicholas Mesarites was active in the events of his day. During the revolt of John the Fat, Nicholas helped protect the Church of the Virgin of the Pharos, where he served as *skeuophylax*, from the depredations of the usurper's partisans; he later composed a narrative of the occasion and of his involvement. He explained that he wrote the story because at the time of the usurpation his throat was so sore from his exertions that he could not tell his friends what had happened.[62]

Through a comparison of Nicholas's description of the Church of the Holy Apostles with that of Constantine of Rhodes written in the middle of the tenth century, the new personalization of subject matter becomes obvious (exs. 54–57). Constantine's poem schematically described the church from the top down, then, by a simple enumeration of a few feast scenes in the order in which they occurred in Christ's life briefly alluded to the building's elaborate decoration. In contrast, Nicholas sketched an impression of the great martyrium, its idyllic setting, and its splendid ornament in the order of his own wanderings. The same Christological images that Constantine saw as flat emblems of truth Nicholas described as emotionally charged fragments of time. He not only saw Lazarus's body brought out of its tomb by Christ, he even smelled its rotting flesh (Ex. 56).[63] This author was imposing his own temporal perspective on the world around him.

The empathetic quality of Nicholas's description of the mosaics of the Holy Apostles is, in fact, also found in contemporary painting. From the mid-eleventh century onward, artists began to increase the expressiveness of their figures. The angels of the Annunciation in SS. Marina e Cristina in Carpignano in Byzantine-held southern Italy (959) and in St. George at Kurbinovo in Macedonia (1191) stand at opposite ends of the range of this development (figs. 50–51).[64] Both Gabriels were depicted as moving rapidly forward, garments waving, and as making similar gestures toward a respectful Virgin. Yet the earlier rendering is stiff in contrast to the later work and lacks its ecstatic emotional content. The intensity of the twelfth-century fresco is not simply a matter of elon-

62. A. Heisenberg, *Nikolaos Mesarites. Die Palastrevolution*, 19.24–20.10.

63. Nic. Mesar. 908.6. Also see A. W. Epstein, "The Rebuilding and Redecoration of the Holy Apostles in Constantinople: A Reconsideration," *GRBS* 23 (1982), 79–92.

64. A. Medea, *Gli affreschi nella cripte ermitiche Pugliesi* (Rome, 1939), 109–18; L. Hadermann-Misguich, *Kurbinovo. Les fresques de Saint-Georges et la peinture byzantine du XII^e siècle* (Brussels, 1975).

gated proportions and active drapery; it depends equally on stark tonal contrasts and increasingly acid hues. In scenes where pity might be aroused in the audience, gesture also became more expressive. For instance (figs. 52–53), the simple symmetry of the Crucifixion in most early tenth-century renderings, like that in the chapel of Kılıçlar Kilise in Cappadocia, was supplanted by a denser, more emotionally charged arrangement, such as that in the late-eleventh- or early-twelfth-century Mavriotissa Monastery near Kastoria in Macedonia.[65] Lamentation and its effects on the participants are clear—the Virgin swoons, John cradles his head in his hand, Longinos is awestruck, the ravaged Christ hangs limp and dead on the cross. The men's brows are knit and the women's faces are streaked with tears. The emotional as well as the theological truth of the icon concerns the artist, his patron, and their audience.

The stylistic innovations that evolved from the eleventh all the way through the twelfth centuries culminated in the ambitious chronicle (*Chronike diegesis*) of Niketas Choniates.[66] This grand overview, covering nearly one hundred years of Byzantine history, was long in the writing; Niketas finished it only at the beginning of the thirteenth century, shortly after the fall of Constantinople in 1204. But it had been begun much earlier, during Niketas's early maturity. Like Psellos's *Chronographia*, Niketas's history was enlivened with complex portraits of his contemporaries. Psellos tended to belittle his characters, interpreting their behavior as a sum of ridiculous traits such as buffoonery, braggadocio, lust, and so on. Choniates, in contrast, elevated his heros, investing them with intense emotions while yet not transforming them into flat personifications of passion; internal contradictions endow Choniates's heros with their vitality. The principal characters of the first part of the chronicle were the cousins Manuel and Andronikos Comnenus. Manuel, the younger son of John II, was still a youth when he became emperor; Andronikos spent his entire life craving the imperial throne, but managed to obtain it only in old age. Choniates described the foibles of Manuel's character: during peacetime he seemed concerned only with pleasure, devoting himself to feasts and to music, but at times of crisis he immediately put aside these diversions (206.60–66). He could be lewd

65. de Jerphanion, *Une nouvelle province*, vol. 1, part 1, 224. A. W. Epstein, "Frescoes of the Mavriotissa Monastery near Kastoria: Evidence of Millenarianism and Anti-Semitism in the Wake of the First Crusade," *Gesta* 21 (1982), 21–29.

66. On Choniates, J. L. van Dieten, *Niketas Choniates. Erläuterungen zu den Reden und Briefen nebst einer Biographie* (Berlin, 1971), 1–60; A. P. Kazhdan, *La produzione intellettuale a Bisanzio* (Naples, 1983), 91–128.

CHANGE IN BYZANTINE CULTURE

226

(54.67–70), he had a quick temper (113.75–78, 171.59–60, 217.37–38), he indulged in astrology (154.49–55, 169.85–95); but simultaneously he could be extremely generous (59.13–16), he was eloquent (210.73–74), he was exceptionally strong and very brave (92.36–38, 93.56–57, 175.44–48), and he was loyal to his friends (95.19–22). Choniates related with great admiration how late in his life the emperor still endured great hardships on behalf of his subjects, leaving the comforts of the palace in order personally to raise the Turkish siege of Klaudiopolis. To this end he hastened to the city, with little baggage to slow his progress, taking neither a cot nor a mattress; he marched at night, his way lit by torches, through Bithynian gorges and forests (197.14–26). While Choniates repeatedly criticized Manuel's political policies, he never failed to excuse the emperor's failures. As if summarizing his judgment of Manuel, Choniates wrote, "who could blame him who fought for the empire and vigorously engaged our assailants, even if his efforts were not successful?"[67] The author sympathized with Manuel despite the emperor's vices and the obvious failure of his policies.

Choniates's attitude toward Andronikos was quite different, but his presentation of the emperor's character remains three-dimensional. He utterly damned the usurper's cruelty, depravity, mendacity, injustice, and cowardice: "He was more than anyone fond of power. Because he so passionately craved the imperial throne, he paved his way [to power] with inhuman behavior, surpassing all tyrants that ever lived" (321.17–19). Here was a monster of cosmic scale. Nevertheless, even Andronikos was depicted as having positive if not redeeming features in his character. He was well educated (229.54; see also 245.73–74), he was a gifted military engineer (281.72–73), he seemed affable (330.75–77), and he was modest in his consumption of food. Moreover, Choniates' final description of the savage reprisals taken by the Constantinopolitan mob on Andronikos is marked by a sincere commiseration for the man's patiently enduring terrible tortures (349f.). Andronikos was a tyrant, but, in the end, he was also a man subject to human passions, desires, and sufferings.

While Choniates in his *Chronicle* was as closely observant as Psellos, his subjectivity was different. Choniates never presented himself as the hero of historical events, although as a high court official he may well have participated in much that he described. Nor is his work an apology; on the contrary, Choniates often appeared in the *Chronicle* amid

67. Nik. Chon. 100.43–45. F. H. Tinnefeld, *Kategorien der Kaiserkritik in der byzantinischen Historiographie* (Munich, 1971), 160–63, has ascribed to Choniates a one-sided, negative opinion of Manuel I.

moral or political failure. For instance, he witnessed Alexios's compulsory monastic vows after this natural son of Manuel I had been charged with conspiracy (Nik. Chon. 425.71–72); he accompanied Manuel Kamytzes in an abortive expedition against the German Crusaders of Frederick Barbarossa (408.4); his attempt to persuade the mob at the meeting of January 25, 1204, not to overthrow the dynasty of the Angeloi was unsuccessful (562.41–53); he was dismissed by Alexios V from his post of logothete (565.13–15). Remarkably, the occasion of which Choniates was most proud was a private rather than a public one—his unarmed rescue of a Greek girl from the hands of a Crusader (590f.). Choniates' personality is not so deliberately and positively presented as Psellos's is in the latter's *Chronographia*; rather, Choniates' character is revealed indirectly. His love of his birthplace, his predilections and tastes are all discernible. Choniates' native Chonae was constantly in the narrative, and the events that took place there or in its surroundings were given disproportionate attention in the *Chronicle*. In addition to his native Meander Valley, Choniates often mentioned Philippopolis, where he had held the post of governor. Not only is there a geographic bias in the *Chronicle*; there is also a professional one. Choniates focused especially on judges, particularly the so-called judges of the *velum*. He was indignant that semi-civilized barbarians who had not yet learned proper Greek were given judicial positions, while those trained in the law took years to obtain their posts (Nik. Chon. 204.12–15). Judges of the *velum* are ubiquitous in the work, either dishonoring their office as did the sycophants of Andronikos, or martyred to their calling, like those judges of the *velum* who were disgraced for their attempted defense of Alexios II's mother (265.3–13). Those judges who supported Andronikos I, Choniates suggested, should not judge, but rather should be judged (267.50–52). From lemmas to his speeches, Choniates is known to have been a judge of the *velum*; hence, while Choniates seldom discussed his own career directly, his many considerations of the men of this office in the *Chronicle* again indicate the subjectivity of his writing.

Choniates' own experience is reflected most subtly in his changing attitudes toward age. In the earliest sections of the *Chronicle*, the author, who was then still a young man, wrote very positively about youth. For him, Manuel, the young emperor, combined maturity's reason with the joyous countenance of youth (50.71–76). Constantine Doukas's youth similarly promised a noble future (193.62–64). Choniates wrote sympathetically of Theodore Angelos and Mamalas, youthful victims of Andronikos I (288.64–65; 311.75–76). In these first parts of the *Chronicle*, old age was treated contemptuously. Andronikos I, whom Choniates

loathed, epitomized the weaknesses of old age: he was senile and decrepit, surpassing Tithonos and Kronos in the number of his years (283.16). There are no less than fourteen allusions to Andronikos's agedness in the *Chronicle*. Similarly, Choniates had no sympathy for John Kontostephanos, who reached the threshold of old age, contrasting his weakness to the "mature [*euelix*, literally, "of good stature"] and manly" strength of Alexios Comnenus, who was blinded on Andronikos's order (369.79–82). Even the people rebelled against the power of old men: when the aged and balding John Doukas attempted to obtain the crown, the people cried out that they did not want to have another old man as ruler; with gray-haired Andronikos they had had their fill of old ghosts on the brink of the grave (345.91–93). John Doukas futilely protested that he had not lost his brains because of old age (385.17). Choniates' bias toward youth in these initial chapters is all the more noteworthy as it stands in such contrast with the traditional great respect for the aged in Byzantium.

By the end of the *Chronicle* the author's attitude toward age had changed; as Choniates grew older, he seemed to become increasingly critical of flamboyant youth. The rebellious pseudo-Alexios was censured as a pretentious adolescent (421.40–41; see also 422.84–87). Choniates wrote with disdain of the young man who replaced Theodore Kastamonites as the emperor's favorite; this interloper was a child still in need of a tutor, an infant who ascended to the helm of the administration as soon as he was out of swaddling clothes (439.70–78). It seemed to the author that young men were everywhere, always incompetent, as commanders and counselors (467.90–112; 474.95–104; 503.51–53; 509.6–7, 14–16; 529.19; 539.15–19; 550.42–43; 626.74–71). He even suggested that instability of reason was typical of the young (435.55).

As might be expected, condemnation of old age disappeared in the later sections of the *Chronicle*. Choniates mentioned the happy old age of the seventy-year-old Kilij Arslan II and the later misery brought upon him by his own children (367.26–27, 413.38–40). He commiserated with Patriarch Niketas II Mountanes (1186–89), whom Isaac II had discharged as senile (405.31–32). If old men were subjected to Choniates' spite, it was pompousness (e.g., in Enrico Dandolo, 538.72–75) or buffoonery (e.g., in Basilakes, 449.58) rather than venerable age that the author mocked. Choniates' views naturally changed as he himself aged. What is noteworthy in the *Chronicle* is that its genre was flexible enough by the late twelfth and early thirteenth centuries to show this personal change.

But it is Byzantium's social anxiety, even more than the author's per-

sonality, that the *Chronicle* incorporates.[68] The sensibility was certainly structured by the traditional duality inherent in Christianity—life is good insofar as it was created by God and is bad to the extent that it has been corrupted by evil. But a pessimism absent from the works of Psellos pervades Choniates' writings. Both Psellos and Choniates wrote during politically difficult periods. Yet Psellos's *Chronographia* still maintains the conceit of Roman power and the assurance that the *imperium* would in the end conquer all. Choniates introduced a new perspective in Byzantine literature; his was a tragic perception of reality. Strangely, Choniates' pessimism did not harden into misanthropy with the horrors and humiliations of the fall of Constantinople to the Latins in 1204. Instead, the author showed in adversity a consistent tolerance toward his fellow human beings. He never lost his feeling for the value of human life. In fact, the central theme of Choniates' *Chronicle* is the societal disease that progressively infected the empire's population, from the mob of Constantinople to the emperor in the Great Palace. Although Choniates' book was begun long before the collapse of the empire, the anxiety that pervades the text seems to anticipate Byzantium's dissolution. This is the ultimate artistry of Choniates' narrative.

Choniates' personal exploration of the world implied a new self-consciousness on the part of the artist and an emergent interest in human phenomena on the part of his audience. The individual perspective Choniates expressed provides an unusual insight not only into his own personality and into the circumstances he described, it also reflects a change in the function of historiography. This work was not an idealized account of the imperial past, to be retold with minor variations in the future; it was a vivid depiction of human transience. Other eleventh- and twelfth-century authors displayed similar attitudes. Even the ecclesiastical art of the period, in its expressive style and pictorial enrichment, shows the artists' new self-concern, though in a more generalized way. This literary and artistic development was intricately intertwined with the modified material and cultural circumstances of Byzantium in

68. For a discussion of the tragic quality of Choniates' writings, A. P. Kazhdan, "'Korabl' v burnom more.' K voprosu o sootnošenii obraznoj sistemy i istoričeskich vzgljadov dvuch vizantijskich pisatelej," *Iz istorii kul'tury srednich vekov i Vozroždenija* (Moscow, 1976), 3–16. For a contrast between Eastern and Western attitudes as embodied in history writing, see A. P. Kazhdan, "Robert de Klari i Nikita Choniat," *Evropa v srednie veka: ekonomika, politika, kul'tura* (Moscow, 1972), 294–99.

the eleventh and twelfth centuries. Once realized, this new anthropo-
centric awareness was not quickly relinquished. Even the economic and
political disruption of the Latin Conquest of 1204 did not eliminate this
new sensibility, although what "renaissance" might have occurred with-
out the brutal dismemberment of the empire is a matter best left to
counter-factual historians.

CONCLUSION

This book is about change in Byzantine culture during the eleventh and twelfth centuries. Two points need to be clarified in this connection. First, while we argue that Byzantine society underwent change within this period, we do not deny continuity. No doubt perennial features were typical of Byzantium throughout the millennium of its existence, and, indeed, some elements of the classical heritage, especially in art and literature, were consciously derived from Greek or Roman antiquity. Such continuity is certainly worthy of study but it is not the subject of this book. Our emphasis on change may be biased, but such is a natural reaction to the deeply ingrained assumption that Byzantine culture was static, if not stagnant.

Second, the changes we have considered were not incidental and haphazard; they formed a coherent pattern that encompassed various fields of human activity, from humble agricultural and craft production to the creation of great monuments and the reformulation of ways of thinking. The revival of urban life provided a setting for many intellectual shifts, including the emergence of educational institutions and the growth of scholarship and science, with an attendant incipient skepticism. The strictures of ideal behavior were relaxed, and the complexity of human nature was considered with greater interest by painters and writers. On the evidence of art and literature, it appears that nature and humanity were less often than before assumed to be in opposition to one another and more often treated as intertwined and complementary. Again, there can be no question as to the tremendous influence exerted by ancient traditions in this cultural reassessment, but the classical tradition did not act on inert matter. We wish to emphasize that the Byzantines used antiquity in the establishment of their own values. Thus,

attitudes toward the past were subject to change during these crucial centuries, just as were other traits of the culture.

Many of our observations coincide with those often made by Western medievalists. But we hope to have identified, also, a peculiarity of Byzantium that will appear foreign to students of the Latin Middle Ages: urban growth in the East did not emerge through conflict with a feudal system. The Byzantine provincial towns of the eleventh and twelfth centuries developed not in a denial of serfdom, great landownership, or episcopal power, but rather evolved concurrently with those structures. The same circumstances that stimulated science and skepticism also fostered aristocratic, martial ideals. Popular modes of cultural expression— from the introduction of vernacular into the rarified realm of Byzantine literature to the proliferation of steatite prophylacteries—merged with aristocratic modes—from the introduction of chivalric romances to the veneration of knightly martyrs—so that distinctions may appear artificial to the critical scholar. Our appreciation of such developments, however, can only be brought into focus by their somewhat arbitrary isolation.

This Byzantine paradox needs clarification. The changes of the eleventh century must be seen against the background of the centralization and codification of the tenth, a century in which, for better or worse, the imperial court at Constantinople overwhelmingly dominated all human activity. In brief, order prevailed. Both the urban developments in the provinces and the growth of semi-feudal estates and private power in the centuries under consideration threatened imperial autocracy. The urban populace and the aristocrats, unexpectedly and (from a Western perspective) paradoxically, were allied; the ideology of order was assaulted from two entirely different social positions. While it would be misleading to speak of a society "pregnant with revolution," it is possible to suggest that Byzantium in the eleventh and twelfth centuries was ripe for change. One of the factors fomenting change in the empire was the breakdown of the "brilliant isolation" imposed on it by the arrogance of the imperial court in the tenth century. The Byzantines became more closely related to their Western and Eastern neighbors, although their interaction frequently took the form of religious disputation. These disputes, however negative their effect on the destiny of the empire may have been, have proved useful for historians: they help us grasp the basic differences between neighboring cultures in the Middle Ages. Certainly Byzantium was by no means an integrated society, nor was the West in any way unified. Nevertheless, a number of differences between the East and the West emerge, although generalizations can always be ques-

tioned on the basis of specifically local investigations. The following points seem to be the most significant: Byzantine society was more individualistic, or atomized, and the nuclear family played a more important role in the East than in the West. Further, other social microstructures remained embryonic. Byzantine society did not evolve a stable hierarchical structure, but rather retained a considerable social mobility. Consequently, the ruling class did not achieve the unity, even an ideal unity, that existed in the medieval West. The role of the state, and of the emperor as the political embodiment of the state, was immeasurably greater in Byzantium. This power of the state was never challenged by independent groups or institutions in the East so much as it was in the West. What caused these radical differences? Were they inherited respectively from the Greco-Oriental and Latin parts of the Roman Empire? Were they created during the great migrations of the early Middle Ages? Or was a common heritage transformed in different ways? This volume does not pretend to offer answers to these basic questions, although perhaps it is not inappropriate for us to end with them.

APPENDIX

TEXTS

Ex. 1:
BYZANTINE INVENTORY. FROM THE PRAKTIKON ENDOWING THE
GRAND DOMESTIKOS ANDRONIKOS DOUKAS WITH AN ESTATE IN
THE DISTRICT OF ALOPEKON (1073 A.D.)

Another enclosed allotment with a field Aribale, a copse of the farm Olynthos. A
meadow of the estate, approximately 40 *modioi* [a *modios* was equivalent to be-
tween 889 and 1,280 square meters]. Seeds for sowing found on this estate:
wheat, 260 *modioi* [*modios* here as a measure of volume conventionally defined as
40 pounds]; barley, 150 *modioi*; beans, 5 *modioi*, seeds of flax, 5 *modioi*. . . . Yokes
of water buffalo two and one yoke of oxen are found there and given over [to
Andronikos], also two plows with all the harness. . . . As far as slaves are con-
cerned, none, since they have all died out. . . . *Paroikoi* [dependent peasants] on
the estate of Baris: . . . George Tsikos has his wife Anna and his son John, an
allotment for one ox, *aktemon* [the poorest category of peasant in the eleventh
century], his tax, one *nomisma* [gold coin] and a half . . . Anna, the widow of
Chasanes, has a daughter Maria, a son-in-law Leo, a yoke [of oxen], a mare. Her
tax is three *nomismata*. Michael Chenarios has his wife Anna, a yoke [of oxen],
non-working cattle [cows], one mare, one donkey, fourteen swine; tax, three
nomismata and ten *miliaresia* [a silver coin, still at that time worth one twelfth of a
nomisma].

MM 6:6f.

Ex. 2:
FAMINE IN SICILY IN ABOUT 950

The Ismaelites occupied the whole country and plundered all the places there. A
horrible famine struck the inhabitants—not only those who dwelt in towns, but

also those who found their abode in the mountains. What a terrible tragedy one could observe; what a plight became manifest! Many Christians at that time ate the flesh of their beloved children—the teeth of parents did not feel disgust at doing what the Jews who were charged with the murder of Christ had dared to commit. Children also tasted the flesh of unlucky parents, and brothers their brothers' flesh. Even wives were not safe from this evil; even they would fill the stomachs of their husbands. The famine was severe; nature assaulted and devoured itself. Such was the great impiety that the sun could see in this region.

> *Historia et laudes SS. Sabae et Macarii*, ed. G. Cozza-Luzi (Rome, 1893), 13, para. 6 (written at the beginning of the eleventh century).

Ex. 3:
THE FAIR IN THESSALONIKI IN THE TWELFTH CENTURY

The festival of St. Demetrios has [in Thessaloniki] the same significance as the Panathenaia in Athens and the Panionia in Miletus. It is the most considerable *panegyris* [meaning both "festival" and "fair"] among the inhabitants of Macedonia. Not only would the local population assemble there, but people from everywhere and of every sort would arrive. Greeks come from every place, as well as the neighboring tribes of Mysians [Bulgarians] who live as far as the Danube and the land of the Scythians, and the inhabitants of Campania, Italians, Spaniards and Portuguese, and Celts from beyond the Alps. To put it precisely, the shores of the Ocean sent suppliants and beholders to the martyr, so great was his glory through the whole of Europe.

I for one, originating from remote Cappadocia, had until now no personal experience of the event and knew about it only from hearsay. So I desired to be a spectator of this sight and see everything without exception. With this purpose I climbed a hill located nearby and, sitting there, could observe the *panegyris* with ease. It looked like this: tents of merchants were pitched in two lines facing one another. The lines ran a long distance, leaving between them a broad lane that allowed for the rush of the crowd. . . . Other tents were set up off this lane. They also formed lines, but not very long ones, as if they were the short legs of a crouching reptile. . . .

Looking down from my hill I saw all kinds "of fabric and thread" [a quotation from Heliod. 10.25], of men's and women's garb produced both in Boeotia and in the Peloponnese and carried on commercial ships from Italy to Greece. Also Phoenicia sent many an object; Egypt, Spain, and the Pillars of Herakles produced the best implements. Merchants brought all these things directly from their countries to old Macedonia and Thessaloniki. But the Black Sea sent its produce first to Byzantium [Constantinople] and therefrom it was brought here and adorned the *panegyris*. Numbers of horses and mules carried their load from there.

> Pseudo-Lucian, *Timarion*, ed. R. Romano (Naples, 1974), 54f.

Ex. 4:
DESCRIPTION OF A LAZY MERCHANT

While all merchants . . . rush to a *panegyris* in order to trade and make a profit, he alone among them all . . . remains sitting before his house, watching them

pass by going full speed to the *panegyris*. He not only remains lazy and indolent, but wastes his time with carousing and harlots; he does not run to the market, but tarries day after day. . . . Or he does arrive at the *panegyris* with the other merchants, but they, having brought with them [sufficient] gold, begin dealing right away, and they buy products in order to make a profit, whereas our man, who did not bring any [money], runs about in search [of someone] from whom to borrow, so that he also might participate in trade. But either before he finds someone to lend him [money] or immediately after, the *panegyris* is over and he has no profit. . . . Sometimes he arrives with money, but instead of dealing efficiently from the very beginning he roams around the tents of the tavern keepers, cooks, and other petty traders in victuals and tastes here and there, eats and drinks, and squanders his gold in drunken revels and licentiousness. . . . Or he wanders around the whole *panegyris* visiting both acquaintances and those he has never met, from his place or from foreign ones. He observes how they are doing, but he himself does not buy or sell. . . . While other people, looking for profit, do not pay attention to robbers or the other difficulties of a long trip, he would be frightened; and even though they [i.e., other merchants] ask him to travel together [with them] and promise to protect him against every danger, he prefers not to follow them, not to join them in enterprise at the *panegyris*.

Symeon the Theologian, *Traités théologiques et éthiques*, ed. J. Darrouzès, vol. 2 (Paris, 1967), 386–88.

Ex. 5:

JEWISH COMMUNITIES IN BYZANTIUM AND THE DISTANCES BETWEEN THEM

No Jews live in the city [Constantinople], for they have been placed behind an inlet of the sea. An arm of the Sea of Marmora shuts them in on the one side, and they are unable to go out except by way of the sea, when they want to do business with the inhabitants. In the Jewish quarter there are about 2,000 Rabbanite Jews and about 500 Karaïtes, and a fence divides them. Amongst the scholars are several wise men, at their head being the chief rabbi R. Abtalion, R. Obadiah, R. Aaron Bechor Shoro, R. Joseph Shir-Guru, and R. Eliakim, the warden. And amongst them there are artificers in silk and many rich merchants. No Jew there is allowed to ride on horseback. The one exception is R. Solomon Hamitsri, who is the king's [Manuel I's] physician, and through whom the Jews enjoy considerable alleviation of their oppression. For their condition is very low, and there is much hatred against them, which is fostered by the tanners, who throw out their dirty water in the streets before the doors of the Jewish houses and defile the Jews' quarter [the Ghetto]. So the Greeks hate the Jews, good and bad alike, and subject them to great oppression, and beat them in the streets, and in every way treat them with rigor. Yet the Jews are rich and good, kindly and charitable, and bear their lot with cheerfulness. The district inhabited by the Jews is called Pera.

From Constantinople it is two days' voyage to Rhodosto with a community of Israelites of about 400, at their head being R. Moses, R. Abijah, and R. Jacob. From there it is two days to Kallipolis [Gallipoli], where there are about 200 Jews, at their head being R. Elijah Kapur, R. Shabbattai Zutro, and R. Isaak Megas, which means "great" in Greek. And from here it is two days to Kales. Here there are about fifty Jews, at their head being R. Jacob and R. Judah. From here it is

two days' journey to the island of Mytilene, and there are Jewish congregations in ten localities on the island. Thence it is three days' voyage to the island of Chios, where there are about 400 Jews, including R. Elijah Heman and R. Shabtha. Here grow the trees from which mastic is obtained. Two days' voyage takes one to the island of Samos, where there are 300 Jews, at their head being R. Shemaria, R. Obadiah, and R. Joel. The islands have many congregations of Jews. From Samos it is three days to Rhodes, where there are about 400 Jews, at their head being R. Abba, R. Hannanel, and R. Elijah.

The Itinerary of Benjamin of Tudela, transl. M. N. Adler (London, 1907), 14.

Ex. 6:
A. HIGHEST TITLES OF THE TENTH AND ELEVENTH CENTURIES

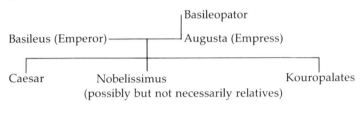

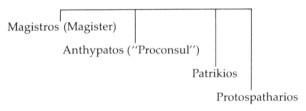

B. HIGHEST TITLES OF THE TWELFTH CENTURY

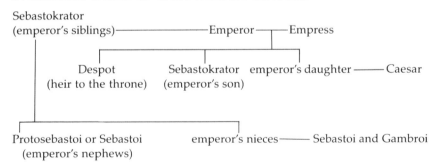

Ex. 7:
WILLIAM OF TYRE ON MANUEL I'S POLICY TOWARD THE LATINS

When Lord Manuel died, that most fortunate emperor of indelible memory, he was succeeded according to both his will and the hereditary law by his young son Alexios, who had hardly reached his thirteenth year. . . . During the reign in

God of the former beloved emperor, the Latin people found favor with him due to the emperor's trustfulness and vigor. He even disdained his Greek manikins, who were soft and effeminate, and, being a man of great generosity and incomparable activity, gave important assignments only to Latins, taking into consideration their fealty and strength. Because they prospered under his rule and enjoyed his generous liberality, the noble and ignoble of the whole universe eagerly collected around him, as around a great benefactor. As they accomplished their service quite well, he was induced more and more to appreciate our people, and promoted all of them to higher ranks. Therefore the Greek nobility, and especially his relatives, as well as the rest of the populace, acquired an insatiable hatred toward our men.

PG 201.857f.

Ex. 8:
THE EMPEROR'S CONTROL OF THE ARMY

On the day dedicated to the memory of Prokopios the Martyr [July 6, 1167], Kontostephanos arranged the army in battle array and he himself donned armor and took up weapons of all sorts. He commanded that the other [commanders] follow his example, led out their detachments and arrayed them in the best possible way. He took under his command the central part of the phalanx, the right wing he gave to Andronikos Lapardas, while other taxiarchs headed the left wing. It was the *strategos* who appointed them. Other phalanxes were also arrayed, but set a little apart from both wings, in order to be at hand when the time came to succor the toiling troops.

While Andronikos [Kontostephanos] was arranging and positioning his troops in such a way, someone arrived from the emperor [Manuel] carrying with him an imperial epistle. In this epistle, it was ordered that [Andronikos] withhold from battle on this day and postpone it until another—the date for the postponed battle was indicated in the letter. The *strategos* took the paper, but put it into his bosom. He himself did not pay any attention to its contents, nor did he reveal the order to the lords who accompanied him; he diverted them from the point (and it was praiseworthy) by talk about different subjects. The reason for [the emperor's] prohibition was the fact that [for him] this day was ominous and absolutely unpropitious for martial events. So it was that the emperor made decisions concerning the most important actions (which in fact must be determined by God's will) on the basis of a constellation or the disposition or motion of the stars, and he obeyed astronomers' words as if they were God's tablets.

Nik. Chon. 153f.

Ex. 9:
THEODORE BALSAMON ON FORTUNETELLING

Noumenia [literally, "new moons"] are the first days of the month. Jews and Hellenes used to celebrate them and to pray while genuflecting so that the rest of the month would be happy. God said about them through the prophet: "Your New Moons and your Sabbaths my soul hated" [Isaiah 1:13–14]. . . . However,

the demonic habit of kindling bonfires and searching for good omens has been preserved to the days of Patriarch Michael [1170–78], the former *hypatos* of philosophers, even in the Queen of Cities. On the evening of June 23 men and women would gather on the beaches of the sea or in certain houses and they would dress the first-born girl as bride. After having supped and danced in a Bacchic frenzy, moving in circles and shouting, they would pour sea water into a brazen vessel with a narrow mouth. Each of them would cast therein some object. They would begin to question the girl about good things and about ill-omened ones, as if she had acquired from Satan the power of telling the future. She would take at random from the vessel an object [from among those that had been cast in] and make a prediction, while the crazy owner held the thing and listened to his proclaimed future, whatever it might be, fortunate or gloomy. In the morning, they would go to the seashore, dancing in chorus and accompanied by the girl. Having scooped up sea water in abundance they would pour it on their dwellings. Moreover, during the whole night they would burn haystacks, jump over them, and prophesize good or bad luck as though they were possessed by demons. They decorated with gilded robes and silk fabrics the house in which they did the fortunetelling, along with the courtyard and the paths; and they would make wreaths of leaves to glorify, as it turns out, the Satan dwelling within them.

PG 137.740B–741C.

Ex. 10:

THEATRICAL GAMES AT THE PALACE OF BLACHERNAE (1200)

The wedding took place just before Lent. The father-in-law, Emperor [Alexios III], had no desire to attend horse races, but the newly married couple urged and demanded games. The emperor tried to appease contradictory desires: he went neither to the Great Palace nor to the stadium [the Hippodrome] but rather ordered the races moved to the Palace of Blachernae and quickly organized a performance there. The bellows of the many-fluted organs located in the palace courtyard were used as turnposts [for the racing chariots], and a certain eunuch—let us omit his name—was disguised as the eparch of the city. He was a rich man occupying an important office and was enrolled among the imperial courtiers. A wicker-work was devised that in the vernacular is called a "wooden donkey" and it was covered with a horsecloth woven with gold. The false eparch maneuvered it to the improvised theater. It appeared as though he were ceremonially riding a horse, while all the time he adroitly pushed the horse's legs forward and neighed. Shortly after that he changed his mask, like the ancient actors, and having taken off the eparch's vestments he appeared as a *mapparius* [the starter for the horse races]. Those who pretended to be contenders were not people of the market or of the common streets, but young nobles who had just grown their first beards. The emperor and the empress, their distinguished relatives, and the upper-level retinue were spectators at this theatrical and laughter-causing game. Nobody else was allowed in. As the moment came for the contenders to race, the eunuch disguised as a *mapparius* came to the center, showed his arms naked to the elbows, and put a spherical silver cap on his head. Thrice

he called the youngsters to contend, and thrice the noble child who stood be-
hind him and who possessed a brilliant title smote the eunuch's buttocks with
his heel when this man bent forward to give the sign.

Nik. Chon. 508f.

Ex. 11:

MICHAEL PSELLOS ON THE MONK ELIAS: LETTER TO AN UNKNOWN ADDRESSEE

This monk Elias desired like his namesake [Elias the Tishbite], who cared noth-
ing for property, neither to possess it nor to think about earthly things, but to
transcend all practical virtues and all intellectual ornament and, traversing the
air, to ascend to God and to moor in ineffable harbors. For this he desired and
longed exceedingly, but the accompanying body, that heavy burden, that earthly
tent, that weighty ballast, held him. Even though he frequently took the first
step, it pulled him down and drew him back. Twice and many more times he
made the attempt, but necessity dragged him down; neither was the ascent to
heaven easy for him nor did the stay on earth bring him satisfaction. He lived
not by himself only (in such a case his trouble would have been less unbearable)
but he had his mother, who laid her expectations upon him, and he had also the
companionship of his relatives. Therefore he went for long trips, sometimes
northward, sometimes to the south; he divided himself between the Orient and
the Occident, not in order to examine what the distance is between Britain and
Thule, nor to understand how the famous Ocean surrounds the continent, nor
to investigate which Ethiopians dwell in the East and which in the West. But his
goal was to come to anchor in your bays bringing some goods from abroad. His
way of life is [that of a] vagrant; as a matter of fact, I can call it philosophical,
since Plato is said to have passed Charybdis three times and that many times to
have crossed the strait of Sicily. Plato, however, met the two Dionysiuses and
rather than profiting from his philosophy, he would have been sold into slavery
had it not been for Annikeris of Aegina, who ransomed him. Elias met hosts of a
different kind, rather like the Phaeacians who entertained Odysseus, so that
when he came back, he had some cymbals in his hands and his mother returned
to life and the crowd of his relatives started dancing.

Sathas, *MB* 5:402f.

Ex. 12:

MICHAEL PSELLOS ON THE MONK ELIAS: LETTER TO THE JUDGE OF THE THEME OF OPSIKION

There is a share of God and [a share] of another one, of Mammon [in mankind].
Pure souls serve God, and those subject to a passionate nature serve Mammon.
There was not until recently a third strain, but the monk Elias introduced it,
since he does not render to God what is God's or to Mammon what is Mam-
mon's, but gives to both parts a fitting share: to God his monastic habit, our holy
anchor, but to Mammon, both the force of his soul and the limbs of his body. So

it turns out that while praising God he fornicates in his mind, and after a whole day of licentiousness, he begins to act with piety. Forthwith he sheds tears and immediately repents of his passions. He is unbalanced and knows only two abodes—the brothel and the monastery.

Scripta min. 2:126f.

Ex. 13:
DESCRIPTION OF THE EMPRESS ZOE (1028–50)

The tasks that women normally perform had no appeal whatever for Zoe. Her hands never busied themselves with a distaff, nor did she ever work at a loom or any other feminine occupation. Still more surprising, she affected scorn for the beautiful dresses of her rank, though I cannot tell whether she was so negligent in the prime of life. Certainly in her old age she lost all desire to charm. Her one and only concern at this time, the thing on which she spent all her energy, was the development of new species of perfumes, or the preparation of unguents. Some she would invent, others she improved. Her own private bedroom was no more impressive than the workshops in the market where the artisans and the blacksmiths toil, for all round the room were burning braziers, a host of them. Each of her servants had a particular task to perform: one was allotted the duty of bottling the perfumes, another of mixing them, while a third had some other task of the same kind. In winter, of course, these operations were demonstrably of some benefit, as the great heat from the fires served to warm the cold air, but in the summer-time the others found the temperature near the braziers almost unbearable. Zoe herself, however, surrounded by a whole bodyguard of these fires, was apparently unaffected by the scorching heat. In fact, both she and her sister seemed naturally perverse.

Michael Psellos, *Chronographia*, transl. E. R. A. Sewter (Baltimore, 1952), 137–38.

Ex. 14:
DESCRIPTION OF ANNA DALASSENA

In the past, when Anna Dalassena was still looked upon as a younger woman, she had impressed everyone as "having an old head on young shoulders"; to the observant her face alone revealed Anna's inherent virtue and gravity. But, as I was saying, once he had seized power my father reserved for himself the struggles and hard labor of war, while she became so to speak an onlooker, but he made her sovereign and like a slave said and did whatever she commanded. He loved her exceedingly and depended on her for advice (such was his affection for her). His right hand he devoted to her service; his ears listened for her bidding. In all things he was entirely subservient, in fact, to her wishes. I can sum up the whole situation thus: he was in theory the emperor, but she had real power. She was the legislator, the complete organizer and governor, while he confirmed her arrangements, written and unwritten, the former by his signature, the latter by his spoken approval. One might say that he was indeed the instrument of her power—he was not emperor, for all the decisions and ordinances of his mother satisfied him, not merely as an obedient son, but as an at-

tentive listener to her instruction in the art of ruling. He was convinced that she had attained perfection in everything and easily excelled all men of that generation in prudence and understanding of affairs.

Anna Comnena, *The Alexiad*, transl. E. R. A. Sewter (Baltimore, 1969), 119–20.

Ex. 15:
PROUD PLEA OF AN IMPRISONED NOBLEWOMAN

 83 High and low I am coming against offense and derision,
 The West and the East are full of my torments,
 The islands and the sea have beheld my shame,
 Those first of the Princes, then that of the Leukas.
 A cruel dungeon waited for me in the Great Palace,
 And now I have found another prison in the Blachernae. . . .
104 I know my appeals will leave your soul cold,
 Streams of tears are senseless and moans useless;
 Let your messenger, armed with a sword, appear
 To commit the execution and free me, the ill-fated,
 From all anxiety and trouble, from tears and trials;
 Grant me your mercy, such a small mercy. . . .
217 Let the judge impartially scrutinize my case,
 Let him pronounce the sentence in accordance with justice,
 Let him condemn me, could he have me convicted!
 I am a conspiratress and enemy—but who is the witness?
 I have been plotting against the emperor—but who has ever heard [me]?
 Let the slanderers speak publicly,
 And if they prove their lie, let the Pantokrator
 Smite me from Heaven with lightning. . . .
305 In the hearth of your wrath I was burned,
 In the hearth of your fury you tried me,
 But there is no base copper in my soul, only
 Pure silver. What are you searching further?

S. D. Papadimitriu, "Ho Prodromos tou Markianou Kodikos," *VV* 10 (1903), 155–63.

Ex. 16:
FROM AN EPITAPH FOR EMPEROR JOHN II

 Beautiful purple garb swaddled me
 and the symbols of supreme power
 embellished me from my tender boyhood.
 The lust for victory shot through my heart
 and taught me first to ride and to draw the bow,
 then gave me the two-edged sword
 and trained me in the hunting labors—
 to kill the bear by the stab of the spear,
 to smite the leaping leopard with an arrow.

 Hist. Ged. no. 25.12–20.

Ex. 17:
MORTAL HUNTING ACCIDENT OF BASIL I

It was August and the Emperor Basil had gone out for the hunt, into Thrace, to the neighborhood of Apameia and Melitias. Finding a herd of deer, he gave chase with the senate and the huntsmen. They were all scattered in every direction in pursuit, when the emperor spurred after the leader of the herd, whose size and sleekness made him conspicuous. He was giving chase alone, for his companions were tired; but the stag, seeing him isolated, turned in his flight, and charged, trying to gore him; he threw his spear, but the stag's antlers were in the way, and it glanced off useless to the ground. The emperor now, finding himself helpless, took to flight; but the deer, pursuing, struck at him with its antlers and carried him off. For the tips of the antlers having slipped under his belt, the stag lifted him from his horse and bore him away, and no one knew this had happened, till they saw the horse riderless. Then Stylianos, called Zaoutzes, and Prokopios the *protovestiarios* showed them all what had happened. They all began running hither and thither, and just managed to catch a glimpse of the object of their search carried aloft by the beast. They gave chase with all speed, but without success; for the stag, when they were well outdistanced, stood panting and breathing hard, but when a rush brought them nearer, straightway bounded off to a good distance. So they were at a loss, till some of the Hetaireia, as it is called, cut off the stag from in front before it was aware, and scattering circle-wise in the mountains, put it up again by shouting. Then one of the Farghanese, managing to ride alongside the deer with a naked sword in his hand, cut the horn-entangled belt through. The emperor fell to the ground unconscious. When he came to himself he ordered the man who had delivered him from danger to be arrested and ordered the cause of such insolence to be investigated. "For," said he, "it was to kill me, not to save, that he stretched out his sword."

Vita Euthymii Patriarch of Constantinople, ed. and transl. P. Karlin-Hayter (Brussels, 1970), 3–4.

Ex. 18:
CONSTANTINE MANASSES ON HUNTING

People invented the riding of horses and hunting not only for the sake of exercise to strengthen their bodies, but also to provide delight to their hearts and excitement to their senses. They are excellent actions, making men hale and healthy, extinguishing their every sickness and raising them to life again. They are also excellent for preparing men for warfare, since they teach them to ride, to pursue, to hold a pattern, and not to spring forward out of line. They teach [men] how to move straight or left or right, how to give their horses free rein and how to urge them on with bridles loosened under fire. One could call them modest exercises, recalling greater deeds. This battle is not man-slaying, this Ares is ironless; his hands are not stained with gore and he does not grasp the murdering spear. They are really excellent, and seem unpleasant and undesirable only for those who do not love beauty.

E. Kurz, "Ešče dva neizdannych proizvedenija Konstantina Manassi," *VV* 12 (1906), 79.1–15.

Ex. 19:
IMPERIAL PALACE OF BLACHERNAE

This King Emanuel [Manuel I] built a great palace for the seat of his government
upon the sea-coast, in addition to the palaces which his fathers had built, and he
called its name Blachernae. He overlaid its columns and walls with gold and sil-
ver and engraved thereon representations of battles before his day and of his
own combats. He also set up a throne of precious stones and of gold, and a
golden crown was suspended by a golden chain over the throne, so arranged
that he might sit thereunder. It was inlaid with jewels of priceless value, and at
night time no lights were required, for everyone could see by the light which the
stones gave forth. Countless other buildings are to be met with in the city.

> *The Itinerary of Benjamin of Tudela,* transl. Adler, 13.

Ex. 20:
IMPERIAL PALACE OF BLACHERNAE

In that place [in the corner of the city by the landwalls and the Golden Horn] the
Palace of Blachernae, although having foundations laid on low ground, achieves
eminence through excellent construction and elegance and, because of its sur-
roundings on three sides, affords its inhabitant the triple pleasure of looking out
upon sea, fields, and city. Its exterior is of almost matchless beauty, but its inte-
rior surpasses anything that I can say about it. Throughout it is decorated elabo-
rately with gold and a great variety of colors, and the floor is marble, paved with
cunning workmanship; and I do not know whether the exquisite art or the ex-
ceedingly valuable stuffs endows it with the more beauty or value.

> Odo of Deuil, *De profectione Ludovici VII in orientem,* transl. V. G. Berry (1948; reprint:
> 1965), 65.

Ex. 21:
A GIRL SEDUCED AND FORSAKEN: EPIC OF DIGENIS AKRITAS

> When I came to it [a spring in the waterless plains of Araby]
> I heard moaning
> Lamentations with weeping and many tears.
> The mourner was a girl most beautiful. . . .
>
> She, when she saw me, up she jumped at once,
> Wrapping herself about in decent order,
> Wiped with her linen the showers from her eyes,
> And gladly thus began to speak to me: . . .
>
> "My own country, young man, is Meferkeh.
> You have heard of Haplorrabdes, the emir of all,
> He is my father, my mother Melanthia.
> I loved a Roman to my own despite,
> One whom my father held captive three years. . . .
>
> And miserable I, occasion found,
> Much riches seized, went off with the deceiver. . . .

Thus all the way rejoicing in each other
We arrived at this fountain which you see;
For three days here reposing and three nights,
Love's changes celebrating without fill. . . .
. . . While we slept together the third night
He rose up secretly, saddled the horses,
And took the gold and better furniture. . . .

He was gone from sight without a word. . . .

I am bereft of all, without all hope;
For to my parents I dare not return,
I am ashamed of neighbours and companions.
Where to find my traitor I know not at all. . . ."

Amazement held me then and made me wonder
Seeing the girl's much love for the young man,
Who had procured her unimagined woes,
Parting from parents, taking wealth away,
Awful desertion in the pathless wild
To wait for nothing but death undeserved. . . .

And when I took her up on my own horse
And we set out to go to the Coppermines
(That was a place nearby in Syria)
I knew not what I was, I was all fire,
Passion increasing utterly within me;
So when we rested as for natural need—
My eyes with beauty and my hands with feeling,
My mouth with kisses and with words my hearing—
I started to do all of lawless action,
And every deed I wanted all was done.
By lawlessness our journey was defiled
By Satan's help and my soul's negligence,
Although the woman much opposed my doing,
Calling on God and on her parents' souls.
The Adversary, champion of the dark,
The foe and enemy of all our race,
Made me ready to forget God Himself.

> *Digenes Akrites*, ed. and transl. J. Mavrogordato (Oxford, 1956), 143–59.

Ex. 22:
A GIRL FORSAKEN (FROM HAGIOGRAPHY)

Early in the morning Lazarus got away from there and took the road toward
Chonae [the ancient Colossae in Asia Minor]. On his way he met some people
from Cappadocia who were also going to visit the shrine of the Archangel.
Lazarus told them about himself and joined the group. There was among them a
girl who was moaning and lamenting gravely. When Lazarus saw her he in-
quired about the cause of her wailing, and he was told by some people that she
had been swindled and led away from her native land and that she had taken

with her a substantial sum of money on the advice of the impostor. The deceiver had taken her money, abandoned her, and disappeared. But she was wailing not only because of this fraud; she quaked from fear of being disgraced by someone, since she was a virgin. When Lazarus learned all this he approached her and conversed with her and convinced both her and, with her help, her companions that he would take care of her until they arrived at Chonae. And so he did. When they arrived at the city, he found some of her relatives and entrusted her to them in order to return her to her native place and to her parents. However, the evil spirit, the real foe and adversary of the good, saw that Lazarus, looking for Christ's grace, not only remained undamaged by his evil arrows, but also guarded the girl. The devil could not tolerate this defeat and ventured to employ another tool in order to defile Lazarus's chastity. In vain the devil toiled. When night came, Lazarus stood in a corner of the parlor and prayed to the Lord, and after that lay down to sleep right on the spot. The evil spirit sent to him a certain woman, in the shape of a nun, who started to incite Lazarus to shameful intercourse. He, however, as if he were escaping a fire, instantly got up and without a word left the place. When he came to another place, he called on God, beseeching Him to release him from the variegated arts of evil and to furnish him a smooth road to the Holy Land.

From the *Life* of Saint Lazarus of Galesios, written by a certain Gregory, his disciple, in the eleventh century. *AASS*, Novembris III (Brussels, 1910), 511A–C.

Ex. 23:
THE PALACE OF A HERO

> Amid this wondrous pleasant paradise
> The noble Borderer raised a pleasant dwelling,
> Of goodly size, four-square of ashlared stone,
> With stately columns over and casements;
> The ceilings with mosaic he all adorned,
> Of precious marbles flashing with their gleam;
> The pavement he made bright inlaid with pebbles;
> Within he made three-vaulted upper chambers,
> Of goodly height, the vaults all variegated,
> And chambers cruciform, and strange pavilions,
> With shining marbles throwing gleams of light.
> The artist had so beautified the work
> That woven seemed to be what there was seen
> From the stones' gay and many-figured show.
> The floor of it he paved with onyx stones,
> So firmly polished those who saw might think
> Water was there congealed in icy nature.
> He laid out in the wings on either side
> Reclining-rooms, long, wondrous, golden-roofed,
> Where the triumphs of all, of old in valor
> Who shone, he painted fair in gold mosaic;
> Began with Sampson's fight against the gentiles,
> How with his hands he strangely rent the lion,
> How of the gentiles' town the gates and bars

He bore on to the hill, when he was prisoned;
The gentiles mocking him, and their destructions;
Lastly the temple's complete overthrow
By him accomplished in those days of old,
And himself being destroyed with the gentiles.
David midmost he showed, without all arms,
Sling only bearing in his hand and stone;
Beyond Goliath too in stature great,
Dreadful to look at mighty in his strength,
From head to foot in iron fenced about,
Bearing a javelin like a weaver's beam
In hue all iron by the painter's art.
He painted too the very moves of war:
Struck rightly by the stone Goliath straight
Fell wounded to the ground immediately;
How David running, lifting up his sword,
Cutting his head off had the victory.
And then the fear of Saul, the meek one's flight,
The thousand plots and God His vengeances.
 The fabled wars he painted of Achilles;
Agamemnon the fair, the baleful flight,
Penelope the wise, the suitors slain,
Odysseus' wondrous daring of the Kyklops;
Bellerophon slaying the fiery Chimaira;
Alexander's triumphs, rout of Darius,
And Kandake, her queenship and her wisdom,
His coming to the Brahmans, then to the Amazons,
And other feats of the wise Alexander,
And hosts more marvels, manifold braveries.
Moses his miracles, the plagues of Egypt,
Exodus of the Jews, ungrateful murmurs,
And God's vexation, and His servant's prayers,
Joshua son of Nun his glorious feats.
This and much else in those two dining-halls
With gold mosaic Digenes depicted
Which gave to those who saw a boundless pleasure.
Within the house was the floor of the court,
Both in length and in breadth having great dimension.
Herein he built a glorious work, a temple
In the name of Theodore the saint and martyr.

Digenes Akrites, ed. and transl. Mavrogordato, 219–23.

Ex. 24:
ANNA COMNENA'S DESCRIPTION OF ITALOS

Italos, although he was a disciple of Psellos, was unable with his barbaric, stupid temperament to grasp the profound truths of philosophy; even in the act of learning he utterly rejected the teacher's guiding hand, and full of temerity and barbaric folly, believing even before study that he excelled all others, from the

very start ranged himself against the great Psellos. With fanatical zeal for dialec-
tic he caused daily commotions in public gatherings as he poured out a continu-
ous stream of subtle argument; subtle propositions were followed in turn by
subtle reasons to support them. . . . When Psellos withdrew from Byzantium
after his tonsuration, Italos was promoted to the Chair of General Philosophy,
with the title, "Consùl of the Philosophers." He devoted his energies to the ex-
egesis of Aristotle and Plato. He gave the impression of vast learning and it
seemed that no other mortal was more capable of thorough research into the
mysteries of the peripatetic philosophers, and more particularly dialectic. In
other literary studies his competence was not so obvious: his knowledge of
grammar, for example, was defective and he had not "sipped the nectar" of
rhetoric. For that reason his language was devoid of harmony and polish; his
style was austere, completely unadorned. His writings wore a frown and in gen-
eral reeked of bitterness, full of dialectic aggression, and his tongue was loaded
with arguments, even more when he spoke in debate than when he wrote. So
powerful was he in discourse, so irrefutable, that his opponent was inevitably
reduced to impotent silence. He dug a pit on both sides of a question and cast
interlocutors into a well of difficulties; all opposition was stifled with a never-
ending string of questions, which confounded and obliterated thought, so
skilled was he in the art of dialectic. Once a man was engaged in argument with
him, it was impossible to escape the man's labyrinths. In other ways, though, he
was remarkably uncultured and temper was his master. That temper, indeed,
vitiated and destroyed whatever virtue he had acquired from his studies; the fel-
low argued with his hands as much as his tongue; nor did he allow his adversary
merely to end in failure—it was not enough for him to have closed his mouth
and condemned him to silence—but at once his hand leapt to the other's beard
and hair while insult was heaped upon insult. The man was no more in control
of his hands than his tongue. This alone would prove how unsuited he was to
the philosopher's life, for he struck his opponent; afterward his anger deserted
him, the tears fell and he showed evident signs of repentance. In case the reader
may wish to know his physical appearance, I can say this: he had a large head, a
prominent forehead, a face that was expressive, freely-breathing nostrils, a
rounded beard, broad chest and limbs well compacted; he was of rather more
than average height. His accent was what one would expect from a Latin youth
who had come to our country and studied Greek thoroughly but without mas-
tering our idiom; sometimes he mutilated syllables. Neither his defective pro-
nunciation nor the clipping of sounds escaped the notice of most people and the
better educated accused him of vulgarity. It was this that led him to string his
arguments together everywhere with dialectic commonplaces. They were by no
means exempt from faults of composition and there was in them a liberal sprin-
kling of solecisms.

Anna Comnena, *The Alexiad*, transl. Sewter, 175–77.

Ex. 25:
JOHN MAUROPOUS, SPEECH ON THE VICTORY OVER LEO
TORNIKES (1047)

O man, what an enormous die you are endeavoring to cast! You are about to
struggle over your soul itself. The danger is horrible, the attempt fearful. You are

falling among swords, you are leaping on the edge of a precipice, your narrow path runs between life and death. Halt, O miserable man! Where are you dashing? Stop, if you have any reason, avoid the steep and slippery road, avoid the risk of falling, reject false expectations. Remember, the future is not secure, your reckless affair is full of peril. Even your success will be shameful, albeit it could seem pleasant. Your success will be a usurpation, the act and the word itself hated by all people both of the past and of the present. But if you fail, you'll be finished, you'll be thrown down into the abyss of Hell. Everyone in his right mind would prefer the humble but secure way rather than a vicious and deadly ascent. Is it not preferable to be in the rank and file without being hated by anybody, rather than rule over all and be detested by everyone? But this foolish man does not answer; he does not give his ear to anything. He is inflamed by his passion, he is drunk with his hopes. He utters, "The die is cast." He closes his eyes, and drawn by the force of his desire, he rushes toward the yawning depth. He takes off the monk's habit, unnecessary and undeserved by him; he puts on lay garments—he, a dog that returned to his vomit [Prov. 26:11], he, Leo, the Lion, who turns out to be a chameleon, accepting and changing various colors, he, who is unable to retain only one, the last and inimitable color. He replaces black by white (the [imperial] purple is lacking yet); he becomes bright after having been gloomy. Nobody could expect this: a former monk, he is now a lord, longing for an even whiter vestment, that of the emperor, to be laid upon him and to distinguish him, contrary to all expectations.

John Mauropous, "Quae in codice Vaticano graeco 676 supersunt," ed. P. de Lagarde, *Abhandlungen der historisch-philologischen Klasse der königlichen Gesellschaft der Wissenschaften zu Göttingen* 28, no. 1 (1881 [1882]), 182, no. 186, #18–19.

Ex. 26:
EULOGY BY GEORGE TORNIKES FOR ISAAC II ANGELOS (1193)

O Emperor magnified by God, I had already desired to eulogize you and just at that time I experienced the same thing as those who, for the sake of investigation, make the beams of their eyes match those of the sun. They, however, are unable to meet painlessly the brilliance of the sun and turn their faces aside. This brilliance cannot be perceived directly because of its exceeding brightness, and therefore they attempt to catch the sun, the leader of the stars, in water mirrors— in this way it allows them to behold its harmless and kind visage. This way conforms to my intention: to behold you through the light-bearing and shining waters of the river Jordan [an allusion to the Feast of Lights commemorating Christ's Baptism], so that, O Sun King, your deeds and your rays were seen undiminished and the luster of your victories appeared in brightness. Let the good Jordan be at this time for my speech what the clear air is for the eyes. . . .

Such is he, O my listeners, our master and emperor, the common good for all, the much-compounded benefit, the union of virtues, the unity of all grace, "the good gift from above" that "comes down" upon us from munificent God [James 1:17]. He has the full right to be called a genuine king, not a false one, for whom the marvelous Plato sought but was not to find, as he himself put it, expressly saying that he had never seen the model and archetype, but only the image depicted, outlined and formed. In this regard we are more fortunate and successful than this wise man, since we have obtained in reality the king whom

he imagined in his dream, the king whose appearance is more delightful for his subjects than all visions. Nobody will remain unsatisfied who has the chance to view his sweet face or to listen to his conversation; to perceive him is equal to the taste of honey, for he actually surpasses in the pleasantness of his tongue the melodious and "clear-voiced orator" of Homer [Nestor; *Iliad* 1.248], whom I pray he will outdo in longevity.

Fontes 2:255, 279.

Ex. 27:
MICHAEL, NEPHEW(?) OF THE METROPOLITAN OF ANCHIALOS ON THE TASK OF TEACHING PHILOSOPHY

Let the Peripatus praise the almighty King. The Academy is to join it in this sacrifice, as well as the revived Lyceum and the majestic ancient Stoa. I beg you to reject and expel as useless all that is rotten and unsound in your tenets and to collect and embellish that which is skillful, refined and supportive of the truth in order to refute falsehood and to undo idle talk. Let the smith's mallet hammer the iron and transform it with heavy blows into a useful thing; let the bird provide the archer with feathers to be fixed in his arrow; let the serpent lend its flesh to physicians in order that, being attacked by its own blows, it becomes weak and ineffective. This is the emperor's newest invention, this is his tribunal rooted in ancient rules, in antique institutions, and which, like the net of the Holy Gospels [Matthew 13.47], is to be cast into the material sea and to gather of every kind, in order to adopt in a proper way that which is pure and genuine, whereas all that is unpure and unholy ought to be spit upon as worthless and dirty garbage.

R. Browning, *Studies on Byzantine History, Literature and Education* (London, 1977), part 4, 189.69–84.

Ex. 28:
CRITIQUE OF THE ESTABLISHMENT: THE WAR OF THE CAT AND MICE

CHEESETHIEF [*Tyrokleptes*]
What does it mean? Do you dare to menace him
who dwells in heaven and who proclaimed to the immortals:
"I will hang the great chain down from the axis of the world
And pull all of you up with my mighty hand" [an allusion to *Iliad* 8.19–20]?

LARDEREATER [*Kreillos*]
O well, I have menaced him a thousand times.
I talked to him about my life,
about my pitiable existence in a small corner,
in utter gloom and darkness.
I am trembling with fear and anxiety,
the poor knowing no pleasure.
I was weeping and bewailing in despair,
striking and scratching my cheeks

and swearing against Zeus, the consul of the Gods,
and I added to my groaning and anger
fearful threats full of danger.

H. Hunger, *Der byzantinische Katz-Mäuse-Krieg* (Graz, Vienna, Cologne, 1968), 90f., v. 88–102.

Ex. 29:
A SCENE IN HELL

After a short silence my good guide said: "O stranger, I am baffled by your boorishness and lack of knowledge of simple things. I wonder whether you know that all mice are the earth's litter and that their tribes appear at the time of drought, when the earth gets cracks? As a matter of fact, it is more proper to regard them as an underground population that has filled up the dwellings of Hades rather than one that lives up there in the world. They do not come down here from there, but they climb up from us, from the bottom of the world to the surface. So do not be astonished that mice live among us and that they are so tame and eat the same food as we do, sharing none of the apprehension of the field mouse. Can you see how manifest is their joy when they look at this old man eating? They are exulting; they move their jaws and lick their lips with their tongues, as if they are more surfeited with fat than the old man himself." What he said was the clear truth, as I could observe while scrutinizing the mice. "Do you notice," he kept saying, "that they are concerned with his beard and only wait until he falls asleep? As soon as they hear him wheezing, as he does in slumber, they'll come to lick his beard, which has been washed by rich juice, and to gulp a bellyful of all the crumbs stuck there. They live on that, and, as you see, they are well fed."

Pseudo-Lucian, *Timarion*, ed. Romano, 67f.

Ex. 30:
ANNA COMNENA ON THE PREDICTION OF A SOLAR ECLIPSE

Alexios saw through the Scythian fraud: their embassy was an attempt to evade the imminent peril, and, if they were granted a general amnesty, it would be a signal for the underlying spark of evil to be kindled into a mighty conflagration. He refused to hear the envoys. While these exchanges were taking place, a man called Nikolaos, one of the under-secretaries, approached the emperor and gently whispered in his ear, "Just about this time, Sir, you can expect an eclipse of the sun." The emperor was completely sceptical about it, but the man swore that he was not lying. With his usual quick apprehension, Alexios turned to the Scyths, "The decision," he said, "I leave to God. If some sign should clearly be given in the sky within a few hours, then you will know for sure that I have good reason to reject your embassy as suspect, because your leaders are not really negotiating for peace; if there is no sign, then I shall be proved wrong in my suspicions." Before two hours had gone by there was a solar eclipse; the whole disk of the sun was blotted out as the moon passed before it [August 1, 1087]. At this the Scyths were amazed. As for Alexios, he handed them over to Leo Nikerites with instructions to escort them under strong guard as far as Constantinople.

Anna Comnena, *The Alexiad*, transl. Sewter, 221 (K. Ferrari d'Occhieppo, "Zur Identifizierung der Sonnenfinsternis während des Petschenegenkrieges Alexios I Komnenos (1084)," *JÖB* (1974), 179–84 discusses this event).

Ex. 31:
DIETARY PRESCRIPTIONS

ABOUT CUCUMBERS

Cucumbers [*angouria*], which formerly were called bottle-gourds [*sikya*], are cold and fluid according to the second degree. The mixture of cold and fluid is very damaging and creates bad juices. Among them one should choose the small ones. They are diuretic and if taken with a severe fever will make the temperature more moderate and significantly milder. However, their constant use could weaken the organs of generation and diminish the desire for sexual intercourse. The dried seeds of cucumbers gain a certain warmth, create a contrary effect and become particularly diuretic.

ABOUT BUTTER

Butter is harmoniously warm and nutritious. It is good for the lungs and the chest and helps to discharge saliva out of them. It is serviceable against the cough produced by cold or dryness. Used in sufficient quantities, butter stimulates [the evacuation of] the stomach. The older it is, the warmer it becomes, and it is more nutritious than any olive oil. It promotes digestion and perspiration, especially in feeble bodies. Therefore it cures swollen glands and tumors when smeared over [them] and alleviates children's pain during teething. If used excessively, it sometimes causes nausea and loss of appetite. In warmer bellies it is frequently transformed into a light bile.

Symeon Seth, *Syntagma de alimentorum facultatibus*, ed. B. Langkavel (Leipzig, 1868), 21f., 27.

Ex. 32:
THE CONCEPT OF IMPERIAL POWER IN THE TENTH CENTURY

The Almighty shall cover thee with his shield, and thy Creator shall endue thee with understanding; He shall direct thy steps, and shall establish thee upon a sure foundation. Thy throne shall be as the sun before Him, and His eyes shall be looking toward thee, and naught of harm shall touch thee, for He hath chosen thee and set thee apart from thy mother's womb, and hath given unto thee His rule as unto one excellent above all men, and hath set thee as a refuge upon a hill and as a statue of gold upon a high place, and as a city upon a mountain hath He raised thee up, that the nations may bring to thee their gifts and thou mayest be adored of them that dwell upon the earth. But Thou, O Lord my God, whose rule abideth unharmed forever, prosper him in his ways who through Thee was begotten of me, and may the visitation of Thy face be toward him, and Thine ear be inclined to his supplications. May Thy hand cover him, and may he rule because of truth, and may Thy right hand guide him; may his ways be made straight before Thee to keep thy statutes. May foes fall before his face, and his enemies lick the dust. May the stem of his race be shady with leaves

of many offspring, and the shadow of his fruit cover the kingly mountains; for by Thee do kings rule, glorifying Thee forever and ever.

Constantine Porphyrogenitus, *De administrando imperio*, transl. R. J. Jenkins (Washington, D.C., 1967), 47.

Ex. 33:
KEKAUMENOS ON FEALTY TO THE EMPEROR

If someone revolts and proclaims himself emperor, do not support his scheme, but stand aloof from him. If you are able to wage war and assault the usurper, fight on behalf of the emperor and the common peace. If you are unable, stand aloof from him, as I have said already, and together with your people seek a fortress, write to the emperor, and try to serve him to the best of your capacity, in order that you and your children and your people be rewarded. If you have no band to seize a fortress, leave everything and flee to the emperor. If, however, you do not dare to escape because of your household, stay with the rebel, but let your mind be turned toward the emperor, and when an occasion comes, commit a praiseworthy deed: while in the camp of the rebel, ally with your dearest [literally, "those who are stronger than the soul"] friends [of your loyalty] and move to seize the rebel. Preserve fealty to the emperor in Constantinople, and you won't fail in your expectations. . . .

I beseech you, my beloved children, whom God gave to me, to side with the emperor and keep serving him, since the emperor who has his seat in Constantinople must always win.

Sovety i rasskazy Kekavmena, ed. G. G. Litavrin (Moscow, 1972), 248.13–27; 268.12–13.

Ex. 34:
NIKETAS CHONIATES ON THE EMPEROR

Each ruler is exceedingly timid and suspicious and enjoys acting like Thanatos [Death], Chaos, and Erebos [Darkness], pruning *eupatridai*, ruining everyone who is high and lofty, casting down as vile refuse the good counselor and cutting off the able and useful general. Earthly rulers simply resemble tall pine trees with leafy crowns: those first breathing the wind begin to move the needles of their branches and to murmur; rulers, in the same way, tremble when they see anyone who is distinguished by his wealth or who surpasses others in his prowess. The crowned prince cannot sleep and remain tranquil if he sees a man who is as beautiful as a statue or as eloquent as a singing [literally, "leader of the Muses"] bird or who has genteel manners. He regards such a man as inducing insomnia, overturning mirth, destroying pleasure, and causing concern. The ruler abuses and blames creative nature for having brought forth other people who are worthy of command, and not him alone, to be first, uppermost, and best among men. Finally, they launch war against Providence and arm themselves against the Godhead by strangling all who are good and slaughtering them as a sacrifice. By so doing they hope to secure quiet and to rejoice in their isolation, [to treat] state property as if it were an ancestral allotment, to exploit free people as slaves, and to treat those who are worthy of command as if they were hired serfs. Due to their power they lose perception and are deprived of reason, and in their wrong thinking they forget the past.

Nik. Chon. 143.43–64.

Ex. 35:
THE BYZANTINE VIEW OF CONSTANTINOPLE

Lift up your eyes round about [Isaiah 49:18], O most orthodox of kings: you are the ultimate cause of all these miracles, and lo, almost all your subjects gather themselves together and come to you. Give ear, shepherd of chosen Israel, you lead this ample people like a flock [Psalms 79:2]. Perceive this multitude whose array is so remarkable, whose obedience so voluntary, whose piety is superhuman and whose love is innate. They all rushed here spontaneously to this holy Zion, to this faithful metropolis, to your new Jerusalem, whose creators and builders were God and you. Therefrom shall go forth the righteousness and the law [Isaiah 2:3], all that you have beautifully taught and indoctrinated and that even earlier was set right in actions. Everyone who has dwelt there misses the city. God is in her midst [Psalms 45:6]. She is not tempest-tossed. He founded her [Psalms 23:2] like the earth upon the floods, a miracle for beholders, a miracle for listeners, a city that is raised above the ground, almost in mid-air, and barely held down by the sea and even less by the land.

Today she welcomes your subjects and makes clearly manifest the grandeur of your might as it really is. She finds unlimited space for thousands and thousands, for crowds uncounted and unmarked, who have streamed as if following a sign from the ends of the world to this splendid and well-seen place, to the common resting-site of the whole *oikouumene*. She accommodates in herself innumerable cities, countries, and tribes whom He gave into your hands, He who by ineffable providence subdued your people to you, the people virtually above all people [Exod. 19:5], exceedingly plentiful like the stars of the sky and the sand on the beach of the sea, welded together from all ages and strata, collected from different ranks and orders—monks and married persons, priests and laymen, magnates and the rank and file, civilians and soldiers, nobles and commons, rich and poor, prominent and humble—but in their essence they all are honorable and worthy servants of such a power and become even more honorable because of your imperial highness and the philanthropy generously poured upon everyone.

John Mauropous, Speech at the Feast of St. George (1047), ed. de Lagarde, "Quae supersunt," 140f.

Ex. 36:
DESCRIPTION OF CONSTANTINOPLE

The city itself is squalid and fetid and in many places harmed by permanent darkness, for the wealthy overshadow the streets with buildings and leave these dirty, dark places to the poor and to travelers; there murders and robberies and other crimes which love the darkness are committed. Moreover, since people live lawlessly in this city, which has as many lords as rich men and almost as many thieves as poor men, a criminal knows neither fear nor shame, because crime is not punished by law and never entirely comes to light. In every respect she exceeds moderation; for, just as she surpasses other cities in wealth, so too, does she surpass them in vice.

Odo of Deuil, *De profectione Ludovici VII*, transl. Berry, 65.

Ex. 37:

VLACHS ON BYZANTINE TERRITORY: STORY FROM THE
REIGN OF EMPEROR ALEXIOS I (1081–1118) AND PATRIARCH
NICHOLAS (1084–1111)

The devil entered the hearts of the Vlachs. They had with them their women, who wore male attire as if they were faithful; they tended sheep and served the monasteries [on Mount Athos]. They brought [*koubalousi*, modern Greek] to the monks cheese, milk, and wool [*mallia*, modern Greek] and prepared dough at the orders of the monasteries. To put it simply, they were serfs [*douloparoikoi*] and for the monks a beloved people. But it is shameful to tell and to listen to what they have done. . . . [The devil] provoked holy old men, after the patriarch issued the order [to expel the Vlachs from Mount Athos], inducing them [to say] that we should die there and should be culpable for our lives. . . . Then one could see a terrible thing that was worthy of great lamentations: the hermit [*hesychastes*] came weeping to those whom he instructed in the eremitic life, and he told them words that the demons had taught him to say. And similarly the *hegoumenos* [abbot] addressed his flock [saying] that from this time on we should have neither life nor relaxation after the Vlachs and their herds were expelled, and that the patriarch has chained the whole mountain, even the woods and the water. . . . And so a whole throng of monks left with the Vlachs right to the leader of the world [Satan]. Sorrow filled our heart, since [it was apparent that] it was not only the demons who enjoyed that [occasion] but also the monks. There were three hundred Vlach *famelia* [households] that the emperor [in his letter] to the patriarch called *katunai*; he frequently thought over the possibility of imposing on them the tithe (*dekateia*), but the administrators of the districts did not support this, for they disliked overburdening the monasteries. . . . O miraculous story! They said that one hermit of the region, a famous one fearful for demons, left together with a certain Vlach, and that a very pious *hegoumenos* left with a man who followed him, and as well other monasteries left as a whole community with their beloved Vlachs. It was possible to see the God-founded, God-protected monasteries guarded only by lame [*koutzos*, modern Greek] and blind old brethren.

Ph. Meyer, *Die Haupturkunden für die Geschichte der Athosklöster* (Leipzig, 1894), 163–65.

Ex. 38:

POLOVTSY AND VLACHS ON BYZANTINE TERRITORY:
ORDINANCE OF ANDRONIKOS I (1184)

The monks of the honorable Monastery of St. Athanasios on Mount Athos informed my imperial majesty that the Cumans [Polovtsy] came up to the mountainous pastures [*planena*] called Pouzouchia that belonged to the monastery, establishing there folds for their animals and letting them graze licentiously; and now they are refusing to pay the customary tithe [*dekateia*] for their animals. If it is really so, my imperial majesty enjoins that tax collectors [*praktores*] from Moglena, on the basis of this ordinance [*prostaxis*] of my imperial majesty enforce them [the Cumans] to pay to the Monastery of St. Athanasios all the tithe, as well as other proper items [*kephalaion*]. They should not dare, after the issue of this ordinance of my imperial majesty, to commit something of the same sort; and they are not allowed to treat the Vlachs and Bulgarians, who are not theirs,

as their dependents [oikeioi]; but the above-mentioned monastery is to exact [payments from them] according to traditional norms. If they do not show a conciliatory spirit, but keep doing wrong in some way or another, or exempting [exkousseuein] the Vlachs and Bulgarians, according to their present illegal practice, the praktores will expel them from the afore-mentioned planena even against their will.

Lavra 1, no. 66.1–6.

Ex. 39:
TURKS IN THE BYZANTINE EMPIRE

The autocrator, even from afar, perceived a strange roar, and whereas all others were puzzled and could not understand whence this strange nocturnal noise came, he alone recognized the roaring river and the numerous Persian armies crossing the stream. O efficient mind knowing with the sharpness of divination! O military experience that even at night is not to be surpassed! O vigilant eye of reason able to distinguish from afar what is hidden by darkness! For you, barbarians, Hell is the only proper abode. Even though you are not rushing thereto, the emperor will send you there against your will. Your gold that you had collected as tribute while crossing the plains of Dorylaion has perished, the numerous armies that your country had nourished have perished, your herds of horses and cows and sheep have perished and you have suffered misfortune, even your most important limbs are severed. Now you are more miserable than yourselves. In great numbers, by tribes and by clans, you all came of your own accord to the Rhomaioi and exchanged the mishaps of liberty for happy serfdom. And now "the wolf shall dwell with the lamb, and the leopard shall lie down with the kid" [Isaiah, 11:6].

Euthymios Malakes, Speech to Manuel I Comnenus, ed. K. Mpones, "Euthymiou tou Malake metropolitou Neon Patron (Hypates) Dyo enkomiastikoi logoi, nyn to proton ekdidomenoi eis ton autokratora Manouel I Komnenon (1143/80)," Theologia 19 (1941–48), 541.15–33.

Ex. 40:
AN EXEMPTION FROM BILLETTING FOREIGN TROOPS (1088)

The whole of the above-mentioned island [Patmos], as well as the monastery with all its properties, is granted exkousseia [exemption] from the billetting [mitata] of all commanders, both Roman [Rhomaioi] and foreign allies, that is the Rus, Varangians, Koulpingoi [an enigmatic people identified with the Kolbiagi of the Russkaja pravda], Inglinoi, Frangoi [Normans], Nemitsoi [Germans], Bulgarians, Saracens, Alans, Abasgoi, the Immortals, and all other Romans and foreigners.

Alexios I's chrysobull for the Monastery of St. Christodoulos on the island of Patmos, MM 6:47.3–7.

Ex. 41:
WESTERN MARRIAGE ALLIANCES

In the year 1180 [this date is uncertain] in the eleventh indiction, Emperor Emanuel sent his envoys, that is Comunianus [Chumnos?], Count Alexios Raynieri Strambo and Baldwin Guercio, with his [the emperor's] niece, in order to marry

her to the brother of the king of Aragon. He, however, turned her down because of his fear of the emperor of Alemania. Eventually they gave her to William, the Good Man [*homo bello*] of the mountain Pezolano [Montpellier]. The imperial envoys concluded and made a pact and agreement with the king of France [Louis VII] that he would give his daughter to the son of Emanuel, the emperor of Constantinople. They accomplished and finished the thing, and brought her on seventeen galleys and two *bussi*, of which four galleys were rigged by William of Mompellieri at his cost, and this William came to Pisa with those four galleys and Chuminianus with one boat, and they entered Pisa on the fifth day of May and were received with great honor by the soldiers and with great acclamation and triumph by the whole population.

Bernardo Maragone, *Annales Pisani*, ed. L. A. Muratori, *Raccolta degli storici italiani*, vol. 6, part 2 (Bologna, 1930), 68f.

Ex. 42:
RUSSIANS IN BYZANTIUM: THE RUSSIAN CHRONICLE (IPATSKY REDACTION)

The year 6670 [1162]. . . . In the same year, the sons of Yurij came to the imperial city, Mstislav and Vasilko, with their mother, and they took with them the young Vsevolod, the third brother. And the king [Emperor Manuel I] gave four towns on the Danube to Vasilko and the district [*volost'*] Otskalan to Mstislav.

Letopis po Ipatskomu spisku (St. Petersburg, 1871), 357.

Ex. 43:
RUSSIANS IN BYZANTIUM (FROM KINNAMOS)

At the same time, Vladislav, one of the principal persons in Russia, came as a refugee to the Romans with his children and his wife and all his forces, and a property along the Danube was granted to him. Previously the emperor had given it to the refugee Vasilika, the son of George, who had the principal place among the chieftains in Russia.

Deeds of John and Manuel Comnenus, transl. C. M. Brand (New York, 1976), 178.

Ex. 44:
RUSSIANS IN BYZANTIUM: LEGEND OF A LEAD SEAL (ELEVENTH OR TWELFTH CENTURY)

The seal of John Ros *protovestes*

ed. V. Laurent, *La collection C. Orghidan* (Paris, 1952), no. 69.

Ex. 45:
RUSSIANS IN BYZANTIUM: AN ANONYMOUS EPIGRAM

On the *enkolpion* that has an honorable stone from Christ's tomb:
A particle of the stone that covered the Tomb, as the foundation stone and the basis [of the *enkolpion*] is carried by Theodore Ros of regal kin.

S. Lampros, "Ho Markianos Kodix 524," *Neos Hellenomnemon* 8 (1911), 153, no. 254.

Ex. 46:

RUSSIANS IN BYZANTIUM: JOHN TZETZES' LETTER TO THE METROPOLITAN OF DRISTRA

I have received the reverend letter sent me by your Holiness, together with your bounty, your most divine Grace, both the young slave who has now been renamed from Vsevolod to Theodore, and that "bull-carved" or, if you like, "Russian-carved," little box for containing ink, on which has been carved in relief out of fishbone a quite unspeakable beauty surpassing the fabled handiwork of Daedalus.

J. Shepard, transl., "Tzetzes' Letters to Leo at Dristra," *Byz. Forsch.* 6 (1979), 196.

Ex. 47:

TZETZES' LINGUISTIC KNOWLEDGE

One finds me Scythian among Scythians, Latin among Latins,
And among any other tribe a member of that folk.
When I embrace a Scythian I accost him in such a way:
"Good day, my lady, good day, my lord:
Salamalek alti, salamalek altugep [altï bäg]," [a]
And also to Persians I speak in Persian:
"Good day, my brother, how are you? Where are you from, my friend?
Asan khais kuruparza khaneazar kharandasi [garu barsa? Xanta(n) ä(r)sär?
 garindaš]?"
To a Latin I speak in the Latin language:
"Welcome, my lord, welcome, my brother:
Bene venesti, domine, bene venesti, frater.
Wherefrom are you, from which theme do you come?
Unde es et de quale provincia venesti?
How have you come, brother, to this city?
Q[u]omodo, frater, venesti in istan civitatem?
On foot, on horse, by sea? Do you wish to stay?
Pezos, caballarius, per mare? Vis morare?"
To Alans I say in their tongue:
"Good day, my lord, my archontissa, where are you from?
Tapankhas mesfili khsina korthi kanda, and so on." [b]
If an Alan lady has a priest as a boyfriend, she will hear such words:
"Do not be ashamed, my lady; let the priest marry you [*to mounin sou*].
To farnetz kintzi mesfili kaitz fua saunge."
Arabs, since they are Arabs, I address in Arabic:
"Where do you dwell, where are you from, my lady? My lord, good day
 to you.
Alentamor menende siti mule sepakha [ila ayna tamurru? min ayna anta? sitti!
 mawlay! Sabah]." [c]
And also I welcome the Ros according to their habits:
"Be healthy, brother, sister, good day to you.
Sdraste, brate, sestritza," and I say, "dobra deni."
To Jews I say in a proper manner in Hebrew:
"You blind house devoted to magic, you mouth, a chasm engulfing flies, [d]
 memakomene beth fagi beelzebul timaie,

You stony Jew, the Lord has come, lightning be upon your head.
Eber ergam, maran atha, bezek unto your khothar."
So I talk with all of them in a proper and befitting way;
I know the skill of the best management.

> ed. H. Hunger, "Zum Epilog der Theogonie des Johannes Tzetzes," in his *Byzantinische Grundlagenforschung* (London, 1973), part 18, 304f.

> [a] Gy. Moravcsik, *Byzantinoturcica* 2 (Berlin, 1958), 19.
> [b] See B. Munkarcsi, "Beiträge zur Erklärung der 'barbarischen' Sprachreste in der Theogonie des J. Tzetzes," *Körösicsoma-Archivum* 1, add. vol. 3 (1937), 267–81.
> [c] transcribed by Irfan Shahid.
> [d] Beelzebub is Lord of the Flies.

Ex. 48:
PATRIARCH MICHAEL KEROULLARIOS ON THE ERRORS OF THE LATINS

You should know that the Romans are pierced not by a single arrow, that is, by [the error of] unleavened bread—that is known by everybody—but also by many and various [arrows], which are necessary to turn aside. This is what the Judaized are doing: the charge impending upon them concerns not only unleavened bread, but also that they eat suffocated animals, shave themselves, celebrate Saturdays, eat abominable meats, that [Latin] monks eat meat [including] pigs' fat and the whole skin that is close to the meat, and that they do not observe the first week of Lent or the week of Abstinence [the second week before Lent] or the week of Cheese [the week preceding the strict Lenten fast]. They will eat meat on Thursday and cheese and eggs on Friday, but will fast the whole day on Saturday. Besides that, there are the following faults: the wrong and harmful addition to the Holy Symbol of the following—"The Holy Spirit, the life-giving Lord, proceeds from both the Father and the Son," and during the holy liturgy they proclaim—"One holy, one Lord Jesus Christ in the glory of God the Father by the Spirit." Further, they prohibit the marriages of priests, i.e., they do not grant priesthood to those who have spouses, but demand that priests remain celibate; two [brothers] might marry two sisters; at the moment of communion in the liturgy the one who administered the liturgy eats the unleavened [particles] and embraces the others; their bishops wear rings on their hands as if they have taken churches as their wives and have to wear the pledge; [bishops] will go to war and stain their hands in blood and kill or be killed; and we are told that while performing baptism they baptize by immersion only while proclaiming the name of the Father and Son and Holy Spirit, and in addition fill up the mouth of the baptized with salt.

> Epistle to Peter, patriarch of Antioch in 1054, *Acta et scripta quae de controversiis ecclesiae Graecae et Latinae saeculo undecimo composita extant*, ed. C. Will (Leipzig, Marburg, 1861), 180–82.

Ex. 49:
BOHEMOND'S CUNNING

Bohemond shuddered at the emperor's threats. Without means of defense (for he had neither an army on land nor a fleet at sea, and danger hung over him on

both sides) he invented a plan, not very dignified, but amazingly crafty. First he left the city of Antioch in the hands of his nephew Tancred, the son of the Marquis Odo; then he spread rumors everywhere about himself: "Bohemond," it was said, "is dead." While still alive he convinced the world that he had passed away. Faster than the beating of a bird's wings the story was propagated in all quarters: "Bohemond," it proclaimed, "is a corpse." When he perceived that the story had gone far enough, a wooden coffin was made and a bireme prepared. The coffin was placed on board and he, a still breathing "corpse," sailed away from Soudi, the port of Antioch, for Rome. He was being transported by sea as a corpse. To outward appearance (the coffin and the behaviour of his companions) he was a corpse. At each stop the barbarians tore out their hair and paraded their mourning. But inside Bohemond, stretched out at full length, was a corpse only thus far; in other respects he was alive, breathing air in and out through hidden holes. That is how it was at the coastal places, but when the boat was out at sea, they shared their food with him and gave him attention; then once more there were the same dirges, the same tomfoolery. However, in order that the corpse might appear to be in a state of rare putrefaction, they strangled or cut the throat of a cock and put that in the coffin with him. By the fourth or fifth day at the most, the horrible stench was obvious to anyone who could smell. Those who had been deceived by the outward show thought the offensive odour emanated from Bohemond's body, but Bohemond himself derived more pleasure than anyone from his imaginary misfortune. For my part I wonder how on earth he endured such a siege on his nose and still continued to live while being carried along with his dead companion. But that has taught me how hard it is to check all barbarians once they have set their hearts on something: there is nothing, however objectionable, which they will not bear when they have made up their minds once and for all to undergo self-inflicted suffering.

Anna Comnena, *The Alexiad*, transl. Sewter, 366–67.

Ex. 50:
THE CAPTURE OF THESSALONIKI BY THE NORMANS

What should I say about those who threw themselves down from the roofs of houses in search of death when the great evil was already surrounding them? They were unable to fly up into the ether (how they did desire that!) but suffered from their weightiness and crashed to their deaths having fallen from a [great] height. And what of those men and women who leaped into wells as into the water of some Kokytos [River of Wailing] or Acheron—the men being afraid of a worse calamity and the women for the sake of their chastity [*semnotes*; literally, "dignity"]? There was nothing strange in this falling and failure [a pun in Greek: *emptosis te kai kataptosis*], since these people not only sought rocks to rend and cover them, hills to roll down and hide them [Luke 23:30 and Revel. 6:16], and the sky itself to fall upon them, but also they imagined somehow that Chaos and Tartarus would give them abode and refuge. Truly the notorious Barathron and other precipices are a trifle for those who long for their own ruin. O! the stones that the barbarians were hurling against them did not permit them to lift their heads, but they covered and buried the wretched.

But woe to them that were with child at that time [Mk. 13:17]. Their beloved

burden given them by nature itself hampered their flight, and they succumbed to the nether world from feebleness [an allusion to *Odyssey* 5.468] even before they were slaughtered by the sword. No less sorrowful was the destiny of the mothers with whom their tender children were fleeing. In the beginning they stayed together, but as evil urged haste, the mothers unfortunately were winning the race. Then they would turn back, but could not find their beloved rivals, who had been murdered at the order of a certain Herodes, or they perished too, being captured by the enemy, who hated those women who returned not to satisfy his lust, but to bewail the last course of their children. And fathers fled away too, leaving their newborns as orphans. Babies wept as if entreating help, but their fathers ran on without turning their heads; in vain was nature calling. . . . Even if a parent managed to save his own life, the children perished, being trampled and pushed down, thus adding to the number of corpses of the adults. In the same way the hairy ram would run away at the sight of wolves, leaving behind his issue, and the wolf has no mercy upon them.

> Eust. *Esp.* 118.3–33.

Ex. 51:

DESCRIPTION OF THE INSURRECTION OF JOHN COMNENUS THE FAT: PREFATORY REMARKS BY CHRYSOBERGES

This worthy oration, [written] according to Hellenic traditions, that I am bringing to be delivered to you, O my king—all this rhetorical skill will be my customary present to you. But which custom am I hinting at, O most gentle of emperors? When a certain person seized a fortress in Hellas and tried, self-elected and self-proclaimed, to establish his tyranny, and eventually was expelled therefrom, and a noble hero beheaded him with his brazen dagger, the whole city brought a reward to the hero for his victory over the tyrant. Well, if an ordinary warrior and private citizen got a reward, according to custom, after he had accomplished his deed, what should I say about the remuneration befitting the thrice-noble hero, the emperor? Take this verbal present, O my king, since you are the tyrant killer and the noble hero who put down this attempt at capricious usurpation. Even if it were your well-born cuirassiers and your steadfast spearmen who toppled to the earth this arbitrary action, you are to be praised for your perfect administration and diligent deliberation, which you set against this confused band of soldiers.

> Nikephoros Chrysoberges, *Ad Angelos orationes tres*, ed. M. Treu (Breslau, 1892), 19–26.

Ex. 52:

DESCRIPTION OF THE INSURRECTION OF JOHN COMNENUS THE FAT: PREFATORY REMARKS BY MESARITES

The majority of those who have a profound and inventive mind, O my listeners, when they compose a story, combine truth and fiction according to their intelligence, since they wish to be persuasive and at the same time to embellish their narrative with elaboration and refinement; the unfitting and trustless source presents these embellishments more frequently than a reliable record of a man

fond of truth. One who learned of events from hearsay and then ventured to relate them is hardly capable of presenting them to his audience without distortion—in the same way that both the peculiarity [of the form] and the blooming gamut of colors characterizing the prototype will escape a painter who, while producing an image on an icon, refuses to trace precisely the prototype and copies the shadows only, not the archetypal image.

I will tell you why and for what purpose I issue my story. Many of you, both those who are acquainted with me and those who are not, know that I am the *skeuophylax* [guardian] of the holy vessels treasured in the most beautiful Shrine at the Pharos of the Virgin named Oikokyra, the head of the household. It is built within the Great Palace of the imperial majesty. Therefore the people asked me often and constantly, when they met me in churches, in the streets and squares, in avenues and alleys, to reveal to them everything from the very beginning of the event—that is, how John piratically assaulted the palace and entered there, what he did until late in the evening and how, at last, this madman was slaughtered by having his head cut off. I grew weary of these innumerable questions; my throat was sore because I had shouted throughout the day—it was July 31— and I could barely wheeze and was deprived of my speaking ability. On that day I had had to walk incessantly about the divine shrine even to repel those who had tried to enter the holy place like rabid, saw-toothed dogs looking for food. Since my voice was feeble and my throat ached, I decided to commit to paper [*charte*] and ink all my observations in order to make them manifest to all inquirers and listeners.

Nicholas Mesarites, *Die Palastrevolution des Johannes Komnenos*, ed. A. Heisenberg (Würzburg, 1907), 19f.

Ex. 53:

A LYRIC POEM BY PRODROMOS

O my passions and desires, I nurtured you when you were small,
and in my heart you grew large.
I looked forward to your maturity and expected your gratitude;
but you only torment me; nothing can be more cruel.

E. Legrand, "Poésies inédites de Théodore Prodrome," *Revue des études grecques* 4 (1891), 72. Translation by S. Franklin.

Ex. 54:

DESCRIPTION OF THE RAISING OF LAZARUS IN THE HOLY APOSTLES IN CONSTANTINOPLE

. . . and again, Lazarus, who had been laid in his grave and had rotted four days long, decaying, his body wholly changed, fully infested with wounds and worms, bound hand and foot in graveclothes and laid out, commanded by the life-bringing word of Christ, leaping from the tomb like a gazelle and thus returning once more to mortal life, having escaped corruption.

Constantine of Rhodes, *Description of the Church of the Holy Apostles in Constantinople*, ed. E. Legrand, "Description des oeuvres d'art et de l'église des saints apôtres de Constantinople," *Revue des études grecques* 9 (1896), 61.834–43.

Ex. 55:

DESCRIPTION OF THE RAISING OF LAZARUS IN THE HOLY APOSTLES IN CONSTANTINOPLE

Look at Martha and Mary, the sisters of the buried man, how on bent knees they are bowed over the feet of Jesus, washing them with the tears of their grief for their brother, and how they move their Teacher to weep with them for the beloved Lazarus, and bring Him who is the source of all succor to common emotion with them. The more vehement of the sisters holds her head high, and by the expression of her face alone, one might say, seeks to beseech the Lord, presenting her request to the Savior chiefly by means of her eyes and by the expression of suffering and grief on her whole face. But the Savior is depicted with a somewhat melancholy expression on His face, and His whole posture has assumed a very kingly and commanding aspect. The right hand rebukes both what is seen, namely the tomb which holds the body of Lazarus, and what is perceived by the mind, namely Hades, which four days before had made haste to swallow his soul. His mouth, however, which spoke little, to use the words of Isaiah, so that his voice was not heard in the streets, but which on the contrary had power for great things, according to another writer—for it is written, "He spake, and it was done"—called forth with a most divine voice to him who was no longer able to hear, only these words, "Lazarus, come forth." And Hades, trembling, as quickly as it could loosed the soul, which it had so eagerly swallowed, and Lazarus' soul once more enters its body, and the corpse rises from the tomb as from a bed and comes to Him who called him, bound in grave clothes like some slave who against his master's wish has run off into the country, and with his whole body shackled with handcuffs and chains on the feet is unwillingly brought back and restored to his owner. His entire body is bloated, wholly unapproachable because of the decay which has set in upon the wasted and putrefying body. The stone at the tomb, which covered Lazarus, has just been rolled away, and the tomb, from which he has now risen, is dark. The disciples cannot support the stench which is given forth by the tomb and by Lazarus; and hold their noses. They wish in curiosity to gaze upon him who is risen, but they roll their eyes backward because of the heavy stench which comes from him; they wish to praise with their lips and their tongues Him who raised him up, but they must cover their mouths with their mantles; they desire to be far from the place, but the strangeness of the miracle holds them and will not let them go. The Apostles are filled with amazement and full of astonishment, perceiving how with a word alone He had just now raised from the tomb a man who has already decayed. What manner of man can He be, they think to themselves, who has wrought such wonders; "Really this is in truth," they say. "He who once breathed the soul into Adam, and gave breath to the father of all, even though as a man, He wipes away the tears of his eyelids. How indeed should death and Hades obey Him, unless, in the words of the prophet, all things did not serve and obey Him?"

Nic. Mesar. 26.2–8.

Ex. 56:

THE SIXTH-CENTURY POET ROMANOS ON THE RAISING OF
LAZARUS

Prooimion: Thou hast come, O Lord, to the tomb of Lazarus
 And Thou hast raised him up after four days among the dead,
 After Thou has conquered Hades, O Powerful One.
 Taking pity on the tears of Mary and Martha (John 9:21–25),
 Thou hast said to them:
 "He will be resurrected and he will rise up
 Saying, 'Thou art the Life and Resurrection.'"
Strophe 1: In considering the tomb and those in the tomb, we weep,
 But we should not; for we do not know whence they have
 come,
 And where they are now, and who has them.
 They have come from temporal life, released from its sorrows;
 They are at peace, waiting for the receiving of divine light.
 The Lover of man has them in His charge, and He has
 divested them of their temporal clothing
 In order that He may clothe them with an eternal body.
 Why, then, do we weep in vain? Why do we not trust Christ, as
 He cries:
 "He who believes in me shall not perish (John 9:25),
 For even if he knows corruption, after that corruption,
 He will be resurrected and he will rise up
 Saying, 'Thou art the Life and the Resurrection'"?

Kontakia of Romanos, Byzantine Melodist, transl. M. Carpenter (Columbia, Missouri,
1970), 1.140.

Ex. 57:

MAUROPOUS EPIGRAM: ON LAZARUS

 Such is the essence of the Writ: listen and behold.
 There was a righteous man, Lazarus, a friend of Christ.
 He died, and the earth and the tomb covered him.
 His relatives wept as they were burying him;
 They did not conceive how mighty is He who loved him.
 So He came there. They cried
 Intensely, wailed and prostrated themselves,
 And they said that He had arrived too late.
 Then He said: "You shall see my power."
 So said the demiurge, "Where is the tomb of my friend?"
 "But look, he stinks, for it is the fourth day!"
 They answered, and looked at the Lord
 As if He who produces life were a hypocrite.
 When going there He groaned and wept,
 And asked for grace from Heaven.
 "You, the Almighty, who look from above, it is possible for you:
 Nearby is the witness. Would you command [it],

Lo, the sorrow will be transformed into a festival.
And He commanded [it]. "Come forth," He cried,
And breathed life into the corpse.
That is what Christ does for his friends,
He leads the dead out of the grave to live,
And the dead man walks, bound with graveclothes,
And is free, takes them off and runs.
The happy [man] will, I suppose, prepare a dinner
To entertain his beloved benefactor,
Through whom he lives again and needs food.

John Mauropous, ed. de Lagarde, "Quae supersunt," 4f.

Index

[Prepared by Peter S. Stern]

Cursus publicus (duty to serve), 18
Cyprus, 12, 27 n, 29, 49, 151, 152, 203; ce-
 ramics in, 41; conquest of, by Richard
 the Lion Hearted, 171; religious art
 and architecture on, 88–89, 111,
 216, 221
Cyrenaica, conquest by Arabs of, 10
Cyril (monk), 88
Cyril Phileotes. *See* Phileotes, Cyril,
 Saint
Cyzicus (town in Asia Minor), 47–48

Dagarabe (town in Armeniakon theme),
 68
Dalassa (a village in the region of
 Melitene), 63
Dalassena, Anna, 64, 101, 242–43
Dalassenos, Damianos, 63, 64
Dalassenos, Romanos, 64
Dalassenos, Theodore, 64
Dalassenos, Theophylaktos, 63–64
Dalassenos family, 63–64
Dalmatia, Cathar church in, 192
Damnastes, medical treatise by, 156
Dandolo, Enrico, Doge of Venice (1192–
 1205), 228
Danielis (a great landowner or ruler in
 Peloponnese), 17
Daniil (Russian pilgrim), 29
Danube River, 48, 49
Daphne (suburb of Antioch), 152, 153
Daphni (church in Greece), 39, 133,
 144, 198
Daphnopates, Theodore, 133, 136 n
Dark Age, use of term, 4–5
David, depiction of, in Byzantine art,
 141, 142, 221
David Kourpalates, the prince of Taiq
 (961–1001), 171
David of Mytilene, 3
Decentralization, Byzantine, 31–56; ar-
 chaeological and literary evidence of,
 31–39; art production as evidence of,
 39–46; and urban economy and in-
 stitutions, 45–56
Deljan, Peter, 114
Demetrianos of Cyprus, 3
Demetrios, Saint, 96, 116, 236
Demetrios of Lampe, 191
Demography, Byzantine, 26–27
Demokritos, 222
Demosiarioi (peasants), 20
Demosion (the state land system), 16–17

Desiderius (abbot of Monte Cassino), 44
Devresse, R., 41 n, 42
Diaconu, P., 33 n
Didactic Admonitions (Spaneas), 207–8
Didacticism, 206–10
Didaskaloi (teachers), Alexios I and,
 128, 129
Didymus harbor (Sidon), 152
Diet, 28–29, 80–82, 253; monastic,
 80–81; in seventh century, 5
Digenis Akritas, 117–19, 182; extracts
 from, 245–46, 247–48
Digests (Justinian), 145
Dinogetia-Garvǎn (town on Danube), 33
Diocletian, Emperor, 76
Dionysiou Monastery (Mount Athos),
 Cod. 587, Gospel Lectionary, 98
Dipylon (Athens), 34
Divorce, laws regarding, 100
Doctrinal Panoply (Zigabenos), 163,
 186–87
Dodekanese Islands, 40 n
Dokeia (Asia Minor), 63
Dokeianos family, 63
Domenico Silvo (Doge of Venice, 1070–
 84), 179
dominium directum, 18
Dorylaion (town in Asia Minor), 38, 47
Doukaina, Anna, Princess, 131
Doukaina, Eirene, Empress, 90, 101,
 202, 204
Doukas, Andronikos, 235
Doukas, Constantine. *See* Constantine X
 Doukas
Doukas, John Caesar, 68, 101, 131
Doukas, John, Isaac II's uncle, 228
Doukas family, 64, 103, 106, 127, 179
doukates (military districts), 71
Dragometia (or Dragovita; near Thes-
 saloniki), 192
Dress, Byzantine, 74–80, 181, 242
droungarios, title, 57, 70
Dualism, as heresy, 162
Dumbarton Oaks Collection, Byzantine
 silver in, 46
dynatos, 21, 56, 57
Dyrrachium (town on Adriatic coast),
 Norman victory at, 24, 174
Džedžovi lozja (location in Bulgaria), 29 n

Eclipse, solar, 252–53
Economy, Byzantine: before eleventh
 century, 2, 8–9, 11; eleventh–twelfth

Designer:	Mark Ong
Compositor:	G&S Typesetters, Inc.
Text:	10/13 Palatino
Display:	Palatino
Printer:	Thomson-Shore, Inc.
Binder:	John H. Dekker & Sons